# Graphic Design for the 21st Century

Grafikdesign im 21. Jahrhundert
Le design graphique au 21ᵉ siècle

**Endpapers**
"Demented Forever Series" for Erste Liga
Gastronomie. Büro für form, 2001.

**Pages 4–5**
Billboard for Adbusters. Jonathan Barnbrook, 2002.

**Pages 10–11**
Advertisement for Rote Fabrik (CH). François Chalet,
2001.

To stay informed about upcoming TASCHEN titles,
please request our magazine at www.taschen.com
or write to TASCHEN, Hohenzollernring 53,
D–50672 Cologne, Germany, Fax: +49-221-254919.
We will be happy to send you a free copy
of our magazine which is filled with information
about all of our books.

© 2003 TASCHEN GmbH
Hohenzollernring 53, D–50672 Köln
**www.taschen.com**

Editorial coordination: Sonja Altmeppen, Cologne
Production: Ute Wachendorf, Cologne
German translation: Annette Wiethüchter, Berlin
French translation: Philippe Safavi, Paris

Printed in Italy
ISBN 3–8228–1605–1

**Acknowledgements**
We would like to express our immense gratitude to all
those designers and design groups who agreed to
take part in this project – there wouldn't have been a
book without your participation. Additionally we offer
our thanks to Anthony Oliver for his excellent new
photography that was specially undertaken for this
project. Lastly and by no means least we must give a
very special mention to Eszter Karpati, our research
assistant, whose good nature and formidable
researching skills have driven the project from
start to finish.

**Danksagung**
Als Herausgeber möchten wir allen Grafikern und
Grafikdesignbüros von Herzen danken, dass sie sich
an diesem Buchprojekt beteiligt haben. Ohne Ihre
bereitwillige Mitwirkung hätte es diesen Band nicht
gegeben. Wir bedanken uns auch bei Anthony Oliver
für seine ausgezeichneten Neuaufnahmen, die er
eigens für dieses Buch angefertigt hat. Last not least
müssen wir unbedingt unsere Forschungsassistentin
Eszter Karpati lobend erwähnen, deren Geduld und
Findigkeit das ganze Vorhaben von Anfang bis Ende
vorangetrieben haben.

**Remerciements**
Nous aimerions exprimer toute notre gratitude aux
graphistes et groupes de graphistes qui ont accepté
de participer à ce projet ; sans eux, ce livre
n'existerait pas. Merci à Anthony Oliver pour ses
excellentes photos prises spécialement pour cet
ouvrage. Enfin, et non des moindres, une mention
spéciale à Eszter Karpati, notre documentaliste,
dont le bon caractère et les formidables talents de
recherche ont guidé ce projet du début à la fin.

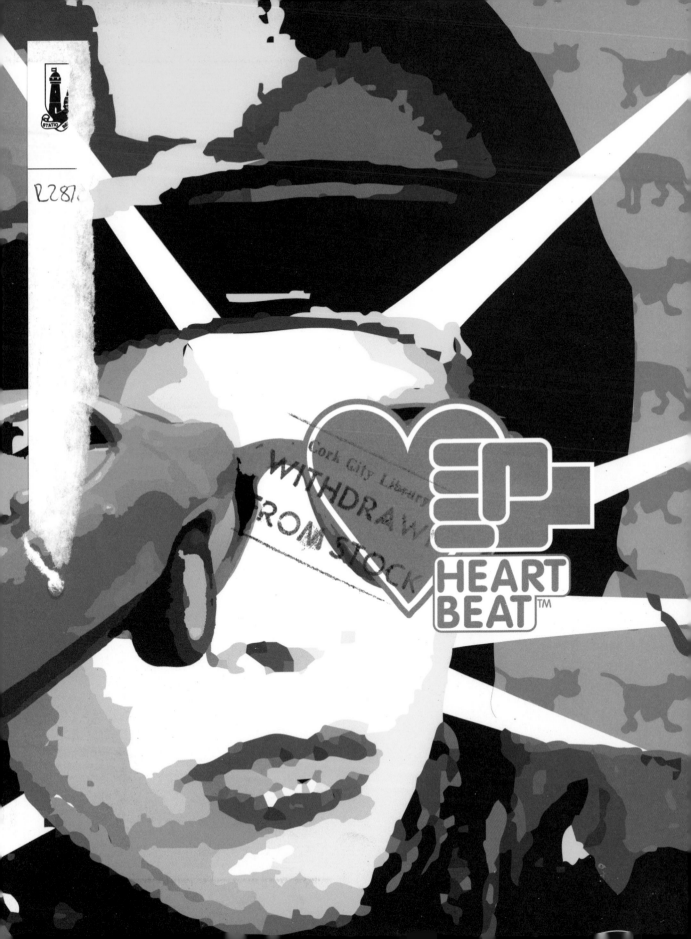

HEART
BEAT ™

# Graphic Design for the 21st Century

**Grafikdesign im 21. Jahrhundert**
**Le design graphique au 21ᵉ siècle**

100 of the World's Best Graphic Designers
Charlotte & Peter Fiell

TASCHEN

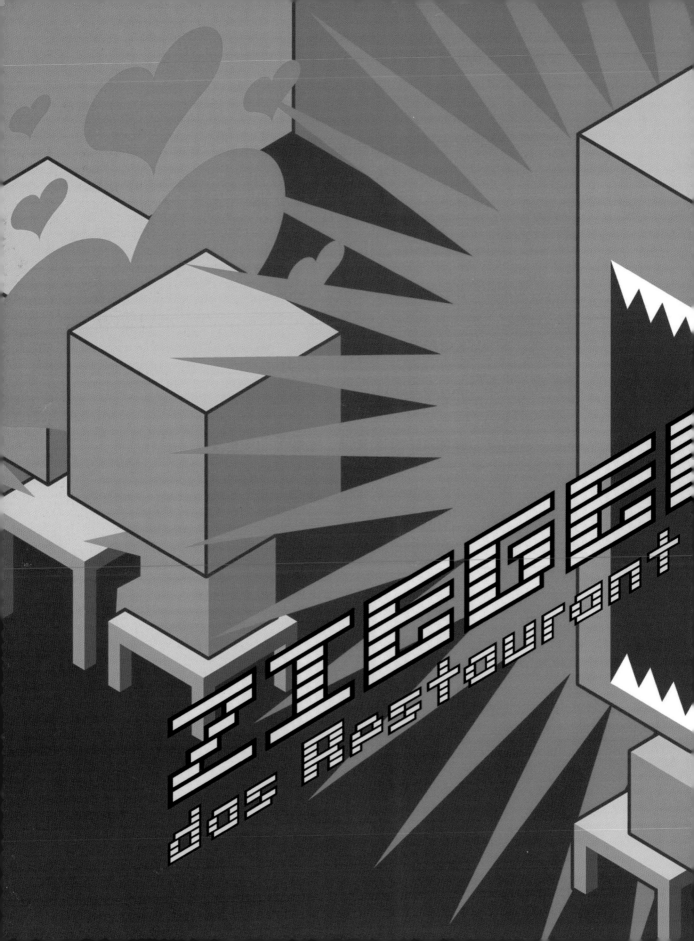

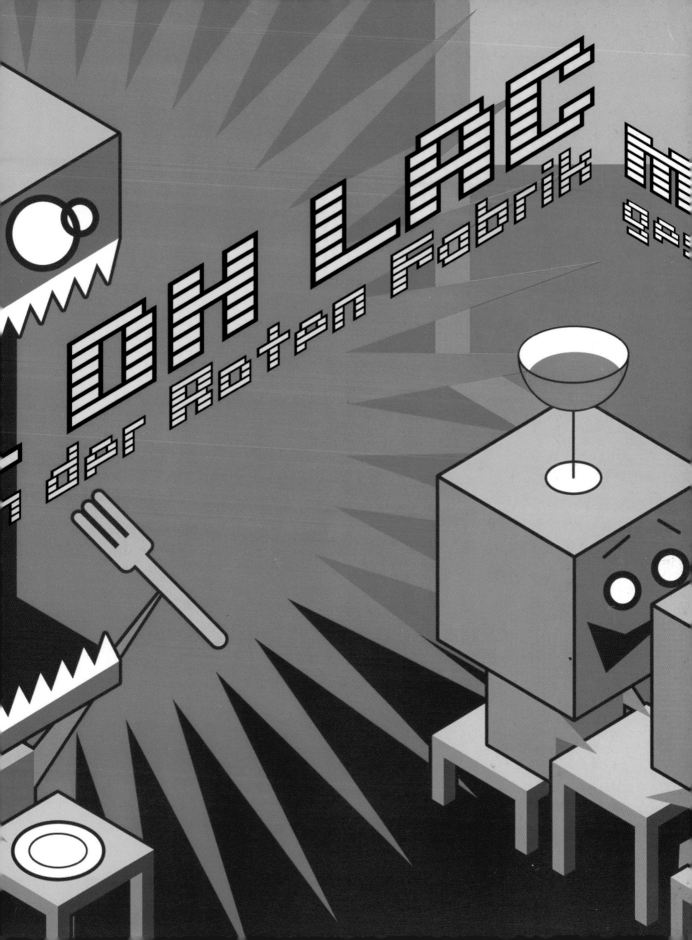

# Graphic Design for the 21st Century

# Grafikdesign im 21. Jahrhundert

# Le design graphique au 21e siècle

Over the last decade the practice of graphic design has undergone a momentous change as pixels have become a handy substitute for print and software has lessened the profession's reliance on its traditional tools of pen and paper. In no other discipline of design has computer technology had such a transforming impact, and this is why "Graphic Design for the 21st Century" has been dedicated to the thoughts and visions of designers working at today's graphic coalface. The one hundred designers included in this celebration of contemporary graphic design have been specifically selected for the forward-looking nature of their work. From the Netherlands and Switzerland to America and Iceland to Japan and Australia, this book features a truly international sampling of graphic design that reveals a shared desire to communicate ideas and values in the most visually compelling way possible.

Throughout our daily lives we are surrounded and peppered by graphic messages. Indeed they have become so much part of the fabric of every-day modern life – from breakfast cereal packaging and advertising billboards to logos on clothes and television company identities – that often we register their codes only on a subconscious level. Against an ever-present insidious backing track of visual Muzak, graphic designers vie for the viewer's attention by shaping communication that is not only visually arresting but also frequently intellectually contesting. To this end they can either grab attention in a bold and direct manner or slowly reel us in with visual ambiguity or double-coded meaning. In an ever-expanding sea of information and images the best attention "snaggers" are those who bait their hooks with meaningful content, quirkily intelligent humour and/or,

Im letzten Jahrzehnt hat sich im Bereich des Grafikdesigns ein revolutionärer Wandel vollzogen, da Pixel zum leicht verfügbaren Ersatz für Druckerzeugnisse geworden sind und Software dazu geführt hat, dass die Grafiker immer seltener auf ihre traditionellen Arbeitsmittel, nämlich Bleistift und Papier, zurückgreifen. In keinem anderen kreativen Fach hat die Computertechnik derart drastische Wirkungen gezeigt und deshalb widmet sich »Grafikdesign im 21. Jahrhundert« den Ideen und Visionen der Gestalter, die das Feld der zeitgenössischen Gebrauchsgrafik kultivieren. 100 Designer sind aufgrund des zukunftsträchtigen Charakters ihres Schaffens ausgewählt worden und haben Beiträge zu diesem Band geliefert. Die Beispiele reichen von den Niederlanden und der Schweiz über Island und Amerika bis nach Japan und Australien, so dass dieses Buch eine wahrhaft internationale Musterkollektion grafischer Arbeiten darstellt, denen der gemeinsame Wunsch zugrunde liegt, Ideen und Werte mit größtmöglicher Überzeugungskraft visuell umzusetzen.

Im täglichen Leben stürmen von allen Seiten unzählige grafische Botschaften auf uns ein – von der Packung der Frühstücksflocken und Werbeplakaten bis zu Markenzeichen auf Kleidungsstücken und den Logos der Fernsehsender. Sie alle sind so sehr Teil unseres modernen Alltagslebens geworden, dass wir ihre Codes schon gar nicht mehr bewusst wahrnehmen. Angesichts der allseits schleichend um sich greifenden »Hintergrund-Bildberieselung« wetteifern die Gebrauchsgrafiker um die Aufmerksamkeit des Publikums, indem sie ihre Botschaften so gestalten, dass sie nicht nur optisch attraktiv, sondern häufig auch intellektuell anspruchsvoll und pfiffig sind. Zu diesem Zweck nehmen sie

Au cours de la dernière décennie, les arts graphiques ont connu une véritable révolution, les pixels prenant le pas sur les caractères d'imprimerie et les logiciels diminuant la dépendance du secteur vis-à-vis de ses outils traditionnels tels que le crayon et le papier. Aucune autre discipline du design n'a été autant transformée par l'impact de l'informatique. C'est pourquoi « Le design graphique au 21e siècle » célèbre le design graphique contemporain en se consacrant aux idées et à la vision des tenants actuels de la profession. Les cents graphistes présentés ici ont été choisis tout particulièrement pour leur travail résolument orienté vers l'avenir. Des Pays-Bas à la Suisse, des Etats-Unis à l'Islande, du Japon à l'Australie, cet ouvrage propose un échantillonnage vraiment international des arts graphiques, reflétant un désir partagé de communiquer des idées et des valeurs de la manière la plus engageante qui soit.

Tout au long de la journée, nous sommes entourés et mitraillés de messages graphiques. Ils font désormais tellement partie du tissu quotidien de notre vie moderne – boîtes de céréales du petit-déjeuner, affiches publicitaires, logos de vêtements, sigles de chaînes de télévision etc. – que, le plus souvent, nous n'enregistrons leurs codes qu'à un niveau subconscient. Sur cette toile de fond omniprésente et insidieuse de gribouillis, les graphistes rivalisent pour attirer l'attention du public en élaborant une communication qui, non seulement accroche le regard, mais, souvent, interpelle l'intellect. Pour ce faire, ils peuvent capter notre attention d'une manière directe et frappante ou

**Opposite** Poster for "Sensation" exhibition. Why Not Associates, 1997.

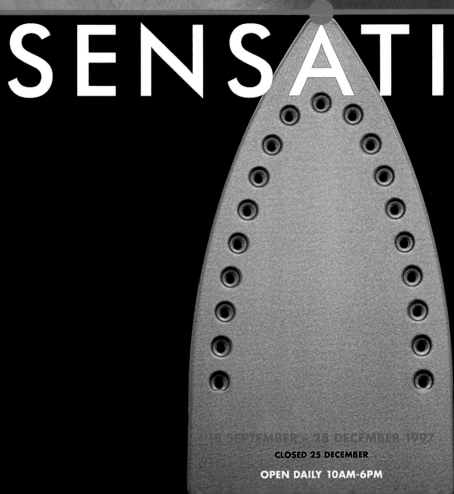

# ROYAL ACADEMY OF ARTS
### PICCADILLY  LONDON  W1

## YOUNG BRITISH ARTISTS FROM THE SAATCHI COLLECTION

# SENSATION

15 SEPTEMBER - 28 DECEMBER 1997

**CLOSED 25 DECEMBER**

**OPEN DAILY 10AM-6PM**

Introduction

**Right** Flyer for Detroit Focus Gallery. Ed Fella, 1990.

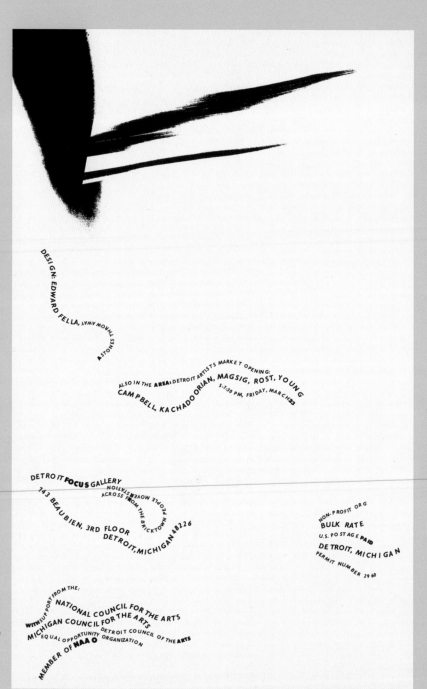

more rarely, genuinely new formal inventiveness. Because of the overwhelming bombardment of visual communications that we all experience on a daily basis, we have not only become more visually literate and culturally savvy in the deciphering of the intentions that lie at the root of the codes, but also our senses have become increasingly jaded by the stylistic sameness of much mainstream, "strategic," marketing-led communication. These days, for something to catch our attention for more than just a few seconds it has to be really thought-provoking or amusing. More than at any other time in the short but prolific history of graphic design, the current pressure on professional practitioners to produce distinctively authentic work that conveys a message in a uniquely captivating way is greater than ever. And that's not all; graphic design just got bigger. The profession has broadened as the boundaries between creative disciplines have become increasingly blurred through the application of – and opportunities presented by – new democratising digital technologies.

For the vast majority of designers in this survey the computer has become their primary tool, but given this, there is also a desire by many to break out of the constraining limitations imposed by off-the-shelf software programmes. The Internet and advanced computing power has delivered greater speed to graphic design practice, yet at the same time this technologically-driven acceleration has also increased the stylistic obsolescence of graphic design solutions – what appears cutting-edge one year will seem old hat the next as new ways of making graphic design provide novel possibilities of expression. Over the last decade graphic design has grown from a primarily static medium of encapsulated messages (books, posters, display ads, etc.) to one that is increasingly about movement and play, and is open to interaction since the advent of screen-based so-called graphic user interfaces (GUI). This

unsere Aufmerksamkeit entweder auf forsche, direkte Weise gefangen oder sie umgarnen uns langsam, nach und nach, mit bildlichen oder sprachlichen Doppeldeutigkeiten. In der heute unaufhörlich wachsenden Informations- und Bilderflut sind diejenigen am erfolgreichsten, die den Betrachter mit sinnvollen Inhalten, witzigen, geistreichen und/oder – was eher selten ist – wirklichen

chercher à nous embobiner lentement en créant une ambiguïté visuelle ou des doubles sens. Dans cet océan d'informations et d'images en expansion constante, ceux qui parviennent le mieux à nous «accrocher» sont ceux qui nous appâtent avec un contenu intelligent, original, humoristique et/ou, plus rare, une véritable inventivité dans la forme. Du fait du bombardement incessant

does not mean, however, that we should be writing obituaries for the printed page. New computer technologies have actually made the execution of books easier – leading to the proliferation of small print-run publications show-casing the work of individual graphic designers. Indeed, this type of publication, along with the numerous journals, exhibitions and award ceremonies dedicated to graphic design, help to raise the profile of this omnipresent yet often invisible profession, while also facilitating the cross-pollination of ideas amongst practitioners. The Internet has also had an enormous impact on the transference of ideas between graphic designers, and has helped to instigate an unprecedented level of collaboration between different design communities throughout the world. It is, however, printed publications such as this one that not only tangibly demonstrate through words and pictures the cultural flux of contemporary graphic design, but may well remain the most accessible record of work made from sprinklings of pixel dust as new media platforms perpetually render not-so-new ones obsolete. In comparison to print, New Media is in its infancy and today's pioneering generation of graphic designers are still grappling with how best to mine its communicative potential. The evolution of graphic design has been and will continue to be inextricably linked with the development of technological tools that enable designers to produce work with ever-greater efficiency.

Apart from illustrating the current output of one hundred leading graphic designers, this survey also includes "in-their-own-words" explanations of their personal approaches to the many challenges faced by anyone currently working in the contemporary visual communications field. The selected designers have also provided their own vision statements of what they think the future of graphic design will hold. Apart from illustrating some of the most interesting graphic design currently being produced, this book also offers insightful predictions on the course of graphic design in the future regarding its convergence with other

formalen Neuheiten ködern. Da täglich unzählige visuelle Botschaften und Informationen auf uns herniederprasseln, sind wir nicht nur beschlagener und gewitzter geworden, was unsere visuelle Wahrnehmung und das Entziffern der Absichten hinter den grafischen Codes angeht, sondern auch abgestumpft gegenüber dem stilistischen Einheitsbrei eines Großteils der gängigen »strategischen«, marktorientierten Werbung. Damit etwas heute unsere Aufmerksamkeit länger als nur einige Sekunden gefangen hält, muss es wirklich amüsant sein oder zum Nachdenken anregen. In der kurzen, aber höchst produktiven Entwicklungsgeschichte der Gebrauchsgrafik standen die Grafiker noch nie unter so großem Druck wie zurzeit, originelle, sich aus der Masse hervorhebende Entwürfe zu liefern, die Werbebotschaften auf unnachahmliche und fesselnde Weise transportieren. Das ist noch nicht alles: Die Welt der Gebrauchsgrafik ist in dem Maße größer geworden, in dem sich die Grenzen zwischen den verschiedenen künstlerisch-gestalterischen Berufen verwischt haben, und zwar durch die Nutzung der neuen, erweiterten Möglichkeiten, die von der allen verfügbaren modernen digitalen Technik geboten wird.

Die meisten der in diesem Band vorgestellten Grafiker benutzen den Computer als Hauptarbeitsmittel. Dennoch verspüren viele den Wunsch, die von der handelsüblichen Software gezogenen Grenzen zu überschreiten. Das Internet und die höhere Rechenleistung der Computer haben die Entwurfsarbeit zwar erheblich beschleunigt, diese von der Technologie erhöhte Geschwindigkeit hat aber auch zum raschen Veralten grafischer Lösungen und Stilmerkmale geführt: Was dieses Jahr hochmodern erscheint, ist schon nächstes Jahr ein alter Hut, wenn neue Techniken auch neue Ausdrucksmöglichkeiten eröffnen. In den letzten zehn Jahren hat sich die Gestaltungsarbeit des Grafikdesigners von einem überwiegend statischen Medium mit fixierten Botschaften (Bücher, Anzeigen, Plakate) zu einem Medium entwickelt, bei dem es zunehmend um Bewegung und Spiel geht, denn mit dem

de communications visuelles que nous subissons quotidiennement, nous avons développé inconsciemment une vaste culture de l'image et avons appris à déchiffrer les intentions qui se cachent derrière les codes. En outre, nos sens sont blasés par l'aspect répétitif des styles de communications « stratégiques » traditionnelles guidées par des intérêts commerciaux. De nos jours, pour qu'un message retienne notre attention pendant plus de quelques secondes, il doit vraiment faire réfléchir ou amuser. Plus qu'à n'importe quelle autre époque dans la courte mais prolifique histoire des arts graphiques, les professionnels subissent une pression sans précédent pour produire un travail authentique et original qui transmette un message d'une manière unique et captivante. Mais ce n'est pas tout. L'importance du graphisme ne cesse de croître. Le secteur s'est élargi à mesure que l'application et les possibilités offertes par les nouvelles technologies numériques ont démocratisé les disciplines créatives et ont rendu de plus en plus floues les frontières qui les séparaient autrefois.

L'ordinateur est devenu l'outil principal de la grande majorité des graphistes présentés ici, même si beaucoup d'entre eux expriment également le désir de se libérer des contraintes imposées par les logiciels proposés dans le commerce. L'internet et la puissance informatique permettent de travailler toujours plus rapidement mais accélèrent aussi le processus d'obsolescence stylistique des graphismes. Ce qui semble révolutionnaire cette année paraîtra désuet l'année prochaine quand de nouvelles manières de concevoir les projets graphiques offriront d'autres possibilités d'expression. Au cours de la dernière décennie, le graphisme est passé d'un média essentiellement statique servant à transmettre des messages fixes (livres, affiches, publicités, etc.) à un outil mobile et ludique, ouvert à l'interaction depuis l'avènement des « Interfaces Utilisateurs Graphiques » (IUG) sur écran d'ordinateur. Cela ne signifie pas pour autant la mort de la page imprimée. En effet, les nouvelles technologies informatiques ont rendu plus facile la réalisation des livres,

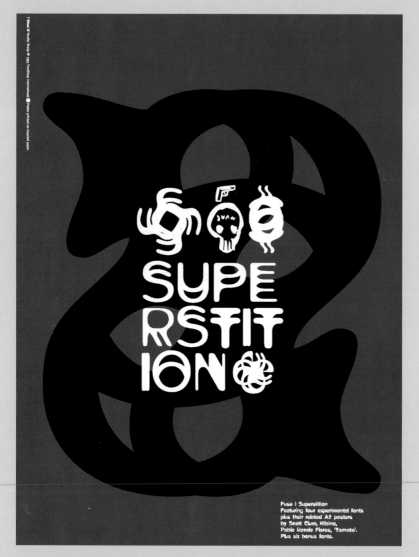

Fuse | Superstition
Featuring four experimental fonts
plus their related A2 posters
by Scott Clum, Hibino,
Pablo Rovalo Flores, 'Tomato'.
Plus six bonus fonts.

disciplines (such as fine art, film, illustration, music), its continuing love affair with advanced technology, its complicity with corporate globalisation, and its adoption of the poetic ambiguity of post-modern cultural interpretation over the direct clarity of modern universal communication. In an attempt to make sense of where graphic design might be heading, we have identified a number of the common concerns and themes raised by the selected designers. These are: the blurring of boundaries between disciplines; the importance of content; the impact of advanced technology; the desire for emotional connections; the creative constraints imposed by commercial software; the distrust of commercialism; the increasing quantity, com-

Aufkommen so genannter grafischer Benutzeroberflächen (graphic user interfaces, GUI) z. B. wird der bisher passive Betrachter zur Interaktion eingeladen. Das heißt allerdings nicht, dass wir nun Nachrufe auf das gedruckte Wort schreiben sollten, denn neue Computertechniken haben tatsächlich die Herstellung von Büchern erleichtert, was eine wachsende Zahl von Publikationen in kleinen Auflagen zur Folge hatte, mit denen sich einzelne Grafiker profilierten. Tatsächlich tragen solche Publikationen im Verbund mit den zahlreichen Zeitschriften und Ausstellungen sowie Preisverleihungen für hervorragendes Grafikdesign dazu bei, das Profil dieser allgegenwärtigen, oft jedoch unsichtbar und anonym wirkenden Berufsgruppe zu

entraînant la prolifération de petites publications sur papier présentant le travail de graphistes indépendants. De fait, ce genre de brochures, tout comme les nombreuses revues, expositions et remises de prix consacrées aux arts graphiques, contribuent à hausser le niveau de cette profession omniprésente mais souvent invisible, tout en facilitant la pollinisation croisée des idées parmi ses praticiens. L'internet a également eu une influence considérable sur la transmission des idées entre graphistes et favorisé la constitution d'un réseau de collaboration sans précédent entre différentes communautés de professionnels à travers le monde. Toutefois, ce sont des ouvrages imprimés tels que celui-ci qui, non seulement exposent de manière tangible avec des mots et des images les courants culturels des arts graphiques contemporains, mais demeureront l'archive la plus accessible de travaux réalisés à partir de poudre de pixels tandis que de nouvelles plates-formes médiatiques rendront perpétuellement obsolètes celles qui les ont précédées. Comparés à l'imprimerie, les médias numériques n'en sont qu'à leurs premiers balbutiements et la génération actuelle de graphistes avant-gardistes en sont encore à chercher à mieux comprendre leur potentiel communicatif. L'évolution des arts graphiques a toujours été et continuera d'être inextricablement liée au développement des outils technologiques qui permettront aux graphistes de travailler avec une efficacité toujours plus grande.

Cet ouvrage ne se contente pas de présenter la production actuelle de cent graphistes de premier plan mais leur permet également d'expliquer avec leurs propres termes leur démarche personnelle face aux nombreux défis auxquels sont confrontés tous ceux qui travaillent aujourd'hui dans le domaine de la communication visuelle. Les graphistes sélectionnés ont également exprimé leur vision de ce que l'avenir réserve aux arts graphiques. Outre le fait de présenter certaines des créations graphiques les plus intéressantes du moment, ce livre émet également des prédictions sur l'évolution du design graphique à la lumière de ses

plexity and acceleration of information; the need for simplification; and (last but by no means least) the necessity of ethical relevance.

To better understand how graphic design got to this stage of development, it is perhaps necessary to briefly outline the evolution of this relatively young profession. While the increasing cross-disciplinary aspect of graphic design practice may seem a new phenomenon, this is not really the case. In the late 19th century the graphic arts* most visibly manifested themselves in the design of large advertising posters in the Art Nouveau style – from the cabaret posters by Henri de Toulouse-Lautrec (1864–1901) to the advertisements for Job cigarette papers by Alphonse Mucha (1860–1939). This kind of commercial art was often undertaken by practicing artists and architect/designers and as such was highly influenced by contemporary developments in the fine and applied arts. The new profession of graphic design was, however, mainly confined to the creation of posters and books, and was closely related to the British Arts & Crafts Movement's promotion of "art" printing. At this stage, even when mechanised printing was used, the results often still appeared handprinted. It was not until the early years of the 20th century that the so-called "graphic arts" were used to develop comprehensive and integrated corporate identities. In

schärfen und zugleich die wechselseitige Anregung ihrer einzelnen Mitglieder untereinander zu fördern. Das Internet hat den Gedanken- und Erfahrungsaustausch unter den Grafikern entscheidend vorangetrieben und dazu beigetragen, ein in dieser Intensität und Ausdehnung noch nie da gewesenes Maß an Kooperation rund um den Globus zu schaffen. Es sind allerdings Druckerzeugnisse wie das vorliegende Buch, die den Gang des zeitgenössischen Grafikdesigns nicht nur in Texten und Bildern belegen, sondern auch die zugänglichste und dauerhafteste Informationsquelle aus bunten Rasterpunkten bleiben werden, denn die neuesten Internetportale werden kontinuierlich die weniger neuen ersetzen und überflüssig machen. Im Vergleich zum gedruckten Wort und Bild stecken die »neuen Medien« noch in den Kinderschuhen und die zeitgenössischen Pioniere der Computergrafik sind noch damit beschäftigt, das digitale Potenzial in all seinen Facetten zu erforschen und zu erschließen. Die Entwicklung des Grafikdesigns wird auch weiterhin unauflöslich mit der Entwicklung der dafür notwendigen Technologie – Hardware wie Software – verknüpft bleiben, die es den Grafikern erlaubt, mit immer größerer Effektivität zu arbeiten.

Das vorliegende Buch illustriert nicht nur das aktuelle Schaffen von 100 führenden Grafikdesignern bzw. Designbüros, sondern enthält auch deren Selbstdarstellungen und Erklärungen zu ihren persönlichen Auffassungen über die zahlreichen Herausforderungen, denen sich heute jeder, der im Bereich der visuellen Kommunikation arbeitet, stellen muss. Auch geben die ausgewählten Designer wunschgemäß Auskunft darüber, wie sie die Zukunft des Grafikdesigns sehen. In diesem Überblick findet der Leser nicht nur Abbildungen einiger der interessantesten Arbeiten aus jüngster Zeit, sondern auch fundierte Informationen über die Zukunft des Gewerbes,

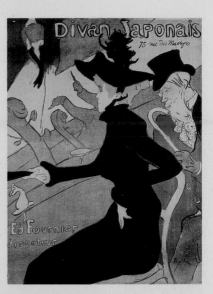

liens avec d'autres disciplines (telles que les beaux-arts, le cinéma, l'illustration, la musique), de sa longue histoire d'amour avec la technologie de pointe, de sa complicité avec la mondialisation, et de sa prédilection pour l'ambiguïté poétique de l'interprétation culturelle postmoderne par rapport à la clarté de la communication universelle moderniste. En cherchant à cerner les orientations futures du design graphique, nous avons identifié un certain nombre de préoccupations et de thèmes communs soulevés par les graphistes sélectionnés. Il en ressort les points suivants : l'effacement des frontières entre les disciplines ; l'importance du contenu ; l'impact de la technologie de pointe ; l'envie de retrouver des liens émotionnels ; les contraintes créatives imposées par les logiciels commerciaux ; la méfiance du mercantilisme ; la quantité, la complexité et l'accélération croissantes de l'information ; le besoin de simplification ; (enfin mais non des moindres) la nécessité d'une déontologie pertinente.

Pour mieux comprendre comment les arts graphiques en sont arrivés à ce stade de développement, il est sans doute utile de retracer l'évolution de cette profession relativement jeune. L'aspect multi-disciplinaire du design graphique peut paraître relativement nouveau mais ce n'est pourtant pas un phénomène récent. A la fin du 19e siècle, les arts graphiques* s'exprimaient de la manière la plus

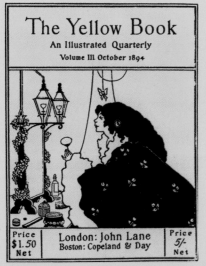

**Opposite** Poster for Fuse, promoting new digital typeface. Research Studios, 2001.
**Left** Cover for the Yellow Book, volume III. Aubrey Beardsley, 1894.
**Top** Poster for Divan Japonais. Henri de Toulouse-Lautrec, 1892.

1907, for example, Peter Behrens (1868–1940) was appointed artistic adviser to the well-known German manufacturer AEG, and subsequently became the first designer to introduce such a programme. Designers were, however, still jacks-of-all-trades. One day they would be designing furniture and lighting, the next day textiles or ceramics, and because of this graphic design was seen as just another field in which artists or architect/designers could try their hand. The well-known logo of the Carlsberg brewery, for instance, was initially devised by the Danish ceramicist and furniture designer Thorvald Bindesbøll (1846–1908) in 1904.

The emergence of this new discipline during the early years of the 20th century led to the founding of the American Institute of Graphic Arts (AIGA) in New York in 1914 – the first organization to be specifically set up for the promotion of what was then termed "graphic arts". It was not until the First World War, however, that the importance of graphic design as a tool for propaganda was firmly established, most notably by James Montgomery Flagg (1877–1960), who created the famous "I Want You for US Army" recruiting poster showing Uncle Sam (based on a self-portrait). Following the war's end, the Art Directors Club was founded in New York in 1920 so as to raise the status of advertising – a growing area of the graphic arts that was distrusted by the general public because of the false claims and visual excesses that had become associated with it. The Art Directors Club subsequently staged exhibitions and produced publications that showcased the most creative advertising work, and in so doing helped to establish a greater professionalism within graphic design practice. Reflecting the discipline's move away from the subjectivity of fine art to the objectivity of design, the American typographer William Addison Dwiggins (1880–1956) reputedly first coined the term "graphic design" in 1922.

After the enormous upheavals of the First World War, many people put their faith in new technology and

seine Verflechtung mit anderen Disziplinen – bildende Kunst, Film, Illustration, Musik –, seine enge Beziehung zur neuesten Technik, seine Komplizenschaft mit der wirtschaftlichen Globalisierung und darüber, dass Grafiker heute vielfach der poetischen Vieldeutigkeit postmoderner kultureller Interpretationen den Vorzug vor der universellen Klarheit der Moderne geben. Im Bemühen um eine sinnvolle, begründete Aussage über den Weg, den das Grafikdesign einschlagen wird, haben wir zunächst einmal bei den ausgewählten Vertretern des Fachs eine Reihe von gemeinsamen Zielen und Themen identifiziert: den Wunsch nach Aufhebung des fachlichen Schubladendenkens, die vorrangige Bedeutung von Inhalten, den Einfluss modernster Technologie auf die Arbeitsergebnisse, den Wunsch nach emotionalen Verbindungen und nach Überwindung der von der handelsüblichen Software gezogenen Grenzen, das Misstrauen gegenüber dem Kommerz, die zunehmende Menge, Komplexität und Beschleunigung der Informationsflüsse, die Notwendigkeit der Vereinfachung und – last, but not least – die Notwendigkeit ethisch vertretbarer Entwürfe.

Zum besseren Verständnis der aktuellen Situation des Grafikdesigns muss man vielleicht zuerst einmal die Entwicklung dieses relativ jungen Berufszweigs zurückverfolgen. Der zunehmend interdisziplinäre Charakter der Berufspraxis mag als neues Phänomen erscheinen, ist es aber eigentlich nicht. Im späten 19. Jahrhundert hat sich die Kunst der Gebrauchsgrafik* am deutlichsten in großen, im Jugendstil bzw. im Stil des Art nouveau entworfenen Werbeplakaten niedergeschlagen – von denen, die Henri de Toulouse-Lautrec (1864–1901) für Pariser Cabarets schuf, bis zur Job-Zigarettenwerbung von Alphonse Mucha (1860–1939). Derartige »kommerzielle Kunstwerke« stammten häufig von ansonsten freischaffenden Künstlern sowie Architekten und kunsthandwerklichen Gestaltern und waren daher meist stark von den Entwicklungen in der bildenden und angewandten Kunst ihrer Zeit geprägt. Der neue Beruf des Gebrauchsgrafikers war eng

visible à travers les grands placards publicitaires de style Art nouveau, des affiches de cabaret d'Henri de Toulouse-Lautrec (1864–1901) aux publicités pour le papier à cigarette «Job» d'Alphonse Mucha (1860–1939). Cette forme d'art commercial étant souvent confiée à des artistes et des architectes / designers, elle était donc fortement influencée par les développements contemporains dans les beaux-arts et les arts appliqués. Le nouveau métier de graphiste, lui, se limitait principalement à la création d'affiches et de livres et était étroitement apparenté à la promotion de l'imprimerie «d'art» de l'Arts & Crafts Movement britannique. A cette époque, même avec l'impression mécanique, les résultats semblaient souvent imprimés à la main. Il fallut attendre le début du 20$^e$ siècle pour que les «arts graphiques» soient utilisés pour développer des identités d'entreprises complètes et intégrées. En 1907, l'architecte – designer Peter Behrens (1868–1940) fut nommé conseiller artistique de la célèbre firme allemande AEG, inaugurant un nouveau type de collaboration de ce genre. A l'époque, les créateurs étaient encore des hommes-orchestres, concevant tantôt des meubles et des luminaires, tantôt des tissus et des céramiques, etc. De ce fait, le graphisme n'était considéré que comme un domaine parmi tant d'autres dans lequel ils pouvaient exercer leurs talents. Le célèbre logo des brasseries Carlsberg, notamment, fut

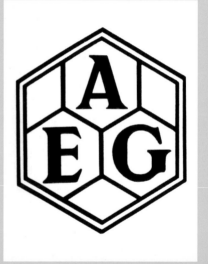

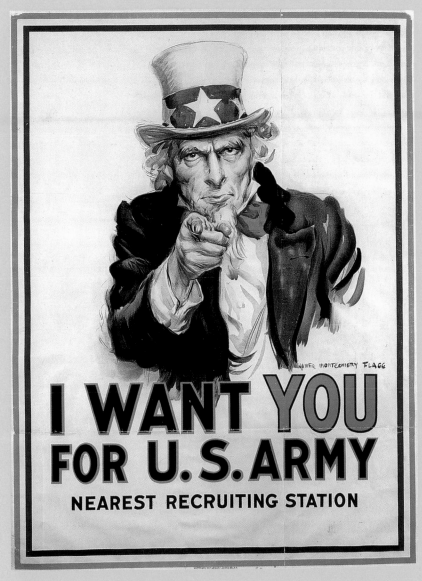

**Top** Poster for the US Army. James Montgomery Flagg, 1917.
**Opposite** Trademark for AEG. Peter Behrens, c.1908.

conçu à l'origine par le céramiste et créateur de meubles danois Thorvald Bindesbøll (1846–1908) en 1904.

Au cours des premières années du 20e siècle, l'émergence de cette nouvelle discipline entraîna en 1914 la création à New York de l'A.I.G.A. (American Institute of Graphic Arts), la première organisation fondée tout particulièrement pour la promotion des «Arts Graphiques». Toutefois, ce ne fut qu'après la Première Guerre mondiale que l'importance du design graphique comme outil de propagande fut fermement établie, notamment par James Montgomery Flagg (1877–1960), auteur de la célèbre affiche de recrutement «I Want You for US Army» montrant l'Oncle Sam (d'après un autoportrait). Après la fin de la guerre, l'Art Directors Club fut fondé à New York en 1920 pour promouvoir le statut de la publicité, un domaine des arts graphiques qui ne cessait de prendre de l'importance mais qui suscitait la méfiance du grand public en raison des annonces mensongères et des excès visuels qui lui étaient associés. L'Art Directors Club organisa des expositions et fit paraître des publications présentant les publicités plus créatives, favorisant ainsi un plus grand professionnalisme au sein du métier de graphiste. Reflétant le nouveau statut de cette discipline, qui s'éloignait de plus en plus de la subjectivité des beaux-arts pour se rapprocher de l'objectivité du design, le typographe américain William Addison Dwiggins (1880–1956) aurait été le premier à employer le terme de «design graphique» en 1922.

Après les grands bouleversements de la Première Guerre mondiale, nombreux furent ceux qui misèrent sur les nouvelles technologies et la production de masse, ces dernières ayant déjà donné au monde tout un assortiment de merveilles techniques allant du téléphone et de la T.S.F aux automobiles et aux avions. Balayant la tradition artistique par le progrès industriel, ils avaient une foi quasi religieuse en la standardisation et un désir de dépouillement qui s'appliquait à tout, des meubles aux luminaires en passant par les livres et les affiches, cherchant les formes les

mass-production, which had already given the world an array of technical marvels from telephones and wireless radios to automobiles and aeroplanes. Sweeping artistic tradition away with industrial progress, there was a quasi-religious belief in the benefits of standardisation and an overwhelming desire to strip everything from furniture and lighting to posters and books down to their purest and most elemental form. At the same time new movements in fine art – Futurism, Constructivism

verknüpft mit der Förderung der Druckgrafik durch die britische Arts-and-Crafts-Bewegung und konzentrierte sich auf die Gestaltung von Plakaten und Büchern. Damals sahen selbst maschinengedruckte Arbeiten vielfach immer noch wie Handdrucke aus. Erst in den ersten Jahren des 20. Jahrhunderts bediente man sich der so genannten grafischen Künste, um umfangreiche integrierte Firmenauftritte in Text und Bild zu entwickeln. Ein Beispiel: 1907 wurde Peter Behrens (1868–1940) Architekt und künstlerischer Berater der AEG in Berlin und in der Folge der erste »Designer«, der ein solches Programm einführte. Jeder irgendwie

and De Stijl – emerged that also had a profound impact on the evolution of graphic design. Strongly influenced by these avant-garde impulses, graphic designers associated with the Bauhaus developed a new rational approach to graphic design, which involved the use of bold geometric forms, lower-case lettering and simplified layouts. Often incorporating photomontages, this new kind of graphic design was not only visually dynamic but also had a communicative clarity. Graphic designers aligned to Modernism rejected individual creative expression in favour of what was described by Jan Tschichold (1902–1974) as "impersonal creativity." At the Bauhaus designers such as Lásló Moholy-Nagy (1895–1946), Herbert Bayer (1900–1985) and Joost Schmidt (1893–1948) sought to codify a set of rational principles for graphic design practice through their endorsement of sans-serif typography, asymmetrical compositions and rectangular fluid grids, a preference for photography over illustration, and the promotion of standardized paper sizes.

Prior to and during the Second World War, the Swiss School built on the Bauhaus' developments in order to create a Modern form of graphic design known as the International Graphic Style, which had a

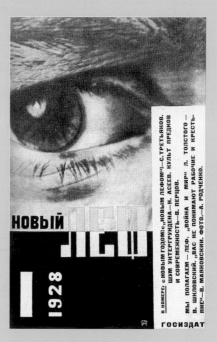

kreativ-künstlerisch tätige Mensch wurde damals noch als »Hans Dampf in allen Gestaltungsgassen« angesehen, der heute vielleicht Möbel und Lampen und morgen Textilien oder Keramiken entwerfen konnte. Aus diesem Grund galt die Gebrauchsgrafik nur als eins von mehreren Betätigungsfeldern für Architekten und Künstler. Das bekannte Logo der Brauerei Carlsberg zum Beispiel wurde 1904 vom dänischen Töpfer und Möbeldesigner Thorvald Bindesbøll (1846–1908) entworfen.

Die Entwicklung des Grafikdesigns als separatem Berufszweig führte 1914 zur Gründung des New Yorker American Institute of Graphic Arts (AIGA), der ersten Institution, die gezielt zum Zweck der Förderung der »grafischen Künste« geschaffen wurde. Erst im Ersten Weltkrieg setzte sich jedoch das Grafikdesign als wichtiges Propagandamittel endgültig durch, vor allem durch die Arbeit von James Montgomery Flagg (1877–1960), Urheber des berühmten Rekrutierungsplakats mit der Überschrift »I Want You for US Army«, auf dem Onkel Sam (nach einem Selbstporträt Flaggs) als Anwerber erscheint. Nach dem Ersten Weltkrieg, im Jahr 1920, gründete sich in New York der Art Directors Club mit dem Ziel, der Gebrauchsgrafik mehr Anerkennung zu verschaffen, da dieses Gewerbe aufgrund falscher Behauptungen seiner Kritiker und eigener »darstellerischer Exzesse« beim breiten Publikum in Verruf geraten war. In der Folge veranstaltete der Art Directors Club Ausstellungen und gab Publikationen heraus, in denen die besten kreativen Werbegrafiken gezeigt wurden. Dadurch trug der Club zur Professionalisierung des Grafikdesigns bei. Der amerikanische Typograf William Addison Dwiggins (1880–1956) prägte 1922 den Begriff »graphic design«, der die Abkehr des neuen Berufszweigs von der Subjektivität der schönen Künste und seine Hinwendung zur Objektivität der

plus pures et élémentaires. Parallèlement, de nouveaux mouvements artistiques – le futurisme, le constructivisme, De Stijl – devaient marquer profondément l'évolution du design graphique. Très influencés par ces impulsions avant-gardistes, les graphistes associés au Bauhaus développèrent une nouvelle méthodologie rationnelle basée sur un recours à des formes géométriques simples, des lettres en bas de casse et des mises en pages épurées. Incorporant souvent des montages photographiques, ce nouveau type de graphisme était non seulement visuellement dynamique mais savait également communiquer avec clarté. Les graphistes associés au modernisme rejetèrent l'expression créative individuelle à la faveur de ce que Jan Tschichold (1902–1974) avait décrit comme de « la créativité impersonnelle ». Au sein du Bauhaus, des créateurs tels que Lásló Moholy-Nagy (1895–1946), Herbert Bayer (1900–1985) et Joost Schmidt (1893–1948) cherchèrent à codifier une série de principes rationnels pour la pratique du design graphique, caractérisés par une typographie aux caractères sans empattement, des compositions asymétriques, des quadrillages rectangulaires et fluides, une préférence pour la photographie plutôt que pour l'illustration, ainsi que la pro-

DAS BAUHAUS IN DESSAU

Dessau, Mauerstraße 36    Fernruf 2896    Diskontogesellschaft Filiale Dessau

KATALOG
DER
MUSTER

VERTRIEB
durch die

BAUHAUS
GmbH

**Top** Cover design for Novyi LEF magazine. Alexander Rodchenko, c.1928.
**Left** Cover for Bauhaus catalogue. Herbert Bayer, 1925.
**Opposite** Poster for the Stedelijk Museum's "Industrial Design" exhibition, Amsterdam. Vilmos Huszár, 1929.

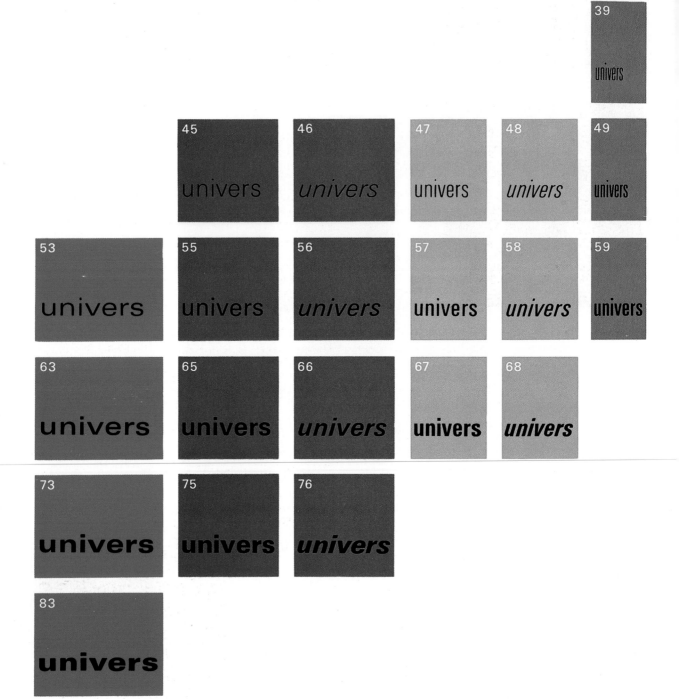

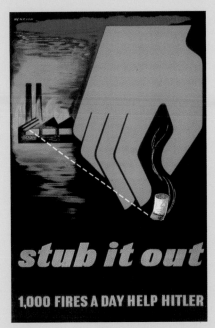

strong reductivist aesthetic that incorporated lots of "white space" and "objective photography" (i.e. realistic images). Precise, direct, and clinical, Swiss School graphic design was centred on the Modernist precept that "Form Follows Function."

During the Second World War, graphic designers, especially in Britain and America, produced bold propaganda posters that similarly displayed the formal purity and aesthetic economy of Modernism. Wartime designers such as Abraham Games (1914–1996), F.H.K. Henrion (1914–1990), and Jean Carlu (1900–1997), fused bold images with short yet powerful slogans, such as "Talk Kills," "We're in it together," and "America's Answer! Production," so as to produce a kind of non-narrative visual shorthand that conveyed the given public information message in the most direct manner possible. This type of high-impact visual communication that sought universal perception was later used for commercial purposes.

**Opposite** "Univers" typeface for Deberny & Peignot. Adrian Frutiger, 1954–57.
**Top** Poster for the British Ministry of Information. Frederick Henri Kay Henrion, 1943.
**Right** Poster for the Kunstgewerbemuseum, Zurich. Joseph Müller-Brockmann, 1960.

präzisen zeichnerischen Gestaltung reflektierte.

Nach den gewaltigen Umwälzungen, die der Erste Weltkrieg mit sich gebracht hatte, setzten viele Menschen ihre Hoffnung in neue Techniken und die Massenproduktion, die der Welt bereits eine Reihe technischer Wunderwerke von Telefonen und Radios bis zu Automobilen und Flugzeugen beschert hatten. Indem sie die kunsthandwerkliche Überlieferung zugunsten des industriellen Fortschritts aufgaben, glaubten sie mit nahezu religiöser Inbrunst an die Wohltaten der Standardisierung und gaben dem überwältigenden Drang nach, alles und jedes – von Möbeln und Beleuchtungskörpern über Plakate bis hin zu Büchern – auf die reinsten, elementarsten Formen zu reduzieren. Gleichzeitig gab es andere, neue Strömungen in der bildenden Kunst – Futurismus, Konstruktivismus, De Stijl –, welche die Entwicklung des Grafikdesigns ebenfalls entscheidend prägten. Unter dem Einfluss dieser avantgardistischen Impulse entwickelten die mit dem Bauhaus verbundenen Grafiker einen neuen rationalen Ansatz für ihre Kunst mit vorzugsweise geometrischen Formen, Kleinbuchstaben, vereinfachten Layouts und vielfach auch Fotomontagen. Diese neue Gestaltungsweise wirkte nicht nur dynamisch, sondern besaß auch große Klarheit in der Aussage. Die der Moderne verpflichteten Grafiker verwarfen den individuellen schöpferischen Ausdruck zugunsten dessen, was Jan Tschichold (1902–1974) als »unpersönliche Kreativität« bezeichnete. Künstler wie Làsló Moholy-Nagy (1895–1946), Herbert Bayer (1900–1985) und Joost Schmidt (1893–1948), die am Bauhaus lehrten, schufen einen Kodex rationaler, sachlicher Prinzipien des Grafikdesigns, zu denen serifenlose Schrifttypen, asymmetrische Kompositionen und fließende rechtwinklige Raster ebenso zählten wie genormte Papiermaße und der Vorrang der Fotografie vor der gezeichneten Illustration.

Vor und während des Zweiten Weltkriegs baute die Schweizer Schule des Grafikdesigns auf den Bauhausprinzipien auf, um eine

motion de formats de papier standardisés.

Avant et pendant la Seconde Guerre mondiale, l'Ecole suisse s'inspira des apports du Bauhaus afin de créer une forme moderniste de graphisme connue comme le « style graphique international ». Sa forte esthétique réductionniste intégrait beaucoup « d'espaces blancs » et de « photographie objective » (à savoir des images réalistes). Précis, direct et clinique, le graphisme de l'Ecole suisse était centré sur le principe moderniste : « la forme suit la fonction ».

Pendant la Seconde Guerre mondiale, les graphistes, notamment en Grande-Bretagne et aux Etats-Unis, produisirent des affiches de propagande stylisées très influencées par la pureté formelle et l'économie esthétique du modernisme. Les créateurs travaillant pendant la guerre, tels qu'Abraham Games (1914–1996), F. H. K. Henrion (1914–1990) ou Jean Carlu (1900–1997), conjuguèrent des images fortes avec des slogans brefs mais puissants tels que Talk Kills (« La parole tue ») ; We're in it together (« Serrons-nous les coudes ») et America's Answer : Production ! (« La réponse de l'Amérique : la production ! »), réalisant une sorte de raccourci visuel non narratif qui transmettait au public ciblé l'in-

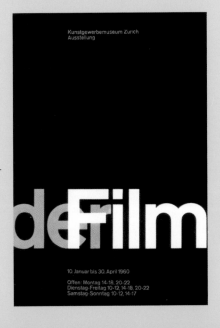

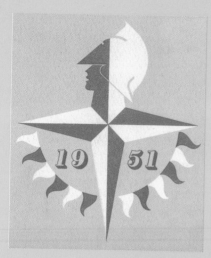

After the Second World War, graphic designers working in the United States, such as Herbert Matter (1907–1984) and Paul Rand (1914–1996), utilized the European avant-garde approach of dynamically combining typography and imagery in order to produce eye-catching, expressive and at times humorous graphic design work for high profile corporate clients, such as IBM and Knoll International. From the immediate postwar years to the late 1950s, there was a dramatic increase in the use of design as a marketing tool, which led to greater specialisation in design practice. By now, graphic design was recognised as a distinct profession rather than just a branch of a general design vocation. During this period the Swiss School's influence spread internationally through the success of Modern typefaces such as Helvetica designed by Max Miedinger (1910–1980) and Edouard Hoffmann in 1957, and Univers designed by Adrien Frutiger (b.1928) that same year, and also through the launch of the journal "New Graphic Design" in 1959. Large corporations increasingly employed graphic designers to help them differentiate their products in an ever-more competitive marketplace. At this time Modern graphic design became almost completely detached from its social foundations and instead became inextricably linked to the consuming desires of corporate advertising. In 1958 the Canadian-born communications theorist Marshall McLuhan (1911–1980) began undertaking an in-depth

moderne Form der Gestaltung zu entwickeln, die als Internationaler Grafikstil bekannt wurde und geprägt war von einer stark reduktionistischen Ästhetik mit vielen »weißen Flächen« und »objektiven Fotos« (d. h. realitätsgetreuen Bildern). Präzise, direkt und mit klinischem Blick stützte sich die Schweizer Schule auf das Motto der Moderne: »form follows function« – die Form folgt dem Zweck.

Im Zweiten Weltkrieg schufen besonders britische und amerikanische Grafiker gewagte Propagandaplakate, die in ähnlicher Manier die Reinheit und Ökonomie der Gestaltungsmittel der Moderne belegen. Amerikanische Grafiker wie etwa Abraham Games (1914–1996), F. H. K. Henrion (1914–1990) und Jean Carlu (1900–1997) verbanden in den Kriegsjahren starke Bilder mit kurzen, schlagkräftigen Slogans wie »Talk kills«, »We're in it together« oder »America's answer! Production«, um mit einer Art Bildstenografie die vorgegebene Botschaft so unmittelbar wie möglich auszudrücken. Diese hoch wirksame visuelle Kommunikationsmethode zielte darauf ab, von allen Bürgern wahrgenommen zu werden, und wurde später auch für kommerzielle Zwecke eingesetzt.

Nach dem Zweiten Weltkrieg folgten viele in den USA tätige Grafiker wie Herbert Matter (1907–1984) und Paul Rand (1914–1996) dem Ansatz der europäischen Avantgarde, indem sie typografische und bildliche Elemente mischten und so augenfällige, ausdrucksstarke und mitunter humorvolle Arbeiten für bedeutende Unternehmen wie IBM und Knoll International schufen. Von der unmittelbaren Nachkriegszeit bis Ende der 50er Jahre des 20. Jahrhunderts kamen grafische Werbemittel zunehmend im Marketing zum Einsatz, was zur größeren Spezialisierung der Grafikdesigner führte. Inzwischen wurde der Beruf des Werbegrafikers als eine spezifische Profession innerhalb der größeren Gruppe grafisch-

formation de la manière la plus directe possible. Ce type de communication à fort impact visuel visant à être universellement déchiffrable fut ensuite repris à des fins commerciales.

Après la Seconde Guerre mondiale, les graphistes travaillant aux Etats-Unis, dont Herbert Matter (1907–1984) et Paul Rand (1914–1996), utilisèrent la démarche européenne avant-gardiste en combinant de façon dynamique la typographie et l'iconographie pour produire des affiches accrocheuses, expressives et parfois humoristiques pour de grandes compagnies telles qu'IBM ou Knoll International. Entre les années de l'immédiate après-guerre et la fin des années 1950, on assista à l'essor considérable du design en tant qu'outil de commercialisation, ce qui entraîna une plus grande spécialisation. Le graphisme était désormais reconnu comme une profession à part entière et non plus comme une simple branche du design. Au cours de cette période, l'influence de l'Ecole suisse se fit sentir à l'échelle internationale grâce au succès de nouveaux types de caractères modernistes tels que Helvetica, créé par Max Miedinger (1910–1980) et Edouard Hoffmann en 1957, et Univers, conçu par Adrien Frutiger (né en 1928) la

**Top** Identity emblem for the Festival of Britain. Abraham Games, 1951.
**Right** Logo for IBM. Paul Rand, 1956.
**Opposite** Cover for "Art and Architecture" magazine. Herbert Matter, 1946.

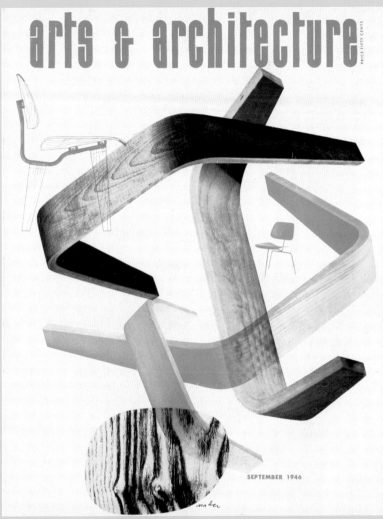

**arts & architecture** PRICE FIFTY CENTS

SEPTEMBER 1946

analysis of contemporary advertising and subsequently concluded, "the Medium is the Massage" (a pun on the term "Mass Age" and an allusion to the media's soft pummelling of culture). What this "Oracle of the Electronic Age" had identified was that image had become more important than content. Of perhaps even greater significance, however, was McLuhan's questioning of where electronic media were ultimately taking society – a subject for debate that has certainy more pertinence now than when it was first raised.

By the late 1960s there was a fundamental questioning of Modernism and its de-humanizing aesthetic blandness. A new generation of graphic designers, including Wolfgang Weingart (b.1941) began ex-

gestalterischer Tätigkeiten anerkannt. In dieser Zeit wurde die Schweizer Schule weltweit bekannt und einflussreich, und zwar aufgrund des Erfolgs der von Schweizern entwickelten neuen Druckschriften: der Helvetica (1957) von Max Miedinger (1910–1980) und Edouard Hoffmann und der Univers (ebenfalls 1957 entstanden) von Adrien Frutiger (*1928) sowie infolge der Gründung der Zeitschrift »New Graphic Design« im Jahr 1959. Große Unternehmen stellten immer mehr Grafiker ein, um ihre Produkte in einem hart umkämpften Markt durch auffällige Werbung aus der Masse der Konkurrenzprodukte herauszuheben. In dieser Zeit erfolgte die fast völlige Loslösung der Gebrauchsgrafik von ihren gesellschaftlich-kulturellen Wurzeln, so dass sie seither als Werbegrafik untrennbar mit den

même année, ainsi que par le lancement en 1959 de la revue « New Graphic Design ». Un nombre croissant de grandes compagnies engagèrent des graphistes pour les aider à différentier leurs produits sur des marchés de plus en plus compétitifs. A cette époque, le design graphique moderniste se détacha presque entièrement de ses racines sociales pour devenir inextricablement lié aux exigences impérieuses de la publicité. En 1958, Marshall McLuhan (1911–1980), célèbre théoricien canadien spécialisé dans la communication, entama une analyse approfondie de la publicité de son temps et en conclut : « The Media is the Massage » (« Le média constitue le message en soi » ; jeu de mots sur le terme « Mass Age », l'âge des masses, et référence à l'aplanissement de la culture par les médias). Cet « oracle de l'ère électronique » avait déjà compris que l'image primait désormais sur le contenu. Plus important encore, McLuhan s'interrogeait sur la direction dans laquelle les médias électroniques entraînaient la société, un sujet à controverse qui est encore plus pertinent aujourd'hui qu'il ne l'était alors.

Vers la fin des années 1960, on assista à une profonde remise en cause du modernisme et de sa neutralité esthétique déshumanisante. Une nouvelle génération de graphistes, dont Wolfgang Weingart (né en 1941), expérimentèrent des compositions plus expressives tout en continuant à suivre la démarche moderniste de l'Ecole suisse. D'autres, tels que Milton Glaser (né en 1929), furent très influencés par le pop art, lui-même fortement inspiré par la publicité. Des artistes comme Andy Warhol (1928–1987), Richard Hamilton (né en 1922) et Peter Blake (né en 1932) puisaient leur inspiration dans le langage visuel de la culture populaire, brouillant encore un peu plus les distinctions entre les beaux-arts et l'art commercial. A la fin des années 1960, une pléthore d'affiches de protestation contre la guerre du Viêt Nam démontrèrent que les graphistes n'avaient pas besoin de recourir à une approche moderniste pour créer des travaux transmettant un message avec force. Tout au long de la décennie, le gra-

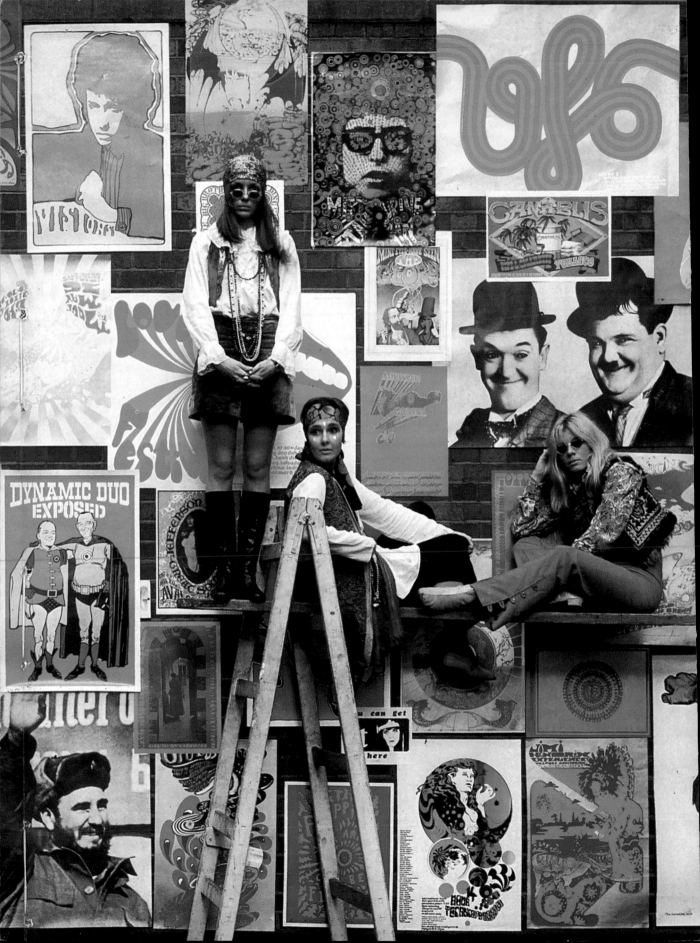

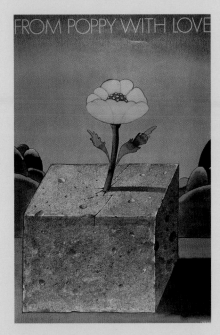

FROM POPPY WITH LOVE

perimenting with more expressive compositions while continuing to follow the Modern approach of the Swiss School. Other graphic designers such as Milton Glaser (b.1929) were highly influenced by Pop Art, which had itself been influenced by commercial art. With artists such as Andy Warhol (1928–1987), Richard Hamilton (b.1922) and Peter Blake (b.1932) looking to the visual language of popular culture for inspiration, the distinctions between fine and commercial art became hazier. In the late 1960s, a plethora of anti-Vietnam War protest posters showed that designers did not have to use a Modernist approach in order to produce work that powerfully conveyed a message. Throughout the 1960s, graphic design expanded into new areas of visual communication such as television and film title sequences. The discipline was now also playing an increasing role in the dissemination of cultural publicity and public information as well as commercial advertising. By the late 1960s graphic designers were also beginning to ex-

**Opposite** Photograph by Patric Ward for the Observer magazine showing a hoarding of psychedelic posters, 1967.
**Top** Poster for Poppy Records. Milton Glaser, 1967.
**Right** Poster for Staatlicher Kunstkredit. Wolfgang Weingart, 1978/79.

Zielen der konsum- und absatzorientierten Wirtschaft assoziiert wird. 1958 begann der kanadische Kommunikationswissenschaftler Marshall McLuhan (1911–1980) mit der Arbeit an seiner gründlichen Untersuchung der aktuellen Situation im Bereich der Werbegrafik und folgerte: »The medium is the massage,« (Wortspiel mit dem Begriff »Mass Age« – Massenzeitalter – und der sanften Bearbeitung der Gesellschaft durch das Medium). Mit seinem »Orakel des Elektronikzeitalters« stellte McLuhan fest, dass das Bild wichtiger geworden war als der Inhalt. Von noch größerer Bedeutung war möglicherweise die von McLuhan gestellte Frage, wohin die elektronischen Medien die Menschheit letzten Endes führen würden – ein Diskussionsthema, das mit Sicherheit heute noch wichtiger ist als damals.

Ende der 60er Jahre wurden die Konzeptionen der Moderne und ihre menschenfeindliche ästhetische Fadheit grundlegend in Frage gestellt. Eine neue Grafikergeneration, zu der auch Wolfgang Weingart (* 1941) zählte, begann mit expressiveren Kompositionen zu experimentieren, während sie andererseits dem modernen Ansatz der Schweizer Grafikschule treu blieb. Andere Grafiker wie Milton Glaser (* 1929) waren stark von der Pop Art geprägt, die ihrerseits Einflüsse aus der Werbegrafik aufgenommen hatte. Durch das Schaffen von Künstlern wie Andy Warhol (1928–1987), Richard Hamilton (* 1922) und Peter Blake (* 1932), die ihre Inspiration aus der Bildsprache der Alltagskultur bezogen, verwischten sich die Grenzen zwischen der bildenden Kunst und freien Grafik einerseits und dem zweckbestimmten Grafikdesign (Gebrauchs-/Werbegrafik) andererseits. Eine Fülle von Anti-Vietnamkrieg-Plakaten der späten 60er Jahre belegen, dass ihre Urheber keinen klassisch-modernen Ansatz benötigten, um Grafiken mit starker Aussagekraft zu schaffen. In den 60er Jahren eroberte das Grafikdesign neue Gebiete der visuellen Kommunikation, unter anderem das Fernsehen und die Vor- und Abspannsequenzen von Spielfilmen. Grafiker spielten nun außer im Bereich der

phisme s'étendit à de nouveaux domaines de la communication visuelle tels que la télévision et le cinéma. La discipline jouait désormais un rôle croissant dans la diffusion de la culture et de l'information publique tout comme dans la publicité. Vers la fin de cette période, les graphistes commencèrent également à exploiter les grandes avancées technologiques survenues dans le tirage photographique, qui leur offraient une liberté créative bien plus grande ainsi qu'une impression couleur moins chère et de meilleure qualité.

A la fin des années 1960 et au cours des années 1970, le graphisme devint encore plus étroitement associé au marketing, de nombreuses sociétés commandant de nouveaux logos – langage universel du capitalisme d'entreprise – afin d'être toujours plus compétitives sur un marché de plus en plus planétaire et basé sur l'image. En réaction à la banalité et à l'uniformité du langage visuel de l'entreprise, l'ère du verseau fut marquée par l'apparition tonitruante et kaléidoscopique du poster psychédélique, soit l'antithèse même de l'affiche inspirée de l'Ecole suisse. Devant le désenchantement croissant face au modernisme et sa récupération par les multinationales, de nombreux graphistes cherchèrent des alternatives. En Grande-Bretagne à la fin des années 1970, le mouvement punk servit de catalyseur à la naissance d'une nouvelle approche,

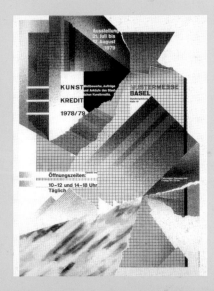

ploit the enormous changes taking place in photographic print technology, which allowed them a far greater degree of creative control and provided them with cheaper and better quality colour printing.

Graphic design became even more closely tied to marketing during the late 1960s and the 1970s with many companies commissioning new logos – the universal language of corporate capitalism – in an effort to compete more effectively in an increasingly global and image-based world. As a reaction against the ascendancy of the banal uniformity of corporate visual language, the Age of Aquarius saw the lurid kaleidoscopic dawn of the psychedelic poster, which was the very antithesis of the Swiss School. In response to growing disenchantment with Modernism and its perceived complicity with big business, many other designers began seeking alternative approaches to graphic design. In the late 1970s, the Punk movement acted as a catalyst for the birth of a new approach to graphics in Britain, which was exemplified by the Sex Pistols' God Save the Queen record sleeve (1977) designed by Jamie Reid (b.1940). This brash rough-and-ready-made anarchic style not only captured the energy and frustrated anger of contemporary youth-culture, but also intentionally mocked the staid aesthetic refinement of Modernism.

Around the same time a New Wave of post-modern graphic design swept Holland and America. Although retaining certain Swiss School elements, New Wave graphic design subverted the holy grid of Modernism and playfully incorporated eclectic cultural references from art, photography, film, advertising and iconic graphic designs from the past. New Wave designers such as Jan van Toorn (b.1932) and April Greiman (b.1948) replaced Modern objectivity with a post-modern subjectivity that evoked viewer response through a new kind of visual poetry. Inspired by the emergence of new forms of electronic media, Californian New Wave work incorporated deconstructed compositions so as to produce a sense of messages being

kommerziellen Werbung auch eine wichtige Rolle in der Verbreitung sozio-kultureller Inhalte und Informationen von öffentlichem Interesse. Ab Ende der 60er Jahre nutzten Grafikdesigner außerdem die revolutionäre neue Offset-Drucktechnik, die mit Druckfilmen arbeitet. Sie erlaubte ihnen ein größeres Maß an kreativer Steuerung des Herstellungsprozesses und lieferte billigere Farbdrucke von besserer Qualität.

Ende der 60er und in den 70er Jahren rückte die angewandte Grafik in noch größere Nähe – und Abhängigkeit – vom Marketing, als viele Unternehmen neue Firmenlogos – Universalvokabeln des privatwirtschaftlichen Kapitalismus – in Auftrag gaben. Damit sollte ihre Wettbewerbsfähigkeit in einem globalen und imageabhängigen Markt gesteigert werden. Als Reaktion auf den Vormarsch banaler Uniformität in der öffentlichen Selbstdarstellung der Industrieunternehmen erlebte das Zeitalter des Wassermanns die grelle kaleidoskopische Geburt des psychedelischen Plakats – der exakten Antithese des rationalen Designs der Schweizer Schule. Infolge ihrer wachsenden Unzufriedenheit mit der Nüchternheit der klassischen Moderne und dem Gefühl, zu Komplizen des Big Business geworden zu sein, suchten viele Grafiker nach alternativen Gestaltungsarten und -mitteln. Die Punk-Bewegung der späten 70er Jahre gab in Großbritannien den Anstoß zu einer neuen grafischen Kunstrichtung, für die das Plattencover der LP »God Save the Queen« (1977) der Sex Pistols beispielhaft ist. Der Entwurf stammte von Jamie Reid (* 1940). Dieser grellbunte, krude, anarchische Stil hielt nicht nur die Energie und frustrierte Wut der damaligen Jugendkultur im Bild fest, sondern nahm auch ganz bewusst die konservativ-seriösen ästhetischen Raffinessen der Moderne auf die Schippe.

Etwa zur gleichen Zeit kam in den Niederlanden und den USA die New

illustrée par la pochette du disque des Sex Pistols « God Save the Queen » (1977), réalisée par Jamie Reid (née en 1940). Ce style anarchique, agressif et fruste traduisait l'énergie et la colère frustrée de la jeunesse tout en parodiant intentionnellement le raffinement esthétique et guindé du modernisme.

Vers la même époque, un nouvelle vague de graphismes postmodernes déferla sur la Hollande et les Etats-Unis. Tout en conservant certains des éléments de l'Ecole suisse, ils détournaient le sacro-saint quadrillage moderniste en introduisant de manière ludique des références éclectiques à l'art, à la photographie, au cinéma, à la publicité et aux motifs graphiques emblématiques du passé. Des graphistes new wave tels que Jan van Toorn (né en 1932) ou April Greiman (née en 1948) remplacèrent l'objectivité moderniste par une subjectivité postmoderne qui

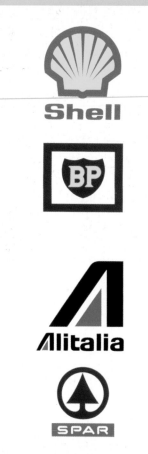

**Right** Logos for Shell and BP. Raymond Loewy Associates, 1967 & 1968. Logos for Alitalia and Spar. Landor Associates, 1969 & 1970.
**Opposite** Cover for the Sex Pistols'"God Save the Queen" single. Jamie Reid, 1977.

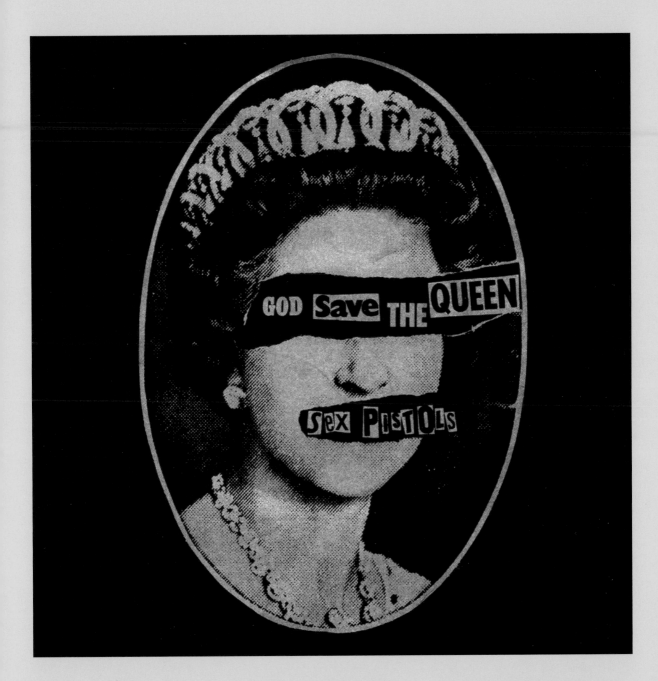

filtered through layers, which in turn affected a strong three-dimensional quality or visual depth. Using Apple Macintosh software, designers created a language of hybrid imagery with encoded messages, while the seemingly random placement of collage-like images provided their work with a refreshing vitality. In 1982, the launch of the large-format graphic magazine Emigre by Rudy Vander-Lans (b.1955) and Zuzana Licko (b.1961) disseminated the ideas be-

Wave des postmodernen Grafik-designs auf. Obwohl sie bestimmte Elemente der Schweizer Schule beibehielten, warfen die New-Wave-Grafiker doch insgesamt das geheiligte Paradigma der Moderne über den Haufen und bauten spielerisch Versatzstücke aus Malerei und Plastik, Fotografie und Film, Werbung und historischen Grafik-»Ikonen« in ihre Entwürfe ein. Grafiker wie Jan van Toorn (* 1932) und April Greiman (* 1948) ersetzten klassisch-moderne

évoquait la réaction du spectateur à travers une forme de poésie visuelle. Inspirée par l'émergence de nouveaux médias électroniques, la nouvelle vague californienne proposait des compositions déconstruites qui créaient l'impression de messages filtrés par des couches superposées, ce qui apportait en retour une forte qualité tridimensionnelle ou de la profondeur visuelle. A l'aide des logiciels d'Apple Macintosh, les graphistes inventèrent un langage ico-

hind this new movement in graphic design to a much wider international audience. Eventually, post-modernism came to mean a multiplicity of graphic styles (often appropriated), which were characterised by visually arresting, layered compositions of frequently indecipherable meaning.

During the 1980s the increasing emphasis on image over content led to the meteoric rise of "the brand", which, with the right help from graphic designers, transcended national preferences to become a globally understood seal of approval. Companies such as Levi's and Nike were quick to understand that "cutting-edge" graphic design could give their products a distinct competitive advantage. At a time when the social glue of traditional institutions,

Objektivität durch postmoderne Subjektivität und ihre neue Art visueller Poesie fand bei den Betrachtern Anklang. Inspiriert von den neuen elektronischen Medien schufen kalifornische New-Wave-Grafiker auch dekonstruierte Kompositionen, um den Eindruck zu erwecken, dass die grafisch umgesetzten Inhalte durch mehrere Schichten gefiltert waren, was eine deutlich dreidimensionale Qualität bzw. optische Tiefe erzeugte. Unter Einsatz von Apple-Macintosh-Software entwickelten Designer in Kalifornien eine Art hybride Bildsprache mit verschlüsselten Botschaften, während die scheinbar zufällige Platzierung von collagenhaften Bildern ihren Arbeiten eine erfrischende Vitalität verliehen. 1982 gründeten Rudy van der Lans (* 1955) und Zuzana Licko (* 1961) die Zeitschrift

nographique hybride contenant des messages codés, tandis que l'insertion apparemment aléatoire d'images rappelant des collages donnait à leurs travaux une vitalité rafraîchissante. En 1982, le lancement de la revue de typographie grand format « Emigre » par Rudy VanderLans (né en 1955) et Zuzana Licko (née en 1961), propagea les idées de ce nouveau mouvement à un public international beaucoup plus vaste. Au bout du compte, le postmodernisme en vint à signifier une multiplicité de styles graphiques (souvent récupérés) caractérisés par des compositions multicouches, visuellement frappantes et au sens fréquemment indéchiffrable.

Au cours des années 1980, la primauté croissante de l'image sur le contenu entraîna l'essor météorique de la « marque » qui, avec l'aide avisée des graphistes, transcendait les préférences nationales pour devenir un label d'approbation compris partout dans le monde. Des compagnies telles que Levi's et Nike comprirent rapidement qu'un design graphique « dans le vent » pouvait donner à leurs produits un net avantage sur la concurrence. A une époque où se fragmentait la cohésion sociale des institutions traditionnelles, de la famille nucléaire à la religion organisée, les marques offraient aux consommateurs un sentiment d'appartenance à un groupe, « sans les responsabilités », qui les aidaient à définir leur propre image. Façonner une marque consiste avant tout à projeter des aspirations et à créer des désirs. C'est l'emballage (le style) plutôt que le produit (le contenu) qui nous séduit à un niveau affectif, d'où le fait que certains logos commerciaux soient vénérés comme de véritables idoles. Toutefois, le facteur de « bien-être » s'émousse rapidement quand on sait que ces baskets ou ces vêtements aux prix exorbitants ont été fabriqués par des ouvriers du Tiers Monde payés une misère. Un sentiment de culpabilité peut alors rapidement venir ternir les ors de la marque. Tout au long des années 1980 et jusqu'au début des années 1990, les graphistes se sont fait les complices de l'essor fulgurant de ce culte du logo, au point de paraître presque totalement insen-

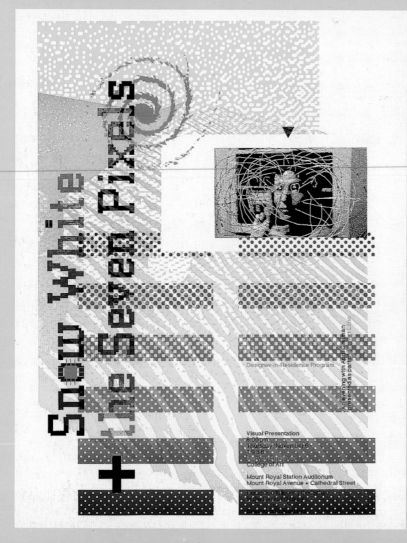

from the nuclear family to organized religion, was becoming unstuck, brands offered the consumer a no-strings-attached sense of belonging while helping them define their self-image. Branding is essentially all about the projection of aspirations and the creation of desires. It is the package (style) rather than the product (content) that appeals to us on an emotional level, and this is the reason why certain commercial logos are worshipped like religious idols. The feel-good factor of a brand, however, can be quickly eroded with the knowledge that those ludicrously expensive trainers, clothes, etc. have been made by wage-slaves in the Third World – quite simply the gilt can turn to guilt. Throughout the 1980s and early 1990s the graphic design profession aided and abetted the meteoric rise of "the brand" and appeared almost completely blinkered to the ills of rampant consumerism.

By the early 1990s, post-modernism had escaped from the confines of design institutions and the music and art scenes and became widely embraced by corporate marketeers desperately searching for the elusive elixir of cool – the very life blood of branding. At long last the gulf between progressive educational theory and mainstream professional practice appeared to have been bridged. There was, however, a growing realisation among a new generation of Late Modern designers – many of whom are included in this survey – that style and content are equally important in the creation of Good Design solutions. Today's New Pluralism in graphic design must be seen on the one hand as a response to the greater multiculturalism of today's global society, and on the other as being prompted by the strong desire of designers to develop their own unique style, which enables them to stand out from the crowd. Many designers are challenging traditional notions of beauty with provocative work that expresses radical ideas. The majority of imagemakers working today have been strongly inspired by developments in art and film and have incorporated aspects of these disciplines into their work, which has in turn led to a

**Opposite** Poster for "Snow White + Seven Pixels" presentation. April Greiman, 1986.
**Right** Calendar for Mart. Jan van Toorn, 1972.

»Emigre«, die einem breiteren internationalen Publikum das Gedankengut der neuen Strömung in der Gebrauchsgrafik vermittelte. In diesem kreativen Bereich bedeutete Postmoderne schließlich eine Fülle unterschiedlicher Stile (häufig auch übernommener Formen), die sich durch optisch reizvolle, geschichtete Kompositionen mit häufig unentzifferbarer Bedeutung auszeichneten.

In den 80er Jahren führte die wachsende Bevorzugung von Bild und Piktogramm gegenüber dem Text zum kometenhaften Aufstieg der »Marke«, die mit kongenialer Unterstützung des Grafikers nationale Vorlieben hinwegfegte, um zum weltweit akzeptierten Gütesiegel zu werden. Firmen wie Levi's und Nike begriffen sehr schnell, dass eine treffsichere Werbung ihren Produkten entscheidende Wettbewerbsvorteile verschaffen konnte. In einer Zeit, in der der gesellschaftliche Leim in Form überlieferter Institutionen – von der Kleinfamilie bis zur kirchlich organisierten Religion – seine bindende Kraft zu verlieren begann, boten Marken den Konsumenten das Gefühl der Zusammen- und Zugehörigkeit ohne Verpflichtungen und halfen ihnen, ihr Selbstbild zu definieren, denn bei der Markenbildung geht es im Wesentlichen um die Projektion von Hoffnungen und Zielsetzungen und um die Erzeugung von Wünschen. Es ist die Verpackung (Stil) und nicht das Produkt (Inhalt), die uns emotional anspricht, und das ist auch der Grund dafür, dass bestimmte Markenzeichen buchstäblich vergöttert werden. Der Wohlfühlfaktor einer Marke kann sich jedoch schnell verflüchtigen, wenn man erfährt, dass diese oder jene wahnsinnig teuren Sportschuhe, Pullover usw. von Lohnsklaven in der Dritten Welt angefertigt worden sind – aus dem Wohl- kann schnell ein Schuldgefühl werden. In den 80er und frühen 90er Jahren unterstützte und förderte die gesamte Grafikdesignbranche den Aufstieg der »Marke« und es schien fast, als sei sie angesichts der Übel eines ungebremsten Konsumdenkens mit Blindheit geschlagen.

sibles aux maux du consumérisme galopant.

Au début des années 1990, le postmodernisme s'était échappé des confins des institutions du design, de la musique et de l'art pour être largement récupéré par les départements de marketing dans leur quête désespérée de l'élixir volatil du « cool », le nerf de la stratégie de marque. Finalement, le gouffre entre la théorie pédagogique progressiste et la pratique professionnelle au sens large semblait avoir été comblé. Toutefois, parmi la nouvelle génération de graphistes du « modernisme tardif », dont bon nombre figurent dans cet ouvrage, on a pu observer une prise de conscience croissante du fait que le style et le contenu sont aussi importants l'un que l'autre dans la création de solutions pour un « Bon Design ». Le nouveau pluralisme d'aujourd'hui doit s'interpréter, d'une part, comme une réaction au multiculturalisme accru de notre société planétaire et, de l'autre, comme l'expression du puissant désir des graphistes de développer leur propre style afin de se démarquer du lot. Bon nombre d'entre eux remettent en question les critères traditionnels de beauté en réalisant des projets provoquants qui expriment des idées radicales. La majorité de ceux qui fabriquent des images aujourd'hui ont été fortement inspirés par les nouveaux courants de l'art et du cinéma et ont intégré des aspects de ces disciplines dans leurs travaux, ce qui, en retour, a élargi l'interprétation de

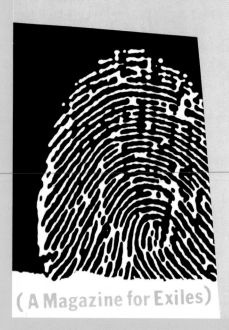

ce que constitue exactement le graphisme. Des graphistes tels que M/M (Paris), Devis & van Deursen ou Jonathan Barnbrook ont tissé des liens étroits avec le monde de l'art. Toutefois, dans la plupart des cas, leur travail demeure assujetti au projet de leur client et, à ce titre, ne peut prétendre à la liberté créative d'un art à part entière, à moins d'être entrepris par eux-mêmes pour eux-mêmes. Afin de laisser parler leur propre créativité et d'exprimer leurs idées personnelles, un nombre croissant de graphistes financent donc leurs travaux exploratoires et expérimentaux avec les revenus de commandes commerciales bien rémunérées (c'est notamment le cas de Jonathan Barnbrook). Beaucoup ont compris que l'ambiguïté peut créer une impression de mystère, ce qui aide à capter puis à retenir l'attention du spectateur. De par ce phénomène, le graphisme est souvent utilisé non plus pour résoudre des problèmes de communication mais pour soumettre des énigmes au public. On remarque également un nombre croissant de graphistes produisant des travaux qui reposent davantage sur le texte, avec un message unique direct et puissant qui n'est plus ouvert à une multitude d'interprétations. La forme directe des messages vient souvent du fait que l'annonceur incarne un idéal et veut promouvoir sa cause avec la plus grande clarté possible. Depuis le début des années 1990, le « subvertising » (jeu de mots entre subvert, « ébranler, faire échouer » et advertising, « publicité ») avec son carambolage de messages commerciaux fait preuve d'une grande efficacité communicative dans sa tentative de mener une révolution antimondialiste. En effet, on paraît aujourd'hui de plus en plus convaincu que la simplification est souvent le meilleur moyen de filtrer l'information dans un océan sans fond de futilités. Il semble qu'à l'avenir, les graphistes auront l'obligation de devenir des « architectes de l'information » afin de créer des outils qui aideront l'utilisateur à mieux naviguer sur les eaux complexes de l'ère numérique.

La longue complicité entre le métier de graphiste et les grandes entre-

broader interpretation of what actually constitutes graphic design. Designers such as M/M (Paris), Mevis & van Deursen and Jonathan Barnbrook have developed close associations with the art world; however, their work in most cases remains constrained by the client's brief and as such can never match the complete creative freedom of art unless it is undertaken by themselves, for themselves. Increasingly designers are therefore subsidizing self-initiated exploratory and experimental work that allows them to express their

Anfang der 90er Dekade war die Postmoderne aus den Beschränkungen der Designinstitutionen, der Musik- und Kunstszene ausgebrochen und eroberte die Welt der Marketingfachleute, die verzweifelt auf der Suche waren nach dem schwer zu fassenden Elixier, dem Herzblut der Markenbildung, dem man den Namen »Cool« gegeben hatte. Endlich war die Kluft zwischen progressiver Bildungstheorie und gängiger Berufspraxis überwunden, so schien es. Allerdings machte sich unter den jüngeren Grafikern der

own creative individuality and personal ideas with revenues from well-paid commercial work (Jonathan Barnbrook for instance). Many have realised that uncertain meaning can evoke a sense of mystery, which can help to capture and hold the viewer's attention. This phenomenon has led graphic design to be used not as a means to solve a communication problem, but as a way of posing the viewer with a communicative riddle. There are also, however, a growing number of designers who are producing more text-based work, which has a single, powerfully direct message that is not open to a multitude of interpretations. Often the directness of messages comes about because the communicator stands for an ideal and wants to promote his/her cause with the utmost clarity. Since the early 1990s, "Subvertising" with its jamming of corporate messages has displayed a strong communicative directness in its attempt to help spearhead an anti-globalisation revolution. Certainly there is now a growing realisation that simplification is often the best way to filter information from an endless ocean of trivia, and that in the future the onus will be on graphic designers to become "information architects" so that they can create

Spätmoderne – von denen viele in diesem Buch vertreten sind – die Erkenntnis breit, dass Stil und Inhalt für gute Designlösungen gleichermaßen erforderlich sind. Der aktuell herrschende neue Pluralismus im Grafikdesign muss einerseits als Folge der größeren Multikulturalität unserer Weltgemeinschaft gesehen werden und andererseits als Ergebnis des ausgeprägten Bemühens vieler Designer um ihren ureigenen Stil, der sie von der Masse abhebt. Viele Grafiker stellen die herkömmlichen Schönheitsbegriffe in Frage, und zwar mittels provokanter Arbeiten, in denen sie radikale Konzepte ausdrücken. Die meisten heute tätigen Bildermacher lassen sich stark von Kunst und Film inspirieren und verarbeiten diese Anregungen, was dazu geführt hat, dass der Begriff Grafikdesign derzeit weiter gefasst und interpretiert wird als früher. Designer wie M/M (Paris), Mevis & van Deursen und Jonathan Barnbrook pflegen enge Beziehungen zur Kunstszene. Ein Großteil ihrer Arbeitsleistung ist jedoch den Vorgaben der Kunden unterworfen und sie können daher niemals die völlige schöpferische Freiheit des bildenden Künstlers erlangen, es sei denn, in ihrer Freizeit zum eigenen Vergnügen. Daher subventionieren Grafikdesigner (zum Beispiel Jonathan Barnbrook) in zunehmendem Maße eigene experimentelle Initiativen aus den Erlösen gut bezahlter Aufträge aus der Wirtschaft. Diese Projekte erlauben es ihnen, künstlerische Individualität zu entwickeln und eigene Ideen umzusetzen. Viele haben erkannt, dass unbestimmte Inhalte etwas Geheimnisvolles haben, das geeignet ist, die Aufmerksamkeit des Betrachters auf sich zu ziehen und gefangen zu halten. Aufgrund dieses Phänomens werden grafische Entwürfe nicht länger als Mittel zur Lösung einer Kommunikationsaufgabe gesehen, sondern als Chance, den Betrachter in das kommunikative Rätsel einzubeziehen. Andererseits gibt es eine

**Opposite** Emigre magazine, issue 1. Rudy Vanderlands, 1984.
**Left** Wall-painted title sequence for the Biennale di Venezia. M/M (Paris) in collaboration with Philippe Parreno, Pierre Huyghe and Dominique Gonzalez-Foerster, 1999.
**Top** Eye magazine. UNA (London) designers, illustration Jasper Goodall, 2001.

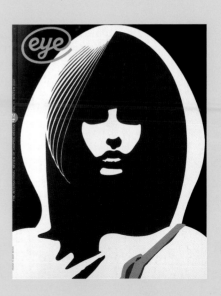

prises a conduit à l'expansion rapide et à la mondialisation d'une culture commerciale. Il est peut-être temps pour ces professionnels de s'interroger sur les fondements éthiques du travail qu'ils produisent. Le graphisme a été trop longtemps utilisé cyniquement comme un moyen d'inciter les consommateurs des pays industrialisés à acheter plus de produits dont ils avaient besoin alors que, dans les pays en voie de développement, des millions de gens n'ont toujours pas accès à l'eau potable, à suffisamment de nourriture, à des médicaments de base et à une éducation même rudimentaire. Pire encore, ces produits superflus sont souvent réalisés dans des ateliers clandestins par des ouvriers exploités et appartenant aux couches les plus démunies de notre société planétaire. Les graphistes ont trop souvent aidé les entreprises à mettre leurs marques en valeur, masquant ces détails sous des campagnes bien léchées. Plutôt qu'aider à vendre des produits discutables – des boissons alcoolisées pour adolescents, des cigarettes, des mauvais produits alimentaires, des voitures polluantes et autres produits pétrochimiques nuisant à l'environnement, ils pourraient mettre leur ingéniosité communicative au service de préoccupations sociales et écologiques vitales. De fait, c'est ce qui est en train de se produire au ni-veau populaire comme on peut le constater en feuilletant le magazine « Adbusters ».

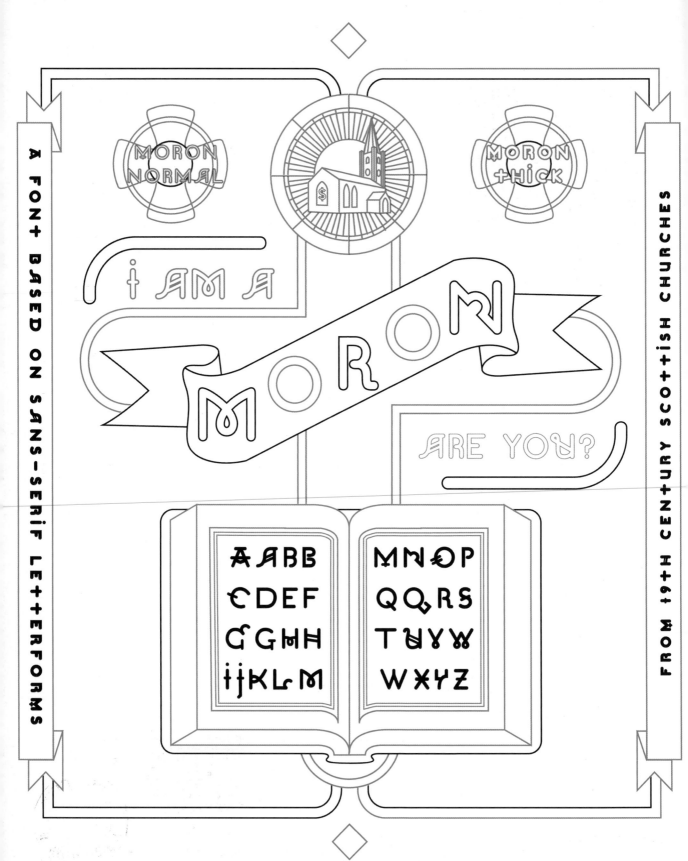

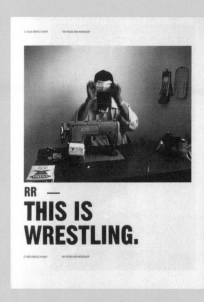

tools that help the user to better navigate the complex seas of the digital age.

The long-standing complicity of the graphic design profession with big business has led to the rapid expansion and globalisation of commercial culture, and perhaps it is now time for practitioners to question the ethical basis of the work they produce. For too long, graphic design has been cynically used as a means to induce people in the developed world to buy more products they don't really need, when in developing nations literally millions still do not have access to clean water, sufficient food, basic medicines or rudimentary education. To make matters worse, these superfluous marketing-driven products are often made in exploitative sweatshops by the most deprived members of our global society. Yet all too frequently, graphic designers have helped corporations gloss over such brand-depreciating details with slick ad campaigns. Rather than helping to sell questionable products – from alcopops, cigarettes and junk food to gas-guzzling cars and environmentally damaging petrochemicals – graphic designers could use their

wachsende Anzahl von Grafikern, die stärker auf Text basierende Arbeiten mit einer einzigen, eindrucksvoll direkten Botschaft entwickeln, die eben nicht eine Vielzahl von Interpretationen zulässt. Die Unmittelbarkeit entsteht in diesen Fällen, weil der Mitteilende ein Idealist ist, der seinen »Fall« mit äußerster Deutlichkeit und Klarheit vorbringen will. Seit Anfang der 90er Jahre hat die Praxis des »Subvertising« (subverting und advertising = Subversion und Werbung) mit ihrer Verballhornung von Firmenwerbungen eine ausgeprägte Direktheit des Kommunikationsstils an den Tag gelegt, die dazu dienen soll, den Kampf gegen die Globalisierung anzuführen. Auf jeden Fall wächst heute die Erkenntnis, dass Vereinfachung in vielen Fällen die beste Methode ist, um wichtige Informationen aus einer endlosen Flut von Trivialitäten herauszufiltern, und dass Grafiker in Zukunft die Pflicht haben, sich zu »Informationsarchitekten« auszubilden, damit sie Werkzeuge schaffen, die dem Benutzer dabei helfen, die vielfältigen Klippen des Computerzeitalters mit mehr Geschick und Effizienz zu umschiffen.

Die lange während Allianz der Gebrauchsgrafiker mit dem Big Business hatte die rasche Expansion und Internationalisierung der Konsum- und Werbekultur zur Folge und es ist daher vielleicht für die in diesem Bereich arbeitenden kreativen Köpfe an der Zeit, die ethischen Grundlagen ihrer Arbeit zu überprüfen. Allzu lange ist die grafische Kunst auf zynische Weise dazu missbraucht worden, die Menschen in den hoch entwickelten Ländern zum Kauf von Produkten zu verleiten, die sie nicht wirklich brauchen, während buchstäblich Millionen in den unterentwickelten Ländern noch nicht einmal sauberes Trinkwasser, ausreichend Nahrungsmittel und die nötigsten Medikamente haben oder eine rudimentäre Schulbildung genießen. Die Situation wird noch dadurch verschlimmert, dass die von den Marketingabteilungen im Westen georderten überflüssigen Waren häufig unter unmenschlichen Bedingungen von den ärmsten Mitgliedern der globalen Gesellschaft zu Hungerlöhnen hergestellt werden.

Par-dessus tout, les graphistes d'aujourd'hui doivent reconnaître qu'ils sont investis d'une responsabilité particulière (et la capacité d'y faire face) non seulement vis-à-vis de leurs clients mais face à la société dans son ensemble. Le pouvoir persuasif phénoménal du design graphique pourrait être maîtrisé et orienté de manière à modifier radicalement la façon dont nous réfléchissons aux questions importantes de l'avenir, du réchauffement de la planète à la dette du Tiers Monde. Bien que tous les travaux réalisés par les graphistes ne relèvent pas du domaine de la prise de décision éthique, la profession doit encore faire basculer la balance du commercial au social si elle veut rester une force culturelle pertinente et vitale.

*Note des auteurs : dans cet essai, nous examinons le design graphique en termes de combinaison de textes et d'images. Naturellement, la typographie en tant que spécialisation des arts graphiques a une histoire beaucoup plus longue.*

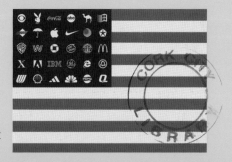

**Opposite** Specimen sheet for the typeface 'Moron'. Jonathan Barnbrook, 2001.
**Top** "Los Amorales" book for Artimo. Mevis & van Deursen, 2001.
**Right** Corporate flag for Adbusters. Shi Zhe Yung, 2000.

communicative ingenuity to highlight vital social and environmental concerns. In fact this is already happening at a grassroots level, as can be gleaned from a casual perusal of Adbusters magazine.

Above all else, graphic designers working today need to acknowledge that they have a special responsibility (and ability to respond) not just to the needs of their clients, but also to those of society as a whole. The phenomenal persuasive power of graphic design could be harnessed and directed in such a way that it radically alters the way people think about the important issues of the future, from global warming to third world debt. Although not all the work done by graphic designers falls into the realm of ethical decision-making, the profession still needs to tip the balance from the commercial to the social if it is to remain a relevant and vital cultural force.

*Please note: for the purpose of this essay we are viewing graphic design in terms of the combination of text and image. Typography as a specialisation of graphic design has, of course, a much longer history.*

Allzu oft haben Werbegrafiker den westlichen Firmen noch geholfen, derartige »markenschädigende« Informationen mittels Hochglanz-Werbekampagnen zu vertuschen. Anstatt Beihilfe zum Absatz fragwürdiger Produkte zu leisten – von Alcopops (alkoholhaltigen Limonaden), Zigaretten und ungesundem Fastfood bis zu bleispuckenden Autos und umweltschädlichen Chemikalien –, könnten Grafiker ihr kommunikatives Talent dazu benutzen, lebenswichtige soziale und ökologische Belange ans Licht der Öffentlichkeit zu bringen. Tatsächlich passiert das schon jetzt – und zwar an der Basis –, wie man schon beim flüchtigen Durchblättern der Zeitschrift »Adbusters« (Anzeigensprenger) bemerkt.

Vor allem anderen aber müssen Grafiker einräumen, dass sie eine besondere Verantwortung dafür tragen (und auch dazu fähig sind), nicht nur die Bedürfnisse ihrer Auftraggeber zu erfüllen, sondern auch die der Gesellschaft als Ganzes. Die phänomenale Überzeugungskraft des Grafikdesigns könnte so mobilisiert und eingesetzt werden, dass sie eine radikale Umkehr im Denken der Menschen über wichtige Zukunftsfragen herbeiführt – von der Erwärmung der Erdatmosphäre bis zum Schuldenberg der Entwicklungsländer. Obwohl nicht alle Arbeiten von Grafikdesignern den Bereich ethischer Entscheidungsfindungen berühren, müssen die Mitglieder der Profession noch den Schritt vom überwiegend kommerziellen zum überwiegend sozialen Engagement vollziehen, wenn sie eine relevante und lebendige kulturtreibende Kraft bleiben wollen.

*Anmerkung: In diesem Essay beschreiben die Begriffe Gebrauchsgrafik oder Grafikdesign die Zusammenstellung von Text und Bild. Die Typografie als spezielle Form der Gebrauchsgrafik blickt natürlich auf eine viel längere Geschichte zurück.*

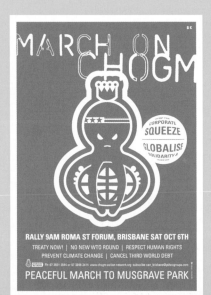

MARCH ON CHOGM

CORPORATE SQUEEZE

GLOBALISE SOLIDARITY

RALLY 9AM ROMA ST FORUM, BRISBANE SAT OCT 6TH
TREATY NOW! | NO NEW WTO ROUND | RESPECT HUMAN RIGHTS
PREVENT CLIMATE CHANGE | CANCEL THIRD WORLD DEBT
Ph 07 3831 1544 or 07 3846 3414 www.chogm-action-network.org subscribe-can_brisbane@yahoogroups.com
PEACEFUL MARCH TO MUSGRAVE PARK

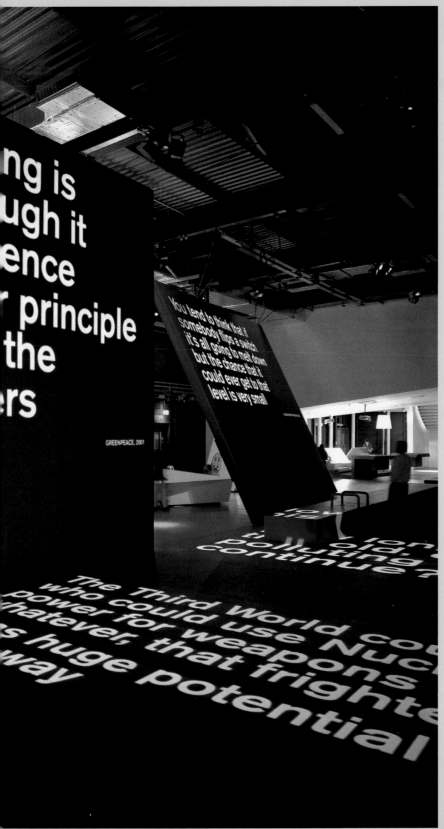

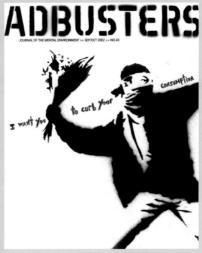

Opposite Poster for Commonwealth Heads of
Government Meeting protest march. Inkahoots, 2001.
Left Exhibition graphics and projected typo-animated
audio-visual installation debating the issues relating to
nuclear power for the Science Museum at BNFL
Visitors Centre, Sellafield, UK. UNA (London)
designers, 2002.
Top Adbusters magazine. Cover design Banksy, Art
Director Paul Shoebridge, 2002.

# Aboud Sodano

## "It's only a job, but a good job."

Opposite page:

**Project**
Paul Smith Spring /
Summer 2002 advertising
print campaign
Photography: Sandro
Sodano

**Title**
Irreverence

**Client**
Paul Smith, London

**Year**
2002

**Project**
A book about the life
of Paul Smith (image
featuring thirty different
covers available)

**Title**
You can find inspiration in
anything, and if you can't,
look again

**Client**
Violette Editions, London

**Year**
2001

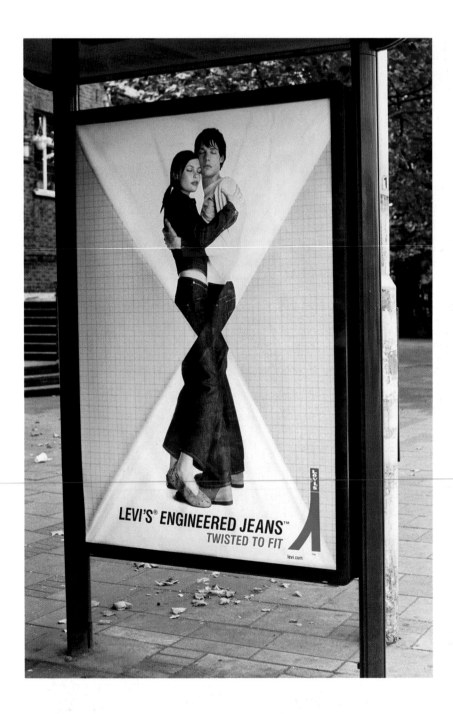

**Project**
Levi's Engineered Jeans
outdoor print campaign
Photography: Rankin

**Title**
Twisted to fit

**Client**
Bartle Bogle Hegarty,
London

**Year**
2000

Opposite page:

**Project**
Paul Smith Autumn
Winter 2002 advertising
print campaign
Photography: Sandro
Sodano

**Title**
Opposites

**Client**
Paul Smith, London

**Year**
2002

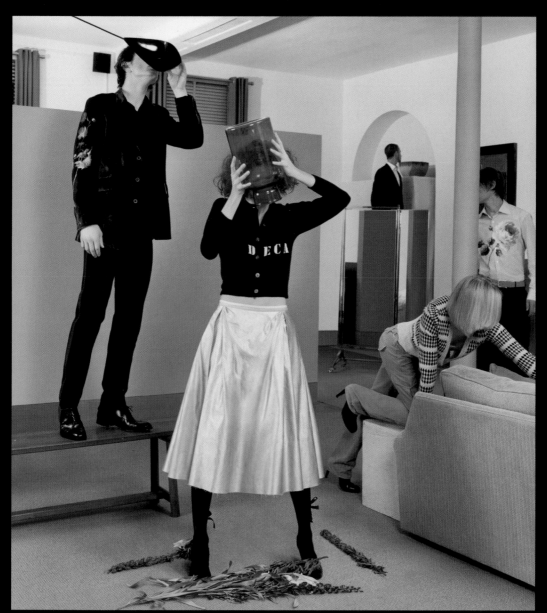

Paul Smith

PAUL SMITH

WESTBOURNE HOUSE, 122 KENSINGTON PARK ROAD, LONDON W11 •
120 KENSINGTON PARK ROAD, LONDON W11 • 40-44 FLORAL STREET,
LONDON WC2 • 84-86 SLOANE AVENUE, LONDON SW3 • 7 THE COURTYARD,
THE ROYAL EXCHANGE, LONDON EC3 • 22-24 BOULEVARD RASPAIL,
75007 PARIS • 108 FIFTH AVENUE, NEW YORK, NY 10011 • PALAZZO
GALLARATI SCOTTI, VIA MANZONI 30, 20121 MILANO • www.paulsmith.co.uk

# Acne

## "Work hard. Have fun."

Opposite page:

**Project**
Art project: Ärliga blå
ögon

**Title**
Ärliga blå ögon / Honest
blue eyes

**Client**
Peter Geschwind / Johan
Zetterquist / Roger
Andersson

**Year**
2001

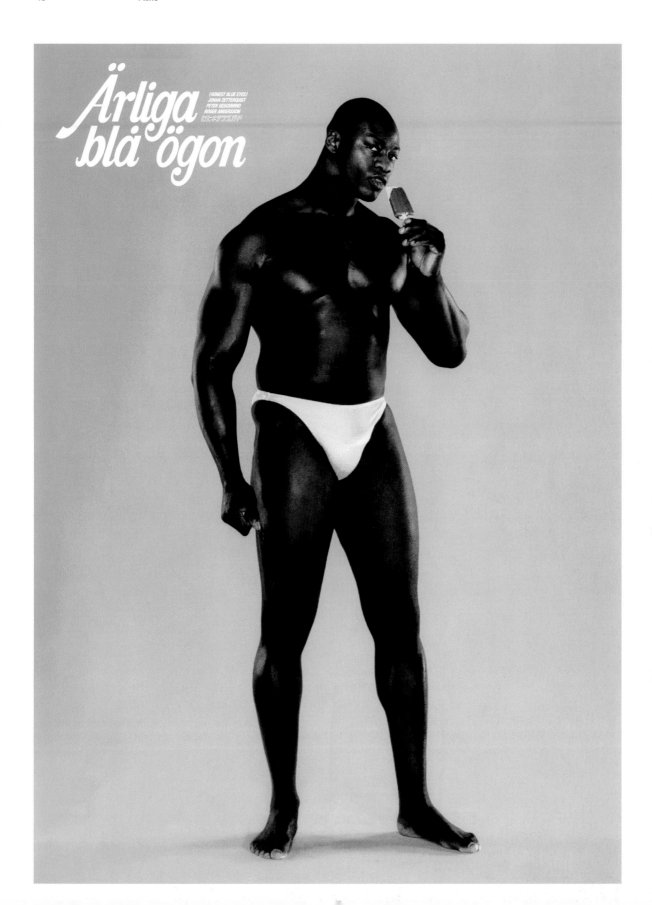

Ärliga blå ögon

(HONEST BLUE EYES)
JOHAN ZETTERQUIST
PETER GESCHWIND
ROGER ANDERSSON

"We live in a 24hr design-driven society where nothing is left un-designed. A need for more graphic design is nowhere to be found in this image infrastructure. Instead, we are in search of great ideas. Design is only a translation of great ideas. Great ideas are what we remember from history and what will make a difference in the future."

» Wir leben heute in einer Welt, die rund um die Uhr von Design getrieben ist, in der es nichts Ungestaltetes mehr gibt. In dieser piktografischen Infrastruktur lässt sich nirgends ein Bedarf für mehr Grafikdesign entdecken. Statt dessen suchen wir nach herausragenden Ideen, denn Grafik ist immer nur die Übersetzung großer Ideen. Aus der Geschichte bleiben immer die großen Visionen in Erinnerung und die werden auch in Zukunft etwas bewegen und verändern. «

« Nous vivons dans une société où tout passe en permanence par le design. Dans cette infrastructure de l'image, nous n'avons pas besoin de plus de graphisme. En revanche, nous sommes en quête de bonnes idées. La création graphique n'est que la traduction de bonnes idées. Elles sont ce que nous retenons de l'histoire et ce qui fera la différence à l'avenir. »

**Acne**
Majorsgatan 11
114 47 Stockholm
Sweden

T +46 8 555 799 00
F +46 8 555 799 99

E contact@acne.se

**Design group history**
1996 Co-founded by Tomas Skoging, Jonny Johansson, Jesper Kouthoofd and Mats Johansson in Stockholm
1998 founded ACNE Action Jeans company
1999 founded Netbaby World Online entertainment company
2000 founded ACNE Film production company; ACNE set up its own advertising agency

**Founders' biographies**
Tomas Skoging
1967 Born in Uppsala, Sweden
1995 Berghs Advertising School, Stockholm
Jonny Johansson
1969 Born in Karlskrona, Sweden
Self-taught
Jesper Kouthoofd
1970 Born in Gothenburg, Sweden
1995 Berghs Advertising School, Stockholm
Mats Johansson
1968 Born in Stockholm
1993–1995 Berghs Advertising School, Stockholm
Pontus Frankenstein (Acne Creative)
1970 Born in Jönköping, Sweden
1996 Beckmans School of Design, Stockholm
David Olsson (Acne Film)
1975 Born in Stockholm
Self-taught

**Recent awards**
2000 Shortlisted, Cannes Lions (x 4); Winner, EPICA; Jury's Special Prize, Utmärkt svensk form (Excellent Swedish Design); Best Music Video, Grammy (Sweden); Advertising Effectiveness Award (Film); Shortlisted, Swedish Golden Egg (Film)
2001 Advertising Effectiveness Awards (Film); Fashion Designer of the Year, Elle Magazine, Stockholm; shortlisted, Cannes Lions (x 1); Winner, EPICA; Finalist, EPICA; Winner, Eurobest Länsförsäkringar; shortlisted, Swedish Golden Egg, (Graphic Design); Silver (x 2), Swedish Golden Egg (Film & Print)
2002 Shortlisted, Swedish Golden Egg (x 2 Film & x 1 Radio); Bronze Award, Clio (Graphic design & product design)

**Clients**
Diesel
Ericsson
Harvey Nichols
H&M
JC
Microsoft
Nissan
Nokia
OLW
SAS
Telia
TV4
Whyred

**Project**
Scandinavian Airlines / children concept

**Title**
Ole

**Client**
SAS / Scandinavian Airlines

**Year**
2000

Opposite page:

**Project**
Zoovillage

**Title**
Spring campaign

**Client**
Zoovillage.com

**Year**
2000

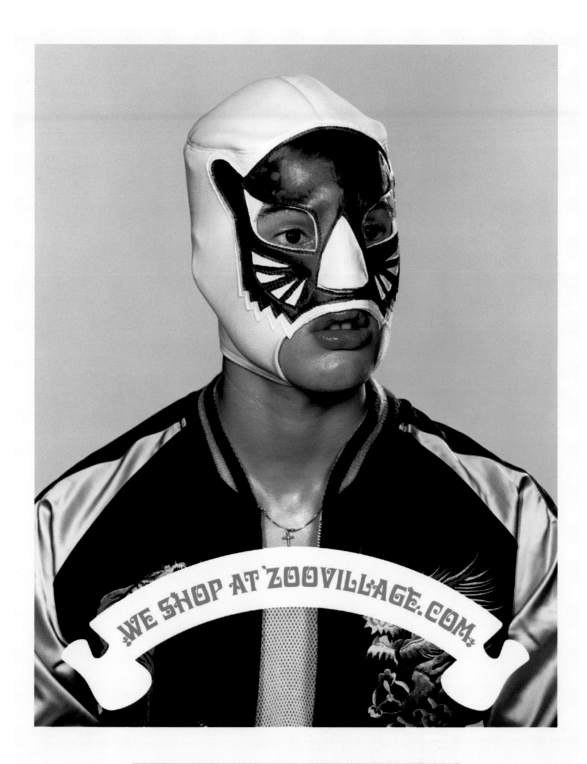

Your local streetwear store. Open 24hrs.

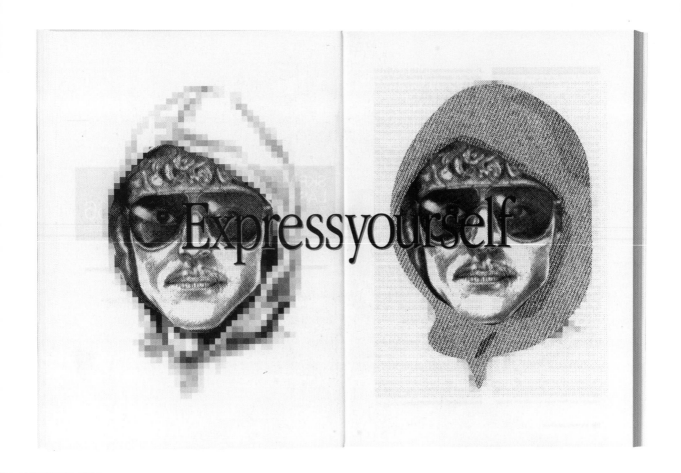

**Project**
Book – cover and inlay
design

**Title**
Media så funkar det /
Media – How it works

**Client**
Mattias Hansson /
Bokförlaget DN

**Year**
2000

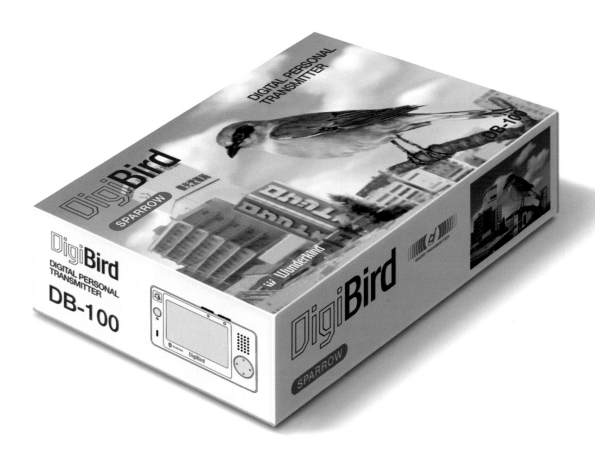

**Project**
Digibird / packaging

**Title**
Sparrow

**Client**
Wunderkind / Acne

**Year**
2001

# Alexander Boxill

## "Appropriate, creative, structured."

Opposite page:

**Project**
Company Brochure

**Title**
Company brochure

**Client**
Self-published

**Year**
2001

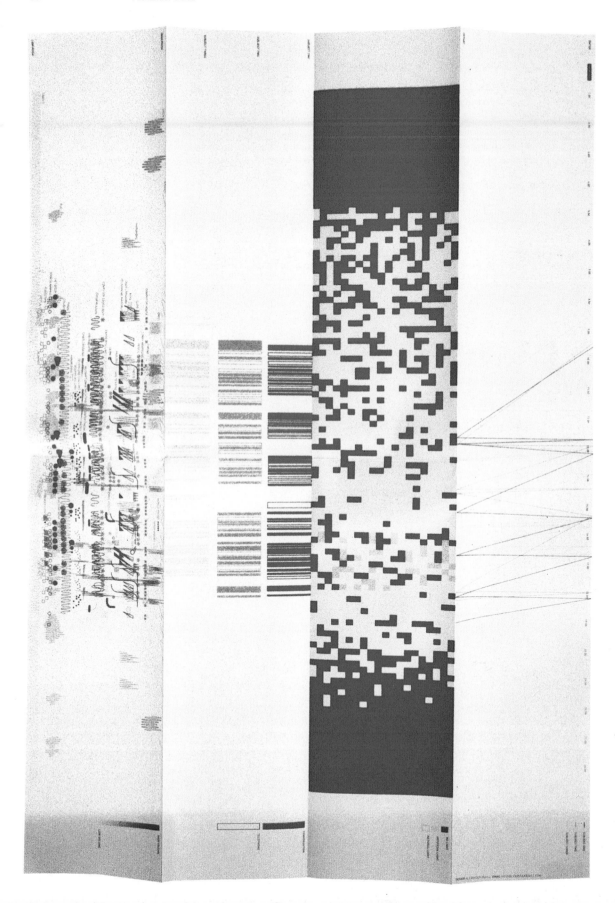

"If this question is about us, then we find it very difficult to answer as the future is one thing we try not to think about … graphic design doesn't exist in isolation and our interests do not lie in just graphic design. Our vision, our design and our needs change as we respond to the changes around us. However, if this question is a more generic probe, then the 'future' would seem to equal an education system which continually increases the amount of graphic design students while decreasing the amount of tutors … and therefore the 'vision' would seem to predict bad news for us all."

»Wenn es bei dieser Frage um unsere eigene berufliche Zukunft geht, haben wir Schwierigkeiten, sie zu beantworten, denn wir versuchen, überhaupt nicht an die Zukunft zu denken … Der Grafiker lebt und arbeitet ja nicht abgeschieden von der Welt und wir interessieren uns auch nicht nur für Grafik. Unsere Vision, unsere Entwürfe und Bedürfnisse wechseln je nachdem, wie wir auf die Veränderungen in unserer Umgebung reagieren. Wenn sich die Frage jedoch auf die Fachdisziplin bezieht, denken wir bei ›die Zukunft‹ an das Bildungssystem, das immer mehr Grafikstudenten hervorbringt, während es zugleich die Anzahl der Lehrer verringert … dann würde unsere Zukunftsvision wohl eher düster aussehen.«

«Si la question porte sur nous, il nous est très difficile de répondre dans la mesure où nous essayons de ne pas penser à l'avenir… Le graphisme seul n'existe pas et nous ne nous intéressons pas au graphisme en soi. Notre vision, notre objectif et nos besoins changent à mesure que nous réagissons aux changements autour de nous. Si la question est d'ordre générique, l'avenir semble nous réserver un système éducatif où il y aurait toujours plus d'étudiants en design graphique et de moins en moins de professeurs… donc une ‹vision› plutôt pessimiste pour tous.»

**Alexander Boxill**
Unit 1
Providence Yard
Ezra Street
London E2 7RJ
UK

T/F +44 20 7729 0875

E info@
alexanderboxill.com

**Design group history**
1994 Co-founded by Jayne Alexander-Closs and Violetta Boxill in London

**Founders' biographies**
Jayne Alexander-Closs
1969 Born in Niath, Wales
1989–1992 BA (Hons) Graphic Design, Central St Martins College of Art and Design, London
1992–1994 MA Graphic Design, Royal College of Art, London
1994+ Lectured at Central St Martins College of Art and Design, London; Middlesex University; Portsmouth Polytechnic; Colchester University
Violetta Boxill
1970 Born in London
1989–1992 BA (Hons) Graphic Design, Middlesex University
1992–1994 MA Graphic Design, Royal College of Art, London
1994+ Lectured at Central St Martins College of Art and Design, London; Middlesex University; Portsmouth Polytechnic; Colchester University

**Clients**
British Council
Business Design Centre
Converse
Design Council
Habitat
Hayward Gallery
Laurence King Publishing
NAM
Royal College of Art
Somerset House Trust
Thames and Hudson

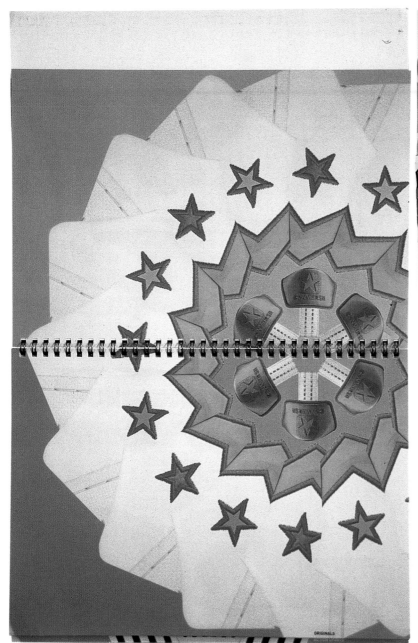

**Project**
Product style guide

**Title**
Converse Fall 2001

**Client**
Converse Europe

**Year**
2001

**Project**
Product style guide

**Title**
Converse Summer 2001

**Client**
Converse Europe

**Year**
2001

Opposite page:

**Project**
Part of the creative
package + identity for a
new art fair

**Title**
Fresh Art Fair

**Client**
Business Design Centre

**Year**
2001

**FRESH ART IS A NEW ART FAIR THAT WILL PROVIDE A RARE PLATFORM FOR INDIVIDUAL INDEPENDENT ARTISTS TO SHOW AND SELL THEIR WORK DIRECTLY TO AN ENTHUSIASTIC BUYING AUDIENCE**

**THE CONCEPT FOR
A NEW ART FAIR**

Artists will be allocated stands
within specific zones including:

* Painting
* Sculpture
* Print
* Photography
* Drawing
* New Media

There will also be a provision
for Fine Art Studio groups
to participate within these
specified zones.

In addition fresh art will provide
a vibrant and competitive
atmosphere for fine art
college graduates to launch
their careers. These graduate
artists will exhibit within a
dedicated zone.

A selection panel will be put
in place to ensure the quality
of the artists selected to
exhibit within these zones.
Potential exhibitors will be
approached through current
partnerships with organisations
such as Britart.com and AXIS
in addition to our current lists
of artists as well as through
advertisements in key and
highly supportive media such
as Art Review magazine.

# Ames Design

"Amidst all of the hype of modern design and computers, we have remained true by generating the majority of our designs by hand, viewing the computer as a tool and not letting it dictate our designs."

Opposite page:

**Project**
Rock poster

**Title**
East Block

**Client**
Pearl Jam

**Year**
2000

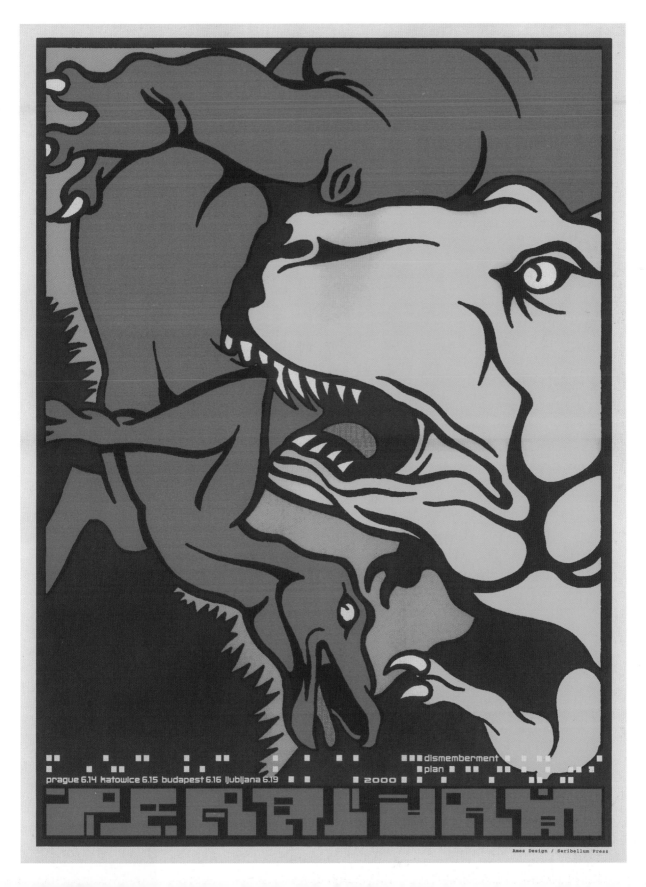

Ames Design / Scribellum Press

"Rage against the machine. The almighty computer has made every housewife and hobbyist a 'designer', bringing mediocrity to the masses. We predict a backlash sparking a throwback era of design in which designers are craftsmen performing a craft. The phrases 'Make it pop' and 'It's got to be more sexy' will be dead to us."

»Wüten gegen die Maschine. Der allmächtige Computer hat aus jeder Hausfrau und jedem Hobbykünstler einen ›Designer‹ gemacht und damit massenhaft Mittelmaß verbreitet. Wir prognostizieren, dass eine Gegenreaktion einsetzen und eine rückwärtsgewandte Design-Epoche einleiten wird, in der Designer wieder als Kunsthandwerker ihr Handwerk und ihre Kunst ausüben werden. Phrasen wie ›es muss poppig sein‹ oder ›es muss sexier sein‹ werden dann nichts mehr bedeuten.«

«Sus à la machine! L'ordinateur toutpuissant a fait de toutes les ménagères et de tous les amateurs des ‹créateurs›, apportant la médiocrité aux masses. Nous prédisons un retour de bâton, suscitant un renouveau de l'époque où le graphiste était un vrai artisan. Les expressions ‹Rends-le popu› ou ‹Faut que ça soit plus sexy› n'auront plus aucun sens pour nous.»

**Ames Design**
1735 Westlake Ave N.
#201
Seattle
WA 98109
USA

T +1 206 516 3020
F +1 206 633 2057

E ames@speakeasy.net

www.amesbros.com

**Design group history**
1996 Co-founded by Coby Schultz and Barry Ament in Seattle, Washington

**Founders' biographies**
Coby Schultz
1971 Born in Helena, Michigan
1993 Graphic Design, Montana State University
1994–1995 Freelance designer, Seattle
1996+ Co-founder, Ames Design, Seattle

Barry Ament
1972 Born in Big Sandy, Michigan
1992 Graphic Design, Montana State University Dropout
1993–1996 Graphic Designer, Pearl Jam Inc., Seattle
1996+ Co-founder, Ames Design, Seattle

**Recent exhibitions**
2002 "Paper, Scissors, ROCK!: 25 years of Northwest Punk Poster Design", USA travelling exhibition

**Recent awards**
1999 Grammy Nomination
2001 Bronze, One Show

**Clients**
Amazon.com
Bates USA
Bozell
EMP
Epic Records
Fallon McElligott
Foote, Cone & Belding
Geffen Records
Giro Helmets
Got Milk?
House of Blues
K2 Snowboards
Kompan Playgrounds
MTV
Morrow Snowboards
Neil Young
Nike
Nissan
Pearl Jam
Phish
PowerBar
Red Bull
Ride Snowboards
Sony Music
TBWA/Chiat/Day
Virgin Records
Warner Bros.
Weiden & Kennedy

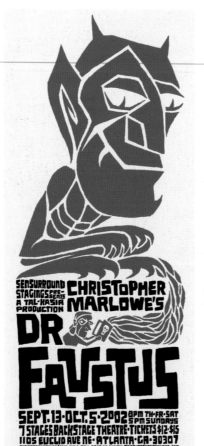

**Project**
Play poster

**Title**
Dr. Faustus

**Client**
Sensurround Stagings

**Year**
2002

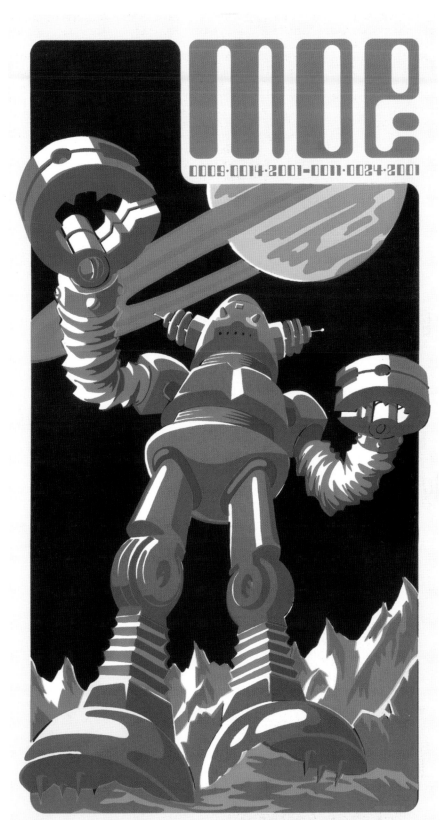

**Project**
Rock poster

**Title**
10th Anniversary

**Client**
Moe.

**Year**
2001

**Project**
Snowboard

**Title**
Fuse Series

**Client**
K2 Snowboards

**Year**
2000

Opposite page:

**Project**
Play Poster

**Title**
The Clive Barker Project

**Client**
Sensurround Stagings

**Year**
2002

# FRANKENSTEIN IN LOVE
## OR THE LIFE OF DEATH BY CLIVE BARKER

# THE HISTORY OF THE DEVIL
## OR SCENES FROM A PRETENDED LIFE BY CLIVE BARKER

SENSURROUND STAGINGS
PRESENTS

# THE CLIVE BARKER PROJECT

PERFORMED IN REPERTORY **JUNE 20TH - JULY 27TH**
AT THE ART FARM
**835 WYLIE ST.** TH-SA AT 8 PM **ALL SEATS $12**
FOR RESERVATIONS, DIRECTIONS, AND A COMPLETE SCHEDULE OF PERFORMANCES CALL (404)524-0302 OR VISIT US ONLINE AT www.sensurroundstagings.com

# Peter Anderson

## "Graphic design should evolve and challenge existing systems of language and perception."

Opposite page:

**Project**
World touring exhibition
"Ultravision"

**Title**
"Transglobal numerals"
Northern Ireland series 1

**Client**
The British Council

**Year**
2000–2001

"Graphic design can control language and also shape our visual urban environment. It is for this reason that I believe we should not allow it to be thrown together in its conceptual construction. Technology has forced changes that many designers and clients have not yet grasped. We have been released from designing solely in blocks and grids, we can embrace the fluid and the organic. We should communicate in an advanced and ever evolving manner, not using quick one-line sellers, not cute, not retro, not post post-modern but real, practically applied and above all, new. We can and should change the way we see the everyday world."

» Grafische Entwürfe sind in der Lage, unsere Sprache zu beherrschen und unsere sichtbare städtische Umwelt zu formen. Deshalb sollten wir nicht zulassen, dass beides beim konzeptionellen Aufbau vermengt wird. Die technische Entwicklung hat uns Veränderungen aufgezwungen, die vielen Grafikern und ihren Auftraggebern noch gar nicht klar sind. Wir sind davon befreit worden, nur in festen Blöcken und Rastern zu denken, wir können uns dem Fließenden und Organischen zuwenden. Wir sollten auf eine fortschrittliche, sich weiterentwickelnde Weise kommunizieren und reale, praktisch anwendbare und vor allem neue Designs liefern. Wir können und sollten unsere Betrachtungsweise der Alltagswelt ändern.«

« Le graphisme peut contrôler le langage et façonner notre environnement visuel urbain. C'est pourquoi nous ne devrions pas le laisser être amalgamé avec sa construction conceptuelle. La technologie a imposé des changements que les graphistes et leurs clients n'ont pas encore eu le temps d'assimiler. Nous avons été libérés des contraintes des blocs et des quadrillages et pouvons désormais travailler dans le fluide, l'organique. Nous devrions communiquer d'une manière pointue, en évolution permanente, sans recourir aux petites phrases accrocheuses, au mignon, au rétro, au post postmoderne mais avec du vrai, du pratique et, surtout, du neuf. Nous pouvons et devrions changer la façon dont nous voyons le monde de tous les jours. »

**Peter Anderson**
(@ Interfield Design)
2nd Floor
21 Denmark Street
London WC2H 8NA
UK

T +44 20 7836 5455
F +44 20 7836 2112

E Pete@
   interfield.freeserve.co.uk

www.interfield-design.com

**Biography**
1989–1992 BA(Hons) Graphic Design, distinction in critical studies, Central St Martins College of Art and Design, London
1992–1994 Post Graduate Advanced Fine Art Printmaking and Photomedia, Central St Martins College of Art and Design, London

**Recent exhibitions**
1998 "An Island's Language", commissioned one-man show, St Lucia Fine Art, St Lucia, West Indies; "Poles of Influence", Island Installation; St Lucia Fine Art, St Lucia, West Indies
1999–2001 "Ultravision", British Council Millennium world touring exhibition
2001 "British Experiment", Westside Gallery, New York; "Innovation Stories", British Design Council, currently touring worldwide

**Project**
European Union press Advertising Campaign (One of ten posters / double page spreads)

**Title**
Plants and flowers

**Client**
Fallon/European Union

**Year**
2000–2001

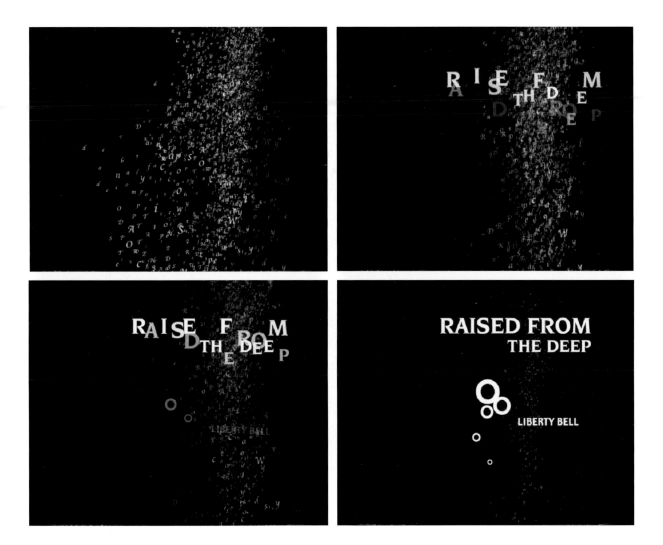

**Project**
Title sequence for
Channel Four
documentary

**Title**
Raised from the Deep

**Client**
John Tober @
Juniper communications

**Year**
2001

**Project**
Treble page spread
IT Magazine (issue
Experiment). Also
Cayenne Stationary:
voucher cover

**Title**
Moving Surnames,
Northern Ireland series 2

**Client**
IT Magazine. Cayenne.

**Year**
2001

# Philippe Apeloig

"Graphic design is the intersection point between art and communication."

Opposite page:

**Project**
Poster for a group
exhibition

**Title**
Celebrating the Poster

**Client**
Eastern Kentucky
University, Richmond,
USA

**Year**
2000

"Having come of age at a time when the computer was introduced and subsequently embraced as a radical new design tool and solution, I and other designers of my generation are seeing it now dominate almost every aspect of design. Design is fundamentally idea-oriented, and designers carry profound influence in their power to shape and communicate cultural concepts. The future of design lies as much in this active and critical role within society as it does in the further development of technology. Graphic design is the art of visualizing ideas, activating space, intuiting proportion. It is the result of meticulous attention to detail. Good graphic design prompts the viewer to meditate, often unconsciously, on potent word/image combinations. Good graphic design is always memorable."

» Da ich in einer Zeit groß geworden bin, in der der Computer aufkam und als radikal neues Gestaltungswerkzeug angewendet wurde, erlebe ich wie andere Grafiker meiner Generation, dass er fast das ganze grafische Gestalten beherrscht. Unsere Arbeit beruht auf Ideen und wir Grafiker üben mit unserer Vermittlung kultureller Konzepte tief greifenden Einfluss aus. Die Zukunft unserer Zunft liegt ebenso in dieser kritischen Rolle wie in der technischen Weiterentwicklung. Grafikdesign ist die Kunst, Gedanken zu visualisieren, Flächen und Räume zu aktivieren und Proportionen zu erspüren. Sie ist das Ergebnis minutiöser Detailarbeit. Gutes Grafikdesign lässt den Betrachter – oft unbewusst – über eindringliche Text-Bild-Kompositionen nachdenken. Gutes Grafikdesign bleibt immer im Gedächtnis haften.«

« Les graphistes semblent se libérer de l'utilisation systématique de l'ordinateur, qui a été considéré comme l'outil miracle capable de résoudre tous les problèmes graphiques. Le design est une question de concept et de communication. Notre avenir sera guidé par le développement des nouvelles technologies et par le rôle actif et critique des designers dans la société. Certes il ne s'agit pas de négliger les aspects techniques: la composition d'une page, le souci des proportions, la qualité de la typographie et l'usage des couleurs; mais le graphisme est avant tout l'art de visualiser des idées. J'aime qu'une affiche donne l'idée de mouvement, de spontanéité, et cela résulte d'un contrôle minutieux de chaque détail. Je veux interpeller le public, le pousser à méditer sur la combinaison entre mot(s) et image(s). Le résultat doit se fixer dans la mémoire. »

**Philippe Apeloig**
41, rue Lafayette
75009 Paris
France

T +33 1 43 55 34 29
F +33 1 43 55 44 80

E apeloigphilippe@
wanadoo.fr

www.apeloig.com

**Biography**
1962 Born in Paris, France
1981–1985 Art and Applied Arts, École Nationale Supérieure des Arts Appliqués/École Nationale Supérieure des Arts Décoratifs, Paris
1984 Diplôme of the École Nationale Supérieure des Arts Appliqués BTS Visual Arts (Brevet de Technicien Supérieur), Paris

**Professional experience**
1983 Internship, Total Design, Amsterdam
1985 Internship, Total Design, Amsterdam
1985–1987 Graphic designer, Musée d'Orsay, Paris
1988 Internship, April Greiman's studio, Los Angeles
1989 Founded Philippe Apeloig Design in Paris
1992–1998 Taught typography, École Nationale Supérieure des Arts Décoratifs, Paris
1993 Art Director, Le Jardin des Modes, Paris
1993–1994 Grant from the French Ministry of Culture to research typography at the French Academy of Art, Villa Medici, Rome
1997+ Design consultant, Musée du Louvre, Paris
1999+ Full-time faculty member, Cooper Union for the Advancement of Science and Art, New York
2001+ Curator, Herb Lubalin Study Center of Design and Typography, Cooper Union for the Advancement of Science and Art, New York

**Recent exhibitions**
1998 Solo exhibition, DDD Gallery, Dai Nippon Printing, Osaka
1999 Solo exhibition, GGG Gallery, Dai Nippon Printing, Tokyo
2000 International Poster Exhibition in Tokushima, Japan; Eastern Kentucky University, Richmond, Kentucky; "Graphic Design, Philippe Apeloig Graphic Design / Posters, Imaging and Multimedia", The Cooper Union School of Art, New York City; "The Lingering Memory": Philippe Apeloig Posters, solo exhibition, Maryland Institute College of Art
2000–2001 Coexistence, Museum on the Seam, Jerusalem, world touring exhibition
2001 "Inside the Word", solo exhibition, Galerie Anatome, Paris; "Le Musée s'affiche – Posters for Museums", solo exhibition, Maison Française of NYU; Graphismes, exhibition at the French National Library for the 50th anniversary of the AGI, Paris; "Nouveau Salon des Cent", exhibition for the centenary of Toulouse-Lautrec's death, touring exhibition; "TypoJanchi", Seoul typography biennale, Korea
2003 Solo exhibition, University of the Arts, Philadelphia USA

**Recent awards**
1998 Certificate of Excellence, STD, International TypoGraphic Awards 98, England
1999 Special Jury Award, Tokyo Type Directors Club
2000 Certificate of Typographic Excellence, New York Type Directors Club
2001 Red Dot Award for High Design Quality, Germany

**Clients**
Achim Moeller Fine Art, New York
American Jewish Historical Society
Arc en rêve, Centre d'Architecture, de Design et d'Urbanisme
Association Française d'Action Artistique
Carré d'Art, Contemporary Museum of Art and Library
Cité du Livre in Aix en Provence
École Nationale Supérieure des Arts Décoratifs, Paris
Éditions Odile Jacob, Paris
Fnac
Imprimerie Nationale, France
Institut National d'Histoire de l'Art, Paris
Knoll
Linotype Library, Germany
Maison Française de New York University
Musée d'Art et d'Histoire du Judaïsme, Paris
Musée des Beaux-Arts de Montréal
Musée du Louvre
Musée d'Orsay
Octobre en Normandie Festival
Réunion des Musées Nationaux, Paris

Opposite page:

**Project**
Project for the French National Board of Education

**Title**
Liberté / Egalité / Fraternité

**Client**
French Ministry of National Education

**Year**
2001

**Project**
New Year's Eve Card

**Title**
New Year's Eve Card

**Client**
Philippe Apeloig Studio

**Year**
2001

Opposite page:

**Project**
Poster for Linotype,
Essen, Germany

**Title**
3rd Design Type Contest
Linotype

**Client**
Linotype

**Year**
1999

■ Call for entries

3.  Type
Design Contest

3rd International
Digital Type
Design Contest.
Deadline:
October, 31, 1999

Put your own creations
to the test!
Send us your best
digital font(s).
An international jury
will choose the winners
in four font categories.

**Categories:**
1. Text Fonts
2. Headline Fonts
3. Experimental Fonts
4. Symbols

Jury:
Andrew Boag (UK)
Irma Boom (NL)
Adrian Frutiger (CH)
Gabriele Günder (D)
Bernd Möllenstädt (D)
Jean François Porchez (F)
Wolfgang Weingart (CH)

Winning awards
total of 40,000 DM
For detailed contest
conditions see reverse

# August Media

"What is special about our studio is that we are a collective of editors, writers, publishers and designers. The exchange of ideas between these specialisms gives our work a particular perspective."

Opposite page:

**Project**
Cover of exhibition catalogue

**Title**
Flying over Water

**Client**
Merrell Holberton

**Year**
1997

# Flying over water
# Volar damunt l'aigua

PETER GREENAWAY

"Designers will learn to read and write."

»Grafiker werden lesen und schreiben lernen.«

« Les créateurs apprendront à lire et à écrire. »

**August Media**
Studio 6
The Lux Building
2-4 Hoxton Square
London N1 6NU
UK

T +44 20 7684 6535
F +44 20 7684 6525

E scoates@
augustprojects.demon.
co.uk

**Design group history**
1998 Co-founded by
Stephen Coates and Nick
Barley in London

**Founders' biographies**
Stephen Coates (Creative
Director)
1962 Born in Cambridge,
England
1981–1984 BA Graphic
Design, Newport College
of Art and Design
1985–1989 Art Director,
Blueprint magazine,
London
1990–1998 Art Director,
Eye magazine, London
1991–1995 Art Director,
Design Review magazine,
London
1993–2002 Art Director,
Tate magazine, London
1998+ Art Director, Sight
and Sound magazine,
London
1998+ Member, Alliance
Graphique Internationale
(AGI)
2000 Co-editor, Impos-
sible Worlds, London
(August/Birkhäuser)

Nick Barley (Publishing
Director)
1966 Born in Yorkshire,
England
1984–87 BA Social
Psychology, University
of Kent
1994–1998 Publisher,
Blueprint magazine,
London
1993–1998 Publisher,
Tate magazine, London
1992–1994 Publisher,
Eye magazine, London
1994–1998 Publisher,
Design Review magazine,
London
1998 Editor, Leaving
Tracks (August/Birkhäuser,
London)
1999 Publisher, Product
of our Time, London;
Editor, Lost and Found,
Basel (Birkhäuser/British
Council)
2000 Publisher, Nothing,
London; Editor, Breathing
Cities, (August/Birkhäuser,
London)
2001 Publisher, Obey the
Giant, London; Editor, City
Levels, London (August)

**Recent exhibitions**
1999–2001 "Lost and
Found: Critical Voices in
British Design" (Curator),
British Council touring
exhibition, Frankfurt,
Mons, Warsaw, Bordeaux
and Stockholm
1999 "Identity Crisis"
(Designer of exhibition
graphics), The Lighthouse,
Glasgow; "Cities on the
Move", Hayward Gallery,
London
2000 FAT/foa/muf, Arc
en Rêve Centre d'Archi-
tecture, Bordeaux;
"Louise Bourgeois",
Tate Modern, London;
"Poetry Lounge", South
Bank Centre, London;
"Brand.New", Victoria
and Albert Museum,
London
2001 "Brassaï", Hayward
Gallery, London
2002–2003 "The Book
Corner", British Council
touring exhibition, Milan,
London and Venezuela

**Recent awards**
1998 Merit, Art Directors
Club, USA; Honourable
Mention, Annual Design
2001 Finalist, The Most
Beautiful Swiss Book of
the Year

**Clients**
Angel Property Group
Agnews Gallery
Arts Council of England
BBC
Birkhäuser Verlag
Booth Clibborn Editions
British Council
British Film Institute
Channel 5
Hayward Gallery
Emap
Faber and Faber
Glasgow 1999
Institute of Contemporary
Arts
Laurence King Publishing
London Arts
MACS Shipping
Modus Publicity
Phaidon Press
Reed Business
Information
Royal Society for the Arts
South Bank Centre
Spafax Airline Network
Tate
Victoria & Albert Museum

**Project**
Spread from exhibition
catalogue

**Title**
Flying over Water

**Client**
Merrell Holberton

**Year**
1997

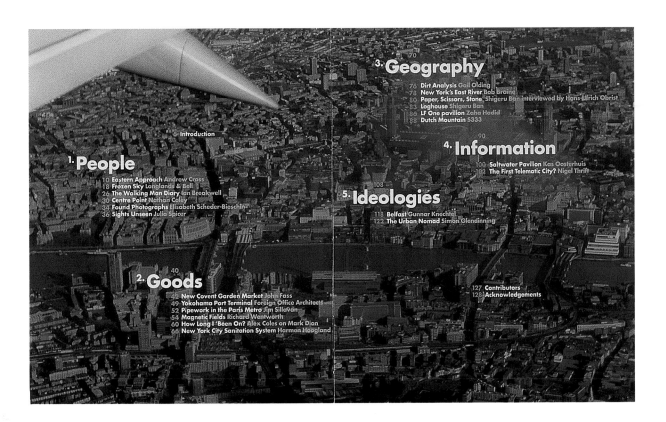

Pipework in
the Paris Metro
Photos by
Jim Sillavan

52          53

**Project**
Book spread

**Title**
Breathing Cities

**Client**
August / Birkhäuser

**Year**
1999

**CARCHI**

P.10

1.

FROM HERE
TO THERE
ALEX S.
MacLEAN
P.2

MIRROR,
SIGNAL,
MANŒUVRE

BRING YOUR
OWN SPACE
HEATHER
PUTTOCK
P.20

SOME
GARA
AND
CROS

A CIP catalogue record for this book is
available from the Library of Congress,
Washington D.C., USA.

Deutsche Bibliothek
Cataloging-in-Publication Data

Carchitecture / ed. by Jonathan Bell.
– Basel ; Boston ; Berlin : Birkhäuser ;
London : August, 2001
ISBN 3-7643-6454-8

Printed on acid-free paper
produced of chlorine-free pulp.
TCF ∞
Printed in Italy

ISBN 3-7643-6454-8

9 8 7 6 5 4 3 2 1

Author: Jonathan Bell, with additional texts
by Liz Bailey, Clare Dowdy, Sandy McCreery,
Heather Puttock and Austin Williams.

August
Publishing director: Nick Barley
Art director: Stephen Coates
Project editor: Alex Stetter
Editorial assistant: Ruth Ward
Picture researcher: Heather Vickers
Production coordinated by:
Uwe Kraus GmbH

Publisher's acknowledgements:
Fiona Bradley, Nicole Liniger, Marit
Münzberg, Anne Odling-Smee,
Anni Scheder-Bieschin, Elisabeth Scheder-
Bieschin, Robert Steiger, Veronika Stetter.

Author's acknowledgements:
Alex de Rijke, Catherine Croft.

Special thanks to Alex Adie.

www.birkhauser.ch
www.augustmedia.co.uk
www.carchitecture.net

Opposite: Matté Trucco's
Fiat Factory at Lingotto,
Turin (1914–26)

**Project**
Book spread

**Title**
Carchitecture

**Client**
August / Birkhäuser

**Year**
2001

ECTURE

# Jonathan Barnbrook

## "Language is a virus, money is a nasty disease."

Opposite page:

**Project**
Why2K? A book
published for the
Millennium featuring
excerpts of British
writing from the past 150
years

**Title**
Cover for 'Why2K?'

**Client**
Booth-Clibborn Editions

**Year**
2000

"There was a time when it was thought that design had an important role in society. It could tell people meaningful information or try to improve our ways of living. Today we seem to have forgotten that design has this possibility. The kind of work that designers seek are the ones for the coolest sports companies, not the ones that will have the most effect on society or add most to culture. It is time for designers to realise that design is not just something 'cool' and that design is also not just about money. We need to take our profession seriously and engage in cultural and critical discussion about what we are doing and aiming for. The modernist idea that designers are transparent messengers with no opinions of their own is no longer valid. We cannot just do our design and say issues such as unethical work practices are not our problem. We cannot say that a lack of meaningful content is not a problem. If we want the respect and attention we think we deserve, then we need to think about what happens to our work when it is seen in society and about the kind of work we want to participate in. Design STILL has the potential to change society and we should start remembering this once more."

» Es gab einmal eine Zeit, in der man Design eine bedeutende gesellschaftliche Rolle zuschrieb. Es konnte sinnvolle Informationen übermitteln oder versuchen, unsere Lebensart zu verbessern. Heute scheinen wir das vergessen zu haben. Grafiker bemühen sich um Aufträge von den coolsten Sportartikelherstellern und nicht von denen, die am meisten für Gesellschaft und Kultur tun. Es ist an der Zeit, dass sich Grafikdesigner bewusst machen, dass es nicht nur darum geht, cool zu sein und Geld zu verdienen. Wir müssen unseren Beruf ernst nehmen und uns an der kritischen Kulturdebatte über unser Tun und unsere Ziele beteiligen. Das Bild vom Gestalter als bloßem Vermittler ohne eigene Ansichten ist längst überholt. Wir können nicht nur an unseren Entwürfen arbeiten und behaupten, Fragen wie unwürdige Produktionspraktiken gingen uns nichts an, das Fehlen sinnvoller Inhalte sei nicht unser Problem. Wenn wir uns die Anerkennung verschaffen wollen, die wir unserer Meinung nach verdienen, müssen wir uns gut überlegen, was unsere Arbeit bewirkt und uns nach Auftraggebern umschauen, die wir unterstützen möchten. Das Grafikdesign hat immer noch das Potenzial, die Gesellschaft zu verändern, und das sollten wir uns wieder ins Gedächtnis rufen.«

« Il fut un temps où l'on pensait que le graphisme jouait un rôle important dans la société. Il pouvait transmettre aux gens des informations utiles ou tenter d'améliorer nos conditions de vie. Aujourd'hui, on semble avoir oublié ces fonctions. Les créateurs cherchent avant tout à travailler pour les compagnies de sport les plus branchées plutôt que sur des projets susceptibles d'avoir un effet sur la société ou d'enrichir la culture. Il serait temps qu'ils se rendent compte que le design n'est pas qu'une affaire ‹branchée› de gros sous. Nous devons prendre notre profession au sérieux et engager un débat culturel et critique sur ce que nous faisons et ce que nous recherchons. L'idée moderniste selon laquelle le graphiste serait un messager transparent sans opinion personnelle n'est plus valable. Nous ne pouvons plus nous contenter de livrer nos travaux en déclarant que des questions telles que le respect de l'éthique professionnelle ne nous concernent pas. Nous ne pouvons plus dire que l'absence d'un contenu qui ait un sens n'est pas un problème. Si nous voulons le respect et l'attention que nous pensons mériter, nous devons réfléchir à ce que devient notre travail une fois lancé dans la société et sur le type de projets auxquels nous avons envie de participer. Le design a ENCORE le potentiel de changer la société. Ne l'oublions plus. »

**Jonathan Barnbrook**
Barnbrook Studios
Studio 12
10–11 Archer Street
London W1D 7AZ
UK

T +44 20 7287 3848
F +44 20 7287 3601

E virus@easynet.co.uk

**Biography**
1966 Born in Luton, England
1988 BA (Hons) Graphic Design, Central St Martins College of Art and Design, London
1989 MA Graphic Design, Royal College of Art, London

**Professional experience**
1990 Founded Barnbrook Design, London

**Recent exhibitions**
1999 "Lost and Found", worldwide touring exhibition by British Council of Contemporary British Design
2001 "Contemporary Graphic Design", Bibliothèque Nationale de France, Paris

**Recent awards**
1998 Gold Prize, The Tokyo Type Directors Club; Gold Award, New York Type Directors Club; Gold Award and Best of Show, Art Directors Club of New York

**Clients**
Adbusters
Barbican Gallery
Beams
Damien Hirst
Institute of Contemporary Arts, London
Museum of Contemporary Art, Los Angeles
Saatchi Gallery
White Cube Gallery

**Project**
Letterform from the typeface "Moron"

**Title**
Moron Font

**Client**
Virus Fonts

**Year**
2001

Opposite page:

**Project**
A series of works that appeared in a South Korean magazine about the North Korean regime

**Title**
North Korea: building the brand

**Client**
Self-published

**Year**
2001

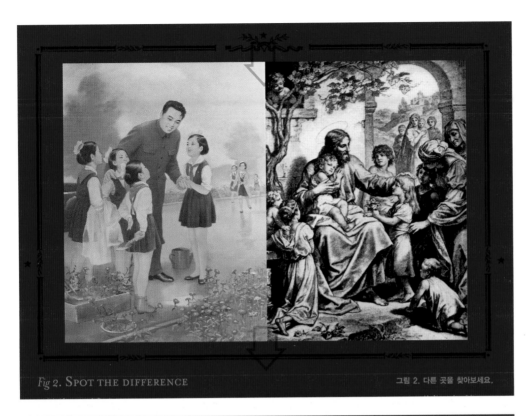

Fig 2. SPOT THE DIFFERENCE　　　　　　　　　그림 2. 다른 곳을 찾아보세요.

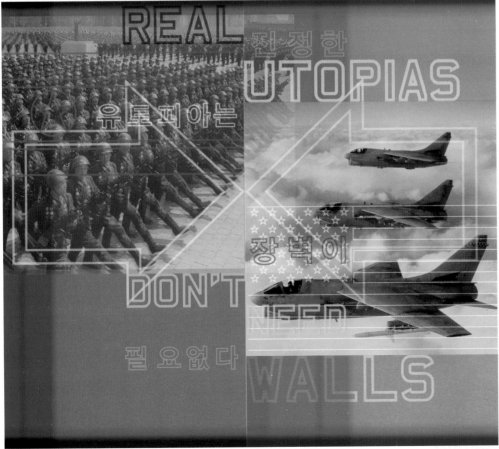

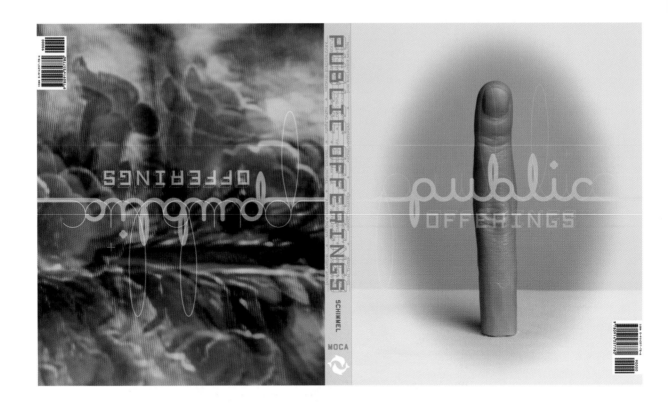

**Project**
Exhibition catalogue for
Museum of
Contemporary Art,
Los Angeles

**Title**
Public Offerings cover

**Client**
Museum of
Contemporary Art,
Los Angeles

**Year**
2001

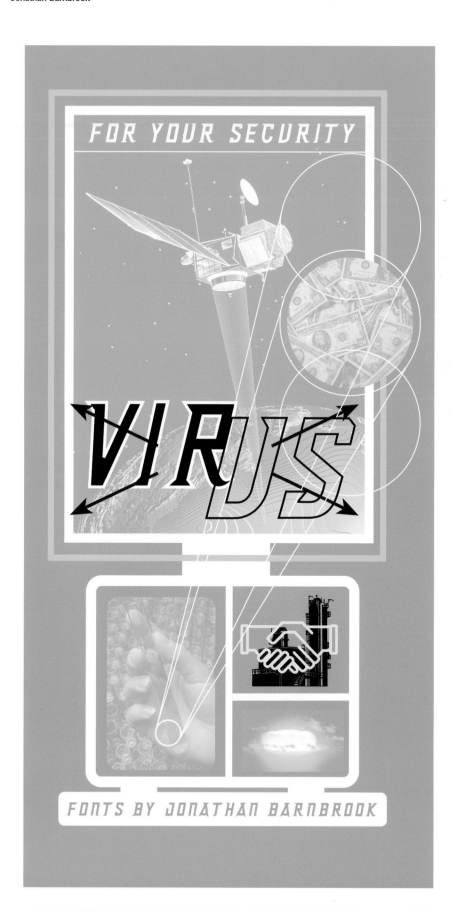

**Project**
A leaflet for the font
company Virus set up to
release the fonts of
Jonathan Barnbrook

**Title**
For Your Security, Virus
leaflet cover

**Client**
Self-published

**Year**
1999

# Ruedi Baur

"The questions that concern me are not simply those of graphic design but issues of orientation, identification and information."

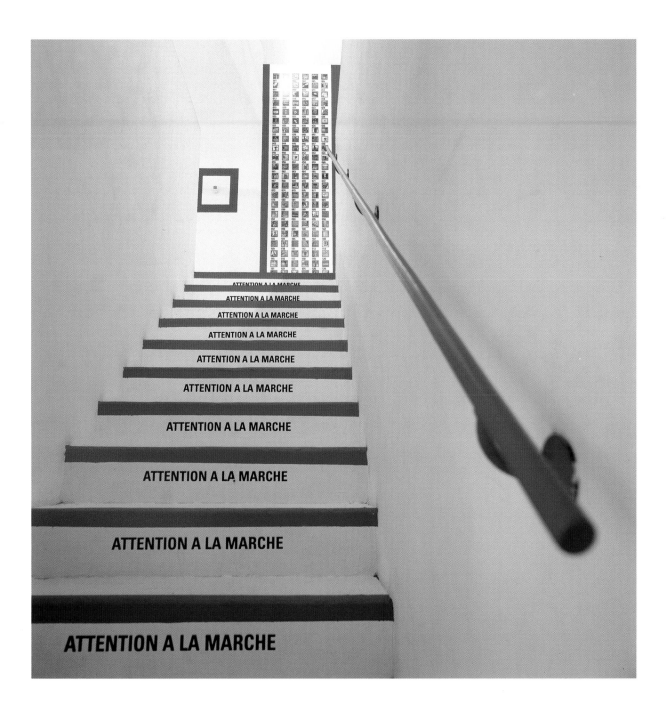

**Project**
Personal exhibition

**Title**
Installation U. Eur. + CH
ou other nationalities,
Strasbourg

**Client**
La Chaufferie

**Year**
1999

"Graphic design is merely one tool among many intended to resolve questions related to orientation, identification and information. In the future we must further enhance our teamwork, and realise in more effective fashion our interdisciplinary approach; respond even better to questions of sense and message, given today's superabundance of ambient information; attempt to break down the barriers between art and design, and between self-initi- ated and commissioned work; further transcend the limitations of graphic design."

» Die angewandte Grafik ist nur ein Medium von vielen, die in der Lage sind, die mit Orientierung, Identifikati- on und Information einhergehenden Fragen zu lösen. In Zukunft müssen wir noch besser im Team zusammen- arbeiten und unsere Projekte in noch stärkerem Maße interdisziplinär ent- wickeln, und zwar im Hinblick auf die Überfülle der von allen Seiten auf uns einstürmenden Informationen. Künf- tig müssen wir versuchen, die Barrie- ren zwischen Kunst und Gebrauchs- grafik zu durchbrechen, zwischen dem freien Schaffen und Auftragsar- beiten. In Zukunft müssen wir die Grenzen des Grafikdesigns noch wei- ter als bisher überschreiten.«

« Le graphisme n'est qu'un outil parmi d'autres susceptible de résoudre les questions liées à l'orientation, l'identi- fication et l'information. Il nous faut à l'avenir encore mieux travailler en équipe, encore mieux aborder nos projets avec une approche transdisci- plinaire. Il nous faut à l'avenir encore mieux répondre aux questions de sens, de message, dans le contexte de surabondance d'informations qui nous entoure. Il nous faut à l'avenir tenter de briser les limites entre l'art et le design, entre le travail d'auteur et le travail de commande. Il nous faut à l'avenir encore mieux dépasser les limites du graphic design. »

**Ruedi Baur**
Intégral
Ruedi Baur et Associés
5, rue Jules Vallès
75011 Paris
France

T +33 1 55 25 81 10
F +33 1 43 48 08 07

E atelier@
integral.ruedi-baur.com

**Biography**
1956 Born in Paris
1975–1980 Graphic Design, Zurich School of Applied Arts
Apprenticeship with Michael Baviera, Zurich and Theo Ballmer, Basel

**Professional experience**
1980 Co-founded Plus Design Studio with Sere- ina Feuerste, Zurich
1981 Co-founded BBV Studio with Michael Baviera and Peter Vetter, Lyon, Milan and Zurich
1982 Established own studio in Lyon
1984–1988 Founded and directed the design gallery Projects, Villeurbanne, France
1988 Transferred activities to Paris, working with Denis Coueignoux and Chantal Grossen
1989 Partnership with Pippo Lionni; founded the Intégral Concept Studio and subsequently created the studio Intégral Ruedi Baur et Associés, Paris
1989–1994 Managed the design department at the École des Beaux-Arts de Lyon in collaboration with Philippe Délis
1990–1992 Curated the Design à la Maison du livre exhibition space in Villeurbanne in collabora- tion with Blandine Bardonnet
1991 Member of the Alliance Graphique Inter- nationale (AGI); Philippe Délis became the third partner in Intégral Concept
1993 Guest Professor at the Hochschule für Gestaltung, Offenbach, Germany

1994–1996 Organized a postgraduate course on the theme Civic Spaces and Design, École des Beaux-Arts de Lyon
1995 Appointed Professor and Head of System Design, Leipzig Academy of Visual Arts (Hochschule für Graphik und Buch- kunst, HfGB)
1997–2000 Rector, Leipzig Academy of Visual Arts
1998–1999 Intégral Concept is expanded to include three new studios: Lars Müller (Baden), Studio Vinaccia (Milan), Lipsky et Rollet (Paris) and two designers: Christine Breton (Marseille) and Pierre-Yves Chays (Chamonix)
1999 Founded the Leipzig Institute of Interdisciplin- ary Design

**Exhibitions**
1989 "Ruedi Baur, conception sur papier" (solo exhibition), Maison du Livre, de l'Image et du Son, Villeurbanne
1991 "Design: Ruedi Baur, Pippo Lionni", Insti- tut für Neue Technische Form, Darmstadt
1994 "Ruedi Baur, intégral concept" (solo exhibition), DDD Gallery, Osaka; GGG Gallery, Tokyo; "Processes in process" (solo exhib- ition), Design Horizonte, Frankfurt/Main
1995 "Meine Augen schmerzen" (solo exhib- ition), Museum für Kunst und Gewerbe, Hamburg
1998 "Pixel compres- sions" (solo exhibition), Central Academy of Arts & Design, Beijing
1999 "U. Eur. + CH ou other nationalities" (solo exhibition), La Chaufferie, Strasbourg

**Clients**
Archaeological Museum Kalkriese
Biennale de l'environ- nement, Seine-Saint- Denis
Centre culturel Tjibaou, Nouméa
Centre national de docu- mentation pédagogique
Centre Georges Pompidou
Cité des sciences et de l'industrie
Cité internationale de Lyon
Cité internationale universitaire de Paris
City of Lyon
City of Nancy
City of Saumur
City of Tourcoing
Domaine national de Chambord
Expo 02 (Swiss national exhibition)
French Ministry of Education
International exhibition Lisbon 1998
Inselspital Berne
Landesmuseum Zurich
Le Cargo, Grenoble
L'Expo 2004 (international exhibition Seine-Saint- Denis)
Mission 2000 en France
Musée d'art moderne et contemporain de Genève
Pôle universitaire européen de Strasbourg
Suermondt Ludwig Museum, Aachen
Union centrale des arts décoratifs

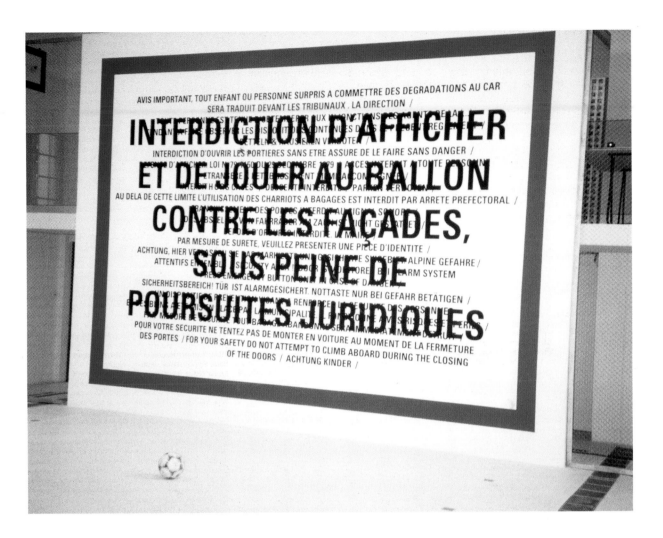

**Project**
Personal exhibition

**Title**
Installation U. Eur. + CH
ou other nationalities,
Strasbourg

**Client**
La Chaufferie

**Year**
1999

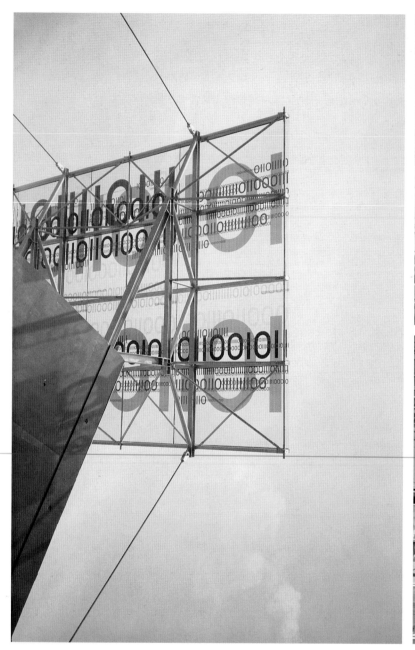

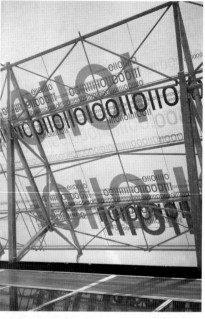

**Project**
Design of the façade and
signage for the Ésisar
school

**Title**
Ésisar Valence

**Client**
DDE de la Drôme,
rectorat de l'académie de
Grenoble, Drac Rhône-
Alpes

**Year**
1997

Opposite page:

**Project**
Design of the façade and
signage for the Ésisar
school

**Title**
Ésisar Valence

**Client**
DDE de la Drôme,
rectorat de l'académie de
Grenoble, Drac Rhône-
Alpes

**Year**
1997

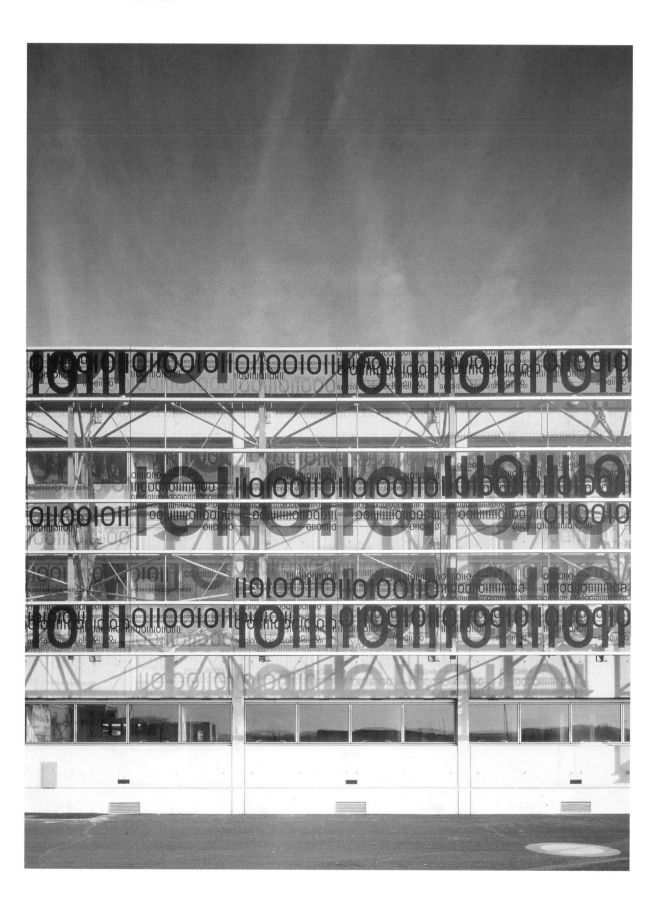

# Jop van Bennekom

## "Refusal and unwillingness are the starting points of most of my work."

Opposite page:

**Project**
Re-Magazine #6

**Title**
The Information Trashcan

**Client**
Self-published

**Year**
2001

Not.

# RE –

©

Re-Magazine #6
From Amsterdam NL
Spring 2001
The Manic Issue
Hfl. 17,50 / 8 Euro

THE
INFORMATION
TRASHCAN

Page 1 continues on page 2.

"I have an unwillingness to represent and refuse to make things one dimensional. My work is complex in its layering and in the positions it takes. I write, edit and photograph – design is just a part of the complex process by which I try to mix all the elements into a new language. In terms of what the future of graphic design will hold, I believe in the old adage, 'Never trust a book by its cover.' I mistrust design now that it has become part of strategy and marketing. The content within the visual aspects of graphic design has become less interesting. Let's concentrate on what we want to communicate, what things represent. Let's de-sign."

» Ich bin nicht gewillt, als Repräsentant für etwas dazustehen, und weigere mich, die Dinge eindimensional darzustellen. Meine Arbeiten sind vielfätig geschichtet, auch in den Positionen, die sie verkörpern. Ich schreibe, fotografiere und betätige mich als Redakteur und Herausgeber. Grafisches Gestalten ist nur ein Teil des komplexen Prozesses, in dem ich alle Elemente zu einer neuen Audrucksform zusammenzusetzen versuche. Was die Zukunft des Grafikdesigns angeht, so glaube ich an den alten Spruch: ›Verlasse dich nie auf Äußerlichkeiten.‹ Ich misstraue der Gebrauchsgrafik, nun, da sie zur Waffe der Marketingstrategen geworden ist. Der inhaltliche Aspekt visueller Kommunikationen ist nicht mehr so interessant. Konzentrieren wir uns auf das, was wir vermitteln wollen, auf das, für das die Dinge stehen. Let's de-sign!«

« Je rechigne à représenter et refuse de réaliser l'unidimensionnel. Mon travail est complexe en ce qu'il repose sur une série de strates et prend des positions. J'écris, je monte, je photographie. Le graphisme n'est qu'une partie du procédé complexe par lequel j'associe tous ces éléments pour créer un nouveau langage. Pour ce qui est de l'avenir de la création graphique je m'en tiens au vieil adage : ‹On ne juge pas un livre sur sa couverture›. Je me méfie du graphisme maintenant qu'il est devenu un outil stratégique de marketing. Le contenu de ses aspects visuels est devenu moins intéressant. Concentrons-nous sur ce que nous voulons communiquer, sur ce que représentent les choses. Dé-signons. »

**Jop van Bennekom**
Prinsengracht 397
1016 HL Amsterdam
The Netherlands

T +31 20 32 090 32

E mail@re-magazine.com

www.re-magazine.com

**Biography**
1970 Born in Scherpenzeel, The Netherlands
1989–1994 BA Graphic Design, Hogeschool voor de Kunsten, Arnhem
1995–1997 MA Graphic Design, Jan van Eyck Academy, Maastricht

**Professional experience**
1997+ Founded "Re-Magazine" – Chief-Editor and Designer
1998–1999 Art Director, "Blvd" lifestyle magazine
1998–2000 Editor/ Designer of "Forum" architectural magazine
2000+ Taught at the Graphic Design Department of the Rietveld Academy, Amsterdam
2000+ Art Director of "SO" fashion label by Alexander van Slobbe
2001: Founded BUTT and KUTT, faggot and dyke zine

**Recent awards**
2000 Young Designer Award, The Amsterdam Fund for Arts; Art Director of the Year 2000, Mercur Magazine Awards of The Netherlands
2001 Dutch Design Prize

**Clients**
Artimo
Centraal Museum Utrecht
De Appel
De Volkskrant
Dutch Ministry of Finance
Forum Magazine
So by Alexander van Slobbe
Van Drimmelen
Viktor & Rolf

**Project**
Graffiti stickers for
Re-Magazine

**Title**
Dead End

**Client**
Self-published

**Year**
2000

Well. You don't know how you feel anymore. You are wondering if there was a time when you knew how you felt. You are trying to find out when you lost control over your emotions. You start wondering whether you have lost control over your emotions. You don't know how you feel about not knowing how you feel. You are wondering if there is anything going on or there is just nothing going on. You will decide that you need a break to find out.

**Project**
Surface, a re-make of
a fashion magazine,
reproduced eighty-three
percent on forty-four
pages

**Title**
Surface

**Client**
Plaatsmaken Publisher

**Year**
1998

Forum Magazine Jaargang 40 / Nr. 3 1999 - fl. 19,50

# Berging

725.35+728.99(051.2)"540.3"(492)=393+20

9 789074 315135

contains:
architecture and more

**Forum Magazine** Driemaandelijks tijdschrift voor architectuur - Architectural quarterly

**Project**
Forum Magazine

**Title**
Berging / Storaget

**Client**
A et A, architectural
society and publisher

**Year**
1999

# Irma Boom

"I try to answer the commissioner's request by raising a new question."

Opposite page:

**Project**
Book on the 50th
anniversary of the
company

**Title**
Light Years 2000–1950

**Client**
Zumtobel Staff, Austria

**Year**
2000

"Graphic design is an interesting profession when one is asked to be a participating developer on a project. Graphic design is not interesting when a designer is asked to make things on demand. The making process is a mutual 'journey' in which both the commissioner and the designer have to be open to the unknown and unexpected. Because you cannot always describe things in words, meetings are important in the search for a direction. When graphic design is a developing process, there is no guarantee of success. My experience in this matter is that it is very interesting and necessary to have a long relationship with a few clients to establish a working method that is valuable for both parties. If there is no time to invest in this, I have no time."

» Der Beruf des Designers ist interessant, wenn man sich an der Entwicklung eines Projekts beteiligen soll. Er ist uninteressant, wenn man nur der Erfüllungsgehilfe des Auftraggebers ist. Der Entstehungsprozess ist eine gemeinsame ›Reise‹, auf der sowohl Auftraggeber als auch Grafiker offen sein müssen für das Unerwartete. Weil man nicht alles nur durch Reden klären kann, muss man sich persönlich treffen. Wenn grafisches Gestalten ein Entwicklungsprozess ist, gibt es keine Erfolgsgarantie. Ich habe erfahren, dass es interessant und notwendig ist, eine gute Beziehung mit wenigen Kunden aufzubauen und eine Arbeitsmethode zu entwickeln, die von beiden Parteien geschätzt wird. Wenn sie keine Zeit dafür investieren wollen, habe ich auch keine Zeit für sie.«

« Le graphisme est un métier intéressant quand on nous demande de participer à l'élaboration d'un projet. Il cesse de l'être quand on doit travailler sur commande. Le processus de réalisation est un ‹voyage› à plusieurs où le commanditaire et le graphiste doivent être ouverts sur l'inconnu et l'inattendu. Comme on ne peut pas tout décrire avec des mots, les réunions servent à chercher une direction. Lorsque le graphisme est un processus de développement, la réussite n'est pas garantie. Je sais d'expérience qu'il est très intéressant et nécessaire d'entretenir une longue relation avec quelques clients afin d'établir une méthode de travail précieuse pour tout le monde. Je n'ai pas de temps pour ceux qui n'ont pas le temps de s'investir dans ce genre de rapports. »

**Irma Boom**
Irma Boom Office
Kerkstraat 104
1017 GP Amsterdam
The Netherlands

T +31 20 627 1895
F +31 20 623 9884

E irmaboom@xs4all.nl

**Biography**
1960 Born in Lochem, The Netherlands
1979–1985 AKI, School of Fine Art, Enschede, The Netherlands

**Professional experience**
1985–1990 Senior designer, Government Publishing, Printing Office, The Hague
1991+ Founded own studio, Irma Boom Office, Amsterdam
1992+ Lecturer, Yale University, New Haven, Connecticut
1998–2000 Tutor, Jan van Eyck Akademie, Maastricht

**Recent exhibitions**
1998 "Do Normal", San Francisco Museum of Modern Art; "Irma Boom on her Books" (solo exhibition), Stroom Center for Visual Arts, The Hague
2000 "19th International Biennale of Graphic Design", Brno, Czech Republic
2001 "Typojanchi", Seoul, Korea; "Graphisme(s)", Bibliothèque National de France, Paris; "Boom Beyond Books" (solo exhibition), Gutenberg Prize Leipzig, Leipziger Stadtbibliothek, Germany
2002 "Double Dutch", Totem Gallery, New York; "Road Show" (touring exhibition), New York (AIGA), Paris (Institut Néerlandais), Mulhouse (Musée des Beaux-Arts/Villa Steinbeck), Valencia (Musée des Beaux-Arts), Baltimore (Maryland Institute College of Art), Barcelona (ADGFAD/Laus 01), Erasmushuis, Djakarta, Stuttgart (Design Center)

**Recent awards**
1998 Overall Winner, Lutki & Smit Annual Report Competition, Culemborg
1999 Award (x4), Collectieve Propaganda van het Nederlandse Boek (CPNB)
2000 Gold Medal, Schönste Bücher aller Welt, Leipzig
2001 Award (x3), Collectieve Propaganda van het Nederlandse Boek (CPNB)
2002 Silver Medal, Schönste Bücher aller Welt, Leipzig

For total oeuvre Gutenberg Preis 2001

**Clients**
Architectural Association, London
AVL/Joep van Lieshout
Berlin Biennale
Birkhäuser Verlag
Centraal Museum Utrecht
De Appel
Ferrari
Forum for African Arts (Cornell University)
Foundation De Appel
Het Financieele Dagblad
KPN/Royal PTT Nederlands
Mondriaan Foundation
NAi publishers
Oeuvre AKZO Coatings
Office for Metropolitan Architecture (OMA)
Oktagon Verlag
Paul Fentener van Vlissingen
Paul Kasmin Gallery
Prince Claus Fund
Prins Bernhard Foundation
Royal Ahrend NV
Royal Library
Rijksmuseum
SHV Holdings NV
Slewe Galerie,
Stedelijk Museum
Stichting CPNB
Stichting De Roos
Stroom
Thoth publishers
United Nations New York
Vitra International
World Wide Video Festival
Zumtobel

**Project**
Postage stamps

**Title**
Dutch Butterflies

**Client**
Royal Dutch PTT, The Netherlands

**Year**
1993

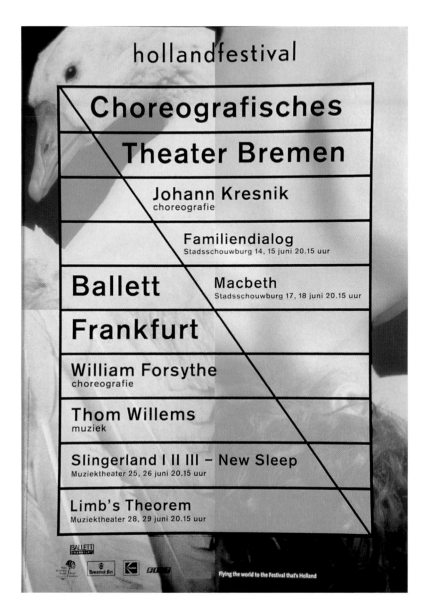

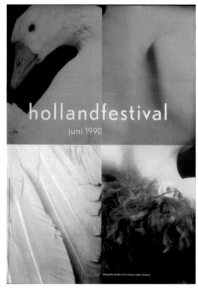

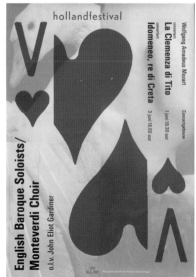

**Project**
Poster for Holland Festival
on Dance and Opera
(top right: the basic
poster)

**Client**
Holland Festival,
The Netherlands

**Year**
1990

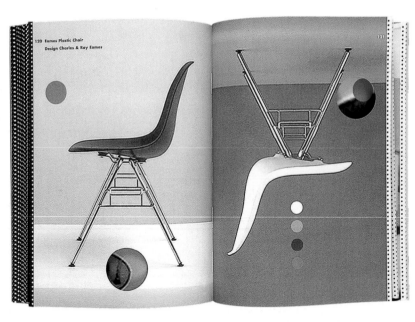

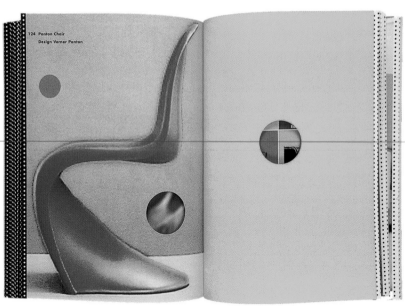

Opposite page:

**Project**
Book as inspiration source

**Title**
Workspirit

**Client**
Vitra, Birsfelden,
Switzerland

**Year**
1998

**Project**
Book focusing on the
most salient examples of
the SHV mentality over
the past 200 years

**Title**
Think Book

**Client**
SHV NV, The Netherlands

**Year**
1996

# Bump

**"Honesty, Humour, Integrity, Boredom, Anger, Deceit."**

**Project**
Poster for ICA night called
"The Club"

**Title**
The thin black line

**Client**
Institute of Contemporary
Art

**Year**
2000

"Teeth that don't need brushing, Cars that drive themselves, Duodesic Domes over City Centres so you don't get wet when it rains, Shoes that never wear out, Dogs that don't need walking, Robots that will iron your pants, Matter travel will be a thing of the past."

»Zähne, die nicht mit der Bürste geputzt werden müssen; Autos, die ohne Fahrer fahren; geodätische Kuppeln über Stadtzentren, damit man vom Regen nicht nass wird; Schuhe, die ewig halten; Hunde, die nicht Gassi geführt werden müssen; Roboter, die deine Hosen bügeln; tatsächliches Reisen wird der Vergangenheit angehören.«

« Des dents qui n'ont pas besoin d'être brossées. Des voitures qui se conduisent toutes seules. Des dômes géodésiques au-dessus des villes pour ne pas se mouiller quand il pleut. Des souliers qui ne s'usent jamais. Des chiens qu'on n'est plus obligé de promener. Des robots qui repassent les pantalons. Le voyage à travers la matière appartiendra au passé. »

**Bump**
5d Rosemary Works
Branch Place
London N1 5PH
UK

T +44 20 7729 4877
F +44 20 7739 4854

E bump@
btconnect.com

**Design group history**
1995 Co-founded by Jon Morgan and Mike Watson in London

**Founders' biographies**
Jon Morgan
1971 Born in Essex, England
1993–1995 MA Illustration, Royal College of Art, London
Mike Watson
1965 Born in Carlisle, England
1993–1995 MA Illustration, Royal College of Art, London

**Recent exhibitions**
1999 "Shopping", curated by FAT; "Stealing Beauty", ICA, London; "Ultravision", British Council touring exhibition of graphic design
2000–2001 "Village Fete", Victoria & Albert Museum, London
2001 "Jam 2", Barbican Art Gallery, London

**Clients**
British Council
Dazed and Confused
Eyestorm.com
Fulham Football Club
ICA
Leagas Delaney
Levi Strauss
M&C Saatchi
Ogilvy and Mather
Royal Academy Schools
Tank

**Project**
STEALING BEAUTY @ the ICA

**Title**
MODEL CITIZENS

**Client**
Product for Bump Industries

**Year**
1999

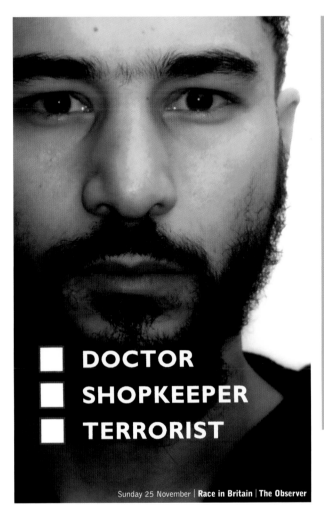

DOCTOR
SHOPKEEPER
TERRORIST

Sunday 25 November | **Race in Britain** | **The Observer**

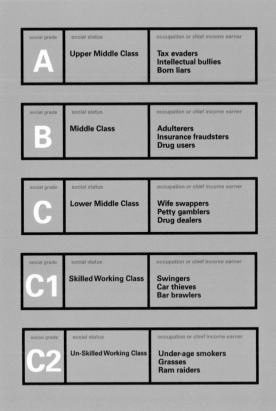

| social grade | social status | occupation or chief income earner |
|---|---|---|
| **A** | **Upper Middle Class** | **Tax evaders**<br>**Intellectual bullies**<br>**Born liars** |
| **B** | **Middle Class** | **Adulterers**<br>**Insurance fraudsters**<br>**Drug users** |
| **C** | **Lower Middle Class** | **Wife swappers**<br>**Petty gamblers**<br>**Drug dealers** |
| **C1** | **Skilled Working Class** | **Swingers**<br>**Car thieves**<br>**Bar brawlers** |
| **C2** | **Un-Skilled Working Class** | **Under-age smokers**<br>**Grasses**<br>**Ram raiders** |

**Project**
The Observer Race Audit
advert

**Title**
Doctor, Shopkeeper,
Terrorist

**Client**
Ogilvy and Mather

**Year**
2001

**Project**
T-shirt collaboration

**Title**
ABC 123

**Client**
Beams / Jipi Japa

**Year**
2002

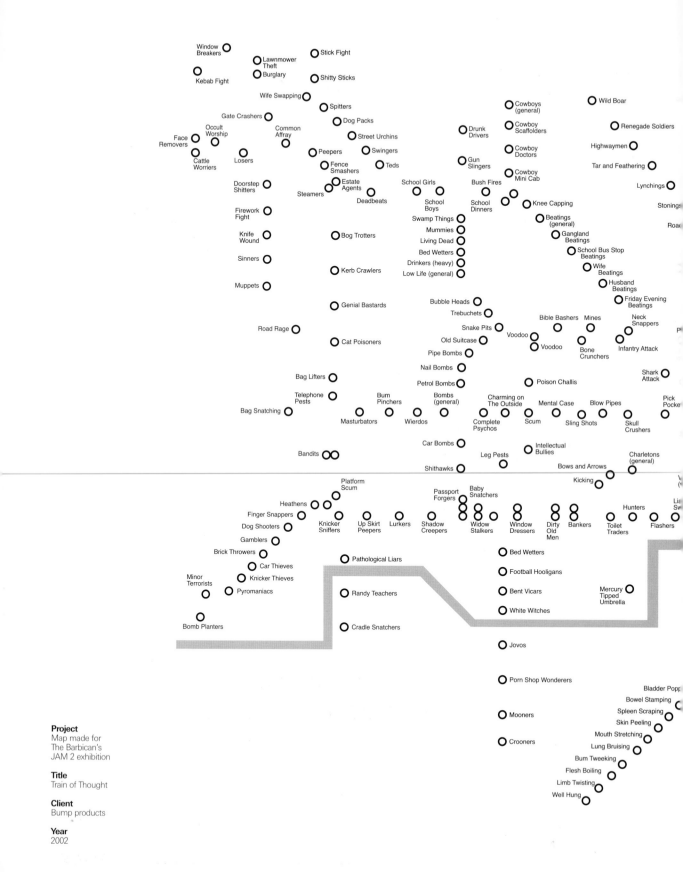

**Project**
Map made for
The Barbican's
JAM 2 exhibition

**Title**
Train of Thought

**Client**
Bump products

**Year**
2002

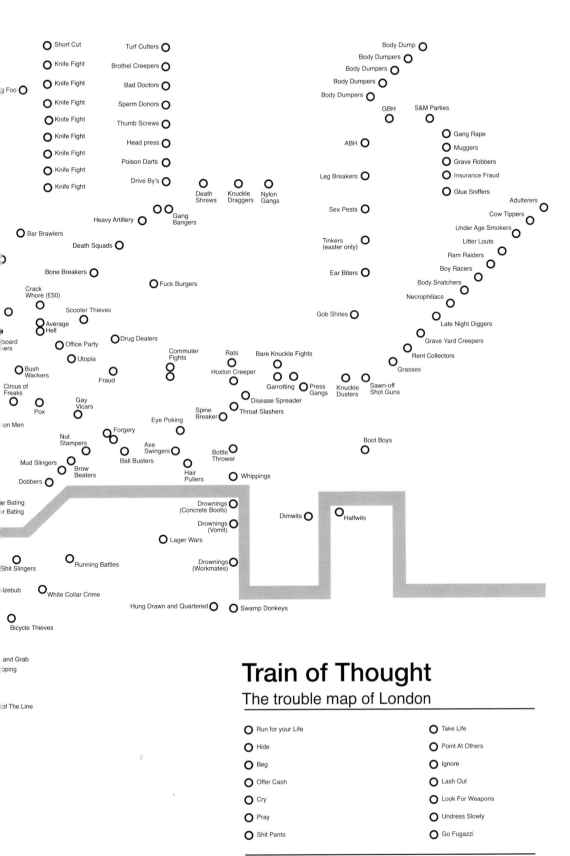

# Train of Thought
## The trouble map of London

| | |
|---|---|
| Run for your Life | Take Life |
| Hide | Point At Others |
| Beg | Ignore |
| Offer Cash | Lash Out |
| Cry | Look For Weapons |
| Pray | Undress Slowly |
| Shit Pants | Go Fugazzi |

© bump 2001

# Büro Destruct

**"surprising – smiling – giving into that eerie feeling delivered to you by buro destruct"**

**Project**
Leftfield Concert
poster/flyer

**Title**
Leftfield

**Client**
Reitschule Dachstock,
Berne

**Year**
2001

"We are not interested in the future of graphic design. We are living in the present of graphic design. Tomorrow will be another present day."

» Die Zukunft des Grafikdesigns interessiert uns nicht. Wir leben in der Gegenwart des Grafikdesigns. Morgen wird wieder heute sein.«

« Nous ne nous intéressons pas à l'avenir de la création graphique. Nous vivons dans le présent du graphisme. Demain sera un autre aujourd'hui. »

**Büro Destruct**
Wasserwerkgasse 7
3011 Berne
Switzerland

T +41 31 312 63 83
F +41 31 312 63 07

E bd@bermuda.ch

www.burodestruct.net
www.typedifferent.com

**Design group history**
1992 Destruct Agency (art agency) founded to encourage and promote young artists by HGB Fideljus in Berne
1993 Graphic designer, Lopetz joined Destruct Agency, which became a graphic design bureau known as Büro Destruct
1995 MBrunner, H1Reber, Pedä Siegrist and Heiwid joined the office
1996 HGB Fideljus left office to concentrate on artistic activities
1999 The book "Büro Destruct" published by Die Gestalten Verlag
2000 Designed "Eletronic Plastic" book for Die Gestalten Verlag
2001 Designed and edited the book "Narita Inspected" for Die Gestalten Verlag
2002 Launched the BD typefoundry
www.typedifferent.com

**Founder's biography**
HGB Fideljus
1971 Born in Berne, Switzerland
1987–1990 Studied Photography at the School of Arts, Berne

**Professional experience**
Classified Information

**Recent exhibitions**
Classified Information

**Recent awards**
Classified Information

**Clients**
Classified Information

**Project**
Nisen Toyko Exhibition

**Title**
Electronics Empire

**Client**
Nisen Tokyo

**Year**
2000

Opposite page:

**Project**
Monthly programme poster (B4)

**Title**
Love May

**Client**
Kulturhallen Dampfzentrale

**Year**
2001

**Project**
Monthly programme
poster

**Title**
KD Kiste

**Client**
Kulturhallen
Dampfzentrale

**Year**
1999

Opposite page:

**Project**
Nisen Exhibition

**Title**
BD-City 2.000

**Client**
Nisen Tokyo

**Year**
1999

# büro für form

**"Good graphic design is the result of the endless search for beauty in things."**

**Project**
Demented Forever Series
Part 03
60 x 60 cm lightbox
images

**Title**
Demented Forever Series

**Client**
Erste Liga Gastronomie
GmbH

**Year**
2001

"While the boundaries within the possibilities of design are changing day by day, the creators are becoming more responsible for the messages hidden in every piece of their work. Graphic design will spread a lot more than simple matter, beauty, emotions or style. It could even be a vision for life. The only thing missing so far is a bit more pathos …"

» Weil sich die Grenzen innerhalb der Möglichkeiten des Grafikdesigns ständig verschieben, tragen die Gestalter immer mehr Verantwortung für die Botschaften, die in jeder ihrer Arbeiten versteckt sind. Grafikdesign wird viel mehr verbreiten als nur Dinge, Schönheit, Gefühle oder Stil. Es könnte sogar zur Lebensart werden. Das Einzige, was noch fehlt, ist ein bisschen mehr Pathos …«

« Si les frontières au sein des possibilités graphiques reculent sans cesse, les créateurs sont de plus en plus responsables des messages cachés dans tous les éléments de leur travail. Le graphisme s'étendra bien au-delà de la simple matière, beauté, émotion et style. Il pourrait devenir une vision de la vie. Il ne lui manque à présent qu'un petit peu plus de pathos…»

**büro für form**
Hopf & Wortmann
Hans-Sachs-Strasse 12
80469 Munich
Germany

T +49 89 26 949 000
F +49 89 26 949 002

E info@buerofuerform.de

www.buerofuerform.de

**Design group history**
1998 Co-founded by Benjamin Hopf and Constantin Wortmann in Munich
2000 Alexander Aczél joined the team as Head of Graphics

**Founders' biographies**
Benjamin Hopf
1971 Born in Hamburg
1993–1998 MA Industrial Design, University of Design, Munich
1996 Department of Advanced Studies, Siemens Design, Munich
Constantin Wortmann
1970 Born in Munich
Self-taught
1996–1997 Freelance Designer, Ingo Maurer, Munich
Alexander Aczél
1974 Born in Munich
1995–1996 Media Designer, Mediadesign Akademie, Munich
1996–2002 Freelance work for various clients
1999+ Member of the Institution of Unstable Thoughts, Kiev
2000+ Head of Graphics, büro für form, Munich

**Exhibitions**
2000 "Don't walk with strangers", Fashion Show for TAK2, Praterinsel, Munich; "Amdamdes" (Projections & Installation), Praterinsel, Munich
2002 "Demented Forever" (Backlight exhibition), Erste Liga, Munich; "Slut Machine" (Backlight exhibition), Erste Liga, Munich

**Recent awards**
2000 IF-Award, Best of Category, Hanover; Design for Europe, Kortijk, Belgium

**Clients**
Bajazzo Verlag
Beast Media
BMG Ariola
Burda Verlag
Cedon Museumshops
Chili Entertainment
Classicon
Condé Nast Verlag
Cream 01
D-Code
Fingermax
Häberlein & Maurer
Habitat
Kundalini
Mu Meubles
Next Home Collection
Osram Lighting
Piranha Media
Publications Verlag
Serien Lighting
Serviceplan
Siemens
Start
SZ Magazin
TAK2

**Project**
Decorative Patterns

**Title**
Patterns02: (Artist Logo)

**Client**
BMG Ariola, Germany

**Year**
2000

Opposite page:

**Project**
Decorative patterns

**Title**
Patterns04: (T-Shirt-Logo)

**Client**
Tak2 Clothing Company

**Year**
2000

**Project**
Demented Forever Series
Part 01
60 x 60 cm lightbox
images

**Title**
Demented Forever Series

**Client**
Erste Liga Gastronomie

**Year**
2001

**Project**
Demented Forever Series
Part 04
60 x 60 cm lightbox
images

**Title**
Demented Forever Series

**Client**
Erste Liga Gastronomie

**Year**
2001

# François Chalet

## "Graphic design – a smiling cat with a tie."

Opposite page:

**Project**
Illustration

**Title**
Education meets
Business

**Client**
Swissair gazette,
Switzerland

**Year**
2001

"More cats, more dogs. In the future there will be more cats, black ones, white ones, blue ones, but there also will be more dogs. I don't like dogs. The cats will have to be clever, because they will be in the minority as they always have been. They are also smaller than dogs. So, things will change, it's the eternal story of dogs and cats."

» Mehr Katzen, mehr Hunde. In Zukunft wird es mehr Katzen geben – schwarze, weiße, blaue –, aber auch mehr Hunde. Ich mag Hunde nicht. Die Katzen werden clever sein müssen, denn sie werden – wie schon immer – in der Minderheit sein. Außerdem sind sie kleiner als die meisten Hunde. So wird sich alles ändern, das ist die ewige Geschichte von Hunden und Katzen.«

« Plus de chats, plus de chiens. A l'avenir, il y aura plus de chats, des noirs, des bleus, mais il y aura aussi plus de chiens. Je n'aime pas les chiens. Les chats devront être malins, parce qu'ils seront en minorité, comme toujours. Ils sont aussi plus petits que les chiens. Donc, les choses changeront, c'est l'éternelle histoire des chiens et des chats. »

**François Chalet**
Prima Linea
52, boulevard du
Montparnasse
75015 Paris
France

T +33 1 53 63 23 00
F +33 1 53 63 23 01

E bonjour@
   françois-chalet.ch
E agency@
   primalinea.com

www.francoischalet.ch
www.primalinea.com

**Biography**
1970 Born in Chêne-Bougeries, Geneva
1990–1996 Studied at the School of Graphic Design, Berne

**Professional experience**
1997–1998 Own graphic design and illustration studio in Berne
1998–2001 Own graphic design and illustration studio in Zurich
2000 Book "Chalet" published by Die Gestalten Verlag
2001+ Worked for the agency and production firm Prima Linea, Paris

**Recent exhibitions**
1999 "Gallery de la Création", Galerie Artazart, Paris; "Release-Party Berliner No.02-magazine", Berlin
2000 Gallery de la Création, Galerie Artazart, Paris
2002 Chalets Frühling, Museum für Kunst und Gewerbe, Hamburg

**Recent awards**
2000 Third prize for Illustration Category, Art Directors Club, Germany; Third prize for Corporate Design Category, Art Directors Club, Switzerland

**Clients**
Absolut OP Vodka
Allegra
Annabelle
Annabelle Creation
Ars Electronica
Beam Records
CB News
Computer Weekly
Debis
Docomo
Ego
Expo.02
Escolette
Facts
Fantoche
Gruntz
GSoA
Harper's Bazaar
IDN
Internet Standard
Jail
Jetzt
Le Monde
MTV
MTV Music Awards
OK assurances
Page
Popnet
Resolve
Riff Raff
Rote Fabrik
Schweizer Familie
soDA
SSR
Strategie
Süddeutsche Zeitung
TV3
Zoo

**Project**
Illustration

**Title**
Internet

**Client**
Schweizer Familie,
Switzerland

**Year**
1999

**Project**
Illustration

**Title**
The Swiss Post conquers
the world

**Client**
Internet Standard,
Switzerland

**Year**
2000

Opposite page:

**Project**
Poster for campaign

**Title**
Die Stadt

**Client**
Escolette (CH)
Agency: fam. müller

**Year**
2000

**Project**
Illustration

**Title**
Sport

**Client**
Gruntz (CH)

**Year**
2002

**Project**
Illustration

**Title**
Berlin

**Client**
Berliner

**Year**
2001

# Warren Corbitt

## "What is thought to be the edge is only the beginning."

Opposite page:

**Project**
Magazine spread

**Title**
periphery

**Client**
Raygun Magazine,
Los Angeles, CA, USA

**Year**
1998

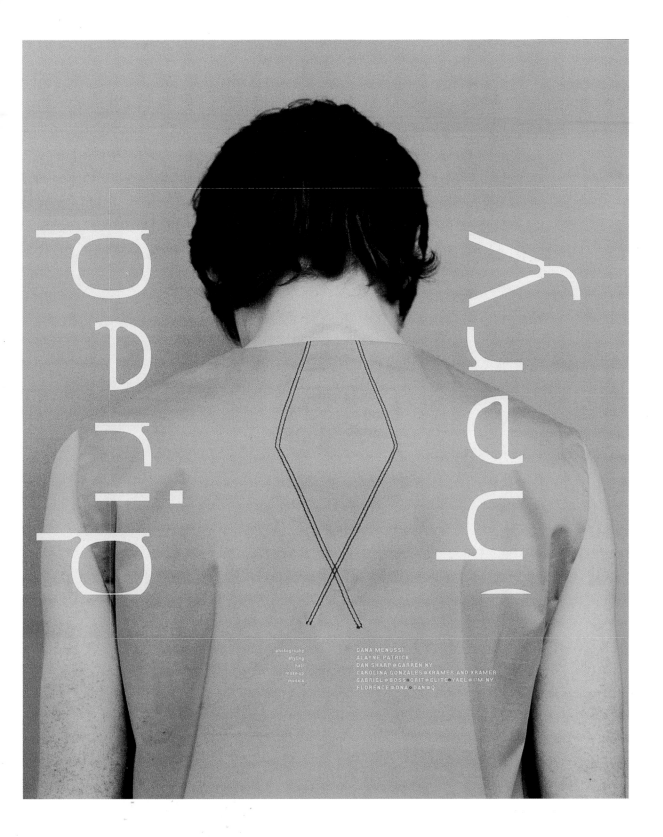

drip

hery

photography    DANA MENUSSI
styling    ALAYNE PATRICK
hair    DAN SHARP @ GARREN NY
make-up    CAROLINA GONZALES @ KRAMER AND KRAMER
models    GABRIEL @ BOSS ● BRIT @ ELITE ● YAEL @ I'M NY
FLORENCE @ DNA ● DAN @ Q

"Shift and progression are implicit to any process of making. When one goes about the daily practice of manufacturing meaning – of defining points of access, framing the inter-action, and ultimately determining the entry and exit points – it is only natural that the shifts in the space WE inhabit, the ontological sac of being, will be influenced, will be bumped. This is nothing new – but what is peeping through the haze is the recognition that the image makers in our midst do more than make pretty pictures."

»Wechsel und Fortschritt gehören implizit zu jedem Herstellungspro-zess. Wenn man täglich mit der Praxis der Produktion zu tun hat – damit, Zugangspunkte zu definieren, den Interaktionsrahmen und schließ-lich die Anfangs- und Endpunkte fest-zulegen –, dann ist es nur natürlich, dass der von uns bewohnte Raum sich verändert, dass der ontologische Beutel des menschlichen Seins beeinflusst und gerüttelt wird. Das ist nicht neu, aber durch den Nebel schimmert die Erkenntnis, dass die Bildermacher in unserer Mitte mehr tun als nur hübsche Bildchen zu erzeugen.«

« Le déplacement et la progression sont implicites dans tout processus de réalisation. Lorsqu'on s'attache quotidiennement à fabriquer du sens, à définir des points d'accès, à enca-drer l'interaction et enfin à déterminer les points d'entrée et de sortie, il est normal que les glissements de l'es-pace que NOUS habitons, la poche d'existence ontologique, en soient affectés, bousculés. Cela n'a rien de nouveau mais à travers le brouillard pointe la reconnaissance que les fai-seurs d'images parmi nous font plus que de fabriquer de jolies images ».

**Warren Corbitt**
54 West 21st Street
Suite 501
New York City
NY 10010
USA

T +1 212 929 7828
F +1 212 929 7638

E warren@one9ine.com

**Biography**
1970 Born in Wilmington, North Carolina
1993 BA Political Theory, Vassar College, Pough-keepsie, New York
1999 MFA 2D Design, Cranbrook Academy of Art, Bloomfield Hills, Michigan

**Professional experience**
1993–1997 Worked at GQ, Condé Nast, House& Garden and Esquire
1996–1997 Founding art director at Swoon.com, a web vehicle for Condé Nast
1997 Lead Art Director, CKS Site Specific, New York City, New York
1998 Co-designed Ray-Gun Magazine, Santa Monica, California
1999 Co-founded one9ine with Matt Owens

**Recent exhibitions**
1998 "Parasite", Cranbrook Academy of Art Museum, Bloom-field Hills, Michigan; "RETinevitable 1", Brook-lyn Bridge Anchorage, New York City
1999 "Juried Summer Show", Cranbrook Acade-my of Art Museum, Bloomfield Hills, Michi-gan; "Opening", Zao, New York City
2001 "Young Guns 3", Art Directors Club, New York City

**Recent awards**
1998 Silver Award, Society of Publication Designers
2000 Art Directors Club, Young Guns
2001 100 show, American Center for Design; Silver Award, Society of Publica-tion Designers

**Clients**
American Documentary/POV
Cooper-Hewitt, National Design Museum
Council for Fashion Designers of America
ESPN Magazine
The Museum of Modern Art
Sony Electronics
Sony Music
Sundance Channel
V2 Records
Wella

**Project**
Postcard series

**Title**
The Alternative Pick

**Client**
The Alternative Pick, NYC, NY, USA

**Year**
2002

Opposite page:

**Project**
Media kit

**Title**
The Alternative Pick

**Client**
The Alternative Pick, NYC, NY, USA

**Year**
2002

MEDIA KIT

THE ALTERNATIVE PICK

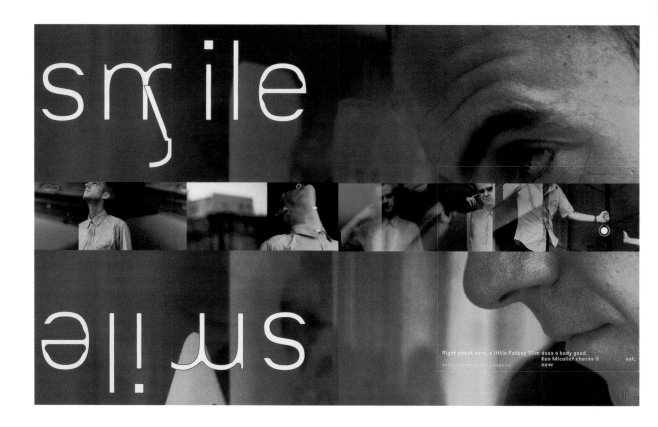

**Project**
Magazine spread

**Title**
smiley smile

**Client**
Raygun Magazine, Los
Angeles, CA, USA

**Year**
1998

Opposite page:

**Project**
Interactive piece for
"The Remedi Project"

**Title**
implicit proportion

**Client**
Self-published for
"The Remedi Project"

**Year**
2000

# Cyan

**"It doesn't make sense to simplify impulses emanating from culture and society to make them easily digestible."**

**Project**
Exhibition catalogue
(cover)

**Title**
Quobo – art in berlin
1989–1999

**Client**
IFA – institute for foreign
cultural relations

**Year**
2000

"A vision in graphic design has to respond to society, politics, economy, techniques and culture. Impulses from outside are translated into visual language and in turn establish a possibility for communication and identification. Graphic design mediates, reveals, includes, transforms, conceals. Not only to demand attention, but be aware of the things that do not only deserve attention but may even require thought and consideration. This means to consequently respect aspects of living together. Graphic design is never an end in itself."

» Eine Vision für das Grafikdesign muss auf die herrschende gesellschaftliche, politische, wirtschaftliche, technische und kulturelle Situation eingehen. Impulse von außen werden in eine Bildsprache übersetzt und eröffnen ihrerseits Chancen zur Kommunikation und Identifikation. Grafikdesign vermittelt, deckt auf, bezieht ein, verändert, versteckt. Nicht nur, um Beachtung zu fordern, sondern um die Dinge bewusst zu machen, die neben Aufmerksamkeit auch Nachdenken und Betrachtung erfordern. Das heißt, dass man die verschiedenen Aspekte des menschlichen Miteinanders konsequent respektieren muss. Grafikdesign ist niemals Selbstzweck.«

« Pour envisager la création graphique, il faut prendre en compte la société, la politique, l'économie, la technique et la culture. Les impulsions externes sont traduites en langage visuel et, à leur tour, établissent une possibilité de communication et d'identification. Le graphisme sert d'intermédiaire, il révèle, inclut, transforme, dissimule. Il permet d'attirer l'attention mais également de prendre conscience de ce qui nécessite de l'attention, voire de la réflexion et de la considération. Cela implique de respecter des aspects de la vie en commun. Le graphisme n'est jamais une fin en soi. »

**Cyan**
Strelitzer Strasse 61
10115 Berlin
Germany

T +49 30 283 3004
F +49 30 283 2869

E mail@cyan.de

**Design group history**
1992 Founded by Daniela Haufe and Detlef Fiedler in Berlin
1996 Cyanpress founded for the design and publication of books
2000 Group joined by Susanne Bax
2000+ Daniela Haufe and Detlef Fiedler are professors at the Academy of Visual Arts, Leipzig
2001 Group joined by Katja Schwalenberg
2001+ Group became a member of AGI

**Founders' biographies**
Daniela Haufe
1966 Born in Berlin (GDR)
Detlef Fiedler
1955 Born in Magdeburg, Germany
1977–1982 Studied architecture at the Hochschule für Architektur und Bauwesen, Weimar

**Recent exhibitions**
1998 "Permanent Design Exhibition", The Museum of Modern Art, New York
1999 "Plakate Grafik-Design", Museum für Gestaltung, Zurich
2000 "Graphistes Autour du Monde", Echirolles, France; "Poster Bienale", Hongbo, China
2001 "Typo-Janchi", Seoul

**Recent awards**
1992–2000 "100 Best Posters" (award received annually), VDG (Verband der Grafik-Designer)

**Clients**
Academy of Fine Arts, Berlin
Bauhaus Dessau Foundation
British Council, Berlin
IFA – institute for foreign cultural relations
Kulturamt Leipzig
Radio Free, Berlin
Staatsoper, Berlin

**Project**
Series of invitation cards for a sound art gallery

**Title**
Singuhr — hörgalerie in parochial 2001

**Client**
Singuhr — hörgalerie in parochial

**Year**
2001

Opposite page:

**Project**
Poster for a sound art gallery

**Title**
Singuhr — hörgalerie in parochial 2000

**Client**
Singuhr — hörgalerie in parochial

**Year**
2000

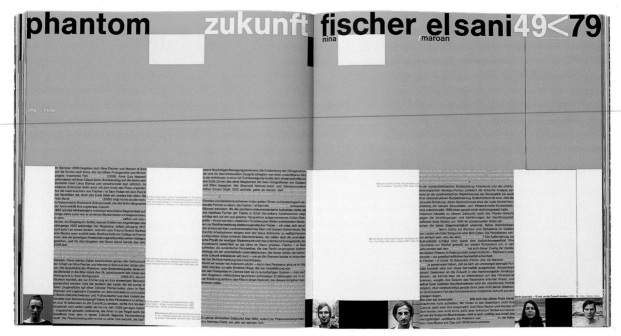

**Project**
Exhibition catalogue
(twin pages)

**Title**
Quobo – art in berlin
1989–1999

**Client**
IFA – institute for foreign
cultural relations

**Year**
2000

**Project**
Design magazine

**Title**
Form+zweck

**Client**
Form+zweck / cyan

**Year**
1996

# DED Associates

## "I am a camera!"

Opposite page:

**Project**
Gifthorse 5

**Title**
Earth

**Client**
Sioux Records

**Year**
2001

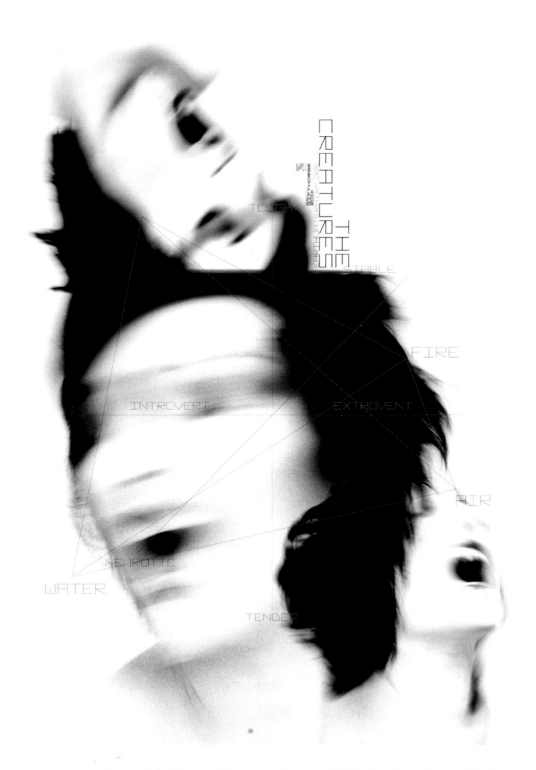

THE CREATURES

TOUGH

STABLE

FIRE

INTROVERT          EXTROVERT

AIR

NEUROTIC

WATER

TENDER

"The evolution of Graphic Design is intrinsically linked to the evolution of the tools by which we deliver those designs. Whilst the fundamentals will remain fixed – 'the necessity to provoke a response through visual means' – the process by which we arrive at that response will be driven by such forces as the homogenising of software and technology, as well as that of cultures and the quest for ever increased speed in communication. It is through the fervent nature of tools such as the internet, which allows the innovative and eager individual as much favour as those key figures or groups already established. It is here that new visual forms of communication will grow and envelop us all."

» Die Geschichte der Gebrauchsgrafik ist eng verknüpft mit der Entwicklung der Arbeitsmittel, mit denen wir die Grafiken erstellen. Während die Grundlagen dieselben bleiben – die Notwendigkeit, mit visuellen Mitteln eine Reaktion hervorzurufen – wird der Prozess, mit dessen Hilfe wir die Reaktion erzeugen, von Kräften wie der Homogenisierung von Software und Technologie sowie von Kulturen und der Suche nach immer schnelleren Kommunikationsmöglichkeiten bestimmt werden. Die ungestüme Natur von Arbeitsmitteln wie dem Internet lässt innovativ denkende dynamische Individuen ebenso zum Zug kommen wie bereits etablierte Schlüsselfiguren oder Gruppen. Hier werden neue Formen der visuellen Kommunikation entstehen und uns alle umgeben.«

« L'évolution de la création graphique est intrinsèquement liée à celles des outils qui nous permettent de concevoir nos travaux. Si les bases fondamentales restent les mêmes (‹la nécessité de susciter une réaction par un moyen visuel›), le processus par lequel nous atteindrons cette réaction sera déterminé par des forces telles que l'homogénéisation des logiciels, de la technologie et des cultures, ainsi par que la quête de moyens de communication toujours plus rapides. Des outils tels qu'Internet apporteront au particulier inventif et déterminé les mêmes avantages qu'aux créateurs éminents ou aux groupes déjà établis. C'est à ce niveau que de nouvelles formes de communication se développeront et nous engloberons tous. »

**DED Associates Ltd.**
The Workstation
15, Paternoster Row
Sheffield S1 2BX
UK

T +44 114 2493939
F +44 114 2493940

E ded@dedass.com

www.dedass.com

**Design group history**
1991 Founded by Jon Daughtry and Nik Daughtry in Sheffield, England

**Founders' biographies**
Jon Daughtry
1970 Born in Sheffield
1988–1990 HND Graphic Design, Lincoln College of Art and Design
1990–1992 MA Graphic Design, Central St Martin's College of Art and Design, London
Nik Daughtry
1970 Born in Sheffield
1988–1990 HND Communication Graphics, Sheffield College
1990–1992 MA Graphic Design, Central St Martin's College of Art and Design, London

**Clients**
Chinese Arts Centre
Chrysalis Music
Galaxy 105
Mastercard
Millennium Experience
MTV
Nissan
Particle Systems
Tate
TBWA

**Project**
Gifthorse 3

**Title**
Fuck

**Client**
Sioux Records

**Year**
2000

Opposite page:

**Project**
Travel Sickness

**Title**
Daddy's Girl/Duck Boys

**Client**
Die Gestalten Verlag

**Year**
2000

**Project**
Do Not Inflate [as this
may impede your exit]

**Title**
Various

**Client**
Laurence King Publishing

**Year**
2001

Opposite page:

**Project**
A0 Poster campaign

**Title**
New Commissions

**Client**
Chinese Arts Centre

**Year**
2001

THE CHINESE ARTS CENTRE IS INVITING ARTISTS OF CHINESE DESCENT TO SUBMIT PROJECT PROPOSALS. THE INVITATION IS OPEN TO VISUAL, COMBINED ARTS AND NEW TECHNOLOGIES PRACTITIONERS TO DISPLAY THEIR WORK IN THE NEW IMPROVED PROJECT SPACE.

For further information and an 'New Commissions' application form please send a first class A4 stamped addressed envelope to:

New Commissions
Chinese Arts Centre
39-43 Edge Street  Manchester M4 1HW
Telephone: 0161 832 7271 Fax: 0161 832 7513
info@cac39.freeserve.co.uk

Deadline for proposals is Friday 24 August 2001

CHINESE
ARTS
CENTRE

# Delaware

## "Simple & Effective."

**Project**
2nd album "SURFIN'
USSR"

**Title**
Fireman

**Client**
Self-published

**Year**
1997

"Graphic design is all about plain living and high thinking. We are a Japanese supersonic group that rocks design and believes that design rocks. The Delaware style is a mixture of music, visual images & texts that is both minimal and pop."

» Beim Grafikdesign geht es um einfaches Leben und komplexes Denken. Wir sind eine japanische Überschallgruppe, die die Designwelt beben lässt und davon überzeugt ist, dass das Grafikdesign die Welt bewegt. Der Delaware-Stil ist eine Mischung aus Musik, Bildern und Texten, die Minimalismus und Pop vereint.«

« Le graphisme est avant tout une affaire de vie dépouillée et de pensée évoluée. Nous sommes un groupe supersonique japonais qui balance du design et qui pense que le design, ça balance. Le style Delaware est un mélange à la fois minimaliste et pop de musique, d'images et de textes. ».

**Delaware**
2C Tokiwamatsu
1–20–6 Higashi
Shibuya-ku
Tokyo 150–0011
Japan

T +81 3 3409 4944
F +81 3 3409 4944

E mail@delaware.gr.jp

www.delaware.gr.jp

**Design group history**
1993 Founded by Masato Samata in Tokyo

**Founder's biography**
Masato Samata
1959 Born in Gumma, Japan
Self-taught

**Recent exhibitions**
2000–2001 "Mobile Gallery", i-mode online show
2001 "Artoon at PS-1", PS-1, New York; "JaPan Graphics", RAS Gallery, FAD, and Convent dels Angels, Barcelona

**Clients**
DoCoMo
Fukoku-Seimei
Iwata-Ya
Yutaka-Shoji

**Project**
i-mode official site
"MOBILE ART"

**Title**
Disc of We Are Alone (left)
Flower Life (center)
Flower (right)

**Client**
NIPPON Enterprise ltd. & DICE ltd.

**Year**
2002

**Project**
4th album "ARTOON"

**Title**
Livin' Dinin'
Kitchen (top left)
Take A Walk (top right)
We Are Alone
(bottom left)
Yeah Yeah Yeah
(bottom right)

**Client**
Self-published

**Year**
2001

**Project**
Homepage "FREEware/
DELAware" issue 62

**Title**
Kimono Dress

**Client**
Self-published

**Year**
2001

 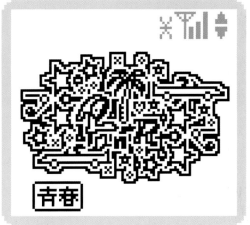

**Project**
"MOBILE GALLERY" on
i-mode

**Title**
Graphic DUB

**Client**
Self-published

**Year**
2001

# Dextro

**"Access to the subconscious by the use of cannabis."**

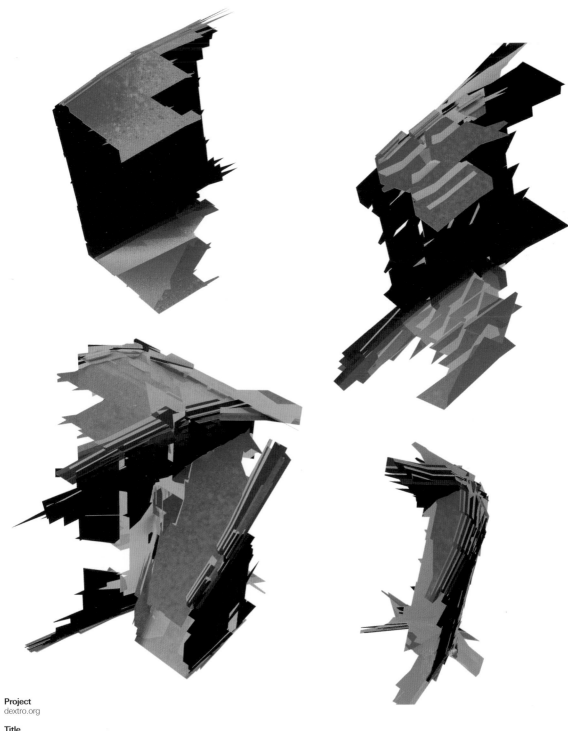

**Project**
dextro.org

**Title**
/

**Client**
Self-published

**Year**
1993

"Peace by rehabilitating the right hemisphere of the brain."

» Frieden durch rehabilitierung der rechten gehirnhälfte.«

« La paix par la réhabilitation de l'hémisphère droit du cerveau. »

**Dextro**
E dextro@dextro.org

**Biography**
Born in Austria
Self-taught
Freelance designer in
Vienna, Tokyo and Berlin
1994+
www.dextro.org
1997+
www.turux.org

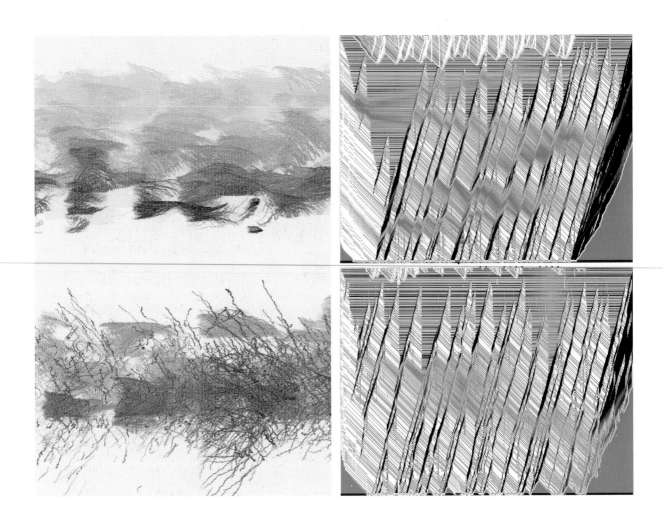

**Project**
dextro.org

**Title**
/

**Client**
Self-published

**Year**
2000

**Project**
dextro.org

**Title**
/

**Client**
Self-published

**Year**
2000

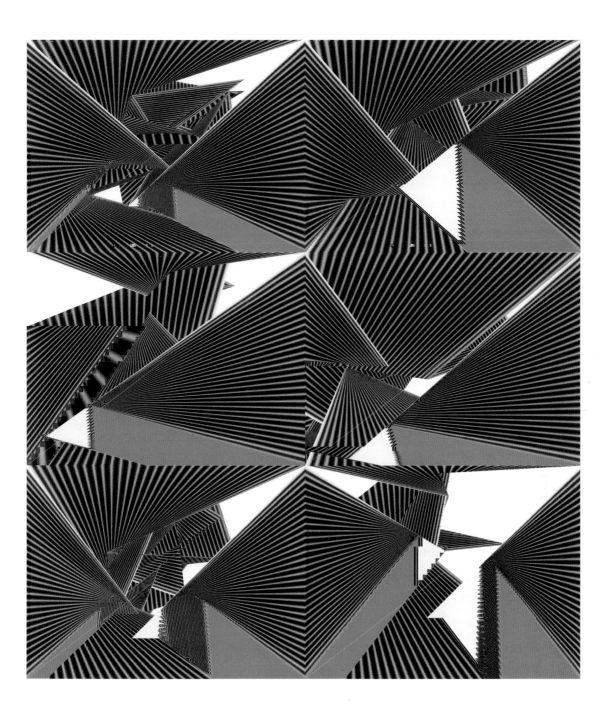

**Project**
dextro.org

**Title**
/

**Client**
Self-published

**Year**
1999

**Project**
dextro.org

**Title**
/

**Client**
Self-published

**Year**
1993

**Project**
dextro.org

**Title**
/

**Client**
Self-published

**Year**
2000

# Daniel Eatock / Foundation 33

## "Say YES to fun & function & NO to seductive imagery & colour!"

Opposite page:

**Project**
Custom utilitarian greeting
card

**Title**
Custom utilitarian greeting
card

**Client**
Self-published

**Year**
1998

# CUSTOM CARD

**Please write or draw a personal message
for the card's recipient in the space below.**

"Graphic Design is artistic, attractive, bad, basic, beautiful, bland, blurred, colourful, communicative, complex, conceived, conceptual, contradictory, contrived, creative, cultivated, current, dapper, dark, decorative, easy, elegant, entertaining, essential, exciting, expensive, fashionable, fast, functional, funky, good, gray, grunge, hard, high, illuminating, illustrative, imaginative, important, inevitable, informative, intelligent, interesting, interpretive, layered, lively, low, modern, necessary, needed, new, numbered, polished, pop, popular, problematic, punk, real, refined, retro, revealing, slow, smart, stimulating, structured, stylish, subjective, subversive, tasteless, tailored, tidy, tight, trendy, visionary."
(Daniel Eatock)

»Grafikdesign ist aktuell, anregend, attraktiv, aufregend, aufschlussreich, ausgeflippt, bunt, dekorativ, dunkel, durchgeplant, einfallsreich, elegant, elementar, erhellend, fesch, funktional, funky, geschliffen, gedämpft, geschmacklos, grau, grunge, gut, hart, illustrativ, informativ, intelligent, interessant, interpretativ, kommunikativ, komplex, konzeptuell, konzipiert, kostspielig, kreativ, kultiviert, künstlerisch, langsam, lebhaft, leicht, maßgeschneidert, modern, modebewusst, neu, nummeriert, notwendig, ordentlich, pfiffig, poppig, populär, problematisch, punky, real, raffiniert, retro, schön, schlecht, schlicht, schnell, schmuck, strukturiert, subjektiv, subversiv, trendy, unerlässlich, unscharf, unterhaltsam, vielschichtig, visionär, wesentlich, wichtig, widersprüchlich, wortkarg.«
(Daniel Eatock)

«Le design graphique est artistique, attirant, bas, basique, beau, bon, branché, chic, chiffré, coloré, communicatif, complexe, conçu, conceptuel, contemporain, contradictoire, convenu, coûteux, créatif, cultivé, décoratif, drôle, éclairé, élégant, essentiel, facile, flou, fonctionnel, fringant, funky, gris, grunge, hard, illustratif, imaginatif, important, inévitable, informatif, intelligent, intéressant, interprétatif, lent, lisse, malin, mauvais, moderne, polymorphe, nécessaire, net, neutre, nouveau, pop, populaire, problématique, punk, rapide, raide, raffiné, réel, rétro, révélateur, sombre, stimulant, subjectif, subversif, sur-mesure, tendance, tendu, utile, visionnaire, vivant, vulgaire.»
(Daniel Eatock)

**Foundation 33**
33 Temple Street
London E2 6QQ
UK

T +44 20 7739 9903
F +44 20 7739 8989

E eatock/solhaug@
foundation33.com

www.foundation33.com

**Design group history**
1999 Co-founded by Daniel Eatock (graphic designer) and Sam Solhaug (architect)

**Founders' biographies**
Daniel Eatock
1975 Born in Boulton, England
1996–1999 MA Graphic Design, Royal College of Art, London
1998–1999 Graphic design intern at the Walker Art Center, Minneapolis, Minnesota; Current Senior Lecturer in Graphic Design at the University of Brighton
Sam Solhaug
1968 Born in Minneapolis, Minnesota
1984–1988 Studied Architectural Environmental Design at the Otis/Parsons Art Institute, Los Angeles and the Parsons School of Design, New York
1987–1989 Worked for Michele Saee, Los Angeles
1989 Worked for Morphosis, Los Angeles
1990–1991 Worked for Shunji Kondo Architecture Studio, Tokyo
1992–1993 Worked for Diller & Scofidio, New York

**Recent exhibitions**
2001 "Design Now", Design Museum, London; "Multi-Ply Furniture", Pentagram Gallery, London

**Recent awards**
2000 Award, Annual Design Review; "40 under 30" Award, I.D. magazine

**Clients**
ADC-LTSN
Alex Poots Artistic Events
Channel Four Television
Design Museum
Eatock Family
Maguffin
Mazorca Projects
Opus Magnum
Walker Art Center

Opposite page:

**Project**
Poster

**Title**
Custom Built: A Twenty-Year Survey of Work by Allan Wexler poster

**Client**
Atlanta College of Art Gallery and City Gallery at Chastain

**Year**
1999

# Custom Built: A Twenty-Year Survey of Work by Allan Wexler

| Buckets, Sinks, Gutters | The Shape of Form / Geometry | Built Structures | Function | Construction Process | Nature and Architecture |
|---|---|---|---|---|---|
| Houses for Painting, 1994 | Drawing 2 x 4, 1997 | Beach Building, 1984 | One Cup of Coffee, 1991 | 7 Hours 24 Minutes, from Indeterminacy Series, 1997 | Forest Houses, 1976 |
| House with Extended Gutters, 1994 | Drawing Chair and Stool, 1998 | Building Using 400 Uncut 2 x 4s, 1979 | Braun "Aromaster" 10 Cup Coffeemaker, 1991 | 5 Hours 35 Minutes, from Indeterminacy Series, 1997 | Thirty Proposals for a Hill (for the DeCordova Museum), 1989 |
| Building for Water Collection with Buckets, 1994 | Three Unfolded Houses,1998 | Crate House, 1991 | Rebuilt Braun Coffeemaker, 1991 | Memory Theater of Giulio Camillo, 1996 | Axonometrics of the House, 1978 |
| Rain Water Filter, 1994 | Scaffold Paper Chair, 1997 | Dining Building with Matching Table, 1981 | Coffee Stained Coffee Cups, 1991 | Little Building for Picnicking, 1981 | The Foundation |
| Umbrella Rain Catcher, 1994 | 24 Unfolded Houses, 1997 | Floor Becoming Table on a Hill, 1992 | Coffee Seeks Its Own Level, 1990 | Screen Chair, 1984 | The Ground Floor |
| Water Storage Unit, 1994 | Upholstered Chair, 1996 | Little Office Building #2, 1988 | Four Steps Seven into a Tablecloth, 1991 | Series #4: Buildings Using Uncut 2 x 4s, 1979 | The Roof |
| Hat for Bottled Rain Water, 1994 | 12 Chairs, 1998 | Mattress Factory Gallery Residence, 1988 | Body Furniture, 1991 | Series #6: Buildings Using Uncut 2 x 4s and 4' x 8' Plywood, 1979 | The Cellar |
| Hat/Roof, 1994 | 12 Unfolding Chairs, 1996 | Persona Kitchen, 1994 | | Series #8: Buildings Using Uncut 2 x 4s and 8' x 16' Glass, 1980 | The Second Floor with Access |
| Expanded Pole, 1994 | Chairs, 1996 | Outdoor Shower, 1962 | | | The Platform |
| | Researching the House, 1997 | Prison Sentences: The Prison as Subject, 1995 | | Series #4: Buildings Using Uncut 2 x 4s and 8' x 16' Cement Slabs, 1980 | The Peak |
| | Sets, 1988-89 | Sukkah with Furniture Made from Its Walls, 1990 | | | The Walls |
| | | Vinyl Milford House, 1994 | | | Gazebo with Inverted Tree Columns, 1983 |

**Project**
Bleeding Art publication
(folded sheet, slip case)

**Title**
Bleeding Art publication

**Client**
Self-published

**Year**
1998

**Project**
Bleeding Art publication
(unfolded sheet)

**Title**
Bleeding Art publication

**Client**
Self-published

**Year**
1998

# Paul Elliman

"Every designer operates as an active participant in a complex set of relations. Isn't that it?"

Opposite page:

**Project**
Looking Closer: AIGA
Conference on Design
History and Criticism
New York, February 24–
25, 2001

**Title**
Poster/Mailer/Print test
pattern

**Client**
AIGA NYC

**Year**
2001

XEROX TEST PATTERN #192.000 (2)

Looking Closer:
AIGA Conference on Design History and Criticism

AIGA

"I was in an online chat room and one of the people in the conversation sent a rainbow through the layers of chat, rippling the text line by line in moving bands of colour. It was very impressive, like a wave of colours crashing onto the beach. Everybody immediately posted things like 'wooooooah, dude,' or 'far out'. And somebody else wrote something like 'cool, maybe that's the future of graphical design!'"

»Ich befand mich in einem Internet-Chatroom und ein Gesprächsteilnehmer schickte einen Regenbogen durch die verschiedenen Beiträge, so dass die Textzeilen sich wellenförmig in dahineilenden Farbbändern aufbauten. Das war sehr eindrucksvoll, wie eine bunte Welle, die auf den Strand zuläuft. Alle im Chatroom tippten sofort Begeisterungsrufe wie ›Aaahhh‹, ›geil‹ oder ›echt abgefahren‹ ein. Ein anderer schrieb so etwas wie ›Cool, das ist vielleicht die Zukunft des Grafikdesigns!‹«

«L'autre jour, dans un forum de discussion en temps réel, un des participants a envoyé un arc-en-ciel entre les couches de la conversation, faisant onduler le texte ligne après ligne par faisceaux colorés. C'était très bien fait, comme une vague de couleurs qui déferle sur la plage. Tout le monde a immédiatement tapé des commentaires du genre ‹Woooah, mec!› ou ‹Génial!› Puis quelqu'un a écrit quelque chose comme: ‹Super, c'est peut-être ça, l'avenir de la création graphique!›»

**Paul Elliman**
47 Lion Mills
394 Hackney Road
London E2 7ST
UK

T +44 20 7613 0378

E paul.elliman@yale.edu

**Biography**
1961 Born in London
1981–1982 Foundation course, Portsmouth School of Art
1982+ Self-taught

**Professional experience**
1984–1986 Member of City Limits Magazine collective
1986–1988 Designer of Wire Magazine, London
1990+ Freelance graphic designer
1991–2002 Taught and lectured at East London University; University of Texas, Austin; Jan van Eyck Academie, Maastricht; Yale School of Art, New Haven, Connecticut

**Project**
Bits

**Title**
M

**Client**
n/a

**Year**
1990–2002

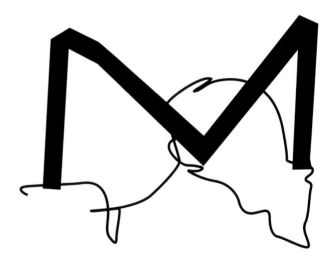

**Project**
Looking Closer: AIGA
Conference on Design
History and Criticism,
New York, February 24–
25, 2001

**Title**
Website/Monitor tests

**Client**
AIGA NYC

**Year**
2001

Looking Closer:
AIGA Conference on Design
History and Criticism

STEVEN JOHNSON
2/24 2001

Looking Closer:
AIGA Conference on Design
History and Criticism

NEAL GABLER
2/25 2001

Looking Closer:
AIGA Conference on Design
History and Criticism

NAOMI KLEIN
2/24 2001

Looking Closer:
AIGA Conference on Design
History and Criticism

ANDREW BLAUVELT
2/25 2001

Looking Closer:
AIGA Conference on Design
History and Criticism

ANDREA CODRINGTON/
PETER HALL/
JULIE LASKY/
MARTY NEUMEIER/
MARTIN C.PEDERSEN/
VéRONIQUE VIENNE
2/24 2001

Looking Closer:
AIGA Conference on Design
History and Criticism

AIGA STAFF:
RICHARD GREFé
DEBORAH ALDRICH
PAMELA AVILES
KELLEY BEAUDOIN
MOLLY BEVERSTEIN
2/25 2001
NEXT PAGE →

Issue 3.4
Art and writing by
Liz Arnold
Sally Barker
John Beagles
Dave Beech
William Blake
Iain Borden
City Racing
Michael Corris
Cross Fish
Nick Eagleton
Paul Elliman
everything Editorial
Jane Gang
Rachel Garfield
Alison Gill
Alexander Gorlizki
Mark Hutchinson
Daniel Jewesbury
Alison Jones
Jeff Koons
Paul McCarthy
Paul O'Neil
Jemima Stehli
Nicola Tyson

£3.50

Opposite page:

**Project**
Looking Closer: AIGA
Conference on Design
History and Criticism
New York, February 24–
25, 2001

**Title**
Conference titles/Projector
tests

**Client**
AIGA NYC

**Year**
2001

**Project**
Cover of Everything
Magazine

**Title**
Everything Magazine

**Client**
Everything Magazine,
London

**Year**
2001

# Experimental Jetset

"We believe in the abstraction of functionality, and the functionality of abstraction."

Opposite page:

**Project**
Letterhead, postcard,
business card

**Title**
Giljam, Plaisier,
Jacobs & Sillem
(four-sided letterhead)

**Client**
Giljam, Plaisier,
Jacobs & Sillem

**Year**
1998

# ir Peter Plaisier
# Architect bna

Willemsparkweg 132    T 020 6755625
1071 HP Amsterdam    F 020 6723284

## ir Peter Plaisier
## Architect bna

### ir Peter Plaisier
### Architect bna

ir Taco Sillem
Architect

ir Taco Sillem
Architect

ir Taco Sillem
Architect

"On utopia, materialism and dialectics. We don't see our designs as possible means to achieve a perfect future society. We'd rather look for perfection in the material reality of the design itself: utopia IN design, not THROUGH design. Rather than regarding our work as an accumulation of images, or as 'visual communication', we are more interested in underlining the physical proportions of graphic design. We create objects, not images. Other points of interest include dialectics and paradoxes. The way static objects trigger dynamic situations, for example. Or the notion that abstraction, a movement away from realism, is in fact a movement towards reality. And, what we consider as the essence of our work, the naive idea of searching for absolute solutions for relative problems."

» Über Utopie, Materialismus und Dialektik
Wir betrachten unseren Ansatz nicht als Möglichkeit, eine zukünftige perfekte Welt zu erschaffen. Wir suchen lieber nach der Perfektion in der materiellen Realität des Designs selbst: Utopie IM Design, nicht DURCH Design. Wir sehen unsere Arbeit nicht als eine Ansammlung von Bildern oder als ›visuelle Kommunikation‹, wir sind eher an der Betonung der physischen Proportionen des Grafikdesigns interessiert. Wir schaffen Objekte, nicht Bilder. Ebenfalls von Interesse sind Dialektik und Paradoxe. Zum Beispiel die Art, wie statische Objekte dynamische Situationen auslösen. Oder die Vorstellung, dass Abstraktion, eine Bewegung, die vom Realismus wegführt, eigentlich eine Bewegung zum Realismus hin ist. Und – dies betrachten wir als Essenz unserer Arbeit – die naive Idee, nach absoluten Lösungen für relative Probleme zu suchen.«

« De l'utopie, du matérialisme et de la dialectique.
Nous ne considérons pas nos créations comme un moyen de construire une société future parfaite. Nous préférons rechercher la perfection dans la réalité matérielle du graphisme lui-même : l'utopie DANS le graphisme, et non PAR lui. Plutôt que de considérer notre travail comme une accumulation d'images ou de la ‹communication visuelle›, nous visons à mettre en valeur les proportions physiques du graphisme. Nous ne créons pas des images mais des objets. Parmi nos autres centres d'intérêts : la dialectique et les paradoxes ; la manière dont les objets statiques déclenchent des situations dynamiques ; ou encore la notion que l'abstraction, un mouvement se démarquant du réalisme, soit en fait un mouvement vers la réalité ; enfin, l'essence même de notre travail, l'idée naïve de chercher des solutions absolues à des problèmes relatifs. »

**Experimental Jetset**
Jan Hanzenstraat 37
1st floor
1053 SK Amsterdam
The Netherlands

T +31 20 468 6036
F +31 20 468 6037

E experimental@jetset.nl

www.experimentaljetset.nl

**Design group history**
1997 Co-founded by Erwin Brinkers, Marieke Stolk and Danny van den Dungen in Amsterdam

**Founders' biographies**
Erwin Brinkers
1973 Born in Rotterdam
1993–1998 Studied Graphic Design at the Gerrit Rietveld Academy, Amsterdam
Marieke Stolk
1967 Born in Amsterdam
1993–1997 Studied Graphic Design at the Gerrit Rietveld Academy, Amsterdam
2000+ Teaches at the Gerrit Rietveld Academy, Amsterdam
Danny van den Dungen
1971 Born in Rotterdam
1992–1997 Studied Graphic Design at the Gerrit Rietveld Academy, Amsterdam
2000+ Teaches at the Gerrit Rietveld Academy, Amsterdam

**Recent exhibitions**
1998 "Salon International de l'Affiche", UNESCO House, Paris; "Do Normal", San Francisco Museum of Modern Art; "Streetwise", Kunsthal, Rotterdam; "Standpunten", Kunsthal, Rotterdam; "Standpunten 2", De Witte Dame, Eindhoven; "SuperNova (Black Metal Machine)", Bureau Amsterdam SM, Amsterdam
1999 "AEX (Modular Meaning)", Stedelijk Museum, Amsterdam; "Modes d'Emploi", FBK, Amsterdam; "31 Flavours of Doom", De Gele Rijder, Arnhem
2000 "Elysian Fields", Centre Georges Pompidou, Paris; "Dutch Graphic Design in Context", Graphic Bienale, Brno, Czech Republic
2001 "Movement", Sendai Mediateque, Tokyo; "HD Holland Design", ACTAR RAS Gallery, Barcelona

**Clients**
BodyCom Technologies
Centre Georges Pompidou
Colette
De Appel
Droog Design
Dutch Royal Mail
PTT/KPN
Gingham Inc.
Keupr & Van Bentm
Maastricht Art Fair
Netherlands Design Institute
Purple Institute
So by Alexander van Slobbe
Stedelijk Museum, Amsterdam
Witte De With

**Project**
Catalogue for group show

**Title**
Elysian Fields
(organized according to
phases of sleep)

**Client**
Centre Georges
Pompidou /
Purple Institute

**Year**
2000

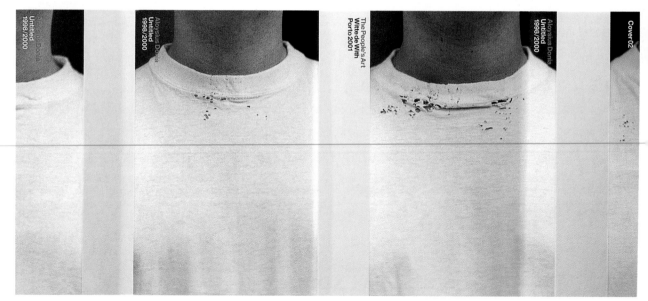

**Project**
Catalogue for group show

**Title**
The People's Art
(catalogue featuring
twenty seperate dust
covers)

**Client**
Witte de With

**Year**
2001

**Project**
Magazine

**Title**
Emigre 57
(Lost Format
Preservation Society)

**Client**
Emigre

**Year**
2000

# Extra Design

## "Make it as simple as it can be."

Opposite page:

**Project**
Illustration

**Title**
Kitty Building

**Client**
IdN

**Year**
2000

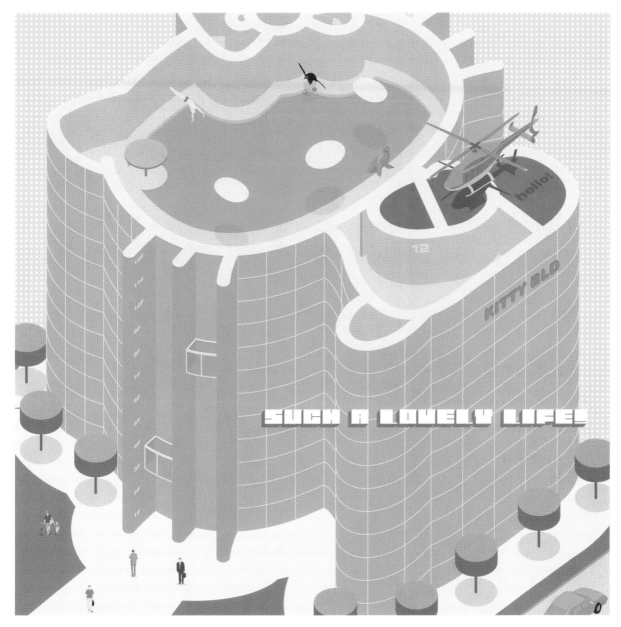

"It's hard to tell. What will be happening in the future is something we can't even imagine at this moment. A couple of years ago, we didn't expect to use the Internet and email this often. It's essential for us now. The future of graphic design is something we can't predict."

»Das ist schwer zu sagen. Was noch geschehen wird, können wir uns im Moment noch nicht einmal vorstellen. Vor einigen Jahren hätten wir auch nicht gedacht, dass wir Internet und E-Mail so ausgiebig und ständig benutzen würden. Dabei sind inzwischen beide für uns unerlässlich. Die Zukunft des Grafikdesigns lässt sich unmöglich vorhersagen.«

«C'est difficile à dire. A l'heure actuelle, on ne peut même pas imaginer ce que sera l'avenir. Il y a quelques années, qui aurait cru qu'on utiliserait autant l'internet et le courrier électronique ? Aujourd'hui, ils nous sont devenus indispensables. On ne peut pas prédire l'avenir du graphisme. »

**Extra design**
E shin@extra.jp.org

www.extra.jp.org
www.extract.jp
www.kgkgkg.com

**Design group history**
1997 Founded by Nobutaka Sato in Sapporo, Japan
1998 Shin Sasaki joined design group

**Founders' biographies**
Nobutaka Sato
1973 Born in Japan
Shin Sasaki
1974 Born in Japan

**Recent exhibitions**
2000 "Nisen Tokyo Exhibition", Journal Standard Shinjuku, Tokyo;
2001 "Poster Exhibition", IdN Fresh Conference 2001, Hong Kong; "one-dotzero", Saatchi & Saatchi Gallery, Tokyo; "I love Utopia", Zouk, Singapore

**Recent awards**
2001 Gold Prize, Sapporo Art Directors Club

**Clients**
Air Do
Creative Review
IdN
MTV2
Orix
So-net Channel
Soulbossa Production
Ricoh

**Project**
Magazine Cover

**Title**
Extra Design

**Client**
Design Plex

**Year**
2001

Opposite page, top:

**Project**
Postcards

**Title**
Brown, & BB

**Client**
Self-published

**Year**
2000

Opposite page, bottom:

**Project**
Illustration

**Title**
Eating, & Fake

**Client**
Selfish

**Year**
2000

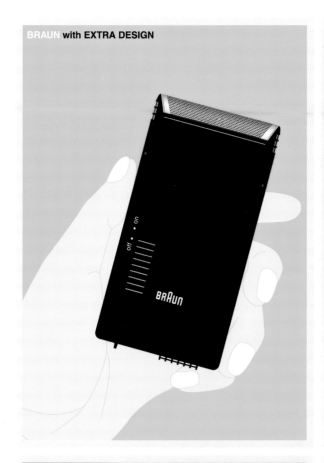

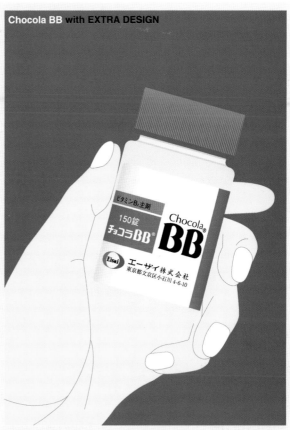

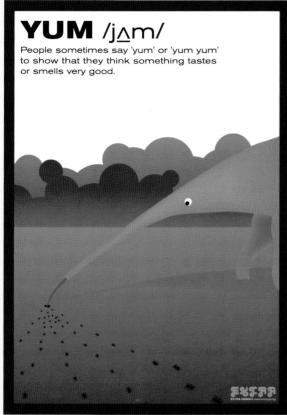

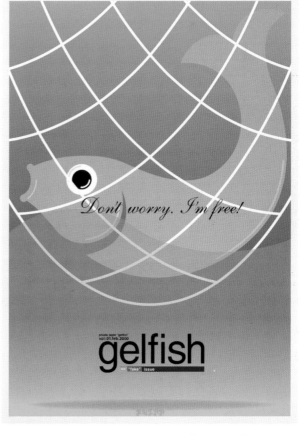

# C.R.D. TIME TABLE
## club radio dictionary
## on air list

## 01 TOKYO SHIBUYA

SHIBUYA FM "VOICE" 78.4MHz
▶MO'INFO→SHIBUYA FM, "VOICE" ▶CALL : 03-3456-4977
▶FAX↑ : 03-3456-4978 ▶HOME : http://www.parco-city.co.jp/shibuya-fm/

SHIBUYA FM 78.4

|      | 18:00 | 18:55 | 19:00 |
|------|-------|-------|-------|
| Mon  | ▶▶ DEPTHEAD 提供 : DEPT STORE | CLUB KING INFORMATION | ▶▶ PRIMO PIATTO 選曲 : UNITED FUTURE ORGANIZATION |
| Tue  | ▶▶ AMBG – ANY MUSIC, BUT GOOD 選曲 : EDWIN | CLUB KING INFORMATION | ▶▶ LIVE C.R.D. |
| Wed  | ▶▶ HYSTERIC RADIO 選曲 : HYSTERIC GLAMOUR | CLUB KING INFORMATION | ▶▶ RECOYA CONNECTION 協力 : MUTEKI RECORDS, MANHATTAN RECORDS |
| Thu  | ▶▶ MUSIC WAVE | CLUB KING INFORMATION | ▶▶ SPECIAL HOUR |
| Fri  | ▶▶ FROM TIME CAFE 提供 : BEAMS | CLUB KING INFORMATION | |

CLUBKING
▶CALL : 03-3418-3399
▶FAX↑ : 03-3418-3545
▶MAIL : crd@clubking.com

## 02 OSAKA MINAMI

YES-fm 78.1MHz ▶MO'INFO ▶CALL : 06-6646-1212 ▶FAX↑ : 06-6646-1213
▶HOME : http://www.78l.net/
スタート！ 19:00に聞き逃した方、夜にリベンジチャンスです！

THIS IS REAL OSAKA

|      | 19:00 | 19:58 | 0:00 - 0:58 |
|------|-------|-------|-------------|
| Mon  | ▶▶ DEPTHEAD 提供 : DEPT STORE | | REPEAT |
| Tue  | ▶▶ AMBG – ANY MUSIC, BUT GOOD 提供 : EDWIN | | REPEAT |
| Wed  | ▶▶ HYSTERIC RADIO 選曲 : HYSTERIC GLAMOUR | | REPEAT |
| Thu  | ▶▶ MUSIC WAVE | | REPEAT |
| Fri  | ▶▶ FROM TIME CAFE 提供 : BEAMS | | REPEAT |

## 03 FUKUOKA TENJIN

YES-fm Vol_TM, "FREE WAVE" 77.7MHz
▶CALL : 092-734-6393 ▶FAX↑ : 092-734-1982
▶HOME : http://www.freewave777.com/

FREE WAVE

|      | 23:00 | 24:00 | 25:00 |
|------|-------|-------|-------|
| Mon  | | | ▶▶ AMBG – ANY MUSIC, BUT GOOD 提供 : EDWIN |
| Tue  | | | ▶▶ RECOYA CONNECTION 協力 : MUTEKI RECORDS, MANHATTAN RECORDS |
| Wed  | | | ▶▶ HYSTERIC RADIO |
| Thu  | | | ▶▶ MUSIC WAVE |
| Fri  | ▶▶ PRIMO PIATTO 選曲 : UNITED FUTURE ORGANIZATION | | ▶▶ FROM TIME CAFE 古着甲板、コミュエスタ豊橋、南馬越一郎・青野智一・谷沢洋 (BEAMS) |

Opposite page:

**Project**
T-shirt

**Title**
Love Tennis

**Client**
Zoomit

**Year**
1999

**Project**
Page Layout

**Title**
Dictionary

**Client**
Club King

**Year**
2001

# Farrow Design

"A designer is duty bound to push the client as far as they will go."

**Project**
CD packaging
Sculpture: Yoko by Don
Brown courtesy of Sadie
Coles HQ

**Title**
Spiritualized
Let it come down

**Client**
Spaceman/Arista

**Year**
2001

"Clarity, Form, Function."          » Klarheit, Form, Funktion. «          « Clarté, forme, fonction. »

**Farrow Design**
23–24 Great James Street
Bloomsbury
London WC1N 3ES
UK

T +44 20 7404 4225
F +44 20 7404 4223

E studio@
  farrowdesign.com

www.farrowdesign.com

**Design group history**
1995 Founded by Mark
Farrow in London

**Founder's biography**
Mark Farrow
1960 Born in Manchester,
England
Self-taught
1986–1990 3A, London
1990–1996 Farrow,
London
1996+ Farrow Design,
London

**Recent exhibitions**
1998 "Experimentadesign
99", Lisbon
2000 "Sound Design
2000", British Council,
global touring exhibition

**Recent awards**
1997–1998 Award (x10),
Music Week CAD
1998 Award, Most
Outstanding Record
Sleeve, D&AD
2001 Award, Most
Outstanding Consumer
Website, D&AD
2002 Award, Most
Outstanding Music
Packaging Design, D&AD;
Gold Award, Art Directors
Club of Europe

**Clients**
Atlantic Bar & Grill
BMG Records
Booth-Clibborn Editions
British Museum
Channel 5
Coast
Cream
Cream Records
D&AD
EMI Records
Epic Records
Gruppo Limited
Harvey Nichols
Levi Strauss Europe
London Records
Mash
MTV
Jasper Morrison
Museum für Gegenwarts-
kunst, Basle
Marc Newson Limited
Parlophone Records
Saatchi & Saatchi
Sadie Coles HQ
Science Museum,
London
SCP
Sony Music
Tate Modern
Virgin Records
WEA Records
Wilkinson Eyre Architects

**Project**
CD packaging

**Title**
Dave Clarke
Archive one

**Client**
Deconstruction

**Year**
1996

**Project**
Book cover

**Title**
D&AD Annual

**Client**
D&AD

**Year**
1999

**Released
08 03 99**

**Available on
2xCD and 12"**

# Orbital        Style

Opposite page:

**Project**
Poster

**Title**
Orbital
Style

**Client**
London Records

**Year**
1999

**Project**
Book design

**Title**
Kylie

**Client**
Darenote Ltd /
Booth-Clibborn Editions

**Year**
1999

# Fellow Designers

## "We try to make things the way we would like them ourselves."

Opposite page:

**Project**
Poster

**Title**
Banana

**Client**
Fellow Designers,
exhibition

**Year**
2000

"Good design today is probably very similar to what was good design yesterday and what will be good design tomorrow. The graphic expression may change but outstanding design will always stand out."

Love, Eva & Paul.

»Gute Grafik ist heute wahrscheinlich so ziemlich dasselbe wie es gute Grafik gestern war und morgen sein wird. Die Ausdrucksformen mögen sich ändern, aber herausragendes Design wird immer aus der Masse hervorstechen.«

Love, Eva & Paul.

« Le bon graphisme d'aujourd'hui répond probablement aux même critères que celui d'hier et que celui de demain. L'expression graphique peut changer, mais les créations exceptionnelles sortent toujours du lot. »

Love, Eva & Paul.

**Fellow Designers**
Hälsingegatan 12
113 23 Stockholm
Sweden

T +46 8 33 22 00
F +46 8 31 24 10

E paul@
fellowdesigners.com

www.fellowdesigners.com

**Design group history**
1997 Paul Kühlhorn and Eva Liljefors founded Fellow Designers after graduating: Paul from Konstfack (University College of Arts, Crafts and Design), Stockholm and Eva from Beckmans School of Design, Stockholm
2000 Fellow Designers joined Agent Form (Swedish design agency)
1998–2001 Taught graphic design at Beckmans School of Design and Konstfack, Stockholm

**Recent awards**
1998 Affe – Best Swedish Poster of the Year, Rabarbers
1999 Affe – Best Swedish Poster of the Year, Sårskorpor
2000 Guldägget, Silver Egg for Posters, Stockholm City Theatre

**Clients**
Adidas
Cultural Centre of Stockholm
Dagens Nyheter
Memfis Film
Moonwalk
Raptus
Respons
Sonet Film
Stockholm City Theatre
Svensk Form
Telia

**Project**
Magazine

**Title**
Bang

**Client**
Bang

**Year**
1999

Opposite page:

**Project**
Poster
Photo: Martin Runeborg/Bauer

**Title**
Excellent Swedish Design

**Client**
Utmärkt Svensk Form

**Year**
2001

Utmärkt Svensk Form 2001    Svensk Form    Stockholm
13 sept – 28 okt    Skeppsholmen    www.svenskform.se

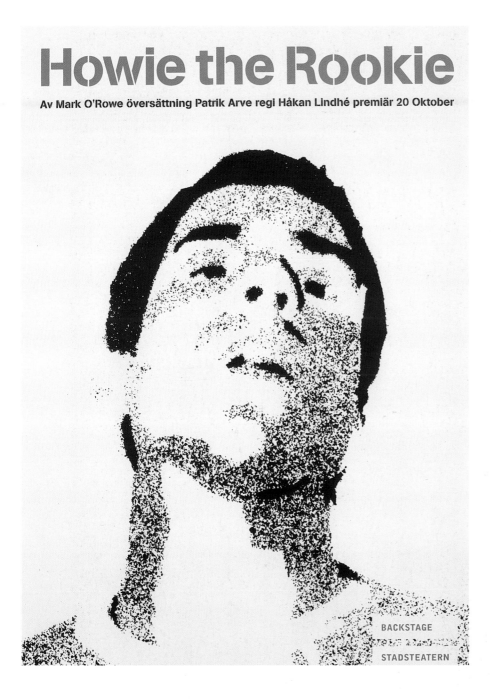

# Howie the Rookie

**Av Mark O'Rowe översättning Patrik Arve regi Håkan Lindhé premiär 20 Oktober**

BACKSTAGE
STADSTEATERN

Opposite page:

**Project**
Theatre poster

**Title**
Rabarbers

**Client**
Stockholm city theatre

**Year**
1998

**Project**
Theatre poster
Image: Jonas Banker

**Title**
Howie the Rookie

**Client**
Stockholm city theatre

**Year**
2000

# Flúor

"Design: When shape, colour, sound…
have a specific meaning and/or purpose
that is not only emotional."

Opposite page:

**Project**
Catalogue

**Title**
26os Encontros
Gulbenkian de Música
Contemporânea

**Client**
Fundação Calouste
Gulbenkian

**Year**
2002

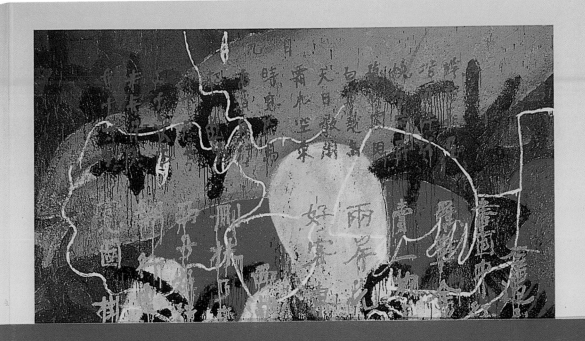

 /Contém índice completo de compositores,
obras e intérpretes dos Encontros Gulbenkian
de Música Contemporânea 1977/2001

# 26<sup>os</sup> Encontros Gulbenkian de Música Contemporânea

oriente / ocidente

20 maio 02 junho
2002

"Design is all about knowing the past, the present, the future. These three words and meanings will lead us into processes and methods that result in an objective and clear response. This relation will break existing boundaries in communication and will create new ones regarding the interaction with time, space and imagination. In the last decades of the 20th century graphic design established itself in the minds of a wider audience, not only as the materialization of an idea but as a part of it. The content experience is more related to its visual interpretation than ever before. That's the cultural space that graphic design is conquering.
Media and technologic boundaries are less evident, making design less attached to a specific media solution and more related to a style and content. This will simply push us into new solutions. The recent remixes of past trends in mainstream media are only possible because of the relevance that they had in their own time. As language is becoming global and ideas more specific, graphic design is growing, becoming an important cultural reference."

"No formulas, only elements"

» Beim Grafikdesign geht es um die Kenntnis der Vergangenheit, Gegenwart und Zukunft. Diese drei Begriffe führen zu Prozessen und Methoden, die ihrerseits in objektiven Lösungen resultieren. Diese Beziehung wird bestehende Kommunikationsbarrieren überwinden und im Bereich der Interaktion zwischen Zeit, Raum und Vorstellungskraft wieder neue Hindernisse schaffen.
In den letzten Jahrzehnten des 20. Jahrhunderts hat sich Design im Bewusstsein der breiteren Öffentlichkeit nicht nur als Umsetzung einer Idee, sondern als deren Bestandteil durchgesetzt. Das Begreifen des Inhalts hat heute mehr mit der grafischen Interpretation zu tun als je zuvor. Hier liegt das kulturelle Feld, das die Gebrauchsgrafik gerade erobert.
Die Grenzen der Medien und der Technik sind weniger klar, was zu einer schwächeren Bindung des grafischen Entwurfs an spezifische Medien und einer stärkeren Bindung an Stil und Inhalt führt. Die jüngste Wiederbelebung früherer Trends in den Massenmedien war nur möglich, weil diese Strömungen zu ihrer Zeit relevant waren. In dem Maße, in dem die Ausdrucksformen globaler, die Ideen dagegen spezifischer werden, entwickelt sich das Grafikdesign weiter und wird zum wichtigen kulturellen Bezugspunkt.«

»Keine Formeln, nur Elemente«

« En création graphique, il faut avant tout connaître le passé, le présent et le futur. Ces trois mots et leur sens nous guident à travers des processus et des méthodes qui débouchent sur des réponses claires et objectives. Cette relation brisera les frontières qui existent au sein de la communication et en créeront de nouvelles concernant l'interaction du temps, de l'espace et de l'imagination.
Au cours des dernières décennies du XXᵉ siècle, la création graphique s'est imposée non plus uniquement comme la matérialisation d'une idée mais comme une partie de l'idée. L'expérience du contenu est plus que jamais liée à son interprétation visuelle. C'est l'espace culturel que le graphisme est en train de conquérir. Les limites des moyens et de la technologie sont moins évidentes, le rendant moins dépendant d'une solution spécifique à un média et davantage lié à un style et à un contenu. Cela nous poussera simplement vers de nouvelles solutions. Les remix récents des tendances du passé n'ont été rendus possibles que grâce à la pertinence qu'elles avaient à leur propre époque. A mesure que le langage devient plus planétaire et les idées plus spécifiques, la création graphique se développe, devenant une référence culturelle importante. »

« Pas de formules, rien que des éléments »

**Flúor**
Rua Correia Garção 13–1º
1200–640 Lisbon
Portugal

T +351 21394 20 47
F +351 21394 20 49

E fluor@fluordesign.com

www.fluordesign.com

**Design group history**
2000 Founded by Ana Maria Empis, Carlos Rei, Filipe Caldas de Vasconcellos, Isabel Lopes de Castro, Lénia Silveira, Leonel Duarte and Pedro Santos

**Founders' biographies**
Ana Maria Empis
1973 Born in Lisbon
1991–1995 Degree in Communication Sciences, Universidade Autónoma de Lisboa
1995–1996 Collaboration at national newspaper "Publico" – Stock and Capital Markets, Lisbon
1996–1997 Junior Account Manager at GD – Publicidade e Design
1997–2000 Senior Account Manager at Ricardo Mealha, Atelier de Design, Lisbon
2000–2001 Founding Partner and Account Manager Senior at Flúor Design & Comunicação, Lisbon

Carlos Rei
1972 Born in Lisbon
1990–1992 Bachelor of Ceramics Design at ESAD-Escola Superior de Arte e Design, Caldas da Rainha, Portugal
1992–1996 Bachelor of Communication Design at University of Lisbon
1996–2000 Senior Designer at Ricardo Mealha, Atelier de Design
2000 Founding Partner and Senior Designer at Flúor Design & Comunicação
Filipe Caldas de Vasconcellos
1974 Born in Lisbon
1990–1992 Buckingham Browne & Nichols School, Cambridge, Massachusetts
1992–1995 B.A. Art History and Communication, American University in Paris
1995–1996 Junior Account Executive at MKT Publicidade, Lisbon
1996–1998 Senior Account Executive and Account Executive at

Ammirati Puris Lintas, Lisbon
1998–1999 International Account Manager at Ammirati Puris Lintas, Paris
1999 Account Supervisor at Young & Rubicam, Lisbon
1999–2000 Executive Director at Ricardo Mealha, Atelier de Design, Lisbon
2000–2001 Founding Partner at Flúor Design & Comunicação
Isabel Lopes de Castro
1974 Born in Lisbon
1992–1997 Degree in Communication Design, University of Lisbon
1997–1998 Junior Designer at Finalíssima, Arte & Desenho, Lisbon
1998–2000 Senior Designer, Ricardo Mealha, Atelier de Design
2000–2001 Founding Partner and Senior Designer at Flúor Design & Comunicação

Lénia Silveira
1973 Born in Huambo, Angola
1992 1st year at ISCSPE-Instituto Superior de Ciências Sociais e Políticas, Lisbon
1992–1995 Customer Service Agent at TWA, Lisbon
1995–2000 Office Manager at Ricardo Mealha, Atelier de Design
2000 Founding Partner and Office Manager at Flúor Design & Comunicação
Leonel Duarte
1974 Born in Santarém, Portugal
1992–1997 Degree in Communication Design at University of Lisbon
1993–1997 Freelance designer
1998–2000 Senior Designer at Ricardo Mealha, Atelier de Design
2000–2001 Founding Partner and Senior Designer at Flúor Design & Comunicação

Pedro Santos
1973 Born in Lourenço Marques, Mozambique
1993–1997 Degree in Communication Design, IADE-Instituto Superior de Design e Marketing, Lisbon
1993–1998 Post Graduate Degree at EINA – Escola de Desseny i Arte, Barcelona
1993–1997 Freelance designer
1995–1996 Practising Designer at ARTVISÃO, Comunicação e Imagem, Lisbon
1997–1999 Junior Designer at Euro RSCG Design, Lisbon
1999–2000 Senior Designer at Ricardo Mealha, Atelier de Design
2000–2001 Founder and Senior Designer at Flúor Design & Comunicação

**Recent awards**
2001 Bronze Award, Clube de Criativos de Portugal

**Clients**
Associação Industrial Portuguesa
Associação ModaLisboa
Associação de Turismo de Lisboa
Lisboa Welcome Center
Mercado da Ribeira
Câmara Municipal de Silves
Causaefeito
Cerger
Companhia Portuguesa de Higiene
Danone Portugal
Departamento de Estatística do Trabalho, Emprego e Formação Profissional
Discovery Park
Dilop
eartweb.net
Fundação Calouste Gulbenkian
Fundação Luso-Americana
Fundação Oriente
guiadoseventos.com
Grupo Media Capital-Telelista
ICEP
Inland Promoção Imobiliária
Instituto das Comunicações de Portugal
Instituto Português de Museus
Jornal Público
Laboratórios Azevedos
Marina Cruz Cabeleireiros
Museu do Chiado
Museu Nacional de Etnologia
Pedro Salgado
PT Prime
Quercus
Região de Turismo do Algarve
Resul Equipamentos de Energia
Socosmet
Táscomfome.com
W Investimentos
Whitehouse Imobiliária

**Project**
Catalogue

**Title**
Surrealismo em Portugal 1934–1952

**Client**
Museu do Chiado

**Year**
2002

**Project**
Catalogue

**Title**
26os Encontros
Gulbenkian de Música
Contemporânea

**Client**
Fundação Calouste
Gulbenkian

**Year**
2002

/ Grande Auditório Gulbenkian
19.00h

**Nieuw Ensemble**
(Amsterdão)
Harrie Starreveld, flauta
Ernest Rombout, oboé
Arjan Kappers, clarinete
Martine Sikkenk, syntbfilo
Helenus de Rijke, guitarra
Herman Halewijn, Fredrike de Winter,
Ron Colbers e Rene Dussoren, percussão
Heleen Hulst e Anna McMichael, violino
Frank Brakkee, viola
Jeroen den Herder, violoncelo
Rozemarie Heggen, contrabaixo

Herman Hale Wijn, direcção de cinema

Emílio Pomárico, maestro
**Ellen Schuring,** soprano
**Nigel Robson,** tenor
**Shi Kelong,** barítono
**Dong Ya,** pipa
**Fang Weiling,** zheng

**Obras-Primas
de Compositores
Chineses**

**Chen Qigang**
(China/França)
*Poème Lyrique II*
(1990) – 15'

**Xu Shuya**
(China/França)
*Vacuité / Consistance*
(1996) – 15'

**Qu Xiaosong**
(China/EUA)
*Mist*
(1991) – 10'

Intervalo

**Mo Wuping**
(China)
*Fan II*
(1991) – 10'

**Guo Wenjing**
(China)
Suíte da ópera *Wolf Cub Village*
(1997) – 16'

maio                                                    maio

Índice
de Compositores e Obras

# Fold 7

## "We make design with big, strong legs and child-bearing hips."

Opposite page:

**Project**
Illustrations for Create
Online opening pages,
contents and cover

**Title**
Generation Web

**Client**
Create Online

**Year**
2000

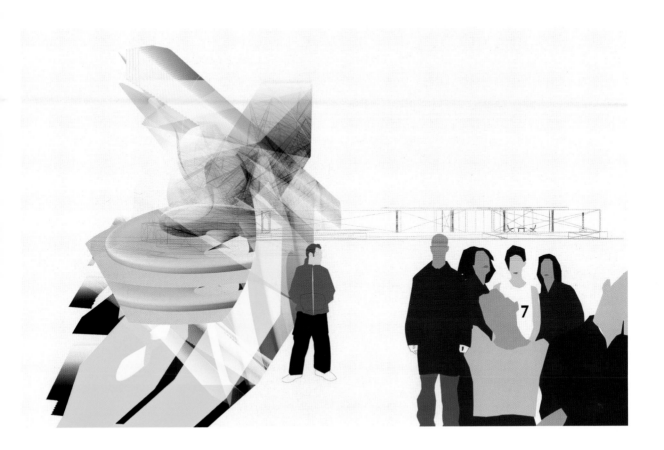

"Due to the almost complete take-over of computers in our modern world, there has been a fusion of, and easier access to, all media. From your home computer you can build websites, make music, edit videos, design logos and so on. Technology has opened doorways to everywhere for everyone. Web design has become a 'hobby'. Everyone is now a designer. In the future, many design agencies will become 'style' agencies. Computer software will be created to offer 'design styles'. Like Photoshop filters today can create a Van Gogh or Matisse 'style', soon you'll be able to input your data and just select a style – Swiss Style, Vaughan Oliver Style, Dance Compilation CD Style – and your computer will do the rest of the work. We believe that being able to use a design package and being a designer are not the same thing. Good design comes from strong ideas, and it takes a human brain, not a computer, to create ideas. Fold 7 predicts a re-birth of hand skills, and a new found interest in the simple pleasure of drawing. Mankind in general, in an attempt to slow down the destruction of this planet, will move towards a more organic way of living, a natural and nature loving way of life. This will be reflected in the work of 'true' designers. The computer junkies will disappear under a self-made mountain of vector graphics, and on this mountain the Fold 7 School of Doodling on Post-It Notes will be founded. We better start growing our hair now …"

» Die Eroberung der modernen Welt durch den Computer hat die Fusion und Offenheit sämtlicher Medien gebracht. Vom häuslichen Computer aus können wir Internetportale aufbauen, Musik spielen, Videos editieren, Logos gestalten usw. Die Technik hat allen überall die Türen geöffnet. Webdesign ist zum Hobby geworden und jeder zum Designer. Künftig werden viele Designbüros zu ›Stilberatungsagenturen‹ mutieren. Man wird Programme mit ›Designstil-Angeboten‹ entwickeln. Wie man schon heute mit Photoshop-Filtern im Stil von Van Gogh oder Matisse arbeiten kann, wird man bald nur noch die eigenen Daten eingeben und einen Stil auswählen müssen (Schweizer Schule, Vaughan Oliver, Dance Compilation CD), der Computer erledigt den Rest. Gutes Design erwächst jedoch aus starken Ideen und für die braucht man ein Menschenhirn und keinen Computer. Fold 7 glaubt an das Comeback handwerklicher Fertigkeiten und an ein neues Interesse an den einfachen Freuden des Zeichnens. Um die Zerstörung unseres Planeten aufzuhalten, werden sich die Menschen weltweit einer ›organischeren‹ Lebensweise zuwenden, einem naturverbundenen Leben. Das wird sich auch im Schaffen der ›wahren‹ Designer bemerkbar machen. Die Computerfreaks werden unter einem selbst angehäuften Berg aus Vektorgrafiken verschwinden, auf dessen Gipfel man die ›Fold-7-Schule der Kritzeleien auf gelben Haftzetteln‹ gründen wird. Wir sollten schon mal unsere Haare wachsen lassen …«

« Dans notre monde moderne, la prise de pouvoir des ordinateurs a entraîné la fusion et une plus grande accessibilité de tous les moyens de communication. Depuis notre ordinateur, on peut construire des sites Internet, faire de la musique, monter des bandes son, créer des logos, etc… L'infographie est devenue un violon d'Ingres. Désormais, tout le monde crée. A l'avenir, de nombreux bureaux de design deviendront des ‹bureaux de styles›. Des logiciels proposeront des ‹styles de graphisme›. Bientôt, il suffira d'entrer ses données et de choisir un style : le style suisse, le style Vaughan Oliver, le style CD de compilation Dance et l'ordinateur se chargera du reste. Mais pour nous, savoir utiliser un logiciel et être un créateur sont deux choses différentes. Le bon graphisme naît de bonnes idées, or les bonnes idées sortent d'un cerveau humain. Fold 7 prédit la renaissance du travail à la main, un regain d'intérêt pour le plaisir simple de dessiner. L'humanité dans son ensemble, dans une tentative pour ralentir la destruction de la planète, s'orientera vers une manière de vivre plus organique, plus naturel et écologique. Cela se reflétera dans le travail des ‹vrais› créateurs. Les accros de l'ordi disparaîtront, engloutis sous la montagne de leurs propres graphiques vectoriels et, au sommet de cette montagne, Fold 7 fondera l'école de l'art de faire des gribouillis sur des post-it. On ferait mieux de se laisser pousser les cheveux dès maintenant. »

**Fold 7**
Shepherdess Walk
47 Underwood Street
London N1 7LG

T +44 20 7251 0101
F +44 20 7251 0202

E mail@fold7.com

www.fold7.com

**Design group history**
1995 Co-founded by Ryan Newey and Simon Packer in London

**Founders' biographies**
Ryan Newey
1974 Born in Kingswinford, Midlands, England
1990–1992 Photography ND, Stourbridge College of Art
1992–1994 Photography and Design HND, Bournemouth and Poole College of Art and Design
1994–1995 Postgraduate degree in Design, Bournemouth and Poole College of Art and Design

Simon Packer
1972 Born in Gloucester, England
1990–1992 Graphic Design ND, Nene College
1992–1994 Graphic Design HND, Bournemouth and Poole College of Art and Design
1994–1995 Postgraduate degree in Design, Bournemouth and Poole College of Art and Design.

**Recent awards**
1999 Commendation European Design Annual; Gold award, Association of Illustrators; Silver Award for Best Use of Illustration, Creative Circle
2000 Named Best Website Design for www.confused.co.uk CADS 2002; Winner Best TV Ad

**Clients**
Canon
Dazed and Confused
EMI
Firetrap
Harvey Nichols
London Records
Ministry of Sound
Muji
Orange
Ted Baker
Virgin

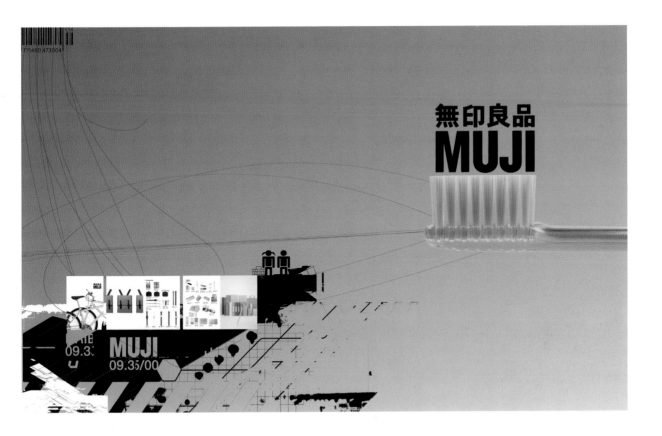

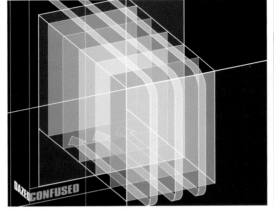

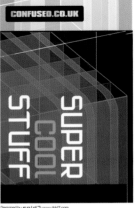

**Project**
Early spread for the
experimental Fold 7 book
"Chemistry", published
August '02 by Laurence
King, using previous work
for Muji as a base

**Title**
Muji Re-Mixed

**Client**
Self-published

**Year**
2002

**Project**
Press ads for
www.confused.co.uk

**Title**
Super Cool Stuff

**Client**
Dazed & Confused

**Year**
2001

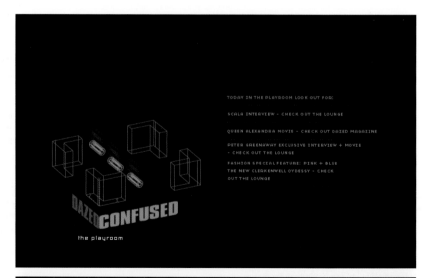

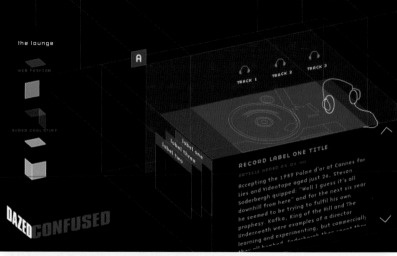

**Project**
www.confused.co.uk

**Title**
Main navigation, Decks +
Bass (music reviews)
page, Play Room

**Client**
Dazed & Confused

**Year**
2000

**Project**
Orange Out Here

**Title**
Market research mood
board

**Client**
Orange

**Year**
2001

**Project**
Orange Brand Guidlines
site

**Title**
Site plan

**Client**
Orange

**Year**
2001

# Dávid Földvári

## "Ugly=Beautiful"

Opposite page:

**Project**
Personal work, part of a
sequence of five images

**Title**
We believe

**Client**
Self-published

**Year**
2002

"There is still a fear of the unknown and a lack of trust that exists in current art direction, which in turn leads to designers and illustrators all too often producing comfortable and unchallenging work in order to survive. This leads to the mass media being flooded with an endless amount of visual information that essentially all looks the same, and as a result it fails to excite or convey anything new. Graphic designers and illustrators aren't machines that can churn out the same product endlessly, and the most successful projects are always those that allow for creative freedom and experimentation."

» Unter Artdirectors herrscht immer noch Angst vor allem Unbekannten und mangelndes Vertrauen, was Grafiker und Illustratoren allzu oft dazu veranlasst, gefällige und unprovokante Entwürfe zu produzieren, um zu überleben. Das führt dazu, dass die Massenmedien mit einer ausufernden Flut visueller Informationen überladen werden, die im Wesentlichen alle gleich aussehen und weder aufregend sind noch etwas Neues bringen. Grafiker und Illustratoren sind keine Maschinen, die kontinuierlich das immer gleiche Produkt ausstoßen können, und am erfolgreichsten sind schließlich immer die Projekte, die schöpferische Freiheit und Experimente zugelassen haben.«

« La peur de l'inconnu et la méfiance perdurent parmi les directeurs artistiques d'aujourd'hui. Du coup, les graphistes et les illustrateurs produisent trop souvent des travaux pépères et sans grand intérêt pour survivre. Les médias se retrouvent ainsi inondés d'un flot ininterrompu d'informations visuelles où tout se ressemble, n'apportant rien de nouveau ni d'excitant. Les créateurs ne sont pas des machines qui peuvent ressasser le même produit à l'infini et les projets les plus réussis sont toujours ceux qui laissent la part belle à la liberté, la créativité et l'expérimentation. »

**Dávid Földvári**
Big Photographic
Warehouse D4
Metropolitan Wharf
Wapping wall
London E1W 3SS
UK

T +44 20 7488 0794
F +44 20 7702 9366

E bp@bigactive.com

www.bigactive.com

**Biography**
1973 Born in Budapest
1992–1996 BA(Hons)
Graphic Design and
Illustration, Brighton
University, Sussex
1999–2001 MA
Communications, Royal
College of Art, London

**Professional experience**
1999+ Freelancer,
represented by Big
Photographic, London

**Recent exhibitions**
2001 "UKNY", Trump
Tower, New York

**Clients**
Dazed & Confused
Foot Action USA
London Records
Nike
Nova Magazine
Penguin
Random House
Real Pitch Project

**Project**
Album cover for the band
"A"

**Title**
HiFi Serious

**Client**
London Records, UK

**Year**
2002

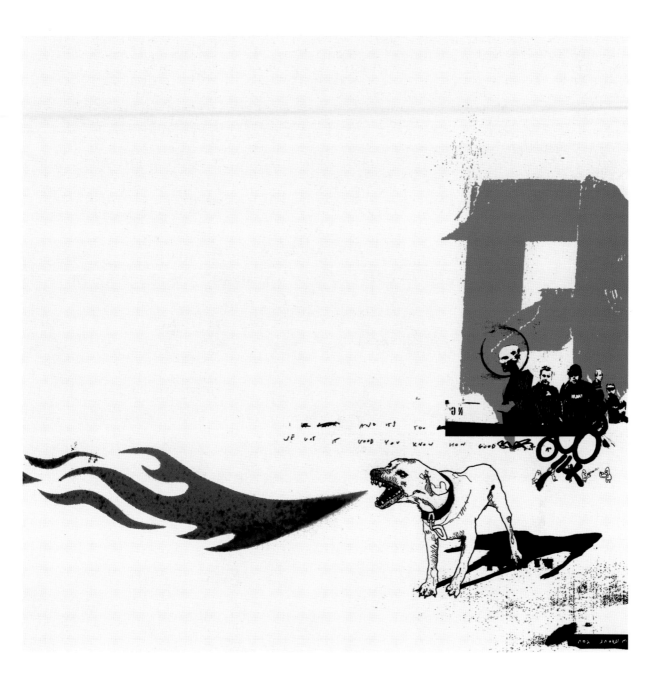

**Project**
Single sleeve prototype
for the band "A"

**Title**
Flamespitter (early work in
progress for "Starbucks")

**Client**
London Records, UK

**Year**
2002

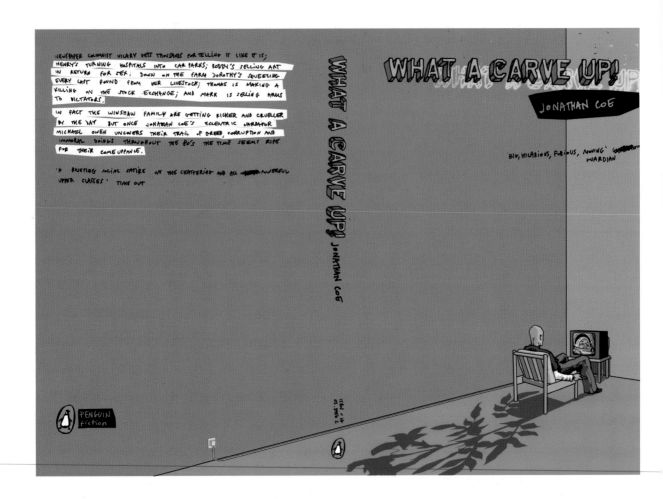

**Project**
Book cover

**Title**
"What A Carve Up" by
Jonathan Coe

**Client**
Penguin, UK

**Year**
2001

Opposite page:

**Project**
"Crash and Learn" ad
campaign, part of a
sequence of four images

**Title**
Masochist (Italian version)

**Client**
Nike ACG, Wieden
Kennedy Amsterdam,
The Netherlands

**Year**
2001

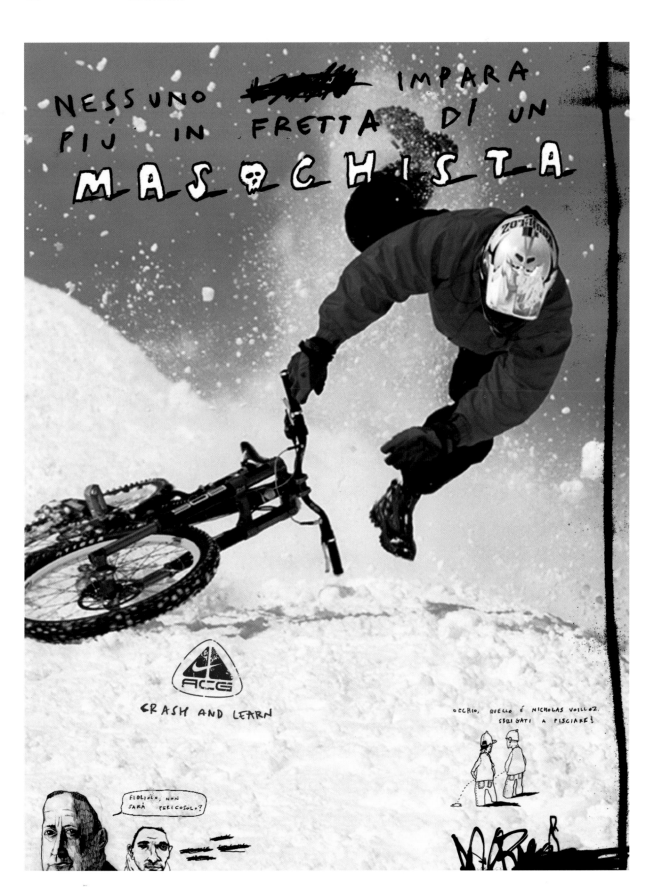

# Form

## "The future and past make the present inspiring."

Opposite page:

**Project**
Form promotional poster

**Title**
Form In Oslo (Homage to Freia)

**Client**
Self-published

**Year**
2002

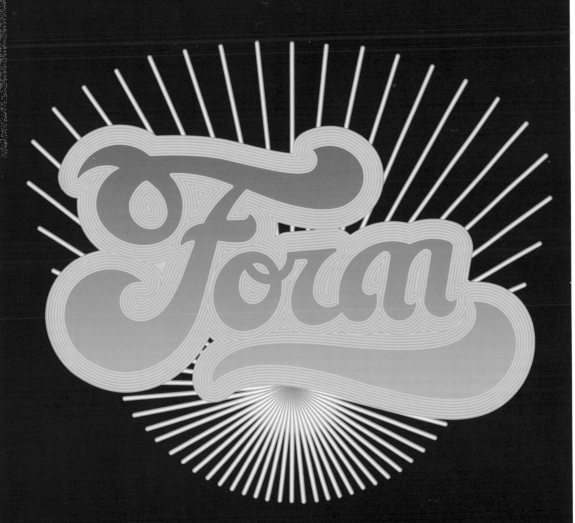

# Form® in Oslo

Faglig seminar
Visueltdagene 2002
Vika Kino
26.04.2002 @ 14.45

Grafill  T: 23 10 36 30  E: grafill@grafill.no  W: www.grafill.no
Form®  W: www.form.uk.com  UniForm®  W: www.uniform.uk.com

"Simplicity and directness underline the way that we work. There's an honesty in trusting what feels instinctively right, and a strength in accepting one's emotions without hiding behind intellectual pretension and over-laboured strategy.

The 21st century is a myriad of graphic ideas and styles – from futuristic to retro, from high street commercialism to underground cool. We don't deliberately set out to create a style. We work with clients to create concepts and solutions that solve their problems, but which also look and feel great to us. We experiment with images, typography and paper stocks, drawing on references that stretch from music and films to fine art. A minimalist layout, for example, counterbalanced with a strong use of imagery, colour and logo design is what drives us. Good design is essentially timeless.

Our recent move into clothing with the UniForm label is another example of how we've mixed styles and formats, transferring graphics onto fabrics, experimenting with different printing techniques, materials and finishes. There should be no constraints when it comes to design but there is a certain amount of obsession in continually striving to push the boundaries."

» Einfachheit und Direktheit kennzeichnen unsere Arbeit. Es ist ehrlich, auf das zu vertrauen, was man instinktiv für richtig hält, und es zeugt von Stärke, Gefühle zuzulassen, ohne sich hinter intellektuellen Prätentionen und ausgeklügelten Strategien zu verstecken.

Das Grafikdesign des 21. Jahrhunderts wird aus unzähligen grafischen Ideen und Stilen bestehen – von futuristisch bis retro, von Massenwerbung bis subkultur-cool. Wir arbeiten nicht bewusst auf einen eigenen Stil hin. Wir entwickeln zusammen mit unseren Kunden Konzepte und Lösungen, die den Zweck erfüllen, von denen wir aber auch selbst begeistert sind. Wir experimentieren mit Bildern, Typografie und Papiersorten und verarbeiten Elemente aus Musik, Film und bildender Kunst. Ein minimalistisches Layout kombiniert mit kraftvoller Bildsprache, Farben und Logo ist für uns zum Beispiel eine reizvolle Aufgabe. Gutes Design ist im Großen und Ganzen zeitlos.

Unser Einstieg ins Modegeschäft mit der Marke UniForm ist ein weiteres Beispiel dafür, wie wir Stile und Anwendungen verbinden: Wir übertragen grafische Entwürfe auf Stoffe und experimentieren mit Stoffdrucktechniken, Materialien und Appreturen. Das Gestalten sollte keinen Zwängen unterliegen, doch hat das ständige Bemühen um die Überwindung von Grenzen etwas von Besessenheit.«

« Nous travaillons dans un style simple et direct. Il y a une honnêteté dans le fait de se fier à ce que l'on ressent instinctivement comme étant correct et une force dans le fait d'accepter ses émotions sans se cacher derrière des prétentions intellectuelles et des stratégies laborieuses.

Le XXIe siècle est une myriade d'idées et de styles graphiques. Nous ne cherchons pas délibérément à créer un style. Nous travaillons avec des clients pour concevoir des concepts et des solutions à leurs problèmes mais d'une manière qui nous plaise et nous apporte quelque chose. Nous expérimentons avec des images, des typographies et des textures de papier, puisant nos références dans la musique, le cinéma ou les beaux-arts. Ce qui nous inspire, par exemple, c'est une mise en page minimaliste contrebalancée par une iconographie forte, des couleurs vives et un logo bien dessiné.

Notre incursion récente dans le domaine de la mode avec la marque UniForm est une autre illustration de la manière dont nous mélangeons les styles et les formats, transférant les graphismes sur des tissus. En graphisme, il ne devrait pas y avoir de contraintes, mais il y a un côté obsessionnel à vouloir toujours repousser les limites. »

**Form**
47 Tabernacle Street
London EC2A 4AA
UK

T +44 20 7014 1430
F +44 20 7014 1431

E studio@form.uk.com

www.form.uk.com

**Design group history**
1991 Co-founded by Paul West and Paula Benson in London

**Founders' biographies**
Paul West
1965 Born in Weymouth, England
1983–1984 Art Foundation course, Shelly Park School of Foundation Studies, Boscombe, Dorset
1984–1987 BA (Hons) Graphic Design, London College of Printing, London
1987–1989 Designer, Peter Saville Associates, London
1989 Freelance designer, with Vaughan Oliver / V23, London
1989–1990 Designer, 3a (now Farrow Design), London
1991 Co-founded Form, London
1997 Co-founded UniForm (clothing label), London

Paula Benson
1967 Born in Durham, England
1984–1985 Art Foundation course, Gloucester College of Arts & Technology, Cheltenham
1985–1988 BA (Hons) Graphic Design, Central St Martins School of Art and Design, London
1988–1989 Designer, The Design Solution, London
1989–1990 Freelance designer
1991 Co-founded Form, London
1997 Co-founded UniForm (clothing label), London

**Recent awards**
2000 Silver Award nomination, D&AD Awards; Finalist (x2), Corporate Brochures Donside Awards

**Clients**
BMG Records
Darkside FX
Dazed and Confused
Design Council
East West Records
Fabulous Films
Girls 4 Football
MTV
Mute Records
Staverton
The Moving Picture Company
Translucis
Universal/Island Records
Virgin Records
Vision on Publishing
VH1

Opposite page:

**Project**
Safe-T UniForm

**Title**
Safe-T UniForm range and press release

**Client**
UniForm

**Year**
2002

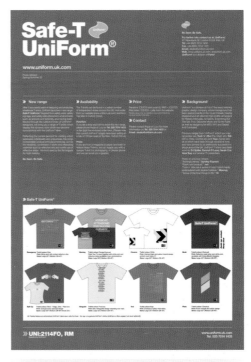

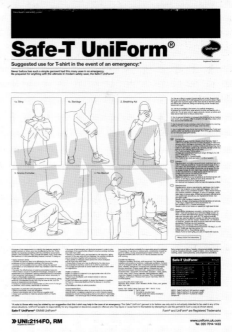

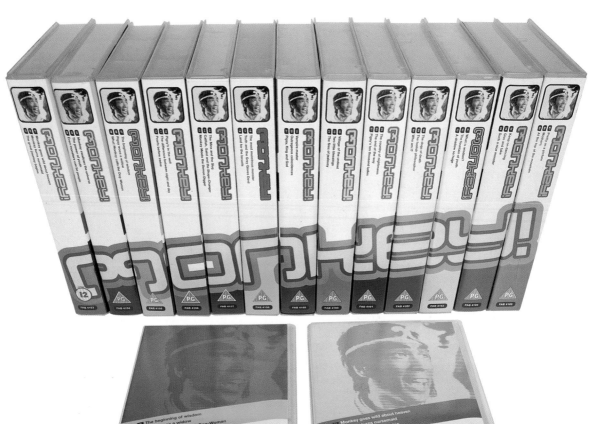

**Project**
Monkey!

**Title**
Video series

**Client**
Fabulous Films

**Year**
2000

Opposite page:

**Project**
Left: Event banner
Right: Title sequence

**Title**
design in business week
2001

**Client**
Design Council

**Year**
2001

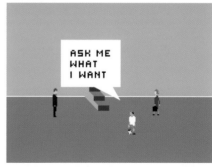

# Tina Frank

## "I want you to fall into my pictures and stay with them for some time."

Opposite page:

**Project**
CD Sleeve for MEGO 035:
Endless Summer, by
Christian Fennesz

**Title**
Endless Summer

**Client**
Mego

**Year**
2001

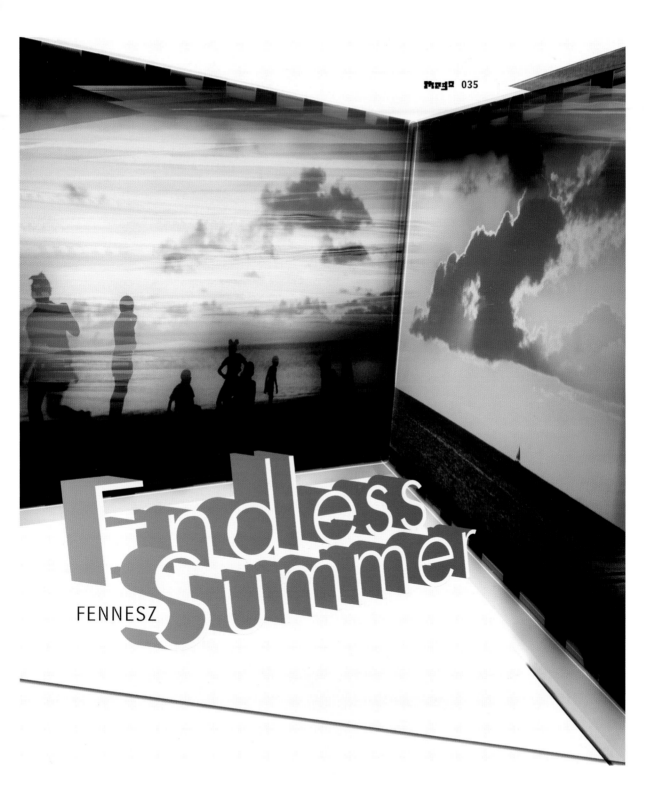

"It will be a 'wow' and a 'zoom', some things going fast, other things really slow. Design will become sound and sound will become design. Design will become anything and everything will become design. Even no-design will be designed. The public nowadays is already much more aware of graphic design than – lets say some 20 years ago. Even the regular school kid already knows the hipster-advantage of the perfect cool logo on their mobile telephones. Design will be needed in even more spaces, places we haven't yet thought about. We will be bombarded with moving design on every little street corner. What the poster-advertisements on the street are now will become big screens with flying pixels. Websites built to function as posters on the streets and used as starting points for the daily soap opera. I don't know yet if I will like it."

» Es wird ›wow‹ machen und ›zoom‹, manche Dinge werden superschnell sein, andere wieder richtig langsam. Design wird zu Sound und Sound wird zu Design. Design wird Nichts werden und alles wird zu Design. Selbst ›non-designte‹-Dinge werden absichtlich so entworfen. Die Öffentlichkeit ist heutzutage bereits viel aufmerksamer auf Design als – sagen wir – vor 20 Jahren. Selbst ein Schulkind kennt bereits den Hipster-Vorsprung, den Coolness-Faktor beim richtigen Logo am Display des eigenen Mobiltelefons. Design wird an immer mehr Stellen benötigt, an Plätzen, an die wir vorher noch gar nicht gedacht haben. Wir werden bombardiert werden mit bewegtem Design an jeder Straßenecke. Was heute die Straßenposter sind, werden in Zukunft riesige Bildschirme mit fliegenden Pixeln sein. Webseiten gebaut als Poster auf der Straße, als Startpunkte für die tägliche Seifenoper. Keine Ahnung, ob mir das gefallen wird …«

« Ce sera un ‹Hou la la!› et un ‹Zoom!›, certaines choses allant vite, d'autres très lentement. La création graphique deviendra sonore et le son deviendra graphique. Le graphisme deviendra tout, et n'importe quoi deviendra du graphisme. Même le non graphisme sera soumis au graphisme. Aujourd'hui, le public est déjà beaucoup plus au fait qu'il y a une vingtaine d'années. L'écolier lambda est déjà conscient de l'image qu'apporte le logo parfaitement cool de son portable. Le graphisme s'imposera dans plus d'espaces, dans des lieux auxquels nous n'avons pas encore pensé. A chaque coin de rue, nous serons bombardés par des graphismes animés. Les grandes affiches d'aujourd'hui seront remplacées par des écrans géants aux pixels volants. Des pages web seront conçues comme des affiches de rue et serviront de points de départ à des feuilletons à l'eau de rose quotidiens. Je ne sais pas encore si ça me plaira beaucoup. »

**Tina Frank**
designby frank/scheikl
Mayerhofgasse 20/6
1040 Vienna
Austria

T +43 1 505 60 66

E hello@frank.at

www.frank.at

**Biography**
1970 Born in Tulln, Austria
1989–1992 Studied Design at the Graphische Lehr- und Versuchsanstalt, Vienna

**Professional experience**
1992–1993 Designer, MetaDesign, Berlin
1994 Designer, Nofrontiere, Vienna
1995 Started own studio Inwirements Tina Frank, Vienna
1995 Co-founder and Art Director, U.R.L. Agentur für Informationsdesign GmbH, Vienna
1997 Co-founder, Skot (videoband), Vienna
1999 Co-founder, Lanolin (label dedicated to visual experiments)
2000 Co-founder, U.R.L., Berlin

**Clients**
Blumenkraft [TM]
Ellert Fotografie
design now austria
FontShop Austria
FontShop Germany
idea records
Kunstnet Austria
Mego / M.DOS / M.DBS
Mica (Music Information Center Austria)
Scope
UMG Germany
Zoom Kindermuseum

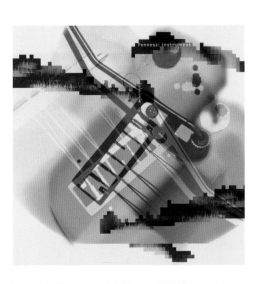

**Project**
LP Sleeve for MEGO 004: instrument, by Christian Fennesz

**Title**
instrument

**Client**
Mego

**Year**
1995

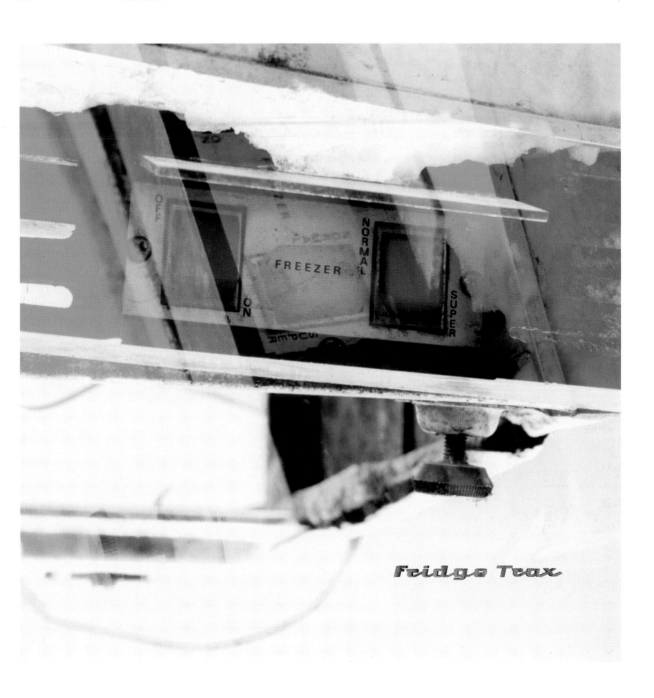

**Project**
LP Sleeve for MEGO 001:
fridge trax, by General
Magic & Pita

**Title**
fridge trax

**Client**
Mego

**Year**
1995

photos by Ilpo Väisänen
cover by Tina Frank

WWW.MEGO.AT
© MEGO 2001

**Project**
CD Sleeve for MEGO 037:
asuma, by Ilpo Väisänen

**Title**
asuma

**Client**
Mego

**Year**
2001

Ilpo Väisänen: **Asuma**

**mego** 037

mego 037

Asuma
Ilpo Väisänen

# Vince Frost

## "Love It!"

Opposite page:

**Project**
CSD Lecture poster

**Title**
Frost lecture tour poster

**Client**
Charter Society of Design

**Year**
1999

VINCE FROST
MARCH 1999
CSD VOICEBOX LECTURES
2-CALEDONIAN UNIVERSITY,
GLASGOW. 3-SALFORD.
UNIVERSITY, MANCHESTER.
4-FROST DESIGN LONDON.
TICKETS 0171 831 9777 ADMISSION 7PM
MEMBERS £6 NONMEMBERS £8 STUDENTS £4-50
SPONSORED BY HOUSE OF NAYLOR, ARTOMATIC & PHOTONICA

"Our guiding principle at Frost Design is that we never let anything bland or recessive out the door. We accept that our work has to fight for attention amid a daily onslaught of media messages. Of course our work has to communicate the right proposition, be relevant to the target audience and use cost-effective media. That's taken as read. But above all, it has to get noticed. It must have impact. We create work that demands to be seen."

» Unser Prinzip bei Frost Design ist es, niemals etwas Langweiliges oder Rückschrittliches aus dem Haus zu lassen. Wir akzeptieren, dass wir darum kämpfen müssen, unserer Arbeit im Wust der täglich durch diverse Medien vermittelten Informationen Beachtung zu verschaffen. Natürlich müssen unsere Projekte die richtigen Angebote machen, die Zielgruppe tatsächlich ansprechen und kosteneffiziente Mittel einsetzen. Das wird vorausgesetzt. Vor allem aber müssen sie bemerkt werden, Wirkung zeigen. Unsere Entwürfe wollen gesehen werden.«

« Chez Frost Design, nous avons pour principe de ne jamais laisser sortir de nos bureaux quelque chose de neutre ou de récessif. Nous sommes conscients que notre travail doit s'efforcer de retenir l'attention dans un déluge permanent de messages médiatiques. Naturellement, il doit communiquer la bonne proposition, avoir un sens pour le public ciblé et être rentable. Cela paraît évident. Mais avant tout, il doit se faire remarquer. Il doit avoir un impact. Nous créons des travaux qui exigent d'être vus. »

**Vince Frost**
Frost Design
The Gymnasium
56, Kingsway Place
Sans Walk
London EC1R OLU
UK

T +44 20 7490 7994
F +44 20 7490 7995

E info@frostdesign.co.uk

www.frostdesign.co.uk

**Design group history**
1994 Founded by Vince Frost in London

**Founder's biography**
Vince Frost
1964 Born in Brighton, England
1965 Spent 16 years in Canada
1981 Graphic Design, West Sussex College of Design
1988 Freelance designer, Howard Brown and Pentagram, London
1989 Joined Pentagram on full-time basis
1992 Associate, Pentagram, London
1994 Founded Frost Design, London
1995 Art Director, The Saturday Independent Magazine, London
1996 Elected Fellow Chartered Society of Designers (FCSD)
2001 Art Director, Laurence King Publishing, London; Bath University Lecture; Design Indaba Lecture, Cape Town, South Africa; D&AD Awards Judging, Brighton; LAUS Awards Judging, Barcelona; University of Delaware, Newark, Delaware; ISTD Awards Judging; D&AD Lecture New Blood; Design Indaba Workshop Series 1 'A Frosty Day In Durban'; Design Indaba Workshop Series 2 'A Frosty Day In Cape Town'
2002 ICAD Judging Ireland; AIGA Lecture, Washington, DC; AGDA (Australian Graphics Design Association); 'A Frosty Day Down Under' 7 City's Sydney, Canberra, Brisbane, Hobart, Adelaide and Perth; University of Delaware, Newark, Delaware; The Typographic Circle @ RIBA; Elected AGI Member

**Recent awards**
1997 Merit Award (x4) and Distinctive Merit Award, Art Directors Club (ADC), 76th Annual Awards; Bronze, VK Paper Honour for the Best Typography and Silver, Typeworks Honour for Best Typography, Creative Circle; Shortlisted for Graphic Designer of the Year, BBC Design Awards; Merit (x3), D&AD Awards; Graphis Awards (x2); Distinctive Merit and Merit, New York Art Directors Club
1998 Merit (x4) and Silver Nomination, D&AD Awards
1999 Tokyo Type Director's Club award, TDC Annual; Merit Award, Art Directors Club (ADC), 78th Annual Awards; Highly Commended, The 10th Design Week Awards; Certificate of Excellence (x6), European Design Annual
2000 17th International Poster Biennale, Warsaw; Distinction Award, Art Directors Club (ADC), 79th Annual Awards; Winner, The 11th Design Week Awards; Highly Commended, The 11th Design Week Awards; Merit Award, Society of Publication Designers (SPD), USA; Certificate of Excellence (x3), European Design Annual
2001 Graphis Letterhead 5 (x2); D&AD Annual (x2), Silver nominated for D&AD Typography for Advertising; Elected Member ISTD
2002 Graphis Annual (x4)

**Clients**
400 Films
4th Estate Publishing
Architecture Association
Arts Foundation
Burnham Niker
Cicada
Clarks
D&AD
Design Council
Douglas and Jones
Faber and Faber
Financial Times
Fusion
Glassworks
Great Eastern Dining Rooms
Independent
News International
Nike
Nokia
Laurence King Publishing
LIFT
Phaidon Press
Photonica
Polaroid
Polydor
Poole Pottery
Rotovision
Royal Mail
Sony
Serpentine Gallery
Thunderchild
Time Inc
Victoria & Albert Museum
Verdant
Violette Publishing
Virgin Records
Wapping Project

**Project**
Identity and Signage for
joint exhibition between
the Victoria & Albert
Museum and Serpentine
Gallery

**Title**
Give & Take

**Client**
Victoria & Albert Museum /
Serpentine Gallery

**Year**
2000

**Project**
Poster

**Title**
LIFT 01

**Client**
London International
Festival of Theatre

**Year**
2000

**Project**
Photonica European
Catalogue

**Title**
Photonica E 43

**Client**
Photonica

**Year**
1999

# Gabor Palotai Design

"Design is ▬▬▬▬▬▬▬▬
▬▬▬▬▬▬▬▬▬▬
▬▬▬▬▬▬▬"

Opposite page:

**Project**
Poster

**Title**
Illustratörsboken 2000

**Client**
Arvinius Förlag

**Year**
2000

illustratörsboken 2000 arvinius förlag

"Design is ▬▬▬▬▬        » Design ist ▬▬▬▬▬        « Le design est ▬▬▬▬▬

**Gabor Palotai Design**
Västerlångatan 76
11129 Stockholm
Sweden

T +46 8 248818
F +46 8 248819

E design@
  gaborpalotai.com

www.gaborpalotai.com

**Biography**
1956 Born in Budapest
1975–80 National
Academy of Arts, Crafts
and Design in Budapest
(MA)
1981 Moved permanently
to Stockholm
1981–83 The Royal
Swedish Academy of Fine
Arts, Stockholm
1982–83 Beckmans
School of Design,
Stockholm

**Professional experience**
1983–1990 Art Director
and graphic designer for
advertising agencies
1988 Established Gabor
Palotai Design
1991–2001 Guest profes-
sor in different design
schools in Stockholm

**Recent exhibitions**
1983–2001 Participation
in a number of design
exhibitions, e. g. in
Stockholm, Berlin,
London, Gothenburg,
Malmö etc.
One man exhibitions in
Stockholm, Gothenburg,
Helsinki, Paris, Budapest

**Recent awards**
1984–2001 Excellent
Swedish Design Awards
(x18), Stockholm
1987–2001 Received
numerous other awards
including The Golden Egg
Awards and nominations
by the Swedish Advertis-
ing Federation
1984–2001 Five working
scholarships, Arts Grants
Committee, Stockholm

**Clients**
Consulting on a broad
range of design projects.
During many years as a
graphic designer made
works for most of the
biggest Swedish com-
panies. Works also in the
field of experimental
photography and textile
design.

**Project**
Book about illustrators

**Title**
Illustrations for Arvinius
Förlag

**Client**
Arvinius Förlag

**Year**
2000

**Project**
Maximizing the audience
(bookjacket). Gabor
Palotai Graphic Designer
Works 85–2000

**Title**
Maximizing the audience

**Client**
Self-published

**Year**
2000

**Project**
Maximizing the audience
(details from the book).
Gabor Palotai Graphic
Designer
Works 85–2000

**Title**
Maximizing the audience

**Client**
Self-published

**Year**
2000

# James Goggin

"Hand-made, lost-found, multi-coloured, faux-naïf, simple-abstract, content-driven."

Opposite page:

**Project**
Screen-print

**Title**
Golden Boxes

**Client**
Self-published

**Year**
2002

"It should be remembered that graphic design, in comparison to contemporary art or architecture for example, is still a largely invisible discipline to the general public. Fashion and architecture are self-explanatory in terms of their presence in everyday society, whereas graphic design frequently occupies an area of transparency: when looking at a sign, reading a book or opening a milk carton, its purpose is primarily that of a conduit, transmitting information between content and user. Designers who combine this functional latency with a bold, thoughtful, playful and at times cryptic (even subversive) aesthetic have the most success by not only informing the audience, but also engaging them – making them read between the lines. While the work of graphic designers will continue to achieve ever-increasing visibility – particularly through multi-disciplinary practice in the realms of fashion, film, music and internet – whether or not it's actually recognised as graphic design is another story."

» Man darf nicht vergessen, dass die Arbeit der Grafiker im Gegensatz etwa zur zeitgenössischen bildenden Kunst oder Architektur von der breiten Öffentlichkeit kaum wahrgenommen wird. Mode und Architektur erklären sich selbst, weil sie uns alltäglich begegnen und umgeben, während die Erzeugnisse der Grafiker häufig gewissermaßen unsichtbar sind: Wenn die Menschen ein Schild sehen, ein Buch lesen oder eine Milchtüte öffnen, dann fungieren diese Dinge vor allem als Medium, das dem Benutzer Informationen über den Inhalt vermittelt. Designer, die diese funktionelle Latenz mit kühner, durchdachter, spielerischer und mitunter rätselhafter (ja sogar subversiver) Ästhetik kombinieren, sind deshalb am erfolgreichsten, weil sie das Publikum nicht nur informieren, sondern auch mental beanspruchen – es zwischen den Zeilen lesen lassen. Die Arbeit der Grafikdesigner wird sich auch weiterhin zunehmend bemerkbar machen – besonders durch fachübergreifende Projekte in den Bereichen Mode, Film, Musik und Internet –, ob das dann aber noch als Grafikdesign aufgefasst wird, steht auf einem anderen Blatt.«

« Il faut se souvenir que le graphisme, comparé à l'art contemporain ou à l'architecture notamment, est une discipline encore largement inconnue du grand public. La mode et l'architecture s'expliquent d'elles-mêmes par leur présence quotidienne dans la société, alors que la création graphique occupe fréquemment une zone de transparence : quand on regarde un panneau de signalisation, qu'on lit un livre ou qu'on ouvre une brique de lait, elle sert avant tout de vecteur, transmettant l'information entre le contenu et l'utilisateur. Les graphistes qui conjuguent cette latence fonctionnelle avec une esthétique audacieuse, réfléchie, ludique et parfois cryptique (voire subversive) sont ceux qui réussissent le mieux, non seulement à informer le public, mais également à le séduire, à lui faire lire entre les lignes. Si le travail des graphistes continue à être de plus en plus visible, notamment à travers des pratiques multidisciplinaires dans les domaines de la mode, du cinéma, de la musique et de l'internet, cela ne signifie pas pour autant qu'il soit forcément reconnu en tant que création graphique. »

**James Goggin**
Practise
84 Teesdale Street
London E2 6PU
UK

T/F +44 20 7739 8934

E james@practise.co.uk

www.practise.co.uk
www.all-weather.org

**Biography**
1975 Born in Tamworth, Australia
1994–1997 BA (Hons) Visual Communication, Ravensbourne College of Design and Communication, London
1997–1999 MA Graphic Design, Royal College of Art, London

**Professional experience**
1999 Established own studio "Practise" in London
1999–2000 Lectured and organized workshops in the UK and Switzerland
2000 Started clothing label in collaboration with his wife, Shan, under the name "Shan James"
2001 Both "Practise" and "Shan James" moved to Auckland, New Zealand, for one year. Continued working in UK, Europe and Japan
2002 Founded clothing label "All Weather", making screen-printed T-shirts and sweatshirts

**Recent exhibitions**
1999 "A Grand Design", Victoria & Albert Museum, London
2001 "Inside Out", Kiasma Museum of Contemporary Art, Helsinki
2001 "Favourite Things", Hat on Wall Gallery, London

**Recent awards**
1998 National Magazine Company Award
1999 Royal College of Art/Penguin Book Essay Prize

**Clients**
Anthony d'Offay Gallery
Book Works
Booth-Clibborn Editions
Browns Focus
Channel 4
Concrete PR/Concrete Shop
Fallon (London)
fig-1
Helen Hamlyn Research Centre
Lineto
Preen
Random House
Routledge
Royal College of Art
Shan James
Victoria & Albert Museum
ZOO

**Project**
Screen-printed cotton T-shirt, Spring/Summer 2002 collection

**Title**
Air T-shirt

**Client**
Shan James

**Year**
2001

Opposite page:

**Project**
Screen-printed T-shirts + sweatshirts

**Title**
All Weather

**Client**
Self-published

**Year**
2001/2002

**Project**
Website

**Title**
practise.co.uk

**Client**
Self-published

**Year**
2001

**Project**
Website

**Title**
practise.co.uk

**Client**
Self-published

**Year**
2001

# April Greiman

## "No prophecy here."

Opposite page:

**Project**
Selby Gallery Poster

**Title**
"Objects in Space," Selby
Gallery, Ringling School
of Art

**Client**
Selby Gallery

**Year**
1999

"I believe that all designers come to a task with a unique way of ordering that is particular to their past experiences, and perhaps even their genetic structure. As a student I became aware of these tendencies, and began to trust and develop them. Ideas, hunches and personal visualizations result from that integration of mind and body. Intuition is a kind of non-thinking that cuts through socialization, and is therefore our highest form of intelligence."

» Meiner Meinung nach macht sich jeder Grafiker an die Lösung einer Aufgabe, indem er sie als Erstes je nach Berufs- und Lebenserfahrung und vielleicht sogar Veranlagung nach einem bestimmten System ordnet. Das habe ich schon während des Studiums beobachtet und verfolge und entwickle jetzt selbst diese Instinkte. Einfälle, Eingebungen und persönliche Bilder kommen aus der Einheit von Geist und Körper. Intuition als eine Art des Nicht-Denkens ist unabhängig von der Sozialisation und daher die höchste Form von Intelligenz.«

« Chaque graphiste a sa manière unique d'organiser ses nouvelles missions en fonction de son expérience et, peut-être même, de sa structure génétique. Je m'en suis rendue compte quand j'étais étudiante. J'ai alors appris à me fier et à développer ces tendances. Les idées, les intuitions et les visualisations personnelles découlent de cette intégration de l'esprit et du corps. En tant que ‹non pensée› échappant à la socialisation, l'intuition est notre forme d'intelligence la plus élevée. »

**April Greiman**
Made in Space
620 Moulton Avenue
Suite #211
Los Angeles
CA 90031
USA

T +1 323 227 1222
F +1 323 227 8651

E info@madeinspace.la

www.madeinspace.la

**Biography**
1948 Born in Rockville Center, New York
1966–1970 BFA, Major in Graphic Design, Minor in Ceramics, Kansas City Art Institute, Kansas City, Missouri
1970–1971 Studied Graphic Design under Wolfgang Weingart and Armin Hofmann, Allgemeine Kunstgewerbeschule, Basle, Switzerland

**Professional experience**
1971–1976 Assistant Professor, Philadelphia College of Art
1972–1976 Freelance work in New York City
1974–1975 Anspach, Grossman & Portugal;
1975–1976 Consultant to the Museum of Modern Art with Emilio Ambasz (Curator of Design)
1976 Moved to Los Angeles, California;
1977 Established own design office, April Greiman
1982–1984 Director of Design Department, California Institute of the Arts
1990 Published "Hybrid Imagery: The Fusion of Technology and Graphic Design"
1994 Published "It's notwhatAprilyouthinkItGreimanIs," Arc en Rêve, Artemus Publishers;
1995 19th Amendment Commemorative Stamp, US Postal Service Commission
1998 Published, "April Greiman: Floating Ideas into Time and Space", Ivy Press, Watson-Guptill Publications
2001 Published "Something from Nothing" Rotovision Publisher
2002 April forms new "trans-media" design firm, April Greiman / Made in Space

**Recent exhibitions**
1986 "April Greiman, One Woman Show", Reinhold/Brown Gallery, New York
1987 "April Greiman: Large Scale Posters", touring one-woman exhibition; Pacific Wave, Fortuny Museum, Venice
1988 "The Modern Poster", Museum of Modern Art, New York
1989 "April Greiman", Israel Museum, Jerusalem; One Woman Show, Turner Dailey Gallery, Los Angeles; "Design USA", United States Information Agency – touring exhibition USSR; "The Decade of the Eighties", Western Carolina University
1989–1990 "Graphic Design in America", travelling exhibition, Walker Art Center – Minneapolis, New York City and London
1991 "The International Poster Exhibition", Tel Aviv Museum of Art
1992 "Redroto", Yokohama Creation Center, Japan
1994 "It'snotwhatAprilyouthinkitGreimanis", One-Woman Show, Arc en Rêve Centre d'Architecture Bordeaux, France
1996 "And She Told Two Friends", Woman-Made Gallery, Chicago
1998 "Posters American Style", National Museum of American Art / Smithsonian Institution
2001 "Hybrid Imagery: The Fusion of Technology and Graphic Design", Eisner Museum of Advertising and Design, Milwaukee
2002 "USDesign 1975–2000", Denver Art Museum, Denver, Colorado

**Awards**
1987 Grant Winner, Computer Graphic Studies, National Endowment of the Arts; Winner, UNESCO Competition, Design Quarterly #133
1988 Winner, "The Modern Poster" Competition, The Museum of Modern Art, New York; Grand Prize, 1st "Macintosh Masters Art" contest, Mac World
1990 Award, Fashion Group International, "Look West," Los Angeles
1993 Bronze Medal, Stiftung Buchkunst, Frankfurt Book Fair; "From the Center", Southern California Institute of Architecture (Sci-Arc)
1998 Medalist, American Institute of Graphic Arts (AIGA); Chrysler Award for Innovation
2000 Finalist, 1st National Design Award, Communication Design
2001 Star of Design, Pacific Design Center, Los Angeles; Kansas City Art Institute, Honorary Doctorate
2002 Lesley University, Art Institute of Boston, Honorary Doctorate

**Clients**
Amgen
@Schindler House
AOL / Time Warner
California Institute of the Arts
Coyuchi
Davis Polk & Wardwell
Experience Music Project
General Dynamics
Johnson Fain Architects
Knoll, Group Design
La Jolla Playhouse
MAK Center
PacTel
Quarterdeck
Roto Architects
Samitaur Constructs
Sears
Southern California Institute of Architecture
US West
Vitra International
Xerox

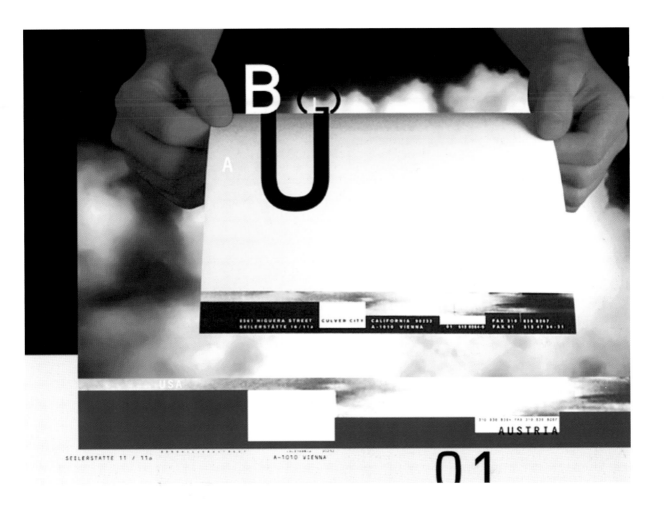

**Project**
Logo and Identity System

**Title**
Letterhead,
Coop Himmelb(l)au

**Client**
Coop Himmelb(l)au
Architects, Vienna and
Los Angeles

**Year**
1990

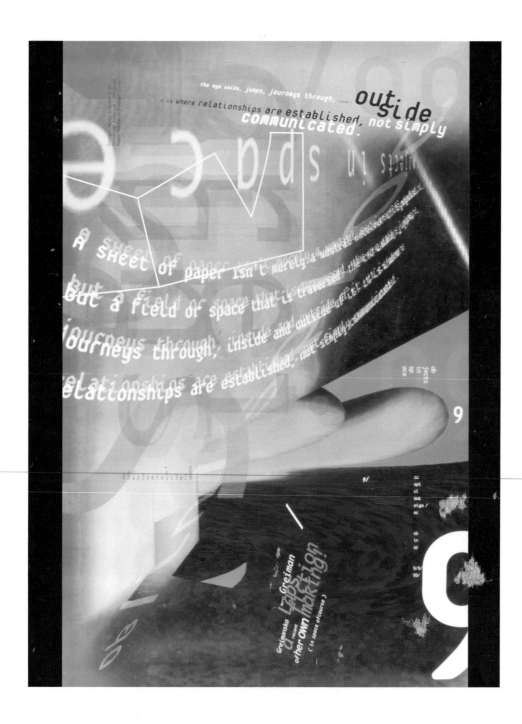

**Project**
AIGA Poster

**Title**
Objects In Space

**Client**
AIGA / Orange County,
California

**Year**
1999

Opposite page:

**Project**
Exterior Signage

**Title**
Main Exterior Signage

**Client**
Southern California
Institute of Architecture
(Sci-Arc)

**Year**
1994

# Fernando Gutiérrez

"It all begins with an idea (ideas make money: money doesn't make ideas) and you respond to that idea, using your knowledge to present it in the most seductive, engaging manner possible."

Opposite page:

**Project**
Magazine cover design

**Title**
Matador Volume E

**Client**
Matador / La Fabrica

**Year**
2000

# MATADOR

Volumen E  7.500 Ptas.   45 Euros          Revista de Cultura, Ideas y Tendencias  1995-2022

"There are more design students and more designers than ever. There are more magazines than ever. More access to information than ever. And more information to decipher than ever. Craft and vocation are being left behind. Good design will prevail, but the amount of bad design is over- whelming. We shouldn't be misled. The struggle continues."

» Es gibt heute mehr Grafikstudenten und Grafiker als je zuvor. Mehr Zeit- schriften als je zuvor. Leichteren Zugang zu Informationen als je zuvor. Und mehr zu entschlüsselnde Infor- mationen als je zuvor. Handwerk und Berufung werden vernachlässigt. Gutes Design wird sich durchsetzen, aber die Menge von schlechtem Design ist überwältigend. Wir sollten uns nicht in die Irre führen lassen. Der Kampf geht weiter.«

« Il n'y a jamais eu autant de créateurs et d'étudiants graphistes. Il n'y a jamais eu autant de publications. Jamais l'information n'a été aussi accessible et il n'y a jamais eu autant d'informations à déchiffrer. L'artisanat et la vocation restent sur la touche. La bonne création perdurera mais on est submergé par des réalisations médiocres. Ne nous égarons pas. Le combat continue. »

**Fernando Gutiérrez**
Pentagram Ltd.
11 Needham Road
London W11 2RP
UK

T +44 20 7229 3477
F +44 20 7727 9932

E email@pentagram.co.uk

www.pentagram.co.uk

**Biography**
1963 Born in London
1983–1986 BA Graphic Design, London College of Printing

**Professional experience**
1986–1992 Graphic designer, CDT Design, London
1990 Graphic designer, Summa, Barcelona
1991 Associate, CDT Design, London
1993–2000 Co-founding partner of Grafica, Barcelona
2000 Became a partner of Pentagram

**Recent awards**
2001 New York Art Directors Club Silver Award, Colors magazine

**Clients**
Colors
Hermes
El Pais
EPS magazine
La Compania de Vinos
Matador
Phaidon Press
Reina Sofia
Telmo Rodriguez
Tentaciones
The Friday Supplement
Vanidad

**Project**
Editorial

**Title**
Tentaciones

**Client**
El Pais

**Year**
1994–the present

**Project**
Magazine cover design

**Title**
Vanidad

**Client**
Vanidad

**Year**
1998

**Project**
Magazine cover design

**Title**
Colors – pictured: issue 43

**Client**
Benetton Group Spa /
La Fabrica

**Year**
2000–the present

**Clarice Lispector**

"Brasília: cinco días"

## Brasília: cinco dias

Olho Brasília como olho Roma: Brasília começou como uma simplificação final de ruínas. A hera ainda não cresceu.

– Além do vento há uma outra coisa que sopra. Só se reconhece na crispação sobre-natural do lago.

– Em qualquer lugar onde se está de pé, criança pode cair, e para fora do mundo. Brasília fica à beira.

– Se eu morasse aqui, deixaria meus cabelos crescerem até o chão.

– Brasília é de um passado esplendoroso que já não existe mais. [...] Também a minha insônia teria criado esta paz do nunca. Também eu, como êles dois que são monges, medi-taria nesse deserto. Onde não há lugar para as tentações. Mas vejo ao longe urubus sobrevoando. O que estará morrendo, meu Deus?

– Não chorei nenhuma vez em Brasília. Não tinha lugar.

– É uma praia sem mar.

– Em Brasília não há por onde entrar, nem há por onde sair. [...] De noite estendi meu rosto para o silêncio. Sei que há uma hora incógnita em que o maná desce e umedece as terras de Brasília

– Por mais perto que se esteja, tudo aqui é visto de longe. Não encontrei um modo de tocar. Mas pelo menos essa vantagem a meu favor: antes de chegar aqui, eu já sabia como tocar de longe. [...] De minha insônia olho pela janela do hotel às três horas da madrugada. Brasília é a paisagem da insônia. Nunca adormece.

– Aqui o ser orgânico não se deteriora. Petrifica-se.

– Eu queria ver espalhadas por Brasília quinhentas mil águias do mais negro ônix.

– Brasília é assexuada.

– O primeiro instante de ver é como certo instante da embriaguez: os pés que não tocam na terra.

– Como a gente respira fundo em Brasília. Quem respira, começa a querer. E querer, é que não pode. [...] Eu sei o que os dois quiseram: a lentidão e o silêncio. Os dois criaram também é a idéia que faço da eternidade. Os dois criaram o retrato de uma cidade eterna.

– Há alguma coisa aqui que me dá mêdo. Quando eu descobrir o que me assusta, sabe-rei também o que amo aqui. O mêdo sempre me guiou para o que eu quero; e, porque eu quero, temo. Muitas vêzes foi o mêdo quem me tomou pela mão e me levou. O mêdo me leva ao perigo. E tudo o que eu amo é arriscado.

– Em Brasília estão as crateras da Lua.

– A beleza de Brasília são as suas estátuas invisíveis.

**Italo Calvino**

As cidades invisíveis, São Paulo: Companhia das Letras, 1993, pp. 53-54, trad. Diogo Mainardi (primera edición 1972).

## As cidades e os olhos 1

Os antigos construíram Valdara à beira de um lago com casa repletas de varandas sobre-postas e com ruas suspensas sobre a água desembocando em parapeitos balaustrados. Deste modo, o viajante ao chegar depara-se com duas cidades: uma perpendicular sobre o lago e a outra refletida de cabeça para baixo. Nada existe e nada acontece na primei-ra Valdrada sem que se repita na segunda, porque a cidade foi construída de tal modo que cada um de seus pontos fosse refletido por seu espelho, e a Valdrada na água con-tém não somente todas as acanaladuras e relevos das fachadas que se elevam sobre o lago mas também o interior das salas com os tetos e os pavimentos, a perspectiva dos corredores, os espelhos dos armários.

Os habitantes de Valdrada sabem que todos os seus atos são simultaneamente aque-le ato e a sua imagem especular, que possui a especial dignidade das imagens, e essa consciência impede-os de abandonar-se ao acaso e ao esquecimento mesmo que por um único instante. Quando os amantes com os corpos nus rolam pele contra pele à procu-ra da posição mais prazerosa ou quando os assassinos enfiam a faca nas veias escu-ras do pescoço e quanto mais a lâmina desliza entre os tendões mais o sangue escorre, o que importa não é tanto o acasalamento ou o degolamento mas o acasalamento e o degolamento de suas imagens límpidas e frias no espelho.

Às vezes o espelho aumenta o valor das coisas, às vezes anula. Nem tudo o que pare-ce valer acima do espelho resiste a si próprio refletido no espelho. As duas cidades gêmeas não são iguais, porque nada do que acontece em Valdara é simétrico: para cada face ou gesto, há uma face ou gesto correspondente invertido ponto por ponto no espe-lho. As duas Valdradas vivem uma para a outra, olhando-se nos olhos continuamente, mas sem se amar.

**Project**
Exhibition catalogue

**Title**
F[r]icciones

**Client**
Aldeasa / Museo Nacional
Centro de Arte Reina
Sofia, Madrid

**Year**
2000

# Ippei Gyoubu

## "Coexistence of the bright and dark sides."

Opposite page:

**Project**
Event flyer

**Title**
Camou

**Client**
Camou

**Year**
2001

"I consider graphic design to be 'all things'. I think that the point of calling it graphic design will become nonsense, and that the obstacle of the name will be lost from now on. This means graphic design will become 'natural'. Graphic design is not a sublime thing, but probably has already reached the stage where it has transcended the wall which is not visible to all eyes, and has formed a still newer form. And it will continue expanding from now on, because graphic design is 'all things'."

»Für mich ist Grafikdesign allumfassend. Irgendwann wird man an den Punkt kommen, denke ich, an dem die Bezeichnung unsinnig geworden ist und keine Einschränkung mehr bildet. Das heißt, grafisches Gestalten wird ›natürlich‹, selbstverständlich sein. Die Gebrauchsgrafik schwebt keinesfalls in höheren Sphären, hat aber dennoch vermutlich ein Stadium erreicht, in dem sie die nicht für alle sichtbare Fachgrenze bereits überschritten und eine noch aktuellere Ausprägung gebildet hat. Das Grafikdesign wird von jetzt an expandieren, eben weil es allumfassend ist.«

«Je considère la création graphique comme toutes choses». Le fait de l'appeler graphisme n'aura plus de sens et l'obstacle que représente ce nom sera oublié. En d'autres termes, le graphisme deviendra ‹naturel›. La discipline en soi n'a rien de sublime, mais elle a probablement déjà franchi le cap où elle a transcendé ce mur que tout le monde ne peut pas voir pour revêtir une forme encore plus nouvelle. Elle continuera à s'étendre parce que le graphisme est ‹toutes choses›».

**Ippei Gyoubu**
3–40–22–201 Esaka chou
Suita city
Osaka 564–0063
Japan

T/F +81 6 6821 0710

E ippeix@
   ga3.so-net.ne.jp

www001.upp.so-
net.ne.jp/ippei_gyoubu/

**Biography**
1974 Born in Japan
1989 Art high school
1992 Kobe Design
University Art College

**Professional experience**
1996–2001 Character
designer, SNK (Japanese
video game company)
2001 Began working as a
freelance designer

**Clients**
Bijutsu Shuppan-Sha
Knee High Media Japan

**Project**
Character from comic
strip "MAMMOTH"
magazine

**Title**
The SPANKY

**Client**
Knee High Media Japan

**Year**
2001

Opposite page:

**Project**
Comic strip

**Title**
planet of the fusion

**Client**
Bijutsu Shuppan-Sha

**Year**
2001

**Project**
Illustration for Comickers
magazine

**Title**
Marshmallow

**Client**
Bijutsu Shuppan-Sha

**Year**
2001

# Hahn Smith Design Inc.

## "No rabbits, no hats."

Opposite page:

**Project**
Exhibition catalogue

**Title**
Arnaud Maggs: Works
1976–1999

**Client**
The Power Plant
Contemporary Art Gallery

**Year**
1999

"The best work will always be teamwork. A great game of tennis or hockey is between two skill sets. Design is always at its best when there are challenges and responses, whether it is between the client and designer, writer and designer, designer and artist, or a collaboration between designers. As exciting as the opportunities are that new technology create – and the speed and reach that are now possible – it always comes down to vision and content which will make good work endure. Good design should always consider the way we live and the broadest possible context. We're not sages, we're just trying to do the best we can, to add something to the world, and to earn a decent living."

» Die besten Lösungen entstehen immer als Gemeinschaftsarbeiten. Ein tolles Tennis- oder Hockeymatch ergibt sich aus dem Zusammenspiel von Könnern. Design ist immer dann am besten, wenn es sich Herausforderungen stellt, gleichgültig, ob diese aus dem Zusammentreffen von Auftraggebern und Designern, Autoren und Designern, Künstlern und Designern oder Designern untereinander entstehen. So spannend die von der neuen Technologie gebotenen Möglichkeiten mit ihrer Geschwindigkeit und Reichweite auch sind, letzten Endes kommt es auf die Idee und den Inhalt an, um einer guten Arbeit dauerhaften Wert zu verleihen. Gutes Design sollte immer unsere Lebensart und einen möglichst umfassenden Kontext berücksichtigen. Wir sind keine Weisen, wir versuchen nur unser Bestes zu tun, einen Beitrag zu leisten und genug Geld zu verdienen, um gut zu leben.«

« Les meilleures réalisations seront toujours des travaux d'équipe, comme un beau match de tennis ou de hockey nécessite d'opposer deux équipes compétentes. La création graphique est toujours plus performante lorsqu'il y a des défis et des réponses, que cela se passe entre le client et le créateur, le rédacteur et le créateur, le créateur et l'artiste ou au sein d'une collaboration entre graphistes. Aussi excitantes que soient les possibilités créées par les nouvelles technologies – ainsi que leur vitesse et leur portée – on en revient toujours à la vision et au contenu qui font qu'un bon travail tient la route ou pas. Le bon graphisme devrait toujours prendre en compte la manière dont on vit et le contexte le plus large possible. Nous ne sommes pas des sages, nous essayons simplement de faire de notre mieux, d'apporter quelque chose au monde et de gagner convenablement notre vie. »

**Hahn Smith Design Inc.**
398 Adelaide Street West, Suite 1007
Toronto
Ontario M5V 1S7
Canada

T +1 416 504 8833
F +1 416 504 8444

E studio@ hahnsmithdesign.com

**Design group history**
1995 Founded by Alison Hahn and Nigel Smith in Toronto

**Founders' biographies**
Alison Hahn
1957 Born in Toronto
1981–1985 BFA, Art History and Textile Design, Nova Scotia College of Art and Design, Halifax, Canada
Nigel Smith
1962 Born in Toronto
1981–1984 Fine Art and Graphic Design, Ontario College of Art, Toronto

**Recent exhibitions**
1998 "AIGA 50 Books Awards", New York;
"i-D magazine – Annual Design Review", New York
1999 "100 Show", American Center for Design, Chicago
2000 "Design Effectiveness Award", Toronto
2001 "National Post/Design Exchange Awards", Toronto
2002 "AIGA 50 Books Awards", New York

**Recent awards**
1997–1999 Nominated annually for the Chrysler Awards
1998 Ontario Association of Art Galleries Award; AIGA 50 Books Award; Advertising and Design Club of Canada Award; American Association of Museums, Publications Design Competition; I.D. magazine – Annual Design Review
1999 Design Effectiveness Awards – Finalist; Design Effectiveness Awards – Silver; 100 Show – American Center for Design
2000 Presidential Design Awards; Design Effectiveness Awards; Alcuin Society Award for Excellence in Book Design
2001 National Post – Design Exchange Awards; Ontario Association of Art Galleries Award
2002 American Association of Museums
2002 AIGA 50 Books Award

**Clients**
Art Gallery of Toronto
Canadian Broadcasting Corporation
CIBC Development Corporation
Cooper-Hewitt, National Design Museum
Design Exchange
Dia Center for the Arts
Flammarion Publishers
George R. Gardiner Museum of Ceramic Art
Harvard Design School
Mattel
The Museum of Modern Art, New York
National Film Board of Canada
Power Plant
Rizzoli International Publications
Steelcase Canada
The Whitney Museum of American Art

Opposite page:

**Project**
Newsletter & gallery brochures

**Title**
The Power Plant members' quarterly newsletter

**Client**
The Power Plant Contemporary Art Gallery

**Year**
1999

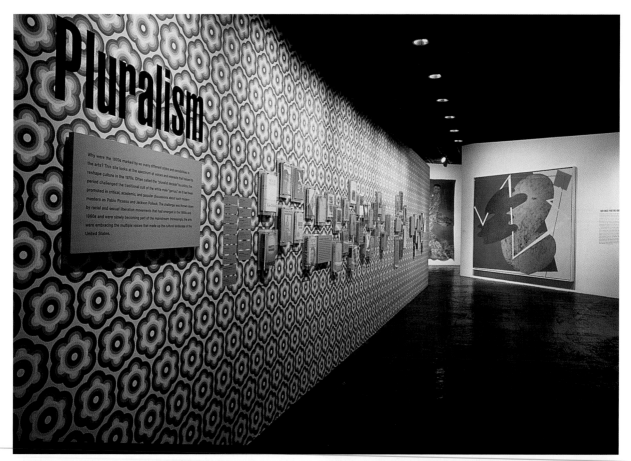

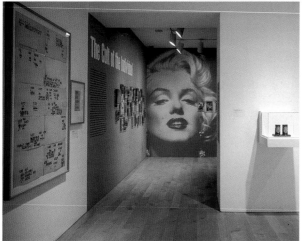

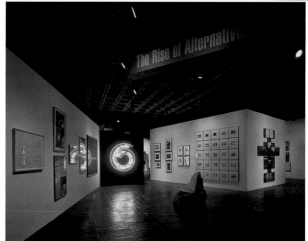

# tim hawkinson

Opposite page:

**Project**
Exhibition graphics

**Title**
The American Century,
Part 2, 1950–2000

**Client**
The Whitney Museum of
American Art

**Year**
1999

**Project**
Exhibition catalogue

**Title**
Tim Hawkinson

**Client**
The Power Plant
Contemporary Art Gallery

**Year**
2000

# Fons M. Hickmann

## "Displace yourself!"

Opposite page:

**Project**
Magazine

**Title**
Der Architekt

**Client**
BDA

**Year**
2001

Der Architekt 225

**Verlust der Mitte**
September 2000
Zeitschrift des Bundes Deutscher Architekten BDA
Verlagsgesellschaft Rudolf Müller

" Learn everything you can. Try everything that comes along. Look at everything there is to see. Search, experiment, make mistakes, fail, stand up. Turn religious, turn conservative, turn radical. And then forget all about it and find your own way to create."

» Lerne, was du kannst. Probiere aus, was du willst. Siehe, was es gibt. Suche, experimentiere, mache Fehler, steige auf Berge und gehe durch Täler. Werde fromm, werde verdorben, werde konservativ und werde radikal. Und dann vergiss all das und lerne, deinen eigenen Weg zu gestalten.«

« Apprends tout ce que tu peux. Essaye ce que tu veux. Vois ce qu'il y a à voir. Cherche, expérimente, fais des erreurs, échoue et relève-toi. Deviens mystique, deviens dépravé, deviens conservateur et deviens radical. Et ensuite oublie tout cela et trouve ton propre chemin afin de créer. »

**Fons M. Hickmann**
Fons Hickmann m23
Mariannenplatz 23
10997 Berlin
Germany

T +49 30 6951 8501
F +49 30 6951 8511

E m23@fonshickmann.de
E hickmann@
fonshickmann.de

www.fonshickmann.de

**Biography**
1966 Born in Hamm, Germany
1968 Afflicted by bouts of typographic fever, since falling into a bowl of alphabet soup as a child
1972 Beginning of school career spent on soccer pitches between Dortmund and Schalke
1991 Crowned as "Guaredisch the First" by the Düsseldorf Typographic Society
1993 Diploma in Graphic Design, University of Applied Design Düsseldorf
1993+ Studies in Philosophy and Communication Science, Düsseldorf and Wuppertal

**Professional experience**
1995 Co-founded Kairos with Gesine Grotrian-Steinweg, Nicolai Sokolow and Volker Bertelmann in Düsseldorf
1996+ Member of TDC, ADC, AGD and ABC
1997 Brief comeback as a striker for the "Tapezistische Fussballfreunde" and winner of the "Golden Fruitcake"
1997+ Lectured at various universities, participated in juries and in numerous publications
1999 Professor of Typography, University of Applied Design, Dortmund
2001 Co-founded Fons Hickmann m23 with Gesine Grotrian-Steinweg and Simon Gallus in Berlin
2001+ Professor of Cognitive Dissonances, All Media and Applied Soccer, University of Applied Arts, Vienna

**Recent exhibitions**
1998 "Type Directors Show", New York; International Biennale Warsaw, Museum Plakatu; Bienal del Cartel en Mexico, Mexico City; "Die 100 Besten Plakate", Berlin; "Brno Design Exhibition", Czech Republic; "Triennale of the Stage Poster", Sofia, Bulgaria; "Golden Bee 4", Moscow; "Festival d'Affiches de Chaumont"
1999 "Type Directors Show", New York; "Die 100 Besten Plakate", Berlin; "International Poster Exhibition", Ningbo, China
2000 International Biennale Warsaw, Museum Plakatu; Bienal del Cartel en Mexico, Mexico City; "Type Directors Show", New York; "Die 100 Besten Plakate", Berlin; "Festival d'Affiches de Chaumont"; Museum on the Seam, Jerusalem; "Poster Exhibition", The Museum of Modern Art, Toyama, Japan
2001 "Die 100 Besten Plakate", Berlin; "International Poster Exhibition", Ningbo, China; "Hong Kong Poster Festival", Hong Kong
2002 "Displace yourself!" (Fons Matthias Hickmann Design on paper and screen), Heiligenkreuzer Hof Gallery, Vienna

**Recent awards**
1998 The 100 Best Posters, Berlin; German Prize for Communication Design; Golden Bee Award, Moscow; Special Award for Poster Art, Triennal, Sofia; Excellence Award, Type Directors Club New York
1999 Excellence Award, Type Directors Club New York; The 100 Best Posters, Berlin; German Prize for Communication Design
2000 German Prize for Communication Design; Honorary Diploma VDG Germany; Bronze Medal, Joseph Binder Award; Excellence Award, Type Directors Club New York; The 100 Best Posters, Berlin; Tokyo TDC Award, Japan
2001 The 100 Best Posters, Berlin; Excellence Award, Poster Exhibition, Ningbo, China
2002 Excellence Award, Type Directors Club New York; First Prize, Kieler Woche (Corporate Design Contest), Germany; ADC Awards, Germany; The 100 Best Posters Jury, Berlin; Red Dot Award, Germany

**Clients**
Ärzte ohne Grenzen
BDA
BMW
Busse & Geitner Architects
Escale Gallery
Frau + Mutter KFD Magazin
Grotrian Pianoforte Company
IFA Galleries
Kieler Woche
Laboratory for Social and Aesthetic Development
Staatstheater Olderburg
Theaterhaus Düsseldorf
UMA records
VMI
Zefa

**Project**
Books and catalogues

**Title**
Time Out

**Client**
Zefa

**Year**
2001

Opposite page:

**Project**
Poster

**Title**
Lettre à l'atelier

**Client**
Théâtre Parlant

**Year**
1997

**Project**
Illustration

**Title**
Football is coming home

**Client**
Page magazin

**Year**
2001

PAGE: 31 Jan 2001 13:35:08
...Die 10 Kreativsten der Kreativen laden wir ein, auf einer Seite der
Page das Thema Kreativitaet zu visualisieren.
Einsendeschluss: Dienstag, den 13.2.01 !!!

FONS: 31 Jan 2001 20:52:15
...aber warum denn so knapp? in der Zeit schaffe ich gerade mal einen
halben Topflappen zu häkeln...

PAGE: 01 Feb 2001 10:29:11
...halber Topflappen wär auch nicht schlecht...

FONS: 01 Feb 2001 12:16:10
na gut, gehe Wolle kaufen...

# Kim Hiorthøy

"John Cage said that all he knew about method was that when he was not working he sometimes thought he knew something, but then when he was working, he found that clearly he knew nothing."

**Project**
Seven-inch record sleeve

**Title**
Torture Happiness/Den
fula skogen bakom köket

**Client**
Smalltown Supersound

**Year**
2000

"For graphic design in the future I think it's important to eat well, and to sleep. But also to read books and learn things and to know about them from as many different perspectives as possible. I further believe that it's good to rely on intuition and to practice solidarity with other people and to practice punk rock."

» Damit das Grafikdesign eine Zukunft hat, ist es meiner Meinung nach wichtig, gut zu essen und genug zu schlafen. Aber auch Bücher zu lesen und neue Dinge zu lernen und sie aus so vielen Blickwinkeln wie möglich zu betrachten. Außerdem halte ich es für gut, sich auf die Intuition zu verlassen, solidarisch mit anderen Menschen zu sein und Punk-Rock zu spielen.«

« Pour l'avenir du graphisme, je pense qu'il est important de bien se nourrir et de dormir. Mais aussi de lire des livres, d'apprendre, et d'examiner les choses sous le plus d'angles possibles. Je crois également qu'il est bon de se fier à son intuition, d'être solidaire des autres et de pratiquer le rock punk. »

**Kim Hiorthøy**
Seilduksgata 25
0553 Oslo
Norway

T +47 22 38 36 02
F +47 22 80 61 01

E kimim@online.no

**Biography**
1973 Born in Trondheim, Norway
1991–1994 Trondheim Art Academy
1994–1995 School of Visual Arts, New York
1995–1996 Trondheim Art Academy
1999–2001 Royal Danish Academy of Fine Art, Copenhagen

**Recent exhibitions**
1998 "Shoot", Galleri G.U.N, Oslo; "Biennale Syd", Kristiansand Kunstforening; "Fellessentralen", Kunstnernes Hus, Oslo
1999 "Tegninger", solo exhibition (drawings), Nils Aas Kunstnersenter, Inderøy
2000 "Sprung!", B.S.A, Copenhagen; "design.scan", Scandinavian Design Center, New York; "eMotion Picture", Galleri f15, Jeløya
2001 "13", Tomato Gallery, London; "Inspirert Design", Kunstindustrimuseet, Oslo; "Tegninger for en hundrings", solo exhibition (drawings), Tegnerforbundet, Oslo
2002 "Contemporary Illustration in Europe", Teatrio, Bolzano; "Form 2002", Norsk Form, Oslo; solo exhibition (paintings), Trøndelag Kunstnersenter, Trondheim
2003 Fotogalleriet, Oslo

**Recent awards**
1995 Spellemanns Award best record sleeve
1996 Spellemanns Award best record sleeve
1997 Spellemanns Award best music video
1998 Norwegian Cultural Council Award for best children's book (illustration); Spellemanns Award best record sleeve; Norsk Forms Award, young designer of the year (graphic design)
2000 Gold Award for Illustration, Visuelt

**Clients**
Adidas
EMI Records
Rune Grammofon
Smalltown Supersound
Sony Music
Stickman Records

**Project**
Book of own work (spread)

**Title**
Tree Weekend

**Client**
Die Gestalten Verlag

**Year**
2000

From top left:

**Project**
Record sleeve

**Title**
SPUNK: Det eneste jeg
vet er at det ikke er en
støvsuger

**Client**
Rune Grammofon

**Year**
1999

**Project**
Record sleeve

**Title**
SPUNK: Filtered Through
Friends

**Client**
Rune Grammofon

**Year**
2001

**Project**
Record sleeve

**Title**
Arne Nordheim: Electric

**Client**
Rune Grammofon

**Year**
1998

**Project**
Record sleeve

**Title**
Biosphere/Deathprod:
Nordheim Transformed

**Client**
Rune Grammofon

**Year**
1998

**Project**
Record sleeve

**Title**
Tove Nilsen: Flash
Caravan

**Client**
Rune Grammofon

**Year**
1998

**Project**
Record sleeve

**Title**
Nils Økland: Straum
Client

**Client**
Rune Grammofon

**Year**
2000

From top left:

| **Project** | **Project** | **Project** | **Project** | **Project** | **Project** |
| Record sleeve | Record sleeve | Record sleeve | Record sleeve | Record sleeve | Record sleeve |
| **Title** | **Title** | **Title** | **Title** | **Title** | **Title** |
| Alog: Red Shift Swing | Alog: Duck-Rabbit | Tore Elgarøy: The Sound of the Sun | Jazzkammer: Timex | Arve Henriksen: Sakuteiki | Chocolate Overdose: Whatever |
| **Client** | **Client** | **Client** | **Client** | **Client** | **Client** |
| Rune Grammofon | Rune Grammofon | Rune Grammofon | Rune Grammofon | Rune Grammofon | Rune Grammofon |
| **Year** | **Year** | **Year** | **Year** | **Year** | **Year** |
| 1999 | 2001 | 2001 | 2000 | 2001 | 1998 |

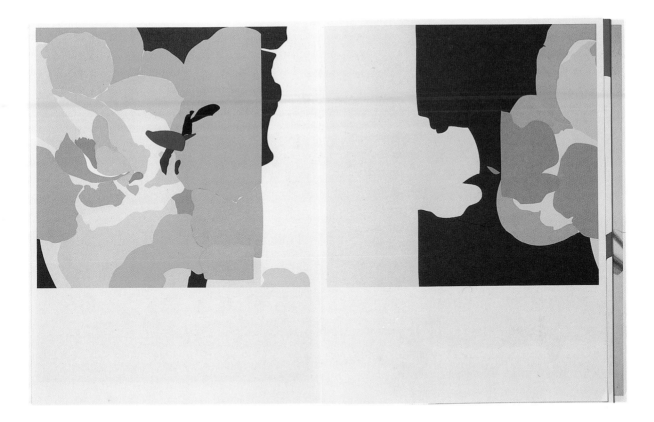

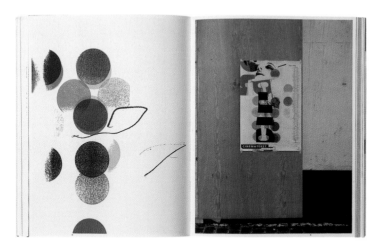

**Project**
Book of own work
(spreads)

**Title**
Tree Weekend

**Client**
Die Gestalten Verlag

**Year**
2000

# Hi-ReS!

"Our philosophy is simple: never do a job you don't believe in. Do every job with as much enthusiasm as if it was your first and as much attention to detail as if it was your last."

**Project**
Website
www.mindthebanner.com

**Title**
Mind The Banner

**Client**
NTT Data

**Year**
2001

"The future of design definitely doesn't lie in one discipline such as web design alone, for us it lies in the connection of design, architecture, the moving image, etc. The web doesn't allow for many things due to the limitations of the screen, the browser etc., but what it can do is to combine many different things and turn them into one and that's the strength of it. No picture on a site will ever be as impressive as a print-out of the same design on A0. It's movement, interaction, the idea of being connected and sound that make the web special."

» Die Zukunft des Grafikdesigns liegt für uns definitiv nicht in einer Spezialisierung wie dem Webdesign allein, sondern in der Fusion von Grafik, Architektur, bewegten Bildern u. Ä. Aufgrund der Beschaffenheit von Bildschirm, Browser usw. bietet das Internet zwar nur begrenzte Möglichkeiten, man kann damit aber viele verschiedene Dinge zu etwas Ganzem kombinieren und genau das ist seine Stärke. Kein Bild auf einer Internetseite wird jemals so eindrucksvoll sein wie der Ausdruck des Bildes im Format A0. Es sind Bewegung, Interaktion, weltweite Verbindungen und Ton, die das Internet zu etwas Besonderem machen.«

« L'avenir du graphisme ne dépend pas que d'une seule discipline telle que l'infographie. Pour nous, il réside dans sa rencontre avec d'autres domaines tels que l'architecture, les images animées, etc. Le web ne permet pas de faire tout ce qu'on veut car il est limité par l'écran, le navigateur etc, mais il tient sa force du fait qu'il peut combiner de nombreux éléments différents et les transformer en un seul. Aucune image d'un site ne sera jamais aussi impressionnante que le tirage sur papier au format A0 du même graphisme. Ce sont le mouvement, l'interaction, l'idée d'être connecté et le son qui rendent le web spécial. »

**Hi-ReS!**
47 Great Eastern Street
London EC2A 3HP
UK

T +44 20 7684 3100
F +44 20 7684 3129

E info@hi-res.net

www.hi-res.net

**Design group history**
1999 Co-founded by Florian Schmitt and Alexandra Jugovic in London; launched soulbath.com

**Founders' biographies**
Florian Schmitt
1971 Born in Frankfurt/Main
1992–1997 Studied Art, Hochschule für Gestaltung Offenbach, Germany
Alexandra Jugovic
1968 Born in Frankfurt/Main
1990–1996 Studied Art, Hochschule für Gestaltung Offenbach, Germany

**Recent exhibitions**
2001 "Semi-detached", interactive installation commissioned by the LUX centre for PANDAEMONIUM, The London Biennial of Moving Images www.pandaemonium.org.uk

**Recent awards**
2001 Silver Award Interactive & Digital Media (Most Outstanding Consumer Website), D&AD Awards; Film Category and Peoples Choice Award, 5th Annual Webby Awards; Gold Award Interactive Media, Art Directors Club of Europe; Best Interactivity, Flash Film Festival London; Best Experimental Site, Flash Film Festival New York
2002 Film Category, 6th Annual Webby Awards; Net Excellence, Net Vision and Honorary Mention, Prix Ars Electronica; Best Experimental Site, Flash Film Festival San Francisco; Silver Award Interactive Media, Art Directors Club New York

**Clients**
Artisan Entertainment US
EMI Records
IFC Films US
Lexus
Mitsubishi Motors Japan
Newmarket Films
Ninja Tune Records
NTT Data Japan
SONY Computer Entertainment Europe
Source Records
Virgin Continental Europe
Virgin Records UK

Opposite page:

**Project**
Website
www.requiemforadream.com

**Title**
Requiem for a Dream

**Client**
ARTISAN Entertainment

**Year**
2000

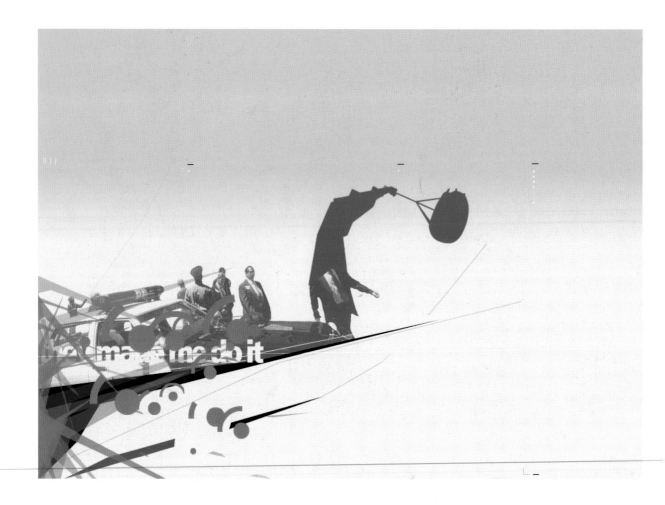

Opposite page:

**Project**
Website
www.donniedarko.com

**Title**
Donnie Darko

**Client**
Newmarket Films

**Year**
2001

**Project**
Website
www.donniedarko.com

**Title**
Donnie Darko

**Client**
Newmarket Films

**Year**
2001

# Angus Hyland

## "Continental modernism meets British eclecticism."

Opposite page:

**Project**
Magazine cover design

**Title**
Nikkei Design, issue dated
April 1999

**Client**
Nikkei Design

**Year**
1999

1999年3月24日発行（毎月1回24日発行）　第142号　1987年8月18日第三種郵便物認可

# 日経 デザイン ⁴

## NIKKEI DESIGN

1999

特集／流通のデザイン

●陳腐化と停滞をブランディングで打破

特別リポート／アップルを蘇らせたデザインの力

"The discipline of graphic design will continue to evolve through technological and aesthetic advances, adapting to meet the needs of the market in an increasingly fashion-conscious world."

» Der Beruf des Grafikers wird sich infolge technischer und ästhetischer Fortschritte entwickeln und sich den Erfordernissen des Marktes in einer zunehmend modebewussten Welt anpassen.«

« Le graphisme continuera à évoluer au fil des progrès techniques et esthétiques, s'adaptant pour satisfaire les besoins du marché dans un monde de plus en plus axé sur la mode. »

**Angus Hyland**
Pentagram Design Ltd.
11 Needham Road
London W11 2RP
UK

T +44 20 7229 3477
F +44 20 7727 9932

E email@pentagram.co.uk

www.pentagram.com

**Biography**
1963 Born in Brighton, England
1982–1986 BA (Hons) Media and Production Design, London College of Printing
1987–1988 MA Graphic Design, Royal College of Art, London

**Professional experience**
1988 Founded his own studio
1998+ Director, Pentagram
2001 Edited Pen and Mouse: Commercial Art and Digital Illustration (Laurence King)

**Recent exhibitions**
1998 "Work From London", British Council touring exhibition
1999 "Ultravision", British Council touring exhibition
2000 "Symbol", London College of Printing
2001–2002 "Picture This", British Council touring exhibition, curated by Angus Hyland

**Recent awards**
1999 D&AD Silver Award; Big Crit Critics Awards (x2)
2000 Grand Prix, Scottish Design Awards
2002 Top Ten Graphic Designers in the UK, Independent on Sunday's selection

**Clients**
Asprey
BBC
BMP.DDB
British Council
British Museum
Canongate Books Ltd
Crafts Council
DCMS
Eat
EMI
Garrard
Getty Images
Globe Theatre
The Imagebank
Penguin Books
Royal Academy
Royal College of Art
Victoria & Albert Museum
Virgin Classics

**Project**
Poster design

**Title**
"Tear Me Up" poster (for a student subscription offer to the magazine Creative Review)

**Client**
Creative Review

**Year**
1996

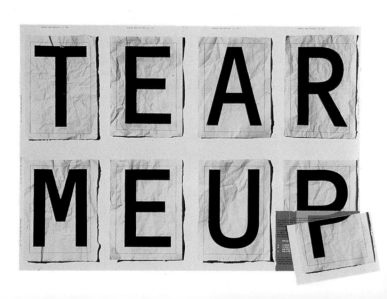

**Project**
Book design and
packaging

**Title**
The Pocket Canon Bibles

**Client**
Canongate Books

**Year**
1998

Crafts Council Gallery,
44a Pentonville Road,
Islington, London N1 9BY
Tel 0171 278 7700
5 minutes from
Angel tube

Free entry.
Tues to Sat 11- 6,
Sun 2- 6, Closed Mon
& Disabled Access

# NO PICNIC

## 9.7.98-
## 30.8.98

Opposite page:

**Project**
Poster

**Title**
"No Picnic" exhibition

**Client**
Crafts Council

**Year**
1998

**Project**
Book cover

**Title**
Dreamer by Charles
Johnson

**Client**
Canongate Books

**Year**
1999

**Project**
Book cover design

**Title**
Scar Culture by Toni
Davidson

**Client**
Canongate Books

**Year**
1999

# Hideki Inaba

## "Thinking is very difficult and very easy."

Opposite page:

**Project**
Magazine cover

**Title**
SAL magazine.
Vol. 003 cover art

**Client**
SAL

**Year**
2001

magazine.

Vol.003        Autumn 2001 FACE Issue Free

"Either everything will be called design or nothing will be called design. The public will decide the direction of design."

» Entweder wird alles als Design bezeichnet werden oder nichts. Die Öffentlichkeit wird die Richtung bestimmen, die das Grafikdesign einschlägt. «

« Soit tout sera appelé design soit rien ne sera appelé design. Le public décidera de l'orientation du graphisme. »

**Hideki Inaba**
Hideki Inaba Design
PK108 2–32–13
Matsubara Setagaya-ku
Tokyo 156–0043
Japan

T +81 3 3321 1766
F +81 3 3321 1766

E inaba@t3.rim.or.jp

**Biography**
1971 Born in Shizuoka, Japan
1993 Degree in Science and Engineering, Tokai University, Japan

**Professional experience**
1997 Started as a freelance graphic designer in Tokyo
1997–2001 Art Director, +81 magazine, Japan
1997+ Art Director, GASBOOK series, Japan
2001+ Art Director, SAL free magazine, Japan

**Recent exhibitions**
2001 "Movement", Sendai Mediatheque, Sendai, Japan; "Buzz Club", P.S.1, New York
2002 "JaPan Graphics", RAS Gallery, Barcelona

**Clients**
+81
GASBOOK / DesignEXchange
IdN / Hong Kong
NTT
SAL
Shift Production
Sony Music
Walt Disney
Wella Japan

**Project**
CD cover

**Title**
RE:MOVEMENT 1

**Client**
SAL

**Year**
2001

Opposite page:

**Project**
Magazine cover art

**Title**
"IdN" magazine (Hong Kong) cover art

**Client**
IdN systems design limited

**Year**
2001

Opposite page:

| **Project** | **Project** |
|---|---|
| Magazine | Magazine covers |
| | |
| **Title** | **Title** |
| Artwork from "+81" magazine | "+81" magazine vol. 10 vol. 11 |
| | |
| **Client** | **Client** |
| +81 | +81 |
| | |
| **Year** | **Year** |
| 2000 | 2000–2001 |

# Inkahoots

## "Direct Design Action!"

Opposite page:

**Project**
Street poster

**Title**
Business is Booming –
Blockade the Stock
Exchange

**Client**
M1 Alliance

**Year**
2001

# M1 : 01/05/01 : 7AM
# BLOCKADE **
# THE STOCK EXCHANGE

CANCEL THIRD WORLD DEBT

ABOLISH THE WORLD BANK,
IMF AND WTO

ECOLOGY BEFORE ECONOMY

OUR WORLD IS **NOT FOR SALE**

## BUSINESS IS BOOMING

## capitalism blows me away

BLOCKADE: 7AM TUESDAY 1ST MAY 2001, AUSTRALIAN STOCK EXCHANGE, 123 EAGLE ST, BRISBANE.
CONTACT: EMAIL M1BRIS-SUBSCRIBE@YAHOOGROUPS.COM; PHONE 3831 2644; WEB WWW.M1BRISBANE.IWARP.COM
DESIGN + inkahoots

" Like the child that closes its eyes and imagines it can't be seen, design now seems wilfully blinded to the anti-human consequences of consumer capitalism. We release rushing torrents of words, images and sounds that often say nothing at all, and at worst deceive and degrade our humanity. We also create electric work with the potential to explore new ways of knowing ourselves. Inkahoots believes our visual language is a site for the organisation of social power. We can close our eyes and pretend the world isn't there, or we can begin to imagine a better world."

» Wie das Kind, das sich vorstellt, dass man es nicht mehr sehen kann, wenn es seine Augen geschlossen hat, so scheint Design im Augenblick willentlich blind zu sein für die Konsequenzen des Konsumkapitalismus. Wir veröffentlichen reißende Ströme von Wörtern, Bildern und Klängen, die oft nichts sagen und im schlimmsten Fall unsere Menschlichkeit täuschen und degradieren. Wir schaffen auch elektrische Arbeit, die uns neue Möglichkeiten bietet, uns selbst kennen zu lernen. Inkahoots glaubt, dass unsere visuelle Sprache ein Ort ist, an dem soziale Macht organisiert werden kann. Wir können unsere Augen schließen und so tun, als ob die Welt nicht da sei. Oder wir können uns eine bessere Welt vorstellen.«

« Comme l'enfant qui, en fermant les yeux, imagine qu'il est devenu invisible, la création semble s'être délibérément mise des œillères pour ne pas voir les conséquences de la consommation capitaliste. Nous déversons des torrents de mots, d'images et de sons qui ne veulent souvent rien dire et qui, dans le pire des cas, trompent et dénaturent notre humanité. Nous réalisons également du travail dynamique qui pourrait nous permettre d'explorer de nouvelles manières de nous connaître nousmêmes. A Inkahoots, on estime que notre langage visuel constitue un espace où organiser le pouvoir social. Nous pouvons fermer les yeux et faire semblant que le monde n'est pas là, ou nous pouvons imaginer un monde meilleur. »

**Inkahoots**
239 Boundary Street
West End
Queensland 4101
Australia

T +61 7 3255 0800
F +61 7 3255 0801

E mail@inkahoots.com.au

www.inkahoots.com.au

**Design group history**
1990 Founded in Brisbane as a community access screenprinting collective working with unions, activists, grass roots political organizations and artists
1994 Became a dedicated multidisciplined design studio focusing on community, cultural and progressive commercial clients. Partners Robyn McDonald (b. 1958) and Jason Grant (b. 1971)

**Clients**
Aboriginal & Torres Strait Islander Commission
Anti-Discrimination Commission
Arts Queensland
Children by Choice
Crime & Misconduct Commission
Domestic Violence Resource Centre
Eco Domo
Ecological Engineering
Family Planning Assoc.
Feral Arts
Foresters ANA
Historic Houses Trust
Kooemba Jdarra
Legal Aid
Murriimage
Queensland Community Arts Network
Queensland Needle & Syringe Program
Queensland Prostitution Licensing Authority
Social Action Office
Tenants Union
Youth Advocacy Centre

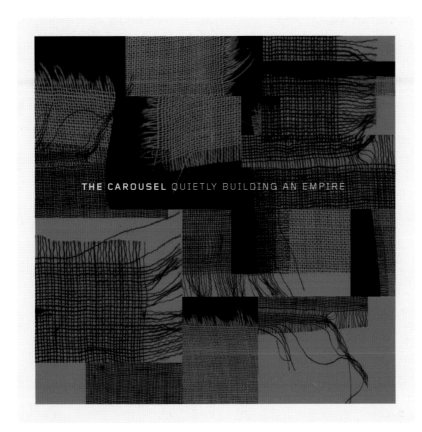

THE CAROUSEL QUIETLY BUILDING AN EMPIRE

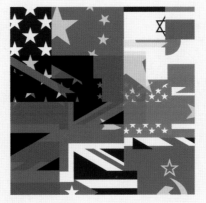

Opposite page:

**Project**
Visual identity /
business cards

**Title**
Various

**Client**
Various

**Year**
1999–2002

**Project**
CD packaging

**Title**
Quietly Building an
Empire

**Client**
The Carousel

**Year**
2001

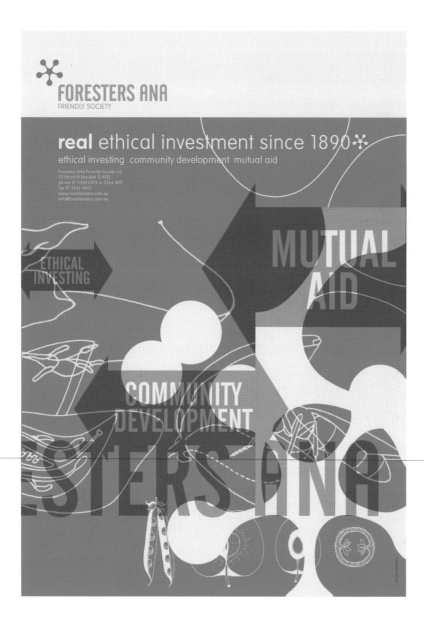

**Project**
Visual identity /
promotional poster

**Title**
Foresters ANA Friendly
Society

**Client**
Foresters ANA Friendly
Society

**Year**
2002

**Project**
Promotional book

**Title**
Public x Private

**Client**
Self-published

**Year**
2000

Opposite page:

**Project**
Protest poster

**Title**
No Vacancy – Evicting the
Homeless

**Client**
West End Community
House

**Year**
2001

NO VACANCY NO SHELTER NO HAVEN NO HARBOUR NO HEART

## EVICTING THE HOMELESS

The squeeze is on. There's no place left to stay in the Sunshine State! Is housing a fundamental human right or a luxury for the privileged? Can we get our governments to secure this right for ALL citizens?

# Intro

## "Aesthetics first"

Opposite page:

**Project**
Poster

**Title**
Howie B - Folk

**Client**
Polydor

**Year**
2001

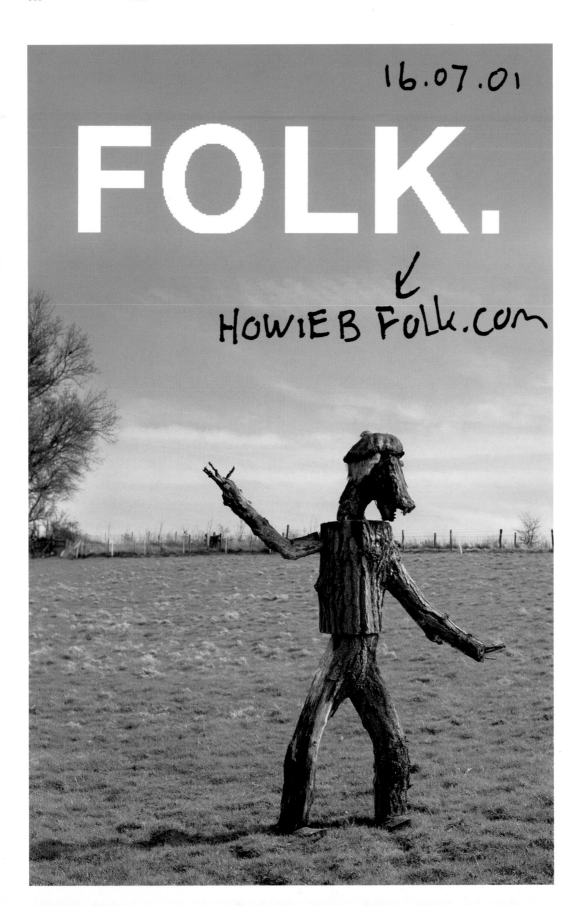

"The increasing use of graphic design as a purely commercial tool is devaluing its currency. The big design groups, and the big buyers of design, talk about 'difference', but they really mean sameness: everything looks the same. Design has been supplanted by branding, but no member of the public ever said: look at that branding! It means that design is becoming a visual sandwich-spread, and the result is blandness, uniformity and timidity. And paradoxically this is being done at a time when interest in visual culture has reached a high-point."

» Die Tatsache, dass die Gebrauchs-grafik in zunehmendem Maße ausschließlich zur Werbung eingesetzt wird, wertet sie ab. Die großen Designbüros und die großen Auftrag-geber sprechen von ›Unterschied‹, meinen in Wirklichkeit aber ›Gleich-heit‹: Alles sieht gleich aus. Design ist durch Markenbildung ersetzt worden, aber keiner würde sagen: ›Guck dir mal diese Markenbildung an!‹ Das bedeutet, dass die grafische Gestal-tung zum visuellen Brotaufstrich geworden ist, und das Resultat sind Reizlosigkeit, Uniformität und Ängstlichkeit. Paradoxerweise geschieht das zu einer Zeit, in der das Interesse an der visuellen Kultur einen Höhepunkt erreicht hat.«

« Le recours croissant au graphisme comme un outil purement commer-cial le dévalue. Les grands bureaux et les grands acheteurs de graphisme parlent de ‹différence› mais il faut plutôt comprendre ‹uniformité› : tout se ressemble. Le design a été sup-planté par la stratégie de marque mais personne dans la rue ne s'est jamais écrié ‹Oh, regarde cette stra-tégie de marque !›. Cela signifie que la création graphique est en train de devenir une pâte à tartiner visuelle. Le résultat est monotone, neutre et timoré. Paradoxalement, cela se produit à une époque où l'on s'est rarement autant intéressé à la culture visuelle. »

**Intro**
35 Little Russell Street
London WC1A 2HH
UK

T +44 20 7637 1231
F +44 20 7636 5015

E jo@intro-uk.com

www.introwebsite.com

**Design group history**
1988 Co-founded by Katy Richardson and Adrian Shaughnessy in London

**Recent exhibitions**
1998 "Sound Design", Levi's Gallery, London (a travelling exhibition of UK record sleeve design)
2000 "Sonar Festival", Barcelona

**Recent awards**
1998 Best Design Team, CADS
2001 Best Design Team, CADS
2002 Best Direct Mail, Design Week Awards; Best Album Design, CADS

**Clients**
Art Fund
Barbican
BBC
British Council
Channel 4
Deutsche Bank
EMI
Mute
Penguin
Royal Academy of Music
Sony

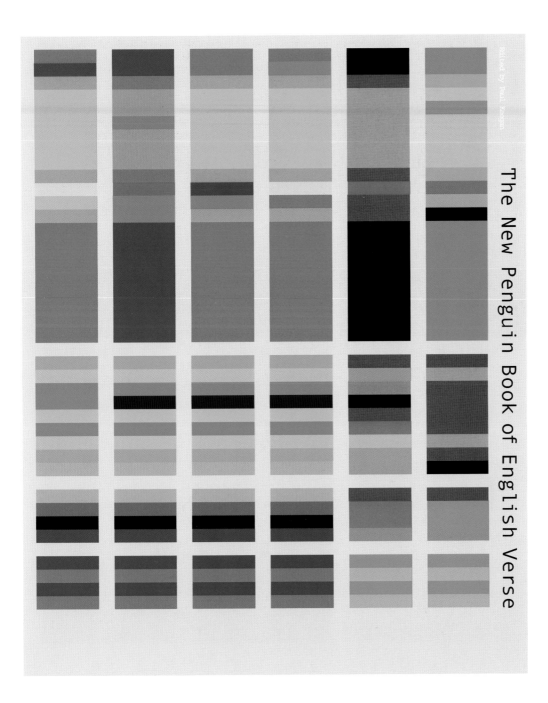

The New Penguin Book of English Verse

Edited by Paul Keegan

**Project**
Book cover

**Title**
The New Penguin Book of
English Verse

**Client**
Penguin

**Year**
2001

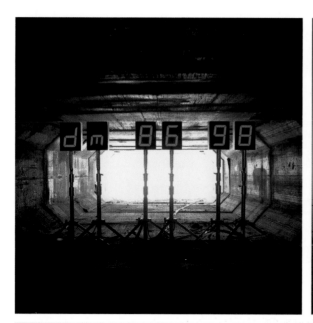 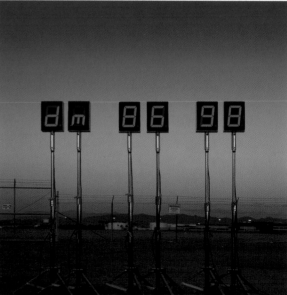

**Project**
Record covers

**Title**
Depeche Mode – singles
1986–98

**Client**
Mute

**Year**
1998

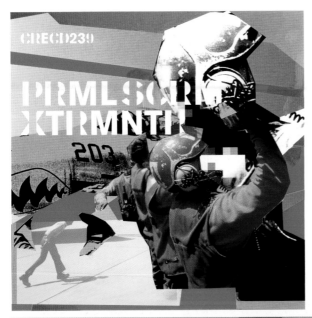

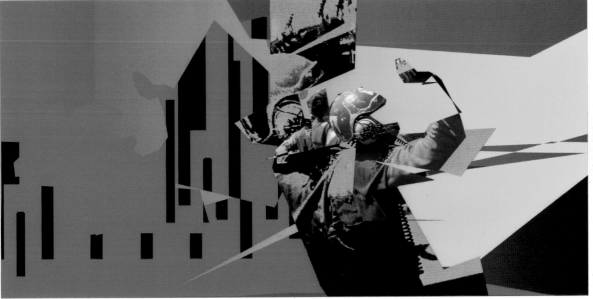

**Project**
CD booklet

**Title**
Primal Scream –
Exterminator

**Client**
Creation

**Year**
2000

# Gila Kaplan

## "To play the strands of a spider's web as if they were cello strings."

Opposite page:

**Project**
Series of five artists'
books in collaboration
with author Sami
Berdugo

**Title**
Local

**Client**
Self-published

**Year**
2000

"We all need to talk in a language that everyone can understand. In Europe; in Asia; on the moon … graphic design will continue to write the dictionary between the language of art and the language of the everyday. In this dictionary a book, painting or film will not be an object but a process. Just as pink is not Pantone 182 or then again – perhaps it is?"

» Wir sollten alle eine Sprache sprechen, die allgemein verständlich ist. In Europa, in Asien oder auf dem Mond – überall wird das Grafikdesign das Wörterbuch für die Vermittlung zwischen Kunst- und Alltagssprache fortschreiben. In diesem Wörterbuch wird ein Buch, ein Gemälde oder ein Film nicht als Objekt, sondern als Prozess aufgeführt. Ähnlich wie Pink nicht Pantone 182 ist – oder etwa doch?«

« Nous avons tous besoin de parler un langage que tout le monde puisse comprendre. En Europe, en Asie, sur la Lune… le graphisme continuera d'écrire le dictionnaire entre le langage de l'art et celui de tous les jours. Dans ce lexique, un livre, un tableau ou un film ne sera pas un objet mais un procédé. Tout comme le rose n'est pas du Pantone 182 – à moins qu'il ne le soit ? »

**Gila Kaplan**
20 Israelis St
Tel Aviv 64382
Israel

F +972 3524 8658

E g_kaplan@zahav.net.il

**Biography**
1971 Born in Tel Aviv, Israel
1992–1996 BA Graphic Design, Bezalel Academy of Art & Design, Jerusalem
1998–2000 MA Graphic Design, Royal College of Art, London

**Professional experience**
1996–1998 Graphic designer, various design studios, Tel Aviv
2000+ Independent studio, Gila Kaplan / Graphic Design, Tel Aviv; Tutor, Shenkar School of Engineering and Design, Tel Aviv
2000 Tutor, Camera Obscura School of Art, Tel Aviv

**Recent exhibitions**
1999 "Stilts", The Israel Association of United Architects, Tel Aviv
2001 "September", Camera Obscura, collaboration, Tel Aviv; The America Israel Cultural Foundation, award winners, collaboration, Tel Aviv

**Recent awards**
1998 Tuition Scholarship, The Gee Trust, London
1999 The America Israel Cultural Foundation Award, Tel Aviv; Commendation, The Folio Society Illustration Awards, (RCA), London
2001 First Prize (book design), Oberon Book Award, Royal College of Art, London; Exhibition Support, Cultural & Educational Department/Municipality of Tel Aviv

**Clients**
Am Oved Publishers
Babel Publishers
Bio-kine
Cure-tech
e-muse
Herzeliya Museum
Nozar Theater
Office 414 / Architecture & Landscape
Orna & Ella
Sommer Contemporary Art Gallery
The Israel Association of United Architects
Zmora Bitan Publishers

**Project**
Series of five artists' books in collaboration with author Sami Berdugo

**Title**
Background Music

**Client**
Self-published

**Year**
2000

**Project**
Series of five artists'
books in collaboration
with author Sami
Berdugo

**Title**
Background Music

**Client**
Self-published

**Year**
2000

הרומן חושף חלקי של דורד פרק איזה טוסטוס עם כידון
מצופה כרום בקצה החצר מתאר את הראקאטתא
טהיריטואליות של חבורת צעירים פאריזאים, שמנסה
לעזור לחייל צעיר להשתמט ממלמות אלג'יריה. הרומן
האנטי-מלחמתי הקצר בזה, ששפעם במשחקי מילים,
בדיחות, הידודים, ציטטטות, שב×אות בכית מבוזנות
ושטים אשל×מר בזמת לשון שנונה, סמכן את תהלוכי
של הקטגר בין דורד פרק ל-OuLiPo וסתגר לספרות
מונטאב'לית, זו וחגית זמנרסקית של הטמר, שהוליף
La Ligne Générale-ל, זבל בטדחתחת האנטי-מלחמות
של המבזור זבר-של-חבר, דחייל צעיר שמכטמר אינו
בעליו אפילי להמזור בטמם, האנטי-גיבור הבורוט,
הקורבנ האולט-מ×.

ואיה, מלוקת אחת עשוד לספטם למאיר מלחמות
אחרונ×, אותו חייל צעיר, ר×ה שמו קאראב'ק,
קאראמנוסטר או קוראמאסטרו, מעלה על מדעת חייל
בעיר צעיר, אזר איתט יודע פרק, פרק אב פרק -
מתני יהוד המפליף, שקושר את חיו במפ הבוט הצפ×דמ×
הזמנג במלחמות העולם השנ×ה, ×שאתם ×סמעד אחר×
אלוקגד צעירה שסטגדית אחר-קך תקפה את חיה גם
אב במשראות של אישורים. ×דמע אב אירבע, שעתיד
להות אזוד מטמפריה הגדולים של גרמה במאם העשרים.

איזה סוסטוס עם כידון מצופה כרום בקצה החצר
הוא כפרו הליריף של דורד פרק הרוזמת אחד בבל.

זורז' פרק

איזה טוסטוס קטן
עם כידון
מצופה כרום
בקצה החצר ?

דורד פרק

מן הראא×ר הוא, שמט×מור שאינו חרד מאחיד המסבנת הליל, ×ען מדי
פעם להתעלות מעל השטח×ת, על מנת לרומם בכ×מה אסת, את ההוזה
שלנו.

כל נטע×: צעירים אמ×גים אלה, שבשבא×ה של המלחמה× נ×מ×ו הכל
(לשוא, למרבה הצער), כד× למ×נע את הגיתוגם האלג'×ר× מחייל צעיר
שאירוע לת×מ×ג, הב-הב יורש×תם האמ×מ×ם של איריאם ואלוליס, של
הריקילס וטולוטב', של הארטגראנואטה, של שלושת המ×סקטרים, ואפ×ל×
של רב-בהוזל× נמו, מנע-אקטופל, ט×ראו-דה-שארדן.

באשר לקוראם שבמולתו×ה של האמפפראה חזאת משאורות אותם
אדישים, אלה ×מצאו במפר קטן זה כד× הסתות דעה והצרות-אגב כד×
לסלק× בהרן טגב, ובמו×יחד מתמון ×את אורז בד××ם, שעש×יי לספק אף
את המשומרים שבהם.

דורד פרק

דורד פרק (1936-1982) נולד בפאריט, והתייתם מהוריו,
מטגוים יהודים פולניים, בגיל שש. הוא היה גבר בקבוצ×ה
הספרות×ת OuLiPo, והתגברב בין הזה× מהחיבור
תשבצ×ם: פרסם רומנ×ם, ×ספר× הגות, מפר×סים, מחזות
×תמנר×אי רד×.

כתייבתו של פרק ×בתה להברות ×לתתעניינ×ות עוד
במ××, ×המרוטונ× שלו באחור מן המפפר×ם החש×בים
במחצ×ה השני×ה של המ×מה העשר×ם ר×ק גדל ×הולך.
בשנת 1994, כמחוזה למפ×ר, הזעניק לפולנטק× הזסמנא
מספר 2817 שם "פרק".

http://www.babel.co.il

0 04620000085 3
463-85

על המ×ריכר, דורד פרק בעב×ר צגגן במצעת שיריי ×תבצי
×צוב ×מטמדה, גילה קטלה

---

יקי מנשנפרו×נד

אקדמיה

נפ×לתה של האמפ×ריה האחרונה

יובם פרשמ×ם, צעיר יטה ×מבר"ק, מבצע לאקדמיה נטמסרטגו
במא ל×דע, הוא מתאבב ב×דמת בעטרה, אך הוא ×בנ×ת
אותו. במ×סזא×ה גיבור×, מ×בר× הרומנ×ם הגדולים של המ×מה
הb-20. ×מכ×-מבע× גילום, ×משאלימ× ×ובם חשוף× לצ×פ×ת
הראא×ה, בג×דת ×ד××ה, ×מא מתעורר דלת, ×וא מתוודע בקט×מגו
לחוק× ×מסתרי האקדמ×ה, ×על מטרה, ל×דהערגזאל×מטראל××
הוא הזטקה אוזג, ×מקטלה,מק× היה מ×ד× ×מ×ר של מבמ×וב.

הרומן אקדמ×ה הוא נאמראה שהורה חטמטומ באתגמאזמ×פה
מגלית מכ× ×ק×מר××, ×ר×וג ×מ×פש×מ, ×אתגמאזמ×פה
מ×באת× ל× מ×מסטרר× גל×× גמזמראה, ×סתם שהמצ פרטגט×,
מ×בקר× כ×ה ×מ×ל×, ×מ×מ×בסאר× ה×דלים או ×מבמ× ל×מר×.
×בטא×יר מ×פ×דות ×מ×דמ× השאתום ×ד×ד×המ× אלמאלגגורא×ת
הוא חנקה אוזט, ×המקדל× ×ק ×מ אוזט שאובר מ×פר×וד× על
מבש××××.

יקי מנשנפרו×נד ×בזל בזמ×ן ב-1975.
מטמד לתואר שנ× להטמ×ות באתג×מרטתה בח×פה.

http://www.babel.co.il

"האמ×ראמ×ה הוא מ×דא×ר פרק, אלא שבטת×ם למחור בד×מ×ות
או ×מ×מ×, האמ×ראמ×ה מהתרת בד×ד×, ×מאדד שאור אמם×
למחת ×ק× מבזרת בד×מ×ה, ×ם למחור אותו לצבות בלמ×ד×
של הן מ×××ד.
במ×ם הזה מתקטד×ה בב×בזר בעל× ×וזן ×דב××ת מ××××
למ×דד×× לחגה אקטר× בשלכעם מ××דהת× ×תר של ×מ×××××××
האקטר×××.

אבל אדם ×מא× שבא ×בבש× הוא אקטר× מן ×מו×ן מטרד מ×ד
×מ×, מבן ל×מזל ×מ×בא אואת×× אחז×ר מבן, ×במב האקטר×
××א× לשלול באז×× מ×מלת× בהן האקטר×, ×מ× ×בא מ×בב×.
לקבל× אוזג טרק ×בן זה מ×מ אמלא בתתו×.
×דדב× שלך, ××דע×× ××ד×××× מבקבפ גל-ל×. ××מבו אוזד×
למ×מ המ×דא×מ×××, ×××בב× של של ××ה מ×מ××ה בד×.
×ם ×בב ×מ×ב מבן מ×בנה לד×מ×, ×מ×אה ×××× ל×ב×××
××א, ××בר× שהם מבב× ××× ×ן מ×××ד× של אמפראחת אחת,
××ר× אואמ ל×××, ×ל× לל××הא, אנג× בנפט, ×ד×
המבתלת× הזדל×× מ×תר במ×מ× ×ה, ×אב הבד××בכ× בנ×מ×
את חתמ×ל× לב×××. ×בל פרטמ×× אב חבד××בם× החזמ×מ×
מא×פרות אזת× בצ××ר× מבתו× של של גב× ×ם ×ה, ×וזן
×ל שלך, ××× ×מ×× בע×דר אם רק אמאר לגמ×ד× על ××××
נמ×ד. לך ×ל אל תמ××× ×את מ××× בכ××, ×אב× ××× שהמ×××, אב× ××××
××ה, אך אל א×וב××" "Nemo enim omnia potest"

0 04620000072 3
463-72

בפעולות אין זכר לאיש
עדו בן-כנען

'בפעולות אין זכר לאיש' הוא ספר על שוטטות בעולמו הנפשי של רועי, סטודנט לפילוסופיה. במקביל ללימודיו הוא עובר טיפול פסיכואנליטי ובתוך כך נקלע לאובססיה במרחב המדומיין של היחסים בין המטפל והמטופל.

רועי שותה את ימיו בפאב תל-אביבי, משוטט ברחובות העיר, בחופיה ובמחוזות האלכוהול והסמים שהיא מאפשרת.

בספר שני קולות: קולו של המספר וקולו של רועי, והשניים הם בעצם אותו הגיבור-עצמו שמחשבתו נודדת בין תפיסות עולם מתנגשות.

זהו ספר על העיר שלמדה לאפשר את הכל, על תודעה שמחפשת את עצמה בשפה ומוצאת את עצמה מחוצה לה, ועל אהבה שרועי לא מצא לקרוא לה בשמה.

"בשלושת הימים שחלמו הועברה הקטרה לחפצים. רועי שלא מצא את הדרך חזרה, פלט-לא פלט: משהו שרציתי לשאול אותך ולא שאלתי בפנישה שעברה. בפגישה לפני האחרונה עמדתי ברמזור ומכונית שחורה בלמה מאחורי, זו היית את? דין ההיימוחזה כדין המציאות עשתה עצמה לא זוכרת להכעיס. רועי לא הבין עוד בטרם נעקרה לו הבינה ואולך לבלוע את הדם בעשרים וארבע השעות שאחרי."

עידו בן-כנען יליד 1970.

מחיר מומלץ: 64 ש"ח

01

בבל (דרום)    סדרה בעריכת חיים פסח    בבל (דרום)

**Project**
Book cover

**Title**
There is no man in the action by Tido Ben Knaan

**Client**
Babel Publishers

**Year**
2002

# KesselsKramer

## "What is graphic design?"

Opposite page:

**Project**
Smartlappen (tearjerker)
Festival campaign

**Title**
I only cry at Smartlappen

**Client**
Smartlappen Festival

**Year**
2001

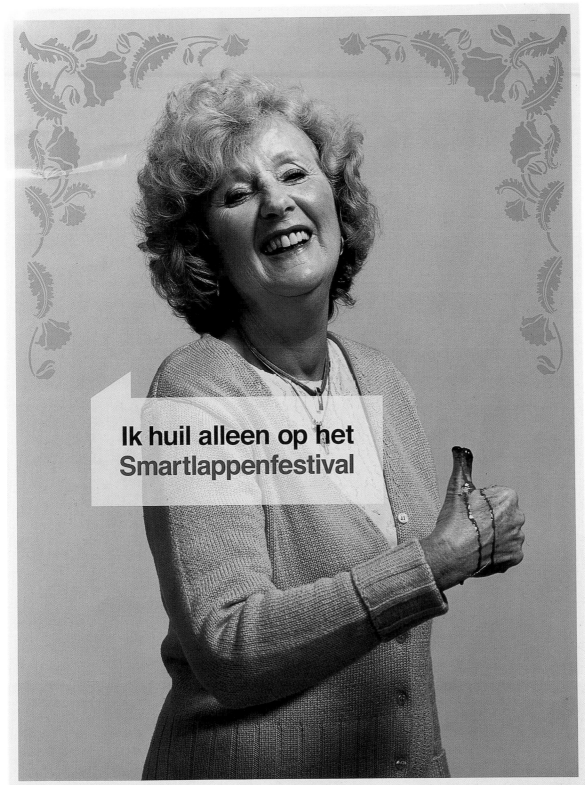

Ik huil alleen op het
Smartlappenfestival

UTRECHT                    16-18 NOV                    2001

toegang gratis – www.smartlappenfestival.nl

"Graphic design is dead. It has been killed by computers with super-high speed chips, gigabyte overload and things called fire-wires. Don't worry. What matters today is not to execute, to kern, or to crop. The idea is the high-chieftain, the lord of the manor. A 'graphic designer' might want to make a film. Send a letter. Or even make a laser sculpture in the shape of a handbag. So be it! Now the real fun begins …"

» Die Gebrauchsgrafik ist tot. Ihre Mörder sind Computer mit ultrahochleistungsfähigen Chips, massenhaft Gigabytes und Fire-wires genannten, blitzschnellen Verbindungen. Keine Sorge. Was heute zählt, ist nicht die Ausführung, das Unterschneiden oder Beschneiden. Die Idee ist der Häuptling, der Herr der Dinge. Ein ›Grafikdesigner‹ will vielleicht einen Film machen, einen Brief schreiben oder gar eine Laserskulptur in Form einer Handtasche schaffen. So sei es! Jetzt beginnt das eigentliche Vergnügen …«

« Le graphisme est mort. Il a été tué par les ordinateurs, les puces ultra rapides, les surcharges de gigaoctets et des machins appelés des ‹firewire›. Pas de panique. L'important aujourd'hui n'est pas d'exécuter, de créner, de rogner. L'idée est d'être le grand chef, le seigneur du château. Un ‹créateur graphique› peut décider de tourner un film, d'envoyer une lettre, ou même de réaliser une sculpture au laser en forme de sac à main. Ainsi soit-il! La fête ne fait que commencer… »

**KesselsKramer**
Lauriergracht 39
1016 RG Amsterdam
The Netherlands

T/F +31 20 530 1060

E church@
kesselskramer.nl

**Design group history**
1996 Co-founded by Erik Kessels and Johan Kramer in Amsterdam
1997 Matthijs de Jongh joined the team as Strategy Director; Pieter Leendertse joined the team as Production Director
1998 Engin Celikbas joined as Managing Director

**Founders' biographies**
Erik Kessels
1966 Born in The Netherlands
1983–1986 Trained at St Lukas Technical College, Boxtel
1986–1991 Art Director, Ogilvy & Mather, Eindhoven and Amsterdam
1991–1993 Art Director, Lowe, Kuiper & Schouten, Amsterdam
1994 Art Director, Chiat Day, London
1995 Art Director, GGT London
1996 Co-founder, KesselsKramer, Amsterdam

Johan Kramer
1964 Born in Utrecht, The Netherlands
1979–1980 Butcher Trade School, Brunswick, Germany
1980–1982 Studied at Ozu Film School, Bombay
1982–1984 Dog-trainer, Amsterdam
1984–1986 Copywriter, FHV/BBDO, Amsterdam
1986–1991 Copywriter, PMSvW/Young & Rubicam, Amsterdam
1994 Copywriter, Chiat Day, London
1995 Copywriter, GGT, London
1996 Co-founder, KesselsKramer, Amsterdam
2002 Part-time Film Director and Managing Director, KesselsKramer, Amsterdam

**Clients**
Diesel Jeans
Fila, The Netherlands
Hans Brinker Budget Hotel
ONVZ
Oxfam International
Radio 1
Remy Cointreau Group

Opposite page:

**Project**
Diesel Autumn/Winter catalogue

**Title**
Save Yourself

**Client**
Diesel Jeans

**Year**
2001

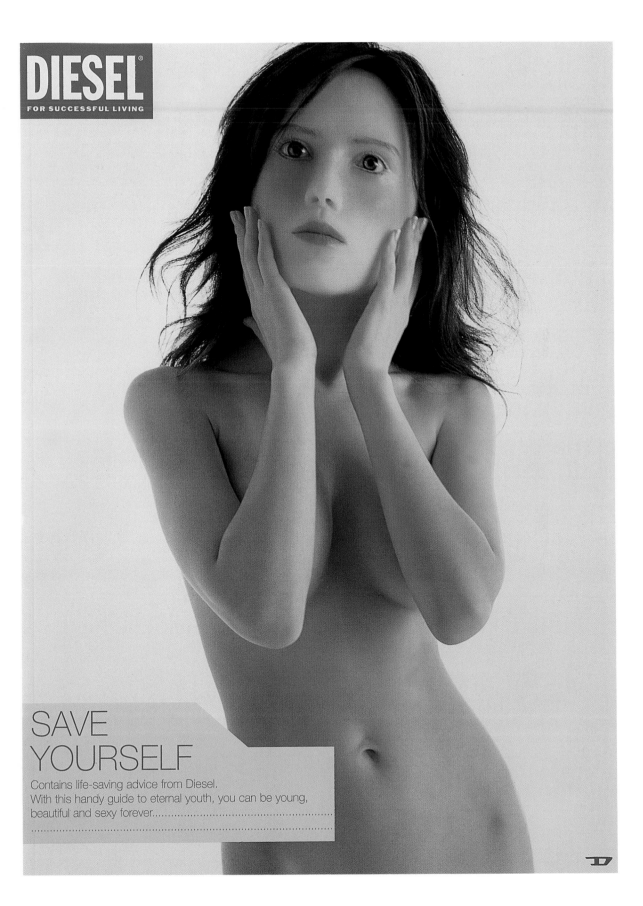

**Project**
Brochure for hotel

**Title**
Just Like Home

**Client**
Hans Brinker Budget
Hotel

**Year**
2001

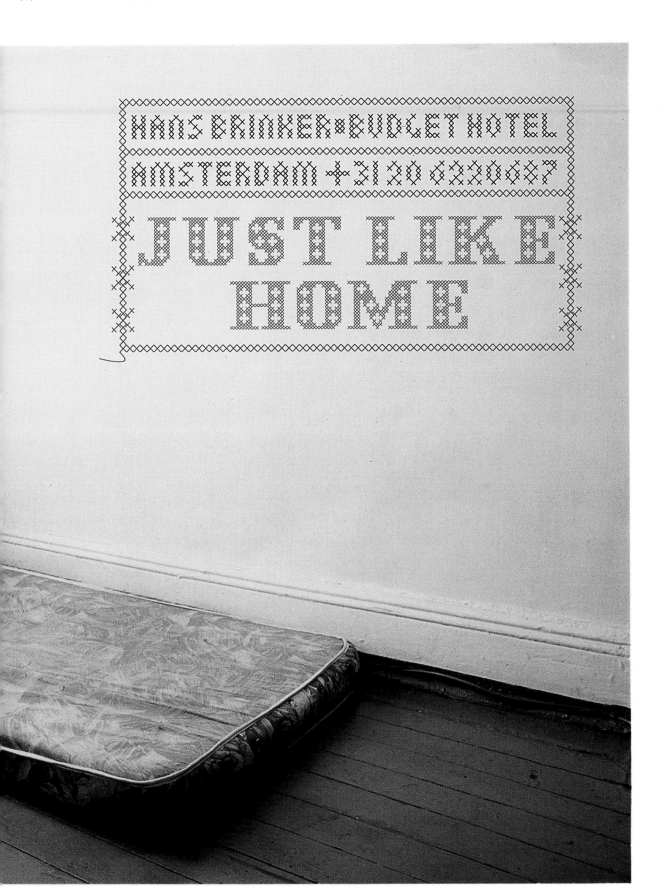

# Scott King

**"There's no point in doing decorative design... it would just interfere with what I had to say..."**

Opposite page:

**Project**
Poster

**Title**
Joy Division, 2 May 1980,
High Hall, The University
of Birmingham, England

**Client**
Self-published

**Year**
1999

Joy Division, 2 May 1980, High Hall, The University of Birmingham, England

"For me the worth of graphic design is its role in heightened moments of popular culture, the times when graphic design has contributed to inflicting change on society at large (Wyndham Lewis' 'Blast', Paris '68, British Punk …). I approach all my projects from the point of view that they are potentially a vehicle that can comment on different aspects of society, while making work that is visually exciting."

» Für mich liegt der Wert der Gebrauchsgrafik in der Rolle, die sie in Hochzeiten der populären Kultur spielt, Zeiten, in denen sie zu allgemeinen gesellschaftlichen Veränderungen beigetragen hat (z. B. Wyndham Lewis' ›Blast‹, Paris 1968, oder die britische Punkbewegung). Ich gehe bei allen meinen Projekten davon aus, dass sie potenziell ein Vehikel für einen Kommentar zu verschiedenen gesellschaftlichen Phänomenen darstellen. Dabei versuche ich, optisch ansprechende Arbeiten zu produzieren.«

« Pour moi, la valeur du graphisme réside dans son rôle lors des moments forts de la culture populaire, lorsqu'il contribue à apporter du changement dans la société dans son ensemble (‹ Blast › de Wyndham Lewis, Paris en mai 68, le punk britannique). J'aborde chacun de mes projets comme s'ils avaient le potentiel de commenter différents aspects de la société, tout en réalisant un travail qui soit visuellement excitant. »

**Scott King**
35 Baker's Hill
London E5 9HL
UK

T +44 20 8806 8336

E info@scottkingltd.com

www.scottkingltd.com

**Biography**
1969 Born in East Yorkshire, England
1988–1992 BA (Hons) Graphic Design, University of Hull

**Professional experience**
1993–1996 Art Director, i-D magazine, London
1997+ Co-founder of CRASH project, London
1999+ Represented as an artist by Magnani gallery, London
2000+ Scott King Limited, London
2001–2002 Creative Director, Sleazenation magazine, London

**Recent exhibitions**
1998 "The Problem Is You", ICA, London; "London's Burning with Boredom Now", billboard, Cubitt, London
1999 "How Shall We Behave?", Robert Prime, London; CRASH, ICA, London; CRASH, billboard, the Westway, London, commissioned by the ICA; "Urban Islands", Cubitt, London
2000 "The Robin Hood Complex", Forde, Geneva; "Etat des Lieux #2", Centre d'Art Contemporain, Fribourg; "Flatplan", Magnani, London
2001 "Part True Part False Like Everything", San Filippo, Torino
2002 "Scott King", Magnani, London; "Air Guitar", various galleries, UK

**Recent awards**
2001 Total Publishing Magazine Design Awards, Best Front Cover of the Year; and Best Designed Feature of the Year

**Clients**
Blast First / Mute
Earl Brutus
Institute of Contemporary Arts (ICA)
Malcolm McLaren
Michael Clark Dance Company
Pet Shop Boys
Sleazenation Magazine

**Project**
Print

**Title**
I'M WITH STUPID

**Client**
Scott King

**Year**
2001

Opposite page:

**Project**
Magazine

**Title**
Sleazenation

**Client**
Sleazenation

**Year**
2001

# SLEAZENATION
A MOLOTOV COCKTAIL OF FRONTLINE FASHION, ART, MUSIC AND DESIGN WITH ADDED INSOUCIANCE

**BOMB CULTURE**

HELMUT NEWTON
MOGWAI
THE ANTWERP SIX
GENESIS P-ORRIDGE
NOBUYOSHI ARAKI
FUTURA 2000
AUTECHRE
KLAUS NOMI

# SLEAZENATION
AN ABUNDANCE OF SUBLIME FASHION, ART, MUSIC AND DESIGN WITH A PEEK AT BLONDIE'S FLUFFER

**Some people should be shot**
Our photographers take on Britain

Sonic Youth

Whilst the UK press has gone 'mad' for the pretty progenitors of New York's current rock'n'roll renaissance, Sonic Youth remain largely unimpressed. Rather than delighting in stylised retrospection, the key for 'the Youth' is – and always has been – moving forward musically. Sleaze caught up with Thurston Moore, Kim Gordon, Lee Ranaldo, Steve Shelley, William Winant and new member Jim O'Rourke over dinner, to discuss their forays into avant garde, experimental music and to contemplate the changing face of New York. Text Lauren Zoric Photography Alandair McLellen

oung people: Sonic Youth – sacred cows who haven't made a decent record since *Daydream Nation*? Or the only living rock band who got out of grunge alive and went deeper underground, where no other rock band has gone before, to make NOIZE and fuck royally with the program? The answer is: whichever way you want it. Kim Gordon: "When I meet people who ask me what I do, I say I play in a band, they're like The Beatles, but more fucked up."

The trouble, or supreme joy, of Sonic Youth, is that any one of them, including Chicago genius Jim O'Rourke and former John Cage percussionist (and Kim Gordon high school pal) William Winant, who join us for dinner the night after their performance at SONAR (a festival of electronic music held annually in Barcelona), are so individually prolific and active across the entire spectrum of the arts, that to whack a tape recorder on the table and attempt to encompass all of their activities with equal respect, and crack the enigmatic nut that Sonic Youth has become, is, ultimately, to invite noble failure.

For the record: At 43, Thurston Moore looks like, and occasionally acts like, an 18 year-old skate punk brat. It's freaky. Lee Ranaldo's partner, photographer/artist Leah Singer, is imminently due to give birth to the couple's first child. He seems vaguely distracted. Jim O'Rourke is dressed for a Chicago winter and often breaks into high pitched hysterical giggling. He eats nothing except dessert, surviving on three espressos and cigarettes. Steve Shelley says little. "I mean, we talk about experimental music for an hour," he finally offers during his chocolate mousse, "and each one of us has ➡

SLEAZENATION.COM 073

# Fig. 03: **Pet Shop Boys** I get along

Fiercely independent, me.

I saw a couple in the supermarket today. They were in love. I wonder if they met there? I could go there today...I am out of fish fingers.

I love internet chat rooms. They're better than being in a real club or pub.

The weekends seem so long.

Other people look so happy.

I like spending time on my own. I'm enjoying getting to know myself again. I've never felt so alone, ever.

**Project**
CD single sleeve

**Title**
I Get Along

**Client**
Parlaphone Records

**Year**
2002

**Project**
CD artwork for Earls
Brutus album "Tonight
You are the Special One"

**Title**
I've got a Window
Wednesday

**Client**
Island Records

**Year**
1998

# Jeff Kleinsmith

## "There are no accidents."

Opposite page:

**Project**
Show poster

**Title**
Sky Cries Mary

**Client**
Rockcandy, Seattle

**Year**
1994

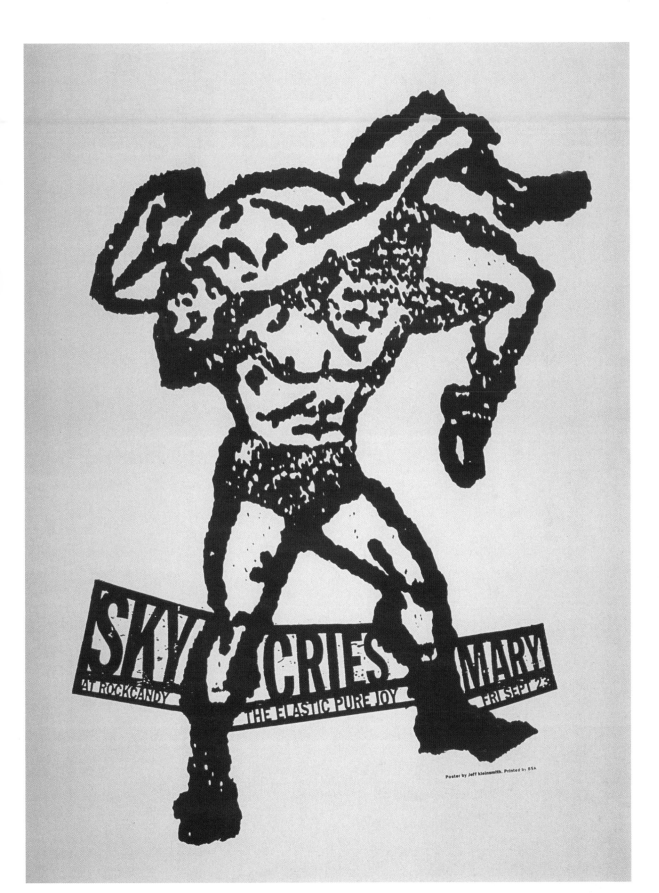

"Inasmuch as anyone's vision is able to penetrate into the future, it seems apparent that the future of graphic design lies in an unfortunate infatuation with technological gimmickry. The survival of design as a vital, evocative and relevant means of communication rests solely on the shoulders of those more committed to its practice than to forecasting its future. That said, the future of the sector of graphic design that interests me lies with as-yet-unknown young designers. Their new synthesis of influences (standing on the shoulders, or stepping in the faces of their forebears), seeing with new eyes – this is all far more exciting to me than the progress of the semantics of imagery, or upcoming trends in technology. Also, it seems, computers will be quite big."

» Wenn man überhaupt daran glaubt, dass man in die Zukunft blicken kann, erscheint es offensichtlich, dass die Zukunft des Grafikdesigns in der unglückseligen Vernarrtheit in technisch erzeugte Effekthascherei liegt. Das Überleben der Gebrauchsgrafik als lebendiges, ausdrucksstarkes und relevantes Kommunikationsmittel ruht ausschließlich auf den Schultern derjenigen, die sich engagiert mit seiner Ausführung statt mit seiner Zukunft beschäftigen. Davon abgesehen interessiert mich persönlich, welche gestalterischen Wege junge, noch unbekannte Designer beschreiten werden. Sie werden die Einflüsse von Designern (in deren Fußstapfen sie treten bzw. denen sie auf die Füße treten werden) zu neuen Formen verschmelzen, sie werden eine neue Sicht der Dinge haben – das finde ich viel spannender als die Fortschritte in der Semantik der Bilder oder neue technologische Entwicklungen. Außerdem, so scheint es, wird der Computer eine wichtige Rolle spielen.«

« Pour autant que l'on puisse se projeter dans le futur, tout porte à croire que l'avenir du graphisme réside dans le triste engouement pour les gadgets technologiques. La survie de la création en tant que moyen de communication vital, évocateur et pertinent repose entièrement sur les épaules de ceux qui sont engagés dans sa pratique plutôt qu'entre les mains des devins. Ceci dit, l'avenir du secteur graphique qui me concerne dépend de jeunes créateurs encore inconnus. Leur synthèse des influences passées (marchant sur les traces de leurs prédécesseurs ou les piétinant), leur regard neuf… tout ceci est bien plus excitant pour moi que le progrès de la sémantique de l'image ou les nouvelles tendances de la technologie. En outre, il semble que les ordinateurs joueront un rôle assez important. »

**Jeff Kleinsmith**
6708 9th Avenue NW
Seattle
WA 98117
USA

T +1 206 441 8441 / 3030
T +1 206 784 2144

E jeffk@subpop.com
E jeff@
    thepatentpending.com

www.subpop.com
www.
thepatentpending.com

**Biography**
1967 Born in Salem, Oregon
1985–1990 BA Graphic Design, University of Oregon

**Professional experience**
1989+ Co-owner, New Rage Records, Seattle
1990 Counter help, Zebra Copy, Seattle
Assistant Art Director, The Rocket Magazine, Seattle
1992 Co-founder, BSK / BLT Screen Printing, Seattle
1993 Art Director, The Rocket Magazine, Seattle
1994+ Art Director, Sub Pop Records, Seattle
2000+ Founder, Patent Pending, Seattle

**Recent exhibitions**
1994 "Poster Show", OK Hotel, Seattle
1995 Permanent collection, Rock and Roll Hall of Fame, Cleveland
1996 "Poster Show", Vox Populi, Seattle
1997 "NW Poster Show", Mike King Gallery, Portland
1998 "NW Poster Show", Mike King Gallery, Portland
1999 EMP feature, Online Gallery, Permanent Collection, Seattle
2000 "Jeff Kleinsmith: 100 Posters and 12 Paintings", Roq La Rue Gallery, Seattle
2002 "Paper, Scissors, ROCK!: 25 years of Northwest Punk Poster Design", Pacific Northwest College of Art, Portland, OR; "The Art of Sub Pop Records", Ground Zero Gallery, Hawaii; "Poster Show", S. S. Nova Gallery, Cincinnati

**Clients**
C/Z Records
Columbia Records
Crocodile
DreamWorks Records
Elektra Records
Empty Space Theatre
Experience Music Project
Graceland
Interscope Records
Moe
One Reel
Paramount
Sonic Boom Records
Sub Pop Records
Terminus Records
The Moore Theatre
The Rocket Magazine
V2 Records
Verve Records

**Project**
Show poster

**Title**
Mogwai

**Client**
The Showbox

**Year**
2001

**Project**
Show poster

**Title**
Afghan Whigs

**Client**
Rockcandy

**Year**
1993

**Project**
Show poster

**Title**
Supersuckers

**Client**
Graceland

**Year**
2000

Opposite page:

**Project**
Show poster

**Title**
Carissa's Wierd

**Client**
The Crocodile Cafe

**Year**
2002

# KM7

## "Fight for optical pleasure!"

Opposite page:

**Project**
Magazine spread for the
issue 'mafia'

**Title**
Mafia-Style

**Client**
Styleguide Magazine

**Year**
2001

"Moving in a world in which reality is becoming more and more a subject to the media, in which MTV-isions dominate and transform our personal way of seeing things, in a world where the media are pushing forward an obfuscation of regionality, I simply want to underline the importance of reaching back to your gut feeling. Create, don't imitate!"

» In einer Welt, in der die Realität immer mehr von den Medien gezeichnet wird, die MTVisierung unsere Sicht der Dinge bestimmt und regionale Grenzen verschwinden lässt, empfinde ich persönlich es als besonders wichtig, auf sein eigenes, aus-dem-Bauch-heraus-Gefühl zu vertrauen. Create, don't imitate!«

« Évoluant dans un monde où la réalité est de plus en plus assujettie aux médias, où les MTV-isations dominent et transforment nos manières individuelles de voir les choses, où les médias favorisent l'obscurcissement des caractères régionaux, je tiens simplement à souligner l'importance de se fier à son instinct. Créez, n'imitez pas ! »

**Designbureau KM7**
Schifferstrasse 22
60594 Frankfurt/Main
Germany

T +49 69 9621 8130
F +49 69 9621 8122

E mai@km7.de

www.km7.de

**Design group history**
1994 Founded by Klaus
Mai in Frankfurt

**Founder's biography**
1960 Born in Schwäbisch
Hall, Germany
1990 Intern, Paul Davis
Studio, New York
1991–1994 Art Director,
Trust Advertising Acency,
Frankfurt
1994 Founded own
design studio, KM7

**Recent awards**
1991 Honourable
Mention, Art Directors
Club Germany
1993 Honourable
Mention (x2), Art Directors Club Germany
1995 Silver Medal and
Honourable Mention, Art
Directors Club Germany
1996 Award for Best
Packaging in Mexico;
Silver Medal and
Honourable Mention,
Art Directors Club
Germany
1998 Honourable
Mention, Art Directors
Club Germany
2001 Honourable
Mention (x2), Art Directors Club Germany
2002 Award for Best
Designed Book, Stiftung
Buchkunst

**Clients**
Audi
DaimlerChrysler
Die Gestalten Verlag
MTV
Nike
Rockbuch Verlag
Sony Music
Swatch
Universal Music
Volkswagen

**Project**
CD-Cover for the band
"Funky Bees"

**Title**
Eifersucht

**Client**
Wolf Promotion

**Year**
1999

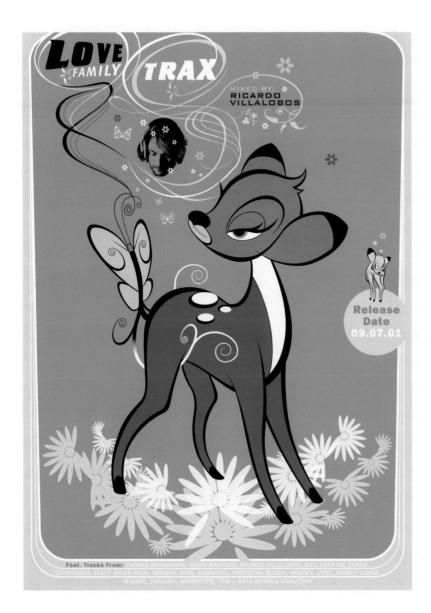

**Project**
Poster for the compilation
"Love Family Trax"
Poster for the event "Love
Family Park"

**Title**
Love Family Park

**Client**
Fedi Chourkair

**Year**
2001

**Project**
On-Air-Design for the
television station MTV

**Client**
MTV networks

**Year**
1999

Opposite page:

**Project**
Album cover for the band
"Tokyo Ghetto Pussy"

**Title**
Disco 2001

**Client**
Sony Music
Entertainment

**Year**
1997

# Christian Küsters

## "Context + Concept + Collaboration >> Communication"

Opposite page:

**Project**
Exhibition poster

**Title**
Superstructure

**Client**
Museum für
Gegenwartskunst, Zurich

**Year**
1998

Angela Bulloch

SUPERSTRUCTURE

4. April – 14. Juni 1998
Museum für Gegenwartskunst
Limmatstrasse 270
CH-8005 Zürich
Dienstag–Freitag 12–18h
Samstag und Sonntag 11–17h

MIGROS
Kulturprozent

Museum
für
Gegenwartskunst
Zürich

"In the future I think that Graphic Design will become more varied, fragmented and ultimately more specialised. From early on in their careers visual communicators will have to choose their area of specialisation. On the one hand it means that it will become increasingly difficult for the individual designer to work successfully across different disciplines within the field of visual communication. Those disciplines can range from font design to photography and digital retouching, over to animation and feature film and might consequently manifest itself in print, digital media or film. On the other hand, this development inevitably opens up more possibilities for various kinds of collaborations. And from my point of view that's where I think the future is; an interesting collaboration between individuals which at its best creates inspiring work."

» Ich glaube, dass Grafikdesign in der Zukunft variantenreicher, fragmentierter und letztendlich spezialisierter sein wird. Schon früh in ihrer Karriere werden Designer sich aussuchen müssen, auf welchen Bereich sie sich spezialisieren wollen. Einerseits bedeutet das, dass es immer schwieriger für den einzelnen Designer werden wird, in vielen Disziplinen der visuellen Kommunikation tätig zu werden, zu denen von Font-Design, Fotografie und digitaler Bildbearbeitung über Animationen und Feature-Filme alles bis zu Print- und digitalen Medien sowie Film gehören kann. Auf der anderen Seite eröffnet die Entwicklung neue Optionen für alle möglichen Kooperationen. Und von meinem Standpunkt aus sieht die Zukunft genau so aus: eine interessante Zusammenarbeit zwischen Individuen, die im besten Fall inspirierende Arbeiten hervorbringt.«

« A l'avenir, je pense que le graphisme sera plus varié, plus fragmenté et, finalement, plus spécialisé. Dès le début de leur carrière, les communicateurs visuels devront choisir leur spécialité. D'un côté, cela signifie qu'il sera de plus en plus difficile pour le graphiste individuel de naviguer librement d'une discipline à l'autre au sein de la communication visuelle. Ces disciplines iront de la conception de polices de caractère, de la photographie et des retouches numériques aux films d'animation ou de fiction, et pourront donc se manifester sous forme de papier, de média numérique ou de film. D'un autre côté, cette évolution ouvrira inévitablement de nouvelles possibilités à différentes sortes de collaborations. A mon avis, c'est là que se situe l'avenir : dans une collaboration intéressante entre des individus qui, quand elle fonctionne bien, crée des travaux inspirants. »

**Christian Küsters**
CHK Design
21 Denmark Street
London WC2H 8NA
UK

T +44 20 7836 2007
F +44 20 7836 2112

E studio@
chkdesign.demon.co.uk

www.acmefonts.net
www.restartinteractive.co.uk

**Biography**
1966 Born in Oberhausen, Germany
1993 BA(Hons) Graphic Design, London College of Printing
1995 MFA, Yale University School of Art, New Haven, Connecticut
1996 Research trip to Tokyo, Japan (Yale University Travel Fellowship)

**Professional experience**
1993 Taught and lectured at Yale School of Art, Central St Martin's College of Art and Design, Antwerp Citype conference, London College of Printing, Camberwell College of Arts
1995 Founded CHK Design, London
1996 Founded Acme Fonts (Digital Typefoundry), London
1997 Art Director and Designer, Booth-Clibborn Editions, London
1998 Art Director and Designer, Black Dog Publishing, London
1999+ Art Director, AD Architectural Design magazine, London
2001 Restart: New Systems in Graphic Design, book concept, co-author with Emily King (Thames & Hudson)
2002+ Art Director, MAKE magazine, London
2002 Design Now – Graphics, exhibition concept, co-curator with Emily King and exhibition design with Marcus Maurer, Design Museum, London

**Recent awards**
1999 New York Type Directors Club Award; Tokyo Type Directors Club Award
2000 Hana Haru Festa 2000, Tokushima, Japan; Tokyo Type Directors Club Award
2001 Tokyo Type Directors Club Award

**Clients**
Academy Editions
Alexander McQueen
Architectural Association
Black Dog Publishing
Booth-Clibborn Editions
Design Museum London
Institute of Contemporary Arts
Laurent Delaye Gallery
Milch Gallery
Museum für Gegenwartskunst, Zurich
Thames & Hudson
Yale School of Architecture

Opposite page:

**Project**
Poster for book launch and lecture for 'Restart'

**Title**
Restart: New Systems in Graphic Design

**Client**
Thames & Hudson, London

**Year**
2001

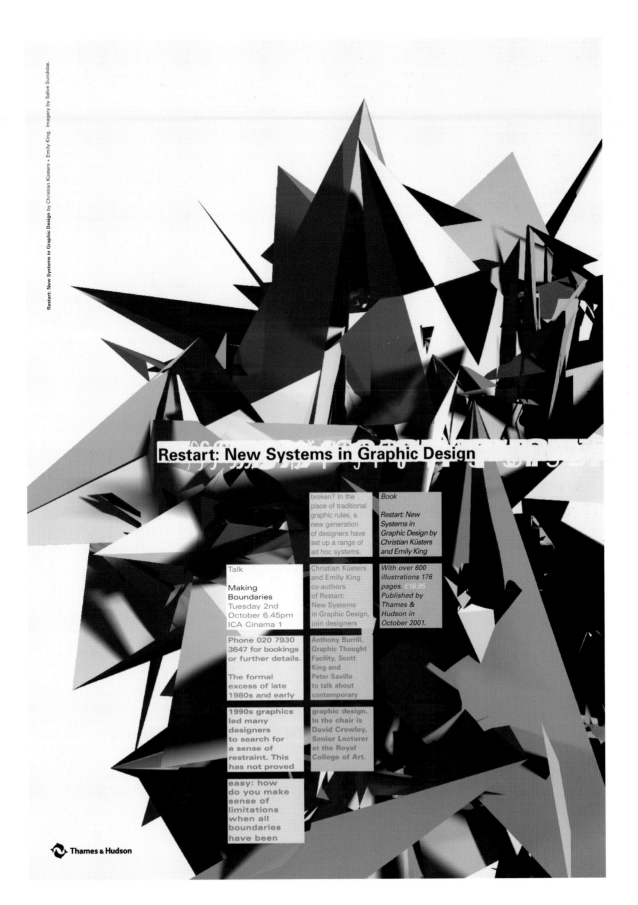

Restart: New Systems in Graphic Design by Christian Küsters + Emily King. Imagery by Salve Sundsbø.

## Restart: New Systems in Graphic Design

broken? In the
place of traditional
graphic rules, a
new generation
of designers have
set up a range of
ad hoc systems.

Book

*Restart: New
Systems in
Graphic Design by
Christian Küsters
and Emily King*

Talk

Making
Boundaries
Tuesday 2nd
October 6.45pm
ICA Cinema 1

Christian Küsters
and Emily King
co-authors
of Restart:
New Systems
in Graphic Design,
join designers

With over 600
illustrations 176
pages. £16.95
Published by
Thames &
Hudson in
October 2001.

Phone 020 7930
3647 for bookings
or further details.

Anthony Burrill,
Graphic Thought
Facility, Scott
King and
Peter Saville
to talk about
contemporary

The formal
excess of late
1980s and early

1990s graphics
led many
designers
to search for
a sense of
restraint. This
has not proved

graphic design.
In the chair is
David Crowley,
Senior Lecturer
at the Royal
College of Art.

easy: how
do you make
sense of
limitations
when all
boundaries
have been

Thames & Hudson

**Project**
Fashion catalogue

**Title**
Pearl in a Battlefield

**Client**
Fashion label "justMariOt"

**Year**
2001

# Lateral Net Ltd

## "Form follows function follows the heart"

Opposite page:

**Project**
Website

**Title**
www.lateral.net

**Client**
Self-published

**Year**
2001

"How does one predict the future? Not having any supernatural powers to speak of, I must use the tried and tested methods of Science Fiction, that of observation, understanding followed by extrapolation. As with the origins of the Universe, the contemporary field of design has returned to the all-encompassing singularity that is known as the pixel. While we leap into this new millennium we embrace the blue shift and as predicted have started going backwards. Simplification, minimalization and sanitization are the buzzwords of the digital design literati. With the bright becoming mute, while those in the dark find themselves feeling increasingly more grey. Hastened perhaps by a generation of designers desiring to recapture their pre-adolescent youth. It would seem in the end that form has finally won its bloody battle against that scourge of all things creative: function. The carcasses of intelligent communication have been left to rot all over the binary front line that is the Internet. If you are to believe any of the above then the following assertions should come as no surprise: 2005 will see the reintroduction of hot metal; 2010 will welcome back the parchment, quill and ink and we'll be back in caves by 2020. So it is written, so it shall be. ;-)"
(Jon Bains – Chairman, Lateral Net)

» Wie sagt man die Zukunft voraus? Da ich keine übernatürlichen Kräfte besitze, muss ich auf die bewährten Methoden der Science Fiction zurückgreifen: zu verstehen und daraus wahrscheinliche Folgen abzuleiten. Wie bei der Entstehung des Universums ist auch das zeitgenössische Design zur elementaren Einheit zurückgekehrt, die wir Pixel nennen. Beim Sprung ins neue Jahrtausend machen wir uns den Wechsel ins blaue Spektrum zu eigen und haben damit begonnen, rückwärts zu gehen. Vereinfachung, Reduktion und Bereinigung lauten die Modeworte der Computerdesignszene. Beschleunigt von einer Designergeneration, die ihre vorpubertäre Jugend wiederfinden möchte. Es scheint, als hätte die Form zu guter Letzt ihren blutigen Kampf gegen die Geißel jeder Kreativität gewonnen, die da heißt Funktion. Man hat die Leichen intelligenter Kommunikation an der binären Front des Internets liegen lassen. Sollten Sie irgendeine der obigen Aussagen für wahr halten, werden die folgenden Sie nicht überraschen: 2005 wird das heiße Eisen wieder eingeführt, 2010 Pergament, Gänsefeder und Tinte und im Jahr 2020 werden wir wieder in Höhlen wohnen. So steht es geschrieben, so wird es sein. ;-)«
(Jon Bains, Vorstand von Lateral Net)

« Comment prédire l'avenir ? N'ayant pas de pouvoirs surnaturels, je dois me rabattre sur les méthodes de science-fiction qui ont fait leurs preuves : l'observation et la compréhension, suivies de l'extrapolation. Comme pour les origines de l'univers, le champ contemporain du graphisme est revenu à l'unicité qui englobe tout, à savoir le pixel. Tandis que nous nous lançons dans ce nouveau millénaire, nous nous acheminons vers la région bleue du spectre et, avons commencé notre régression. Simplification, minimalisation et assainissement sont les mots clefs de l'intelligentsia du graphisme numérique. Les plus vifs sont étouffés et les sombres virent aux gris. Ils sont pressés par une génération de créateurs désireux de retrouver leur jeunesse prépubère. Finalement, il semblerait que la forme ait remporté sa guerre sanglante contre ce fléau de la créativité qu'est la fonction. Les dépouilles pourrissantes de la communication intelligente ont été abandonnées sur le front binaire de l'internet. Si vous croyez ce qui précède, les déclarations qui suivent ne vous surprendront pas : en 2005, nous assisterons au retour du métal chaud, en 2010, à celui du parchemin, de la plume d'oie et de l'encre, en 2020, nous aurons réintégré les cavernes. C'est écrit, il en sera ainsi. ;-) »
(Jon Bains, Président de Lateral Net)

**Lateral Net Ltd**
47–49 Charlotte Road
London EC2A 3QT
UK

T +44 20 7613 4449
F +44 20 7613 4645

E studio@lateral.net

www.lateral.net

**Design group history**
1997 Co-founded by Jon Bains, Simon Crab, Dave Hart and David Jones at Winchester Wharf, Clink Street, London
1999 Moved to Hoxton, London

**Founders' biographies**
Jon Bains
1971 Born in New York
1975 Moved to Scotland
1991 Honourably dropped out of Edinburgh University to set up Convulsion fanzine (first desk top published fanzine and first online fanzine) and the Apocalypse Club (alternative music night), Edinburgh
1994 Launched IUMA (Internet Underground Music Archive by Southern Records), London
1995–1997 Founder, Obsolete (Pioneering new media collective), London
1997+ Co-founder and Chairman, Lateral Net, London

Simon Crab
1963 Born in Liverpool, England
1982–1986 BA Fine Art, Slade College of Art, London
1990–1994 Co-founder, Seven Interactive, London
1995–1997 Member, Obsolete (Pioneering new media collective), London
1997+ Co-founder and Creative Director, Lateral Net, London
Dave Hart
1956 Born in Johannesburg
1980–1982 Brand Manager, Johnson Wax, London
1982–1985 Account Manager, Supervisor and Director, Grey Advertising, London
1987–1989 Account Director, Boase Massimi Pollit, London
1995 Global Development Director, Ogilvy & Mather Worldwide, South East Asia

1995+ In charge of Internet Division, Prince plc. IT Company, London
1995–1997 Partner and Managing Director, H:Kr Limited, London
1997+ Co-founder and Client Services Director, Lateral Net, London
David Jones
1979–1981 Business Studies degree, University of London
1987–1991 Director, Chromatose Films, London
1995–1997 Member, Obsolete (Pioneering new media collective), London
1997+ Co-founder and Creative Director (Concepts), Lateral Net, London

**Recent awards**
1999 Winner, The Emma Awards, International; Winner, Campaign Media Awards, Best Use of New Media, London; Winner, DMA Awards, Best Use of New Media, London; Winner, Media & Marketing Awards (Europe), Best Use of New Media; Winner, New Media Age Effectiveness Awards, London; Silver Award, The One Show, New York; Winner, New Media Age Effectiveness Awards, Consumer Products and Services, Best Use of Online Advertising
2000 Winner FAB (Food & Beverages) Awards; Best Use of New Media, London; Winner, Media & Marketing Awards, Best Use of New Media, London; Campaign Media Awards, Three finalists in Best Use of Media, Best International Campaign, Best Use of Mixed Media, London

2001 Winner, Media Age Awards, Digital Advertising, Finalist, Brand Building and Sponsorship, London; Revolution Awards, Best Use of Online Advertising, London
2002 Winner, Revolution Awards, Best-Integrated Campaign, London

**Clients**
Action Aid
Bloomsbury
British Council
Faber and Faber
Foyer Foundation
Interbrew
Levi Strauss
Mars
Microsoft Xbox
New Grafton Gallery
New Media Knowledge
Odeon
Richard Green
RSPCA
Solange Azagury-Partridge
SSM Coal
TCS

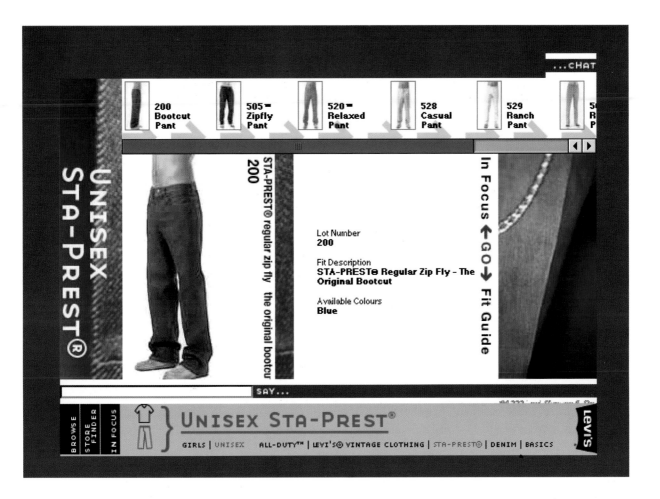

**Project**
Website

**Title**
Levi Concept Browser

**Client**
Levi Strauss

**Year**
2000

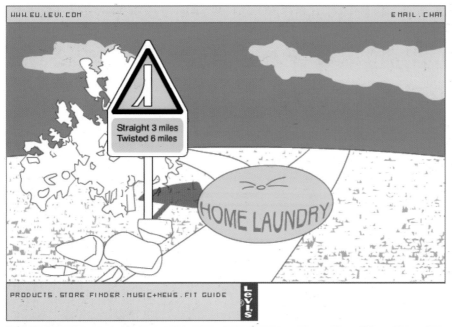

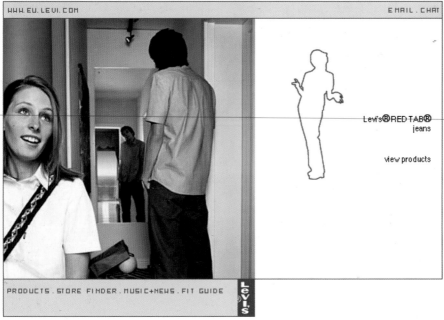

**Project**
Website

**Title**
eu.levi.com Spring 2000

**Client**
Levi Strauss

**Year**
2000

Opposite page:

**Project**
Website

**Title**
The Blairwitch Project

**Client**
Pathe

**Year**
1998

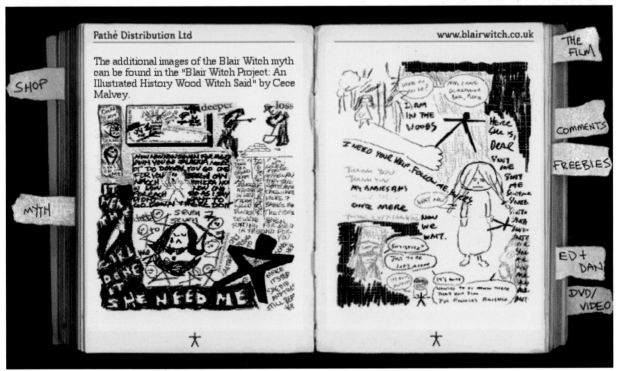

# Golan Levin

**"What is the depth and character of the feedback loop established between the system and its user?"**

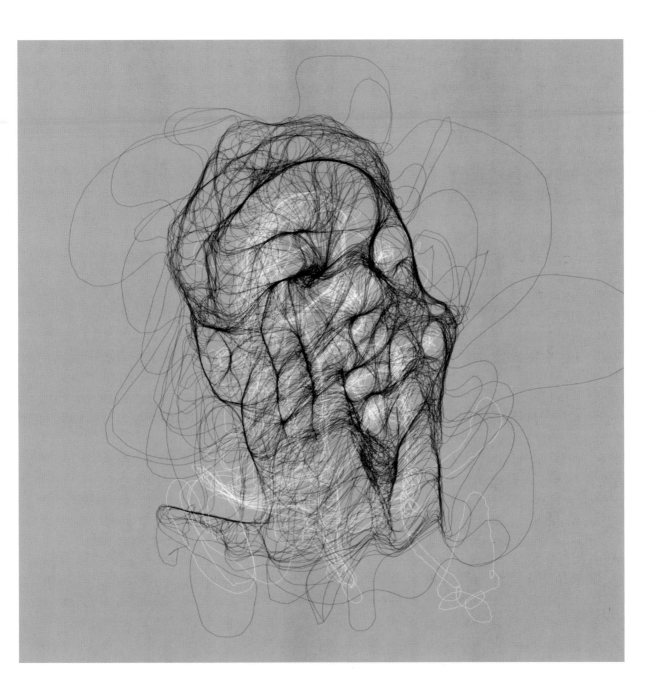

**Project**
Dynamic Abstraction

**Title**
Floccular Portrait
(Paul Yarin)

**Client**
Self-published

**Year**
1999

"In one dystopia, we project ourselves into the art supply store of the near future. The wind howls through the room, whose shelves are empty but for three small cartons: Flash, Photoshop, Illustrator. For today's digital designers – many of whom have eagerly adopted the narrow horizons dictated by this small handful of commercial products – this vision is, I claim, already a reality. And the unquestioned hegemony of these tools has launched an unprecedented proliferation of homogeneous and disposable electronic designs. To state that computers can offer an unimaginably greater world of possible forms than these products is not techno-optimism; as computers are provably capable of simulating any other machine, it is mathematical fact. My own work is simply one person's attempt to reclaim computation as a 'personal medium' of expression. In my design practice, I focus the radical plasticity of the computational medium on an examination of non-verbal communications protocols."

» In einer Dystopie projizieren wir uns selbst in den Künstlerbedarfsladen der nahen Zukunft. Der Wind heult durch diesen Raum, dessen Regale bis auf drei kleine Kartons mit Flash, Photoshop und Illustrator leer sind. Ich behaupte einfach mal, dass diese Vision für die heutigen Computerdesigner – von denen viele voller Eifer die von dieser Handvoll handelsüblicher Produkte vorgeschriebenen engen Horizonte akzeptiert haben – bereits Realität ist. Die unangefochtene Hegemonie dieser Arbeitsmittel hat zur beispiellosen Vermehrung homogener elektronischer Wegwerfdesigns geführt. Zu sagen, Computer könnten eine unvorstellbar größere Menge möglicher Formen erzeugen als diese Programme, ist kein Techno-Optimismus, sondern – da Computer erwiesenermaßen in der Lage sind, jede andere Maschine zu simulieren – eine mathematische Tatsache. Meine eigene Arbeit ist einfach der Versuch eines Einzelnen, den Rechner als ›persönliches Ausdrucksmittel‹ zurückzugewinnen. Ich wende die extreme Plastizität des Computermediums auf die Untersuchung non-verbaler Kommunikationsprotokolle an.«

« Imaginons une contre-utopie où nous nous promenons dans un magasin de fournitures d'art du futur. Le vent hurle à travers la salle dont les rayonnages ne contiennent que trois petites boîtes : Flash, Photoshop et Illustrator. Pour les infographistes d'aujourd'hui, dont beaucoup ont adopté avec enthousiasme les horizons étroits dictés par cette poignée de produits, j'affirme que cette vision est déjà une réalité. L'hégémonie incontestée de ces outils a déclenché une prolifération sans précédent de graphismes électroniques uniformes et jetables. Dire que les ordinateurs peuvent offrir un univers de formes possibles infiniment plus vaste que ces produits relève du techno optimisme. Les ordinateurs étant capables de stimuler n'importe quelle autre machine, c'est un fait mathématique. Mon propre travail consiste simplement à tenter de renouer avec la computation comme ‹moyen personnel› d'expression. Dans la pratique, je concentre la plasticité radicale de l'ordinateur sur un examen des protocoles de communications non verbaux. »

**Golan Levin**
78 S. Elliot Place
Brooklyn
NY 11217
USA

T +1 646 418 7294

E golan@flong.com

www.flong.com

**Biography**
1972 Born in New York City
1994 BS Art and Design, MIT, Cambridge
2000 MS Media Arts and Sciences, MIT, Cambridge, Massachusetts

**Professional experience**
1990–1994 Undergraduate Research Assistant, MIT Media Laboratory, Cambridge, Massachusetts
1993–1994 Interface Design Consultant, Boston Digital Corporation, Woburn
1994–1998 Research Scientist and Interaction Designer, Interval Research Corporation, Palo Alto, California
1998–2000 Research assistant, MIT Media Laboratory, Cambridge, Massachusetts
2000–2002 Computational Designer, Design Machine NYC, New York

**Recent exhibitions**
2001 "Young Guns 3", Art Directors' Club Gallery, New York; "Ars Electronica Museum of the Future", Linz, Austria; Tirana Bienniale, Tirana, Albania; "Animations", P.S.1 Contemporary Art Center, New York; "The Interact '01 Bienniale", Softopia Center, Ogaki, Japan
2002 "Golan Levin/Casey Reas", Bitforms Gallery, New York; "Cibervisión 02", Centre Conde Duque, Madrid; Inaugural Exhibition, Austin Museum of Digital Art, Austin, Texas; "Impressionism Interactive", Fondation Beyeler, Basle, Switzerland; Daejon Municipal Museum of Art, Daejon, Korea

**Recent awards**
2000 Honorary Mention, Tokyo Type Directors Club Awards, Tokyo; Winner, ASCI Digital 2000 Competition, New York; Bronze Medallist, I.D. magazine Interaction Design Awards, New York; Winner, Communication Arts Interactive Design Annual, Palo Alto, California; Best of Interactive Category, BitByBitDigital juried exhibition, Denver, Colorado; Award of Distinction (2nd prize), Prix Ars Electronica 2000, Linz, Austria
2001 Honourable Mention, Interactive Art Prize, Berlin Transmediale '01, Berlin; Artist's Grant, The Greenwall Foundation, New York; Artist's Grant, The Daniel Langlois Foundation, Montreal; Artist's Grant, The Greenwall Foundation, New York
2002 Artist's Grant, New York State Council on the Arts, New York

**Clients**
Art+Com
Full Frontal Media
Public Broadcasting Service
StudioAKA
Swiss National Exposition
Turbulence

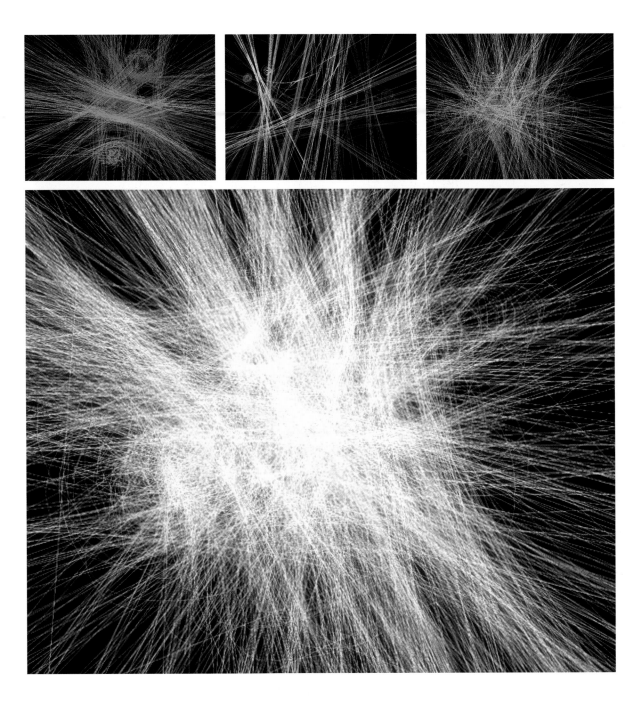

**Project**
Dynamic Abstraction

**Title**
Directrix

**Client**
Self-published

**Year**
1998

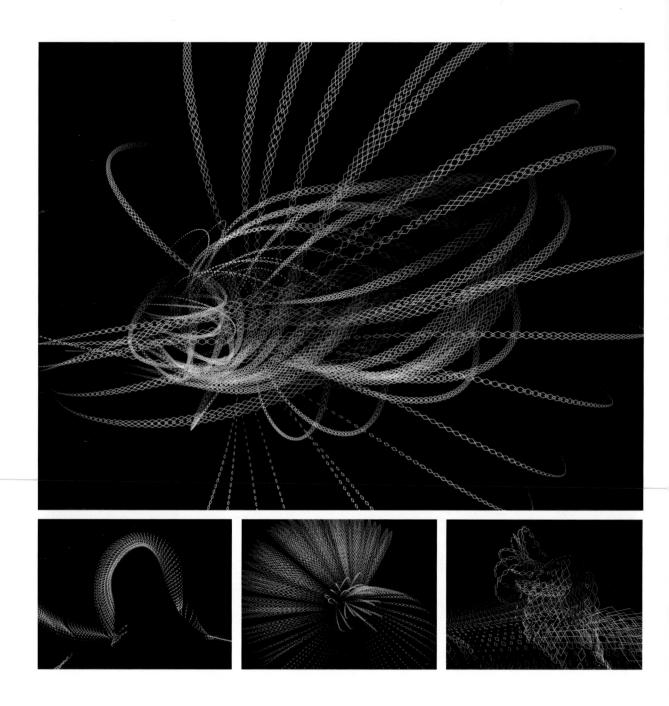

**Project**
Dynamic Abstraction

**Title**
Meshy

**Client**
Self-published

**Year**
1998

**Project**
Dynamic Abstraction

**Title**
Floccus

**Client**
Self-published

**Year**
1999–2000

# Lust

## "Form-follows-process"

Opposite page:

**Project**
Signage

**Title**
Signage for Volharding
Building, The Hague

**Client**
Wils&Co, Architectural
Platform of The Hague

**Year**
1999

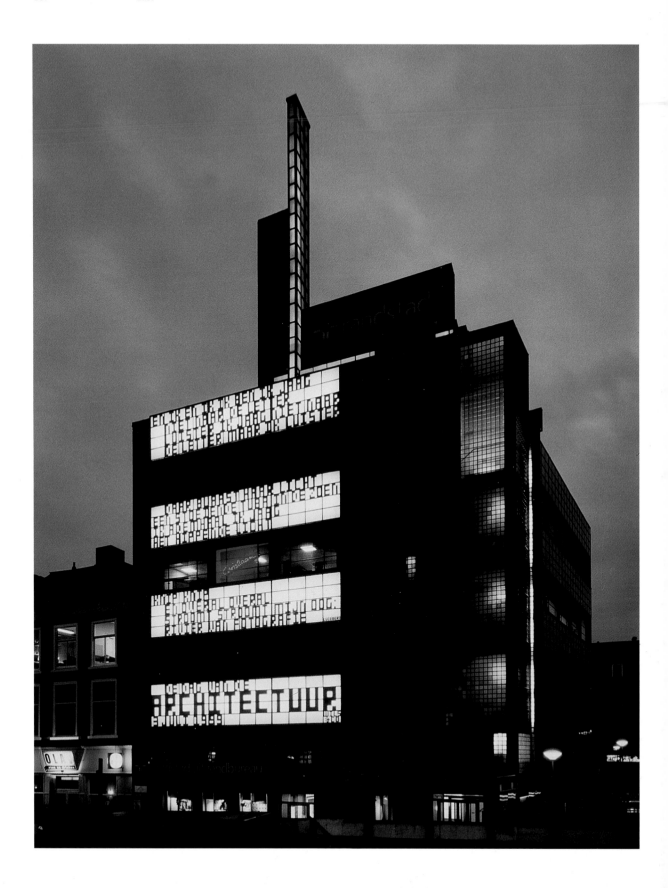

"At the beginning of the 21st century, the decentralization of power and information has produced an extreme number of different cultures and subcultures. People distinguish and define themselves through their direct surroundings, including virtual ones. The complete break with mechanical tools and devices has led to a print culture that is saved by the grace of the human senses. The only right of existence for paper or its substitutes is the natural desire to keep your feet on the ground while your head is in the clouds. The rest of us have become electric."
(Dimi Nieuwenhuizen)

»Zu Beginn des 21. Jahrhunderts hat die Dezentralisierung von Macht und Information eine Fülle verschiedener Kulturen und Subkulturen hervorgebracht. Die Leute definieren sich selbst über ihre unmittelbare Umgebung, einschließlich der virtuellen. Der völlige Bruch mit mechanischen Werkzeugen und Arbeitsmitteln hat zu einer Kultur der Printmedien geführt, die nur durch die Gnade der menschlichen Sinne gerettet wird. Die einzige Daseinsberechtigung des Papiers oder seiner Ersatzstoffe liegt in dem natürlichen Bestreben, mit beiden Füßen auf dem Boden zu bleiben, während der Kopf in den Wolken steckt. Alle anderen hängen am Computer.«
(Dimi Nieuwenhuizen)

«Au début du XXIe siècle, la décentralisation du pouvoir et de l'information a généré une multiplication extrême des cultures et sous-cultures. Les gens se distinguent et se définissent par leur environnement immédiat, y compris le virtuel. La rupture totale avec les outils et les instruments mécaniques a donné lieu à une culture de l'impression sauvée par la grâce des sens humains. La seule raison d'être du papier ou de ses substituts est le désir naturel de garder les pieds sur terre alors que nous avons la tête dans les nuages. Les autres d'entre nous sont devenus électriques».
(Dimi Nieuwenhuizen)

**Lust**
Dunne Bierkade 17
2512 BC The Hague
The Netherlands

T +31 70 363 5776
F +31 70 346 9892

E lust@lust.nl

www.lust.nl

**Design group history**
1996 Co-founded by Jeroen Barendse and Thomas Castro in Utrecht
1999 Dimitri Nieuwenhuizen joined Lust as a partner
2000 Lust moved into the historical house of the Dutch master, Paulus Potter in The Hague

**Founders' biographies**
Jeroen Barendse
1973 Born in Poeldijk, The Netherlands
1991–1993 Studied Graphic Design at the Academy of Arts, Utrecht
1993–1995 Studied Graphic Design at the Academy of Arts, Arnhem
1994 Interned with the designer Lex Reitsma, Haarlem
1995 Graduated from the Academy of Arts, Arnhem
1995–1996 Worked as a freelancer for Roelof Mulder, Arnhem
1996 Co-founded Lust
1998–1999 Involved with Werkplaats Typografie, Arnhem
Currently teaches Graphic Design at the Academy of Arts, Arnhem

Thomas Castro
1967 Born in Queson City, Philippines
1975 Emigrated to Placentia, California
1987–1990 Studied Psychology and Fine Art at the University of California
1991–1993 Studied Graphic Design at the Academy of Arts, Utrecht
1993–1995 Studied Graphic Design at the Academy of Arts, Arnhem
1995–1996 Worked for the Barlock design company, The Hague
1996 Co-founded Lust

Dimitri Nieuwenhuizen
1971 Born in Bergen op Zoom, The Netherlands
1991–1993 Studied Industrial Design at the Delft University of Technology
1993–1997 Studied Man and Activity at the Design Academy in Eindhoven
1996 Founded Studio ZOAB
1997 Graduated with "cum laude" and received the "Wolkenkrabber Prize"
1999 Joined Lust as a partner

**Recent exhibitions**
1997–1998 "A Fictional History of the Internet", Gallery Arti & Amicitiae, Amsterdam
1998 "Do Normal", San Francisco Museum of Modern Art
1999 "Mooi Maar Goed" (Beautiful but Good), Stedelijk Museum, Amsterdam
2000 "InfoArcadia", Stroom hcbk, The Hague; "Le Graphisme Néerlandais", Institut Néerlandais, Paris; Biennale 2000, Brno, Czech Republic
2001 "Exhibit A", Center for Creative Studies, Detroit; "HD (Holland Design/New Graphics)", Galerie Ras, Barcelona

**Clients**
010 Publishers
3.TO Architects
Atelier HSL
Ben & Jerry's
Booth-Clibborn Publishers
City of The Hague
Corus
De Program Workshop
Discreet Logic
Dutch Police
FontWorks UK
Forex Inc.
Huis Marseille: Foundation for Photography
ITO
Jan van Eyck Academie
KPN Research
KPN Telecom
KPN
LOOS
Marshall McLuhan Institute
McKinsey Int'l.
Mecano
Ministry of Foreign Affairs
Museum Boijmans Van Beuningen
Neutelings/Riedijk Architecten
New Media Group
Palmboom & Van den Bout: Urban Planners
Paradiso Club/Concert Hall
PTT Post
Rijksacademie, Amsterdam
Rotterdam 2001: Cultural Capital of Europe
RPHS Architects
ST&M
STROOM hcbk
Third Millennnium Challenge
TNO
TYP
Victor Freijser Achitecture Productions
Vormgevingsinstituut (Design Institute)
Washington Mutual Bank
Waterweg Centrum
Wils&Co Architecture Platform The Hague
YD+I
ZAAZ
Zefir7

**Project**
Website

**Title**
Atelier HSL Website

**Client**
Atelier HSL, Amsterdam

**Year**
2001

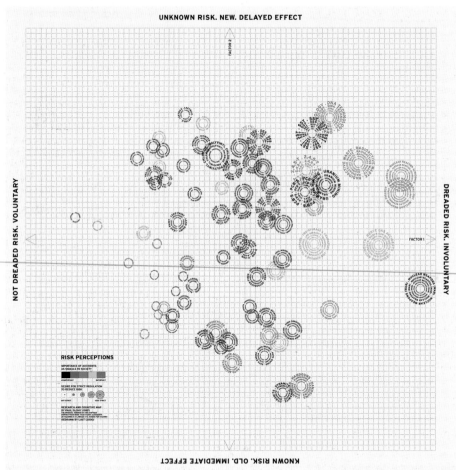

**Project**
Exhibition graphics

**Title**
Risk Perception Carpet for
InfoArcadia

**Client**
Ronald van Tienhoven /
Maärten de Reus /
Stroom HCBK,
The Hague

**Year**
2000

Opposite page:

**Project**
Website

**Title**
LOOS Ensemble Website

**Client**
LOOS Ensemble

**Year**
1999–2000

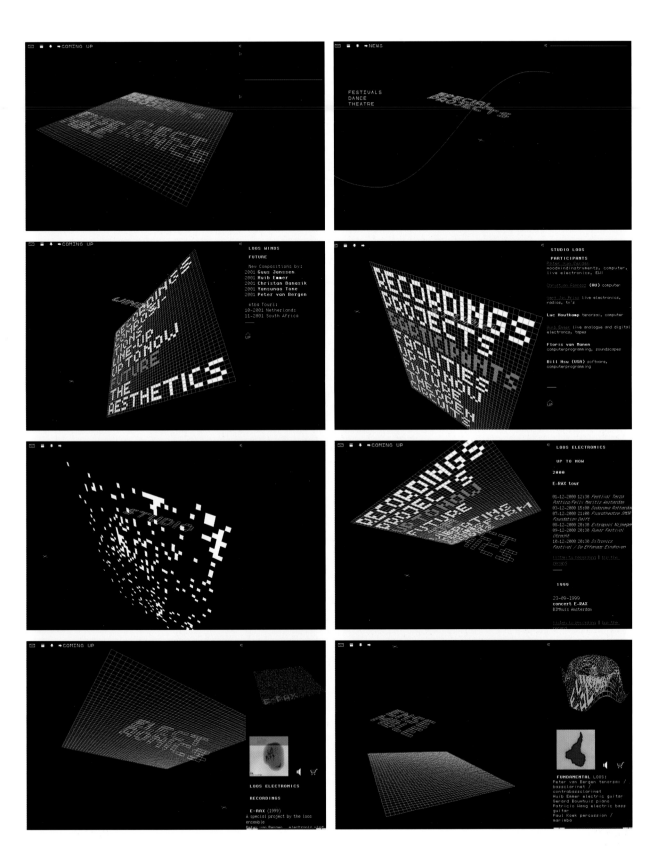

# M.A.D.

"Design is an alternative to ignorance and misconception."

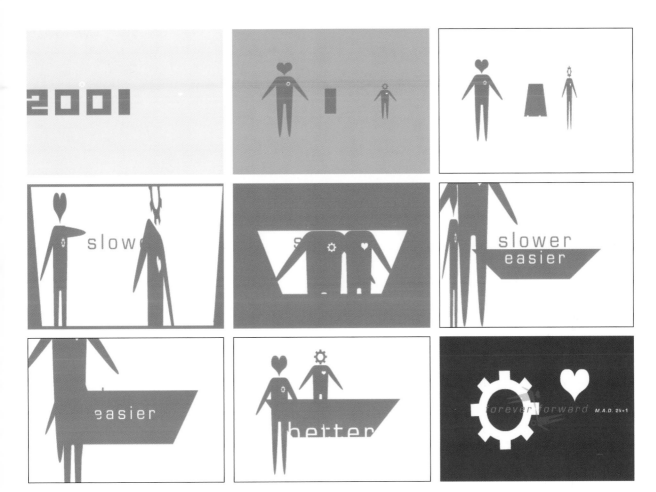

**Project**
Animated New Year's
card

**Title**
2001

**Client**
ONE magazine / DIFFA
[Design Industries
Foundation Fighting Aids]

**Year**
2001

"Graphic design has certainly been one of the faster changing professions in the last decade, but like all other design disciplines it is a part of today's global crisis. We have always designed for the future: in hope of increased pleasure, comfort, power, efficiency and return on investment. This time around we must design because of the past. We must counter a legacy of designs that left us with too much clutter, misinformation, pollution and dangerous inventions. We have progressively learnt to adapt to a world of increased acceleration and complexity. It is now time for the designed world to adapt back to humanity and for us to bring solutions of slowness and simplicity. Innovation should be defined not by novelty, but by sustainability."

» Die Tätigkeit des Grafikers gehört sicher zu den Berufen, die sich im letzten Jahrzehnt am schnellsten verändert haben, aber wie andere gestalterische Berufe auch ist er an der heutigen weltweiten Krise beteiligt. Wir haben immer für die Zukunft entworfen, in der Hoffnung auf mehr Vergnügen, Komfort, Macht, Effizienz und Rendite. Jetzt müssen wir wegen der Vergangenheit gestalten. Wir müssen der Hinterlassenschaft eines Designs entgegentreten, das uns zu viel Unordnung, Desinformation, Umweltverschmutzung und gefährliche Erfindungen beschert hat. Wir haben gelernt, uns einer sich immer schneller drehenden und immer komplizierteren Welt anzupassen. Jetzt muss sich die gestaltete Welt wieder der Menschheit anpassen und es ist an den Designern, langsamere, einfachere Lösungen zu entwickeln. Innovation sollte nicht als Neuheit, sondern als Nachhaltigkeit definiert werden.«

« Le graphisme est certainement l'une des professions qui a le plus changé au cours de la dernière décennie mais, comme toutes les autres disciplines du design, il participe à la crise mondiale actuelle. Nous avons toujours travaillé pour l'avenir dans l'espoir d'augmenter le plaisir, le confort, le pouvoir, l'efficacité, la rentabilité. Cette fois, nous devons œuvrer en songeant au passé. Nous devons contrer un patrimoine encombré de graphismes, de fausses informations, de pollutions et d'inventions dangereuses. Nous avons progressivement appris à nous adapter à un monde toujours plus rapide et complexe. Il est temps de nous réadapter à l'humanité et d'apporter des solutions de lenteur et de simplicité. L'innovation ne devrait pas être étayée par la nouveauté mais par la viabilité. »

**M.A.D.**
237 San Carlos Ave
Sausalito
CA 94965
USA

T +1 415 331 1023
F +1 415 331 1034

E erik@madxs.com

www.madxs.com

**Design group history**
1989 Co-founded by Erik Adigard and Patricia McShane in Sausalito, California

**Founders' biographies**
Erik Adigard
1953 Born in San Francisco
1976–1979 Studied communication, semiotics and fine art, France
1987 B.F.A. Graphic Design, California College of Arts and Crafts, Oakland
1996–1998 Design Director, Wired Digital, San Francisco
2000 Taught new media at California College of Arts and Crafts (CCAC)
Patricia McShane
1953 Born in Brazzaville, Congo
1972–1975 Studied fine art and photography at San Francisco University
1987 B.F.A. Graphic Design with Distinction, California College of Arts and Crafts, Oakland

**Recent exhibitions**
1998 "Webdreamer" ResFest, San Francisco, Los Angeles, New York, London; "Wired", San Francisco Museum of Modern Art
1999 49th International Design Conference in Aspen; "Images + Technology", Typo99, Germany
2000 "National Design Triennial", Cooper-Hewitt Design Museum, New York
2001 "Webdreamer", Sundance Film Festival; "010101: Art in Technological Times", San Francisco Museum of Modern Art
2002 "US Design, 1975–2000", Denver Art Museum; "Chronopolis", La Villette, Paris

**Recent awards**
1998 Chrysler Award for Innovation in Design; Outstanding Achievement, HOW, Self-Promotion Annual; Interactive Media Winner, ACD Web 100; ID, Gold Award, Interactive Media Design Review
1998 First Place, Publish Annual Design Awards

**Clients**
AIGA
Autodesk
Computers Freedom & Privacy
Condé Nast
Harper Collins Publishing
Hotwired
IBM
IDCA
IDG
Ikonic
Inxight
J. Walter Thompson
Levi Strauss
Lotus
Medior
Microsoft
Mother Jones
New York Times
One Magazine
Raygun
Stop Aids Project
Thames & Hudson
Time Magazine
Weiden & Kennedy
Wired Digital
Wired Magazine
Ziff Davis

Opposite page:

**Project**
Poster

**Title**
Design.Digital:
the mouse, the house,
the city

**Client**
International Design
Conference in Aspen

**Year**
1999

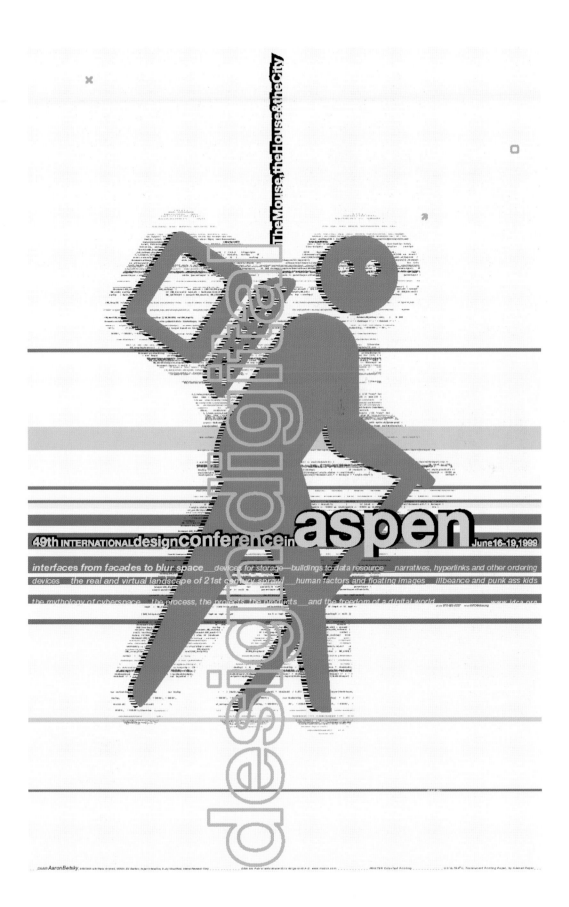

TheMouse,theHouse&theCity

49th INTERNATIONAL design conference in aspen    June16-19,1999

interfaces from facades to blur space___devices for storage—buildings to data resource___narratives, hyperlinks and other ordering devices___the real and virtual landscape of 21st century sprawl___human factors and floating images___illbeance and punk ass kids___the mythology of cyberspace___the process, the projects,the products___and the freedom of a digital world.

# Archi

## tecture

## Must

## Burn

manifesto for an architecture beyond building **Aaron Betsky + Erik Adigard**

**Thames & Hudson**

**Project**
Book cover

**Title**
Architecture Must Burn,
by Aaron Betsky and Erik
Adigard

**Client**
Thames & Hudson /
Gingko Press

**Year**
2000

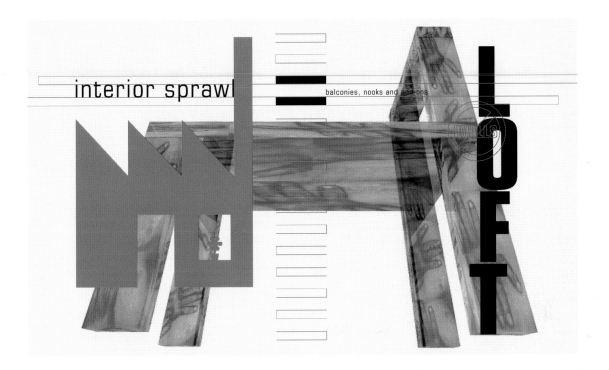

interior sprawl = balconies, nooks and add-ons

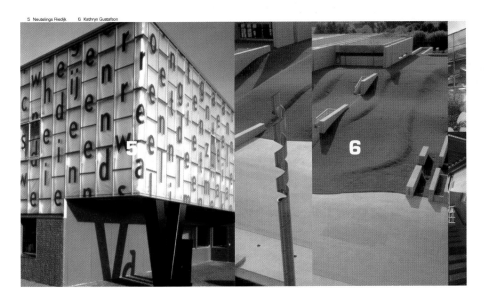

5  Neutelings Riedijk          6  Kathryn Gustafson

**Project**
Book spreads

**Title**
Architecture Must Burn,
by Aaron Betsky and Erik
Adigard

**Client**
Thames & Hudson /
Gingko Press

**Year**
2000

# Gudmundur Oddur Magnússon

## "We must infuse matter with spirit."

Opposite page:

**Project**
Exhibition poster

**Title**
Ofeigur Listhus

**Client**
Ofeigur Gallery /
Dr. Bjarni H. Thorarinsson,
visiotect

**Year**
2001

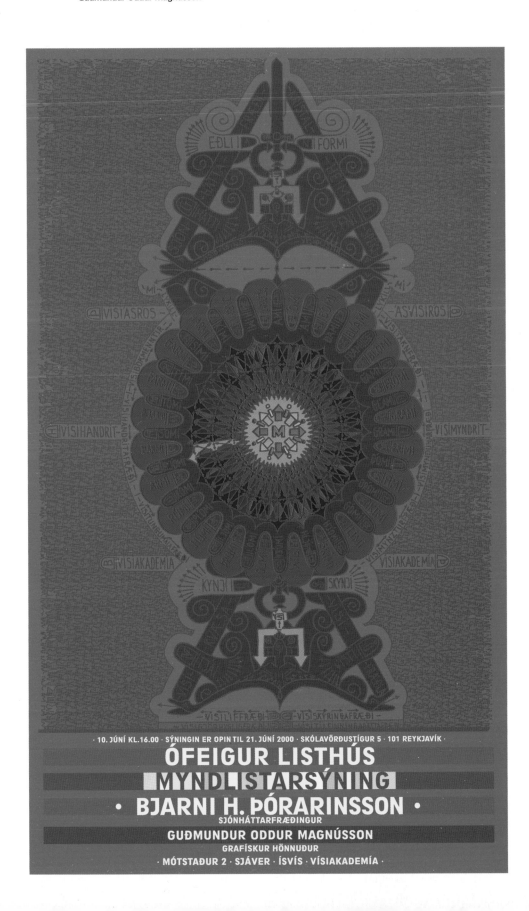

"In retrospect I have always been more interested in the use of visual language rather than finding a 'new' one. My masters more or less emphasized that our world is more about manipulating existing forms and ideas than finding new ones. If something 'new' happens, it never happens because you intend it to but because of pure happy accidents. But controlling or masterminding visual language is not an easy process. You need all human resources: from technical skill, historical awareness and research capabilities to emotional sensations and spirituality. I have a sense of a 'new' Middle-Ages era – by this I mean that we must study the inner light – the study of natural light is over anyway. We must infuse matter with spirit. I sometimes hear the argument that graphic designers must work on three levels only; otherwise it's not visual communication – fine art can work on multi-levels but graphic design only on three! If that was true, graphic art would be boring and reduced to the status of a mere product."

» Wenn ich zurückblicke, habe ich mich schon immer mehr für den Gebrauch der bereits vorhandenen Bildsprache interessiert als für die Erfindung einer ›neuen‹. Meine Lehrer haben mehr oder weniger stark betont, dass es in unserem Beruf eher um das Manipulieren bestehender als um das Erfinden neuer Formen und Ideen geht. Etwas Neues geschieht nicht, weil man das beabsichtigt hat, sondern als glücklicher Zufall. Aber die Bildsprache im Griff zu haben ist keine einfache Angelegenheit. Man braucht dafür sämtliche zur Verfügung stehenden Mittel von technischem Können und Forschergeist über Geschichtsbewusstsein bis zu Gefühlen und Spiritualität. Mir kommt die heutige Zeit wie ein neues Mittelalter vor. Damit meine ich, dass wir uns mit dem inneren Licht befassen sollten, weil die Analyse des natürlichen Lichts ja bereits abgeschlossen ist. Wir müssen der Materie Geist einhauchen. Manchmal wird argumentiert, Grafikdesigner dürften nur auf drei Ebenen arbeiten, sonst wäre ihre Arbeit keine visuelle Kommunikation. Die bildende Kunst könne auf sehr viel mehr Ebenen arbeiten und wir Grafiker nur auf dreien! Wenn das stimmte, wäre unsere Arbeit langweilig und auf den Status eines bloßen Produkts reduziert.«

« Avec le recul, je me rends compte que j'ai toujours été plus intéressé par le recours au langage visuel plutôt que par la découverte d'un ‹nouveau› langage. Mes maîtres ont toujours souligné que, dans notre monde, il s'agissait plus de manipuler des formes et des idées existantes que d'en trouver de nouvelles. Quand il se passe quelque chose de ‹neuf›, ce n'est jamais parce qu'on l'a voulu mais par un heureux hasard. Toutefois, contrôler ou organiser le langage visuel n'est pas une mince affaire. Cela requiert toutes les ressources humaines: des compétences techniques, une conscience historique et des capacités de recherche aux émotions et à la spiritualité. Je sens venir un ‹nouveau› Moyen Âge, je veux dire par là que nous devons étudier la lumière intérieure (de toutes manières, l'étude de la lumière naturelle est terminée). Nous devons infuser de l'esprit à la matière. J'entends parfois dire que les graphistes ne doivent travailler que sur trois niveaux, sinon ce n'est plus de la communication visuelle. Autrement dit, les beaux-arts peuvent utiliser de nombreux niveaux mais le graphisme uniquement trois! Si c'était le cas, la création graphique serait ennuyeuse et réduite au statut de simple produit. »

**Gudmundur Oddur Magnusson**
Storholt 18
105 Reykjavík
Iceland

T +354 692 5356
F +354 562 3629

E goddur@lhi.is

**Biography**
1955 Born in Akureyri, Iceland
1976 Foundation course, Icelandic College of Arts and Crafts, Reykjavík
1977 Printmaking, Icelandic College of Arts and Crafts, Reykjavík
1978–1980 Mixed Media, Icelandic College of Arts and Crafts, Reykjavík
1986–1989 Graphic Design, graduated with honours, Emily Carr College of Art and Design, Vancouver, Canada
1994 Workshop with Wolfgang Weingart
1999 Workshop with David Carson

**Professional experience**
1981–1984 Co-founder and director of The Red House Gallery, Akureyri
1989–1991 Graphic designer, ION design, Vancouver
1991–1992 Graphic designer in Akureyri
1992+ Instructor in graphic design and freelance graphic designer
1995–1999 Head of Graphic Design Department, Icelandic College of Arts and Crafts, Reykjavík
1999+ Director of Studies, Iceland Art Academy

**Clients**
Akureyri Art Museum
Akureyri Summer Art Festival
Badtaste Record Company
Iceland Art Academy
Iceland Art Festival
Iceland Genomics Corporation
Icelandic Parliament
Icelandic Political Science Association
Kitchen Motors rec. company
Reykjavík Art Museum
Reykjavík Jazz Festival
The Living Art Museum
University of Iceland

**Project**
CD cover

**Title**
Kerfill

**Client**
Badtaste Record Company

**Year**
1999

Opposite page:

**Project**
Exhibition poster

**Title**
Brilljonskvida

**Client**
Dillon Bar /
Dr. Bjarni H. Thorarinsson, visiotect

**Year**
2001

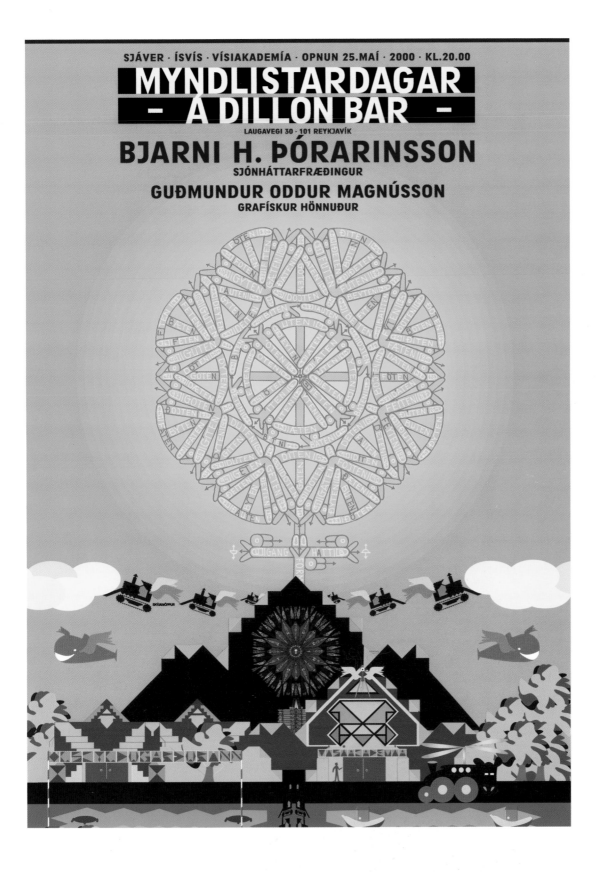

**Project**
Music and poetry festival
poster

**Title**
The Word Music

**Client**
Badtaste Record
Company

**Year**
2000

**Project**
Cover for poetry book

**Title**
Okkar a milli
(Just Between us)

**Client**
Mal & Menning
Publishers

**Year**
1999

# Karel Martens

"With the given content, to call attention – in a personal way – to my client's message."

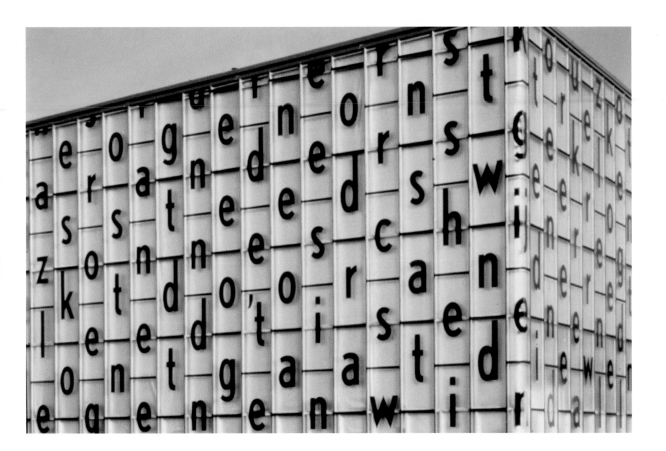

**Project**
Façade design for
the Veenman Printers
building, Ede,
The Netherlands

**Title**
The Veenman Printers
building, Ede,
The Netherlands

**Client**
Neutelings Riedijk

**Year**
1996

"Being there. Nowadays the client is no longer an expert who knows about a special product and is concerned to inform the public about it. More often the client is a committee or a general manager, concerned with 'being out there' and visible with its product.

The designer must still possess expertise (insight, knowledge and command of materials and techniques), but his personal signature has become more important. It may be almost the main issue in the struggle for the attention of the public. In addition, the first stages of the technical realization of design are now also in the hands of the designer. So more than ever before, the designer can make his presence visible. With this development, the goal of graphic design, which used to be to inform the public, has become more focused on the designer: for example, being present here in this book. Being there? Information about the product or about the designer? That is the question."

» Präsent sein. Heute ist der Kunde nicht mehr der Experte, der alles über ein Produkt weiß und der Öffentlichkeit sein Wissen mitteilen will. Meistens ist der Kunde ein Ausschuss oder ein Generaldirektor, der mit seinem Produkt in ›der Welt da draußen‹ präsent sein und wahrgenommen werden will. Der Designer muss immer noch ein Spezialist sein, aber sein persönlicher Stil ist wichtiger geworden und vielleicht das entscheidende Merkmal im Kampf um öffentliche Beachtung. Hinzu kommt, dass heute auch die Anfangsphasen der technischen Herstellung beim Grafiker liegen. Deshalb kann er mehr denn je sich selbst, seinen Stil und seine Arbeit in den Vordergrund stellen. So hat sich das Ziel des Grafikdesigns, die Öffentlichkeit zu informieren, stärker auf den Designer verlagert, zum Beispiel, in diesem Buch präsent zu sein. Präsent sein? Information über das Produkt oder über den Designer? Das ist hier die Frage.«

« Etre présent. Aujourd'hui, le commanditaire n'est plus un expert qui connaît parfaitement un produit dont il veut informer le public. Le plus souvent, il s'agit d'un comité ou d'un directeur général surtout soucieux ‹d'être présent› sur le marché et de la visibilité du produit.

Le graphiste reste le détenteur d'un savoir-faire (une compréhension, une connaissance et une maîtrise des matériaux et techniques) mais sa signature a pris de l'importance. Elle peut même devenir l'élément déterminant dans le combat pour attirer l'attention. En outre, les premières étapes de la réalisation technique du graphisme sont désormais entre les mains du créateur. Il peut donc, plus que jamais, rendre sa présence visible. L'objectif de la création graphique, qui était autrefois d'informer le public, est devenu plus centré sur le graphiste lui-même : par exemple, être présent ici dans ce livre. Etre présent ? Informer sur le produit ou sur le créateur ? Là est la question. »

**Karel Martens**
Monumentenweg 21A
6997 AG Hoog-Keppel
The Netherlands

E km@
werkplaatstypografie.org

**Biography**
1939 Born in Mook en Middelaar, The Netherlands
1961 Commercial Art and Illustration Degree, School of Art and Industrial Art, Arnhem

**Professional experience**
1961+ Freelance graphic designer specializing in typography
1977+ Taught graphic design at Arnhem School of Art; Jan van Eyck Academie, Maastricht; School of Art, Yale University, New Haven, Connecticut
1997 Co-founded the ArtEZ typography workshop with Wigger Bierma for postgraduate education in Arnhem

**Recent exhibitions**
1999 Nominations for Rotterdam Design Prize, Museum Boijmans Van Beuningen, Rotterdam; "Mooi maar goed" (Nice but Good), Stedelijk Museum, Amsterdam; "Type on the edge: The work of Karel Martens", The Yale University Art Gallery, New Haven, Connecticut
1999–2002 Roadshow of Dutch graphic design, Institut Néerlandais, Paris; Villa Steinbeck, Mulhouse; Musée des Beaux-Arts, Valence; Maryland Institute College of Art, Baltimore; ADGFAD; Laus 01, Barcelona; Erasmushuis, Djakarta; Design Center Stuttgart; Gallery AIGA, New York

**Recent awards**
1998 Gold Medal, World's Best Book Design Award, Leipzig Book Fair
1999 Nomination for the design of the façade of the Veenman printing works, Ede, Rotterdam Design Prize

**Clients**
Amstelveen
Apeldoorn
Arnhem
Artez
Bibliotheek TU Delft
Bureau Rijksbouwmeester
De Architecten Cie
De Haan
De Nijl Architecten
Drukkerij Romen en Zonen
Drukkerij SSN
Drukkerij Thieme
Filmhuis Nijmegen
Fonds voor Beeldende Kunsten
Frienden Holland
Geertjan van Oostende
Gelderse Cultuurraad
Hoogeschool voor de Kunsten
Jan van Eyck Academie
Juriaan Schrofer
Katholiek Documentatie Centrum
Keppelsch ijzergieterij
Konduktor Elektro
KPN Nederland
Ministry of Finance
Ministry of Justice
Ministry WVC
Museum Boijmans Van Beuningen
NAi Publishing
Nederlandse Staatscourant
Nel Linssen
Neutelings Riedijk Architecten
Nijmeegs Museum 'Commanderie van St. Jan'
Nijmeegse Vrije Akademie
PTT Kunst en Vormgeving
Rijksmuseum Kröller Müller

Kluwer Publishing
Manteau Publishing
Paul Brand Publishing
Simeon ten Holt
Stedelijk Museum
Stichting Altena
Boswinkel Collectie
Stichting Holland in Vorm
Stichting Joris Ivens
Stichting Leerdam
Stichting Nijmeegse Jeugdraad
Stichting Oase
Stichting Post-Kunst-vakonderwijs
Stiftung Museum Schloss Moyland
SUN Publishing
Te Elfder Ure
Tijdschrift Jeugd en Samenleving
Van Lindonk Publishing
Van Loghum Slaterus
Vereniging Rembrandt
Wolfsmond
World Press Photo

De functie van de vorm

NAi uitgevers

Van den Broek en Bakema 1948–1988 Architectuur en stedenbouw
De functie van de vorm

Van den Broek en Bakema 1948–1988 Architectuur en stedenbouw

Het Rotterdamse architectenbureau Van den Broek en Bakema heeft sinds 1948 een indrukwekkend oeuvre gerealiseerd in binnen- en buitenland. Vooral in de jaren vijftig en zestig speelde het bureau een rol van betekenis, in architectuur, stedenbouw en de spectaculaire synthese daarvan in megastructuren die door Van den Broek en Bakema werden aangeduid als 'architectuur-urbanisme'. Het bureau is verantwoordelijk voor een keur aan bekende projecten zoals de vertrekhal van de Holland Amerika Lijn en het winkelcentrum De Lijnbaan in Rotterdam, bungalowparken van Sporthuis Centrum, de aula van de Technische Hogeschool in Delft, woonwijken als Klein Driene in Hengelo en 't Hool in Eindhoven, en kantoorgebouwen voor Het Parool, de Postcheque- en Girodienst, Heineken, Siemens en Amro. De verschillende essays in deze publicatie behandelen de ideeën van Van den Broek en Bakema, vooral hun grote betrokkenheid bij mens en maatschappij komt hierbij aan de orde. Ook wordt een beeld gegeven van de werkwijze van het bureau. Daarnaast bevat de publicatie een rijk geïllustreerd deel waarin een veertigtal architectonische en stedenbouwkundige projecten wordt gedocumenteerd. De projecten en de verhalen erachter, de inspiraties en de geest van waaruit gedacht werd, zijn vandaag nog altijd van betekenis.

Nederlands Architectuurinstituut, Rotterdam.

ISBN 90-5662-132-7

**Project**
Book designed with
Stuart Bailey and Patrick
Coppens

**Title**
Van den Broek en
Bakema 1948–1988

**Client**
NAi Publishers

**Year**
2000

printed matter \ drukwerk

ISBN 0-907259-20-0

9 780907 259206

extended edition

Book Fair — revised and

Letter at the Leipzig

Awarded the Golden

Winnaar van de

Goldene Letter op de

Buchmesse Leipzig —

uitgebreide heruitgave

**Project**
Book designed with Jaap
van Triest

**Title**
Karel Martens printed
matter \ drukwerk

**Client**
Heineken, Amsterdam /
Hyphen Press, London

**Year**
1996

Opposite page:

**Project**
Animation

**Title**
Not for Resale

**Client**
Self-published

**Year**
1997–2000

# Me Company

## "Go further out and faster."

Opposite page:

**Project**
Björk. Selmasongs

**Title**
Björk as Selma 1

**Client**
One Little Indian Records

**Year**
1999

"The modern, technologically enhanced process of graphic design is already causing people to reconsider what the category means. It's branching out into so many new areas, drawing inspiration and knowledge as it goes. This blurring of conceptual and creative boundaries is vital to the development of the category."

» Der moderne, technisch vorangetriebene Prozess des grafischen Gestaltens gibt schon jetzt Anlass darüber nachzudenken, was Grafikdesign eigentlich bedeutet. Grafiker sind heute im Begriff, in viele neue kreative Bereiche vorzudringen und dabei ungewöhnliche Anregungen aufzunehmen und neues Wissen zu erwerben. Und gerade dieses Verwischen konzeptueller und gestalterischer Grenzen ist wesentlich für die Weiterentwicklung des Grafikdesigns.«

« Les procédés modernes de la création graphique, renforcés par la technologie, nous incitent déjà à revoir le sens de cette discipline. Elle étend ses ramifications dans un nombre croissant de nouveaux secteurs, puisant son inspiration et ses connaissances sur le tas. Ce flou croissant des frontières conceptuelles et créatives est vital pour l'évolution de ce domaine. »

**ME Company**
14 Apollo Studios
Charlton Kings Road
Kentish Town
London NW5 2SA
UK

T +44 20 7482 4262
F +44 20 7284 0402

E paul@
  mecompany.com

www.mecompany.com

**Design group history**
1985 Founded by Paul White in London
2001 Chromasoma was created to run as a sister company to Me Company

**Founders' biographies**
Paul White (Founder)
1959 Born in England
Trained as graphic designer and illustrator
Alistair Beattie (Partner)
1970 Born in England
1992 BA (Hons) English Literature and Language, Oxford University

**Recent exhibitions**
2001 "Luminous", G8 Gallery, Tokyo
2002 "Luminous", Visionaire Gallery, New York

**Clients**
+81
Apple
Björk
Cartoon Network
Coca-Cola
Create
Creative
Dave Clarke
East West
FIFA
Fuji
Hussein Chalayan
I.D.
Idea
IdN
Julien McDonald
Kelis
Kenzo
Kirin
Laforet

MCA
Mercedes
MTV
Nike
One Little Indian Records
Review
Shots
Sony Creative Products
Sony Playstation
Studio Voice
The Face
Toyota
UEFA
Visionaire
V Magazine
Warners
Wired
Zoo
Zoozoom

**Project**
Big Horror

**Title**
Pandora 2

**Client**
Big Magazine

**Year**
2000

**Project**
Explorer

**Title**
Explorer 5.7 &
Explorer 4.2

**Client**
Self-published

**Year**
2001

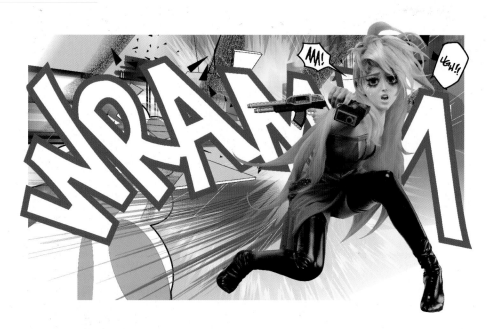

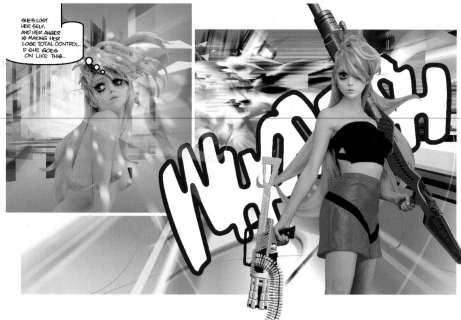

**Project**
Numero Manga
magazine spreads

**Title**
Action Gun £
Big Gun

**Client**
Numero Magazine

**Year**
2001

Opposite page:

**Project**
Numero Orchids
magazine artwork

**Title**
Coelogyne 2.1

**Client**
Numero Magazine

**Year**
2001

# MetaDesign

"Design forms the core of our company
and is the focus of all that we do."

**Project**
Corporate design and
brand development of
Stylepark.com

**Title**
Brochure concept

**Client**
Stylepark

**Year**
2000

"Our name is MetaDesign because we think beyond design, grasping it as a strategic task. This means that, among other things, we consider and integrate design implementation strategies at the outset of every project. The future of graphic design combines basic design skills with the advanced possibilities of information technology – integrating movement, space and sound into highly complex user experiences. However, high complexity demands clear design strategies, systemizing message and emotion into easily understood communication. Through innovative and experimental use of the changing technological possibilities, graphic designers set the tone in the creation of new visual languages, thus contributing to the emergence of cultural trends."

» Wir heißen MetaDesign, weil wir über das Gestalten hinausdenken und es als strategische Aufgabe ansehen. Das bedeutet unter anderem, dass wir uns bei jedem Projekt zunächst Gedanken über die Umsetzung von Gestaltungsstrategien machen und diese dann verarbeiten. Die Gebrauchsgrafik der Zukunft kombiniert grundlegendes gestalterisches Wissen und Können mit den fortschrittlichen Methoden der Informationstechnologie und verbindet Bewegung, Raum und Ton für die Benutzer zu hoch komplexen Erlebnissen. Hohe Komplexität erfordert jedoch klare Gestaltungsstrategien, die Botschaft und Emotion in leicht verständliche Mitteilung bringen. Infolge neuartiger, auch experimenteller, Anwendungen der sich rasch weiterentwickelnden technischen Gegebenheiten wirken Grafiker essenziell an der Schaffung neuer Bildsprachen mit und leisten so einen Beitrag zu neuen kulturellen Trends.«

« Nous nous appelons MetaDesign parce que nous pensons au-delà du design, l'abordant comme une tâche stratégique. Cela signifie que, entre autres choses, nous concevons et intégrons des stratégies d'applications graphiques au début de chaque projet. L'avenir du graphisme associe les compétences de bases aux possibilités avancées de la technologie informatique, intégrant le mouvement, l'espace et le son dans des expériences d'utilisateurs très complexes. Toutefois, cette grande complexité nécessite des stratégies de design très claires, systématisant le message et l'émotion dans une communication facilement compréhensible. A travers une exploitation innovatrice et expérimentale des possibilités changeantes de la technologie, les graphistes inventent de nouveaux langages visuels, contribuant ainsi à l'émergence de tendances culturelles. »

**MetaDesign AG**
Leibnizstrasse 65
10629 Berlin
Germany

T +49 30 59 00 54 0
F +49 30 59 00 54 111

E mail@metadesign.de

**Design group history**
1990 Co-founded by Hans C. Krüger, Ulrike Mayer-Johanssen and Prof. Erik Spiekermann in Berlin
1993 MetaDesign West founded in San Francisco
1999 Prof. Erik Spiekermann left the company
2000 MetaDesign Suisse AG founded in Zurich
2001 Hans C. Krüger left the company

**Founders' biographies**
Ulrike Mayer-Johanssen
1958 Born in Osterburken, Germany
1976–1979 Studied Stage and Graphic Design, Merz-Akademie, Stuttgart
1981–1986 Visual Communication and Painting, HdK (Academy of Art), Berlin
1987 Partner, FAB Kommunikation, Berlin
1990–1991 Special teaching post at the Institute of Journalism and Communication Politics, Berlin
1992+ Held seminars and workshops for the International Design Centre (IDZ), Berlin; Collaborated with Frauke Bochnig (Psychologist at IDZ); Lectured on the Cultural and Marketing Management course at the HfM (Academy of Music), Berlin
1993+ Held seminars and lecturers for RankXerox Germany on colour and form theory
1997+ Held seminars, lectures and workshops for the European School of Management (EAP)

**Recent exhibitions**
1997 "Wegbereiter – Innovationen und Design aus Berlin und Brandenburg", touring exhibition, IDZ (International Design Centre Berlin), Berlin, Frankfurt/Main and Leipzig
2000 "Fünfzig Jahre Italienisches und Deutsches Design" (Fifty Years of Italian and German Design), Kunst- und Ausstellungshalle der Bundesrepublik Deutschland, Bonn

**Recent awards**
1999 Merit Award, Art Directors Club, New York; CyberFinalist, Cannes Lions; Excellent Design, Industry Forum Design, Hanover; Gold World Medal, The New York Festival
2000 Shortlist-Winner, TV Movie Award; Shortlist-Winner, Cyber Lions
2001 Red Dot Award
2001, Design Zentrum NRW

**Clients**
Access
Audi
Berliner Verkehrsbetriebe
Bluewin
Bosch
BP
Bugatti
DMC2
Encyclopaedia Britannica
ETalentWorks
Europäische Verlagsanstalt / Rotbuch Verlag
Gedas
Heidelberger Druckmaschinen
Hewi
IGuzzini
Information Objects
Lucerne Festival
Lamborghini
Nike
Novartis
Popp
Robert Koch-Institut
Roland Berger
Stylepark
The Glasgow School of Art
Verkehrsbetriebe Potsdam
VIAG Interkom
Volkswagen
Voith
Whirlpool

Top:

**Project**
Corporate design and
brand development of
Stylepark.com

**Title**
Basic elements

**Client**
Stylepark

**Year**
2000

Bottom:

**Project**
Online concept and
design of Stylepark.com

**Title**
Online design

**Client**
Stylepark

**Year**
2000

Top:

**Project**
Creation of a new brand

**Title**
Event architecture,
trade fair stand

**Client**
Bluewin

**Year**
2000–2001

Bottom:

**Project**
Creation of a new brand

**Title**
Event architecture, glass-
walled containers and
inflatable tent called
the "Pneu"

**Client**
Bluewin

**Year**
2000–2001

Top:

**Project**
Creation of a new brand

**Title**
Interior design, employees
area

**Client**
Bluewin

**Year**
2000–2001

Bottom:

**Project**
Creation of a new brand

**Title**
Corporate site

**Client**
Bluewin

**Year**
2000–2001

# Mevis & van Deursen

**"Our approach is experimental and content-based."**

**Project**
Catalogue cover

**Title**
From Green Glass to
Airplane – recordings

**Client**
Artimo / Stedelijk
Museum, Amsterdam

**Year**
2001

"As a studio we mainly design posters, catalogues and identities for cultural institutions. We don't believe in conventions. Design should reflect contemporary cultural developments. In the future, we will have a better understanding of our world through information. We will even have more access to information through the effect of globalization, new media, cheaper printing techniques and so on. Graphic designers are desperately needed in this development. Their work is the most significant expression of our time."

» Als Firma gestalten wir hauptsächlich Plakate, Kataloge und Logos für Kulturinstitutionen. Wir glauben nicht an Konventionen. Design sollte zeitgenössische kulturelle Entwicklungen abbilden. In Zukunft werden wir aufgrund der verfügbaren Informationen unsere Welt besser verstehen. Die Globalisierung erleichtert den Zugang zu mehr Information durch die neuen Medien, ebenso durch billigere Drucktechniken und anderes mehr. Grafiker sind ganz dringend auf diese Entwicklung angewiesen. Ihr Werk ist erster und wichtigster Ausdruck unserer Zeit.«

« En tant que bureau de graphisme, nous concevons principalement des affiches, des catalogues et des identités pour des institutions culturelles. Nous ne croyons pas aux conventions. Le graphisme devrait refléter les développements culturels contemporains. A l'avenir, l'information nous permettra de mieux comprendre notre monde. Elle nous sera rendue encore plus accessible par la mondialisation, les nouveaux médias, des techniques d'impression meilleur marché, etc. Les graphistes sont indispensables à cette évolution. Leur travail est l'expression la plus significative de notre temps. »

**Mevis & van Deursen**
Geldersekade 101
1011 EM Amsterdam
The Netherlands

T +31 20 623 6093
F +31 20 427 2640

E mevd@xs4all.nl

**Design group history**
1987 Co-founded by Linda van Deursen and Armand Mevis in Amsterdam

**Founders' biographies**
Linda van Deursen
1961 Born in Aardenburg, The Netherlands
1981–1982 Academy voor Beeldende Vorming, Tilburg
1982–1986 BA Fine Art, Gerrit Rietveld Academy, Amsterdam
Armand Mevis
1963 Born in Oirsbeek, The Netherlands
1981–1982 Academy St. Joost, Breda
1982–1986 BA Fine Art, Gerrit Rietveld Academy, Amsterdam

**Recent exhibitions**
1998 "Standpunten", Kunsthal, Rotterdam; "Mevis & Van Deursen", St Lucas College, Antwerp; "Do Normal", San Francisco Museum of Modern Art; "Best Book Designs", Stedelijk Museum, Amsterdam
1999 "Mooi maar goed", Stedelijk Museum, Amsterdam; "Best Book Designs", Stedelijk Museum, Amsterdam
2000 "Best Book Designs", Stedelijk Museum, Amsterdam; "Mevis & Van Deursen", Zagrebacki Salon, Zagreb
2002 "Design Now: Graphics", Design Museum, London; "Dát was vormgeving – KPN Art & Design", Stedelijk Museum Amsterdam; "Best Book Designs", Stedelijk Museum, Amsterdam

**Recent awards**
1998 I.D. Forty (40 Best Designers Worldwide); Best Book Design, Amsterdam
1999 Best Book Design, Amsterdam; Nomination Theatre Poster Award
2000 Best Book Design, Amsterdam; Nomination Theatre Poster Award
2002 Best Book Design, Amsterdam

**Clients**
Artimo Foundation
Bureau Amsterdam
Gastprogrammering Het Ludion-Gent, Amsterdam
Muziektheater
NAi Publishers
Netherlands Design Institute
Stedelijk Museum Bureau Amsterdam
Stichting Fonds voor Beeldende Kunst, Vormgeving en Architectuur
010 Publishing
Thames & Hudson
TPG Post
Viktor & Rolf
Walker Art Center

**Project**
Catalogue

**Title**
If/Then (single page)

**Client**
Published by Netherlands Design Institute on the occasion of the "Doors of Perception" conference on Play

**Year**
1999

**Project**
Catalogue spreads

**Title**
From Green Glass to
Airplane – recordings

**Client**
Artimo / Stedelijk
Museum, Amsterdam

**Year**
2001

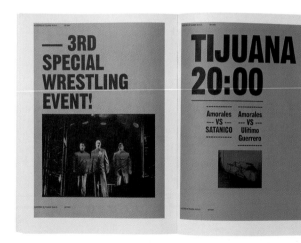

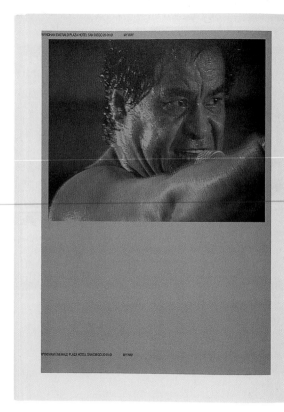

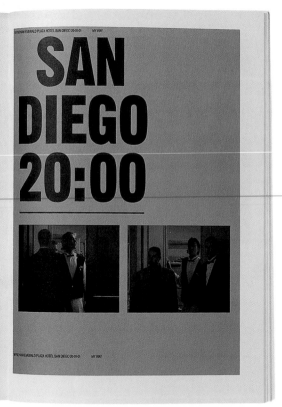

**Project**
Book

**Title**
Los Amorales

**Client**
Artimo

**Year**
2001

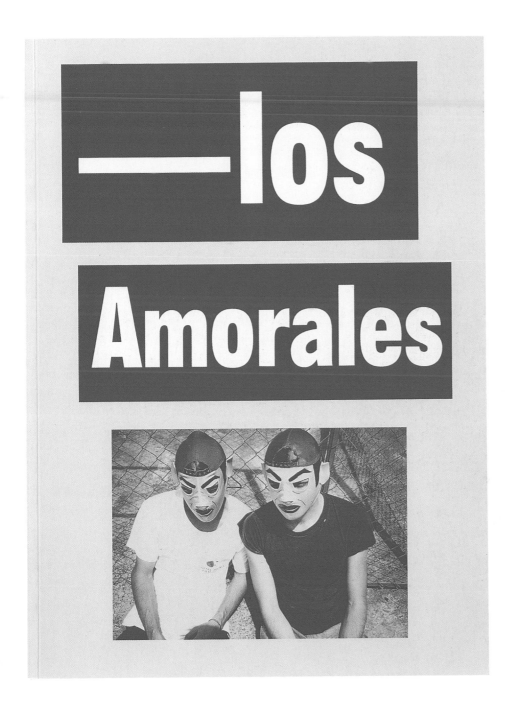

**Project**
Book

**Title**
Los Amorales

**Client**
Artimo

**Year**
2001

# Miles Murray Sorrell / FUEL

"We think graphic design has the biggest potential of all the arts. You can mould it to say anything you want to say, in any voice, at any level."

**Project**
Book

**Title**
Fuel 3000

**Client**
Self-published

**Year**
2000

"A lot of our work falls outside conceived notions of graphic design, but we have never felt the need to conform to any outside view of who and what we should be. We have always been happy with a combination of commercial and self-generated projects. Each area requires a slightly different approach and that challenge is an interest and a motivation. Our own publications articulate ideas that often have difficulty finding a place in our work as commercial graphic designers. As a group we have always been open to what is happening outside graphic design, and this is expressed in the collaborative nature of our books and films."

» Viele unserer Arbeiten fallen aus dem Rahmen der gängigen Auffassungen von Grafikdesign, aber wir haben nie das Gefühl gehabt, wir müssten uns der Meinung anderer darüber, wer und was wir sein sollten, unterordnen. Wir sind mit der Mischung aus Auftragsarbeiten und eigenen Projekten zufrieden. Jeder Bereich erfordert einen anderen Ansatz, was für uns Herausforderung, Faszination und Motivation zugleich bedeutet. Als Team sind wir immer offen gewesen für alles, was außerhalb der Branche läuft, und das drückt sich in unseren Büchern und Filmen aus, die deutlich den Charakter von Gemeinschaftswerken besitzen.«

«Tous nos travaux sortent du cadre des idées reçues sur le graphisme, mais nous n'avons jamais ressenti le besoin de nous conformer à une vision externe de ce que nous devrions être. Nous avons toujours aimé alterner les travaux de commande et nos propres projets. Chaque domaine requiert une approche légèrement différente, ce qui représente un défi à la fois intéressant et motivant. Nos propres publications formulent des idées qui ont souvent du mal à trouver leur place dans notre travail de graphistes publicitaires. En tant que groupe, nous sommes toujours ouverts à ce qui se passe en dehors du monde de la création graphique, ce qu'on exprime par les nombreuses collaborations dans nos livres et nos films. »

**Miles Murray Sorrell / FUEL**
33 Fournier Street
Spitalfields
London E1 6QE
UK

T +44 20 7377 2697
F +44 20 7247 4697

E fuel@fuel-design.com

**Design group history**
1991 Founded by Peter Miles, Damon Murray and Stephen Sorrell at the Royal College of Art, London
1996 Published "Pure Fuel" (Booth-Clibborn Editions)
2000 Published "Fuel 3000" (Laurence King Publishing)

**Founders' biographies**
Peter Miles
1966 Born in Cuckfield, Sussex, England
1990–1992 MA Graphic Design, Royal College of Art
Damon Murray
1967 Born in London
1990–1992 MA Graphic Design, Royal College of Art
Stephen Sorrell
1968 Born in Maidstone, England
1990–1992 MA Graphic Design, Royal College of Art

**Recent exhibitions**
1996 "Jam", Barbican Art Gallery, London
1998 "Powerhouse:UK", London
1999 "Lost & Found", British Council touring exhibition
2000 "UK with NY", British Design Council in New York

**Recent awards**
1995 D&AD Silver Nomination
1999 Prix Ars Electronica Honorary Mention

**Clients**
Adidas
Booth-Clibborn Editions
BT Cellnet First
Caterpillar
DAKS Simpson
Diesel
Laurence King Publishing
Levi Strauss
Marc Jacobs
MTV Europe
Sci-Fi Channel
Sony
Tracey Emin
White Cube Art Gallery

**Project**
Short film

**Title**
Original Copies

**Client**
Self-published

**Year**
1998

**Project**
Short film

**Title**
Original Copies

**Client**
Self-published

**Year**
1998

**Project**
Television commercial

**Title**
Cellnet First

**Client**
Cellnet First

**Year**
1999

Opposite page:

**Project**
Book

**Title**
Fuel 3000

**Client**
Self-published

**Year**
2000

# J. Abbott Miller

"Graphic design is a meta-language that can be used to magnify, obscure, dramatize, or re-direct words and images. It can be powerful, elegant, banal, or irrelevant. It's not inherently anything at all, but pure potential."

Opposite page:

**Project**
Poster

**Title**
The Work of Charles and
Ray Eames:  A Legacy of
Invention

**Client**
Cooper-Hewitt, National
Design Museum

**Year**
2000

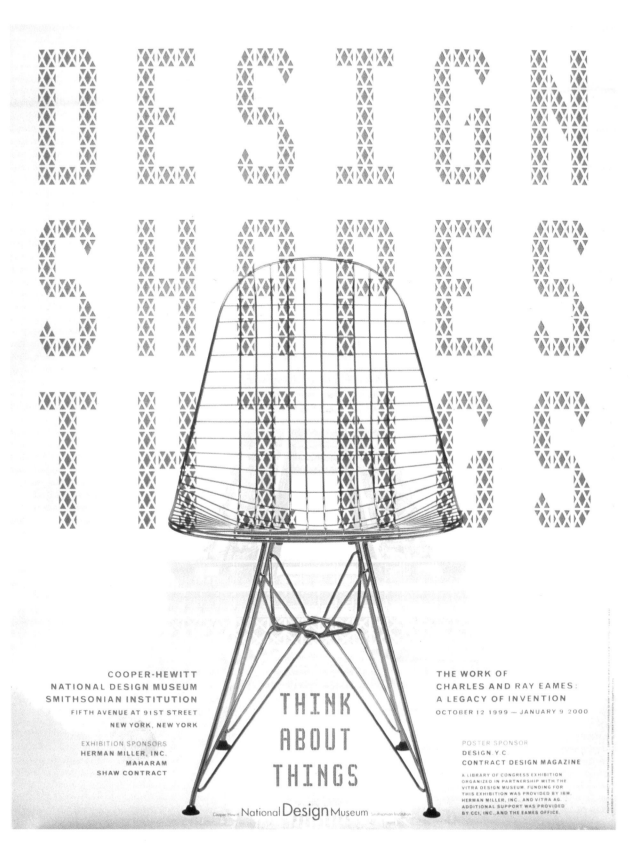

DESIGN
SHAPES
THINGS

COOPER-HEWITT
NATIONAL DESIGN MUSEUM
SMITHSONIAN INSTITUTION
FIFTH AVENUE AT 91ST STREET
NEW YORK, NEW YORK

EXHIBITION SPONSORS
HERMAN MILLER, INC.
MAHARAM
SHAW CONTRACT

THINK
ABOUT
THINGS

THE WORK OF
CHARLES AND RAY EAMES:
A LEGACY OF INVENTION
OCTOBER 12 1999 — JANUARY 9 2000

POSTER SPONSOR
DESIGN.Y.C
CONTRACT DESIGN MAGAZINE

A LIBRARY OF CONGRESS EXHIBITION
ORGANIZED IN PARTNERSHIP WITH THE
VITRA DESIGN MUSEUM. FUNDING FOR
THIS EXHIBITION WAS PROVIDED BY IBM,
HERMAN MILLER, INC., AND VITRA AG.
ADDITIONAL SUPPORT WAS PROVIDED
BY CCI, INC., AND THE EAMES OFFICE.

Cooper Hewitt National Design Museum Smithsonian Institution

"Graphic design faces a potential absorption into information technologies that combine words, imagery, numerical data, voice, and other sensory communication. As the information technologies of the future lay claim to an ever-broadening synthesis of information formats, design is poised to participate in this culture, or to be swallowed up. Design will have to recognize its future as a humanistic filter for media, a blend of art and science that defends the reader, user, and interpreter of codes."

» Die Gebrauchsgrafik sieht sich von der Vereinnahmung durch die Informationstechnologien bedroht, die Worte, Bilder, numerische Daten, Stimme und andere Formen sinnlicher Kommunikation miteinander kombiniert. Da die Informationstechnologien der Zukunft Anspruch auf eine immer umfassendere Synthese von Informationsformaten erheben, stehen die Grafiker in den Startlöchern, um zu dieser Kulturleistung beizutragen – oder von ihr verschluckt zu werden. Die Branche muss ihre Zukunft in ihrer Funktion als humanistischer Filter der Medien sehen, eine Mischung aus Kunst und Wissenschaft, die Leser, Nutzer und Interpreten von Codes schützt.«

« La création graphique risque d'être absorbée par les technologies de l'information qui associent les mots, les images, les données numériques, la voix et d'autres formes de communication sensorielle. A mesure que ces technologies du futur accapareront une synthèse toujours plus vaste des formats de l'information, le graphisme devra choisir entre participer à cette culture ou se laisser engloutir. Il devra prendre conscience de son rôle de filtre humaniste des médias, mélange d'art et de science qui défend le lecteur, l'utilisateur et l'interprète des codes. »

**J. Abbott Miller**
Pentagram Design
204 Fifth Avenue
New York
NY 10010
USA

T +1 212 683 7000
F +1 212 532 0181

E miller@pentagram.com

www.pentagram.com

**Biography**
1963 Born in Gary, Indiana
1981–1985 Art and Design, Cooper Union School of Art, New York
1989–1992 Art History, City University, New York

**Professional experience**
1988+ Taught at various universities in both Europe and the US
1989 Founded studio Design/Writing/Research, New York
1999 Joined Pentagram's New York office as a principal
1997+ Editor of 2wice magazine, New York
1999+ Member, Alliance Graphique Internationale (AGI)
1995+ Member, Editorial Board of Eye magazine, London

**Recent exhibitions**
1998 "The Multiple", permanent exhibition, Davis Museum and Cultural Center, Wellesley College, Wellesley, Massachusetts
1998–1999 "The 30th Anniversary Covers Tour", touring exhibition for Rolling Stone magazine
1999 "J. Abbott Miller: Design/Writing/Research", Pentagram Gallery, London
1999–2000 "Village Works: Photography by Women in China's Yunnan Province", Davis Museum and Cultural Center, Wellesley College, Wellesley, Massachusetts; "John Bull and Uncle Sam: Four Centuries of British-American Relations", the Library of Congress, Washington
2000 "Art of the Ancient Americas", permanent exhibition, Davis Museum and Cultural Center, Wellesley College, Wellesley, Massachusetts; "Divine Mirrors: The Madonna Unveiled", permanent exhibition, Davis Museum and Cultural Center, Wellesley College, Wellesley, Massachusetts; "RockStyle", the Rock and Roll Hall of Fame and Museum, Cleveland, Ohio
2000–2001 "On the Job: Design and the American Office", the National Building Museum, Washington, DC; "Lennon: His Life and Work", the Rock and Roll Hall of Fame and Museum, Cleveland, Ohio; "Cold War Modern: The Domesticated Avant-Garde", Davis Museum and Cultural Center, Wellesley College, Wellesley, Massachusetts
2002–2003 "Harley-Davidson 100th Anniversary exhibition", worldwide touring show

**Recent awards**
1998 International Center of Photography Infinity Award, New York

**Clients**
2wice Arts Foundation
Architecture Magazine
Cooper-Hewitt, National Design Museum
Davis Museum and Cultural Center, Wellesley College
Geoffrey Beene
Guggenheim Museum
Harley-Davidson
Library of Congress
The Museum of Modern Art, New York
National Building Museum
Rock and Roll Hall of Fame and Museum
Rolling Stone
Smithsonian Institution
Vitra
Whitney Museum of American Art

**Project**
Magazine covers

**Title**
Editorial design for 2wice
magazine

**Client**
2wice Arts Foundation

**Year**
1997–present

**Project**
Magazine spreads

**Title**
"Rites of Spring" issue of
2wice magazine

**Client**
2wice Arts Foundation

**Year**
2000

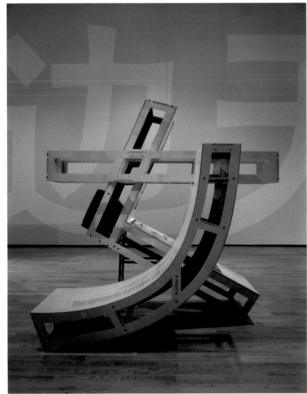

**Project**
Exhibition design

**Title**
Village Works:
Photography by Women
in China's Yunnan
Province

**Client**
Davis Museum / Cultural
Center, Wellesley College

**Year**
1999

# M/M (Paris)

"It is almost by virtue of a logical development in the history of art that we have been called today to work in the field of design."

Opposite page:

**Project**
Generic poster for a series of art films, in collaboration with Pierre Huyghe & Philippe Parreno

**Title**
Ann Lee: No Ghost Just A Shell

**Client**
Anna Sanders Films

**Year**
2000

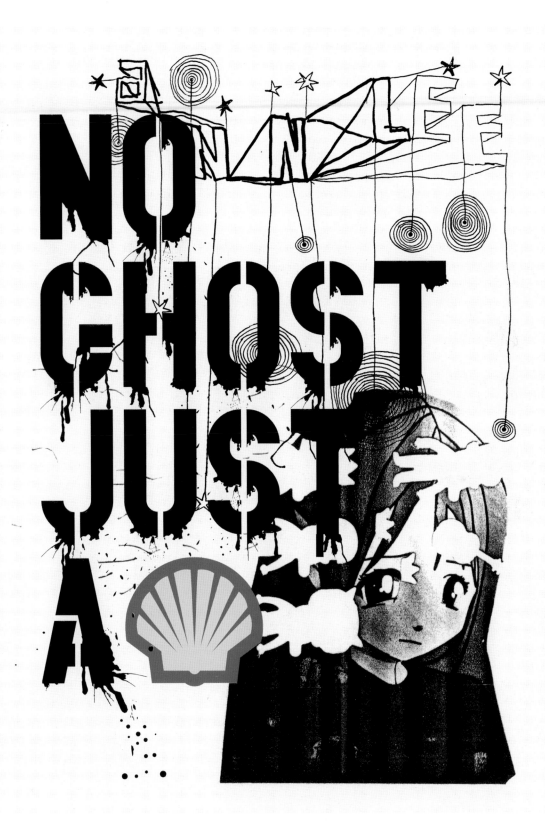

"An image never interests us as such. Its relevance lies in the fact that it contains the sum of preceding dialogues, stories, experiences with various interlocutors, and the fact that it induces a questioning of these pre-existing values. This is what makes for us a pertinent image. A good image should be in between two others, a previous one and another to come."

» Ein Bild ist nie an sich schon interessant. Seine Relevanz beruht darauf, dass es das Resultat vorhergegangener Gespräche, Geschichten und Erfahrungen verschiedener Menschen ist und es Fragen zu den in ihm ausgedrückten Werten provoziert. Das ergibt dann für uns ein treffendes Bild. Ein gutes Bild sollte zwischen zwei anderen stehen: einem früheren und einem späteren.«

« Une image en elle-même ne nous intérese pas. Sa pertinence réside dans le fait qu'elle contienne la somme des dialogues, d'histoires et d'expériences antérieures avec divers interlocuteurs et qu'elle induise un questionnement des valeurs pré-existantes. C'est ce qui nous la rend pertinente. Une bonne image devrait se situer entre deux autres, une précédente et une à venir. »

## M/M (Paris)
5–7, rue des Récollets
75010 Paris
France

T +33 1 4036 1746
F +33 1 4036 1726

E anyone@mmparis.com

www.mmparis.com

## Design group history
1992 Co-founded by Michael Amzalag and Mathias Augustyniak in Paris

## Founders' biographies
Michael Amzalag
1968 Born in Paris
1990 École Nationale Supérieure des Arts Décoratifs, Paris
Mathias Augustyniak
1967 Born in Cavaillon, France
1991 MA Graphic Design and Art Direction, Royal College of Art, London

## Recent exhibitions
1998 "Museum in Progress, Signs of Trouble", Der Standard, Vienna; "La Table", Air de Paris, Paris; "Festival international d'affiches de Chaumont", Maison du Livre et de l'Affiche, Chaumont; "Silver Space: Allegrette Script", Air de Paris, Paris; "Festivital 98", Reading Electric Power Station, Tel Aviv
1999 "M/M", Y-1, Stockholm; "About", with Pierre Huyghe, Philippe Parreno and Dominique Gonzalez-Foerster, D'Apertutto, Venice Biennale; "Souviens toi l'été dernier", Air de Paris, Paris; "Fastforward: mode in den medien der 90er jahre", Künstlerhaus, Vienna
2000 "Etat des lieux #2", Museum of Contemporary Art, Tucson; Collection JRP, Fri-Art, Fribourg; "Xn 00", Espace des Arts, Chalon-sur-Saône; "Au delà du spectacle", with Pierre Huyghe, Philippe Parreno, Centre Georges Pompidou, Paris; "Let's Entertain", with Philippe Parreno, Walker Art Center, Minneapolis; "One Thousand Pictures Falling From One Thousand Walls", with Philippe Parreno, Mamco, Geneva; "DGF/PH/PP", with Pierre Huyghe, Philippe Parreno and Dominique Gonzalez-Foerster, Kunstverein, Hamburg; "No Ghost Just A Shell", with Pierre Huyghe, Philippe Parreno,

Air de Paris/Marian Goodman, Paris and Schipper & Krome, Berlin
2001 "In Many Ways The Exhibition Already Happened", with Pierre Huyghe, Philippe Parreno and R&Sie/François Roche, Institute of Contemporary Arts, London; "We Set Off In High Spirit", with Inez van Lamsweerde & Vinoodh Matadin, Matthew Marks Gallery, New York; "Le Chateau de Turing", with Pierre Huyghe, French Pavilion, Venice Biennale; "Milneufcentseptantesix", with Inez van Lamsweerde & Vinoodh Matadin, Elac (Lausanne), Maison Européenne de la Photographie (Paris); "Cosmodrome", with Dominique Gonzalez-Foerster and Jay-Jay Johanson, Le Consortium, Dijon; "Annlee in Anzen Zone", with Dominique Gonzalez-Foerster, Galerie Jennifer Flay, Paris; "Interludes", with Pierre Huyghe, Stedejlik Van Abbemuseum, Eindhoven; "One Thousand Pictures Falling From One Thousand Walls", with Philippe Parreno, Friedrich Petzel Gallery, New York; "Even More Real Than You", with Pierre Huyghe, Marian Goodman, New York
2002 "Restart: Exchange & Transform", Kunstverein, Munich; "Design Now: Graphics", Design Museum, London

## Clients
APC
Balenciaga
Berlin Biennale
Café Etienne Marcel
Callaghan
Calvin Klein
CDDB Théâtre de Lorient
Centre Georges Pompidou
Frac Champagne Ardenne
Galerie 213
Gingham
Hermès
Jeremy Scott
Jil Sander
Little-i Books
Louis Vuitton
Martine Sitbon
Musée d'art moderne de la ville de Paris
One Little Indian Records
Palais de Tokyo
Patrick Seguin
Pearl Union
Pittimagine Discovery
Schirmer/Mosel
Science
Siemens Artsprogram
Source
The Republic of Desire
Villa Medici
Virgin France
Vitra
Vogue Paris
Yohji Yamamoto

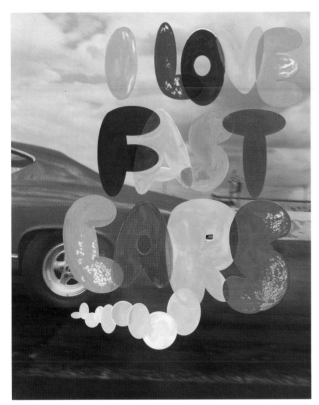

**Project**
A book about muscle cars
and drag racing by
fashion photographer
Craig McDean. Edited &
designed by M/M (Paris)

**Title**
I Love Fast Cars

**Client**
Powerhouse books

**Year**
2000

**Project**
From "French Landscape
1.0", a visual essay by
M/M (Paris) for the
Guggenheim Magazine.
Re-used as a cover image
for Documents sur l'art #12

**Title**
Bébé avec Deleuze

**Client**
Powerhouse books

**Year**
2000

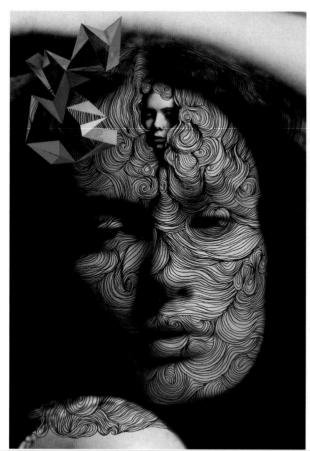

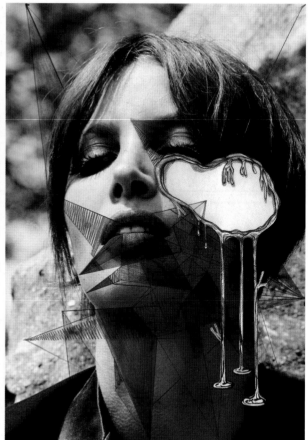

Opposite page:

**Project**
Invitation card for
Balenciaga Fall / Winter
2002/03 collection

**Title**
Balenciaga (Melia)

**Client**
Balenciaga

**Year**
2002

**Project**
Invitation card for
Balenciaga Spring /
Summer 2002 collection

**Title**
Balenciaga (Christy)

**Client**
Balenciaga

**Year**
2002

**Project**
Theatre poster

**Title**
Marion de Lorme

**Client**
CDDB Théâtre de Lorient

**Year**
1999

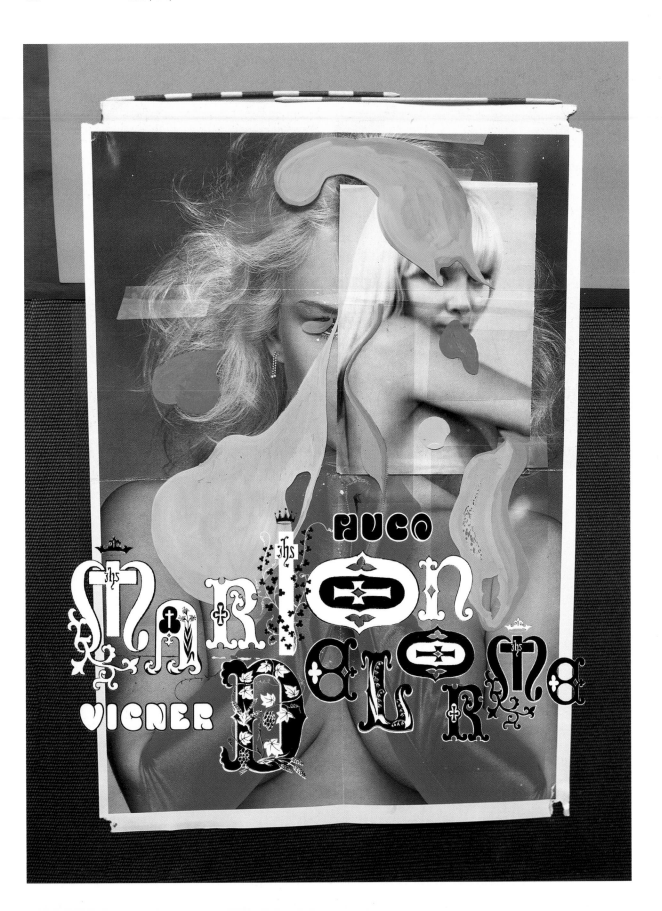

# Mutabor

"Mutabor Design is specialized in the evaluation of trends in terms of significance for product brand and media development – and in the translation of these trends into strategic design solutions."

Opposite page:

**Project**
Designers handbook

**Title**
Lingua Grafica

**Client**
Self-published

**Year**
2001

**MUTABOR** **lingua grafica** ➜ Großes Nachschlagewerk Bildsprache

"Society constantly deals with corporative directions and trends that have influence on its visual and linguistic habits. Graphic design constantly deals with the transformation of shapes, content and points of view. The future of graphic design means bringing all of this together and transposing it into strategic design solutions that are relevant to their audience."

» Unsere Gesellschaft beschäftigt sich fortwährend mit Trends und gesellschaftlichen Strömungen, die einen konstanten Einfluss auf unsere Seh- und Sprachgewohnheiten haben. Grafikdesign beschäftigt sich ständig mit der Veränderung von Formen, Inhalten und Sichtweisen. Die Zukunft des Grafikdesigns wird es sein, diese beiden Pole zu vereinen und in strategische Designlösungen umzusetzen, die für sein Publikum relevant sind.«

« La société absorbe en permanence des directives et des tendances dictées par les entreprises et celles-ci influent sur ses habitudes visuelles et linguistiques. La création graphique traite de la transformation des formes, des contenus et des points de vue. L'avenir du graphisme impliquera de les rassembler tous et de les transposer en solutions stratégiques qui aient un sens pour le public visé. »

**Mutabor**
Barnerstrasse 63 / Hof
22765 Hamburg
Germany

T +49 40 399 224 21
F +49 40 399 224 29

E info@mutabor.de

www.mutabor.de

**Design group history**
Mid-1990 Graphic design magazine Mutabor launched at Muthesius University in Kiel
1998 The co-founders Heinrich Paravicini and Johannes Plass turn the Mutabor design and magazine team into a design agency; Mutabor Design is founded
2000+ Heinrich Paravicini and Johannes Plass serve as jury members of national design awards, give university lectures and attend design conferences; elected as members of the German ADC membership
2002 Mutabor Design is listed in Germany's Top 20 Creative agency ranking, published by "manager magazine", Germany

**Founders' biographies**
Heinrich Paravicini
1971 Born in Göttingen, Germany; grew up in Paris
1991–1997 Studied Communication Design at Muthesius University, Kiel
1996 Academic design research project together with Johannes Plass in California
1994–1997 Worked as a graphic designer in Kiel, Munich and Paris
Johannes Plass
1970 Born in Osnabrück, Germany
1992–1997 Studied Communication Design at Muthesius University, Kiel
1996 Academic design research project together with Heinrich Paravicini in California
1994–1997 Worked as a graphic designer in Kiel, Hamburg and Munich

**Recent awards**
1998 High Quality German Design Award (Communication Design)
1999 Awards for typographic excellence (x4), Type Directors Club New York
2000 High Quality German Design Award (Communication Design)
2001 The Most Beautiful German Book Award, Stiftung Buchkunst; Winner, Hamburg Design Award; Merit, Art Directors Club New York; Finalist Shortlist, German Corporate Design Award; First Prize, German Corporate Magazine of the Year; Awards for Typographic Excellence (x3), Type Directors Club New York
2002 Awards for Typographic Excellence (x3), Type Directors Club New York; Distinctive Merit, Art Directors Club New York; Silver medal, Bronze medal (x2), Art Directors Club Germany; Shortlist (x2), D&AD Awards

**Clients**
Adidas Salomon
BMW
Classen Papier
Coremedia
Distefora Holding
Greenpeace
Hoffmann & Campe Verlag
International School of New Media, Lübeck
Ision Internet
Media Lab Europe, Dublin
Panasonic Germany
Premier Automotive Group
Ravensburger Editions
Sanford Rotring Gmbh
S.Oliver Group
Sinner Schrader
Universal Music

**Project**
Corporate magazine of
Ford Motor Company

**Title**
Premier Magazine

**Client**
Premier Automotive
Group

**Year**
2001/2002

**Project**
Magazine/catalogue for
BMW hydrogen
automobiles

**Title**
BMW Clean Energy
Magalogues

**Client**
BMW

**Year**
2000

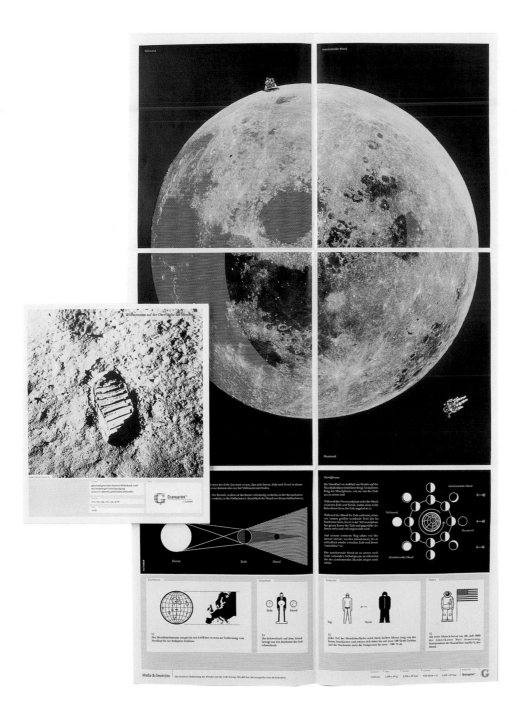

**Project**
Promotional mailing with
poster for a granulated
paper

**Title**
Classen Papier Granuprint
Mailing

**Client**
Classen Papier, Essen

**Year**
2002

# Hideki Nakajima

## "To find a brand new form that does not currently exist."

Opposite page:

**Project**
Poster for 'code
exhibition/new village'

**Title**
S/N

**Client**
Code

**Year**
2002

"Just as the invention of the electric guitar and synthesizer gave birth to rock 'n' roll and to techno music, and the invention of the projector gave birth to film, new technology bears new means of expression. In the same way, new technology in graphic design provides new ways of communicating and, perhaps, novel representations. Not only in design but in all fields of expression it is never true to say 'all possible forms of representation have been exhausted.'"

» Die Erfindung der Elektrogitarre und des Synthesizers hat den Rock'n'Roll und die Technomusik hervorgebracht, die Erfindung des Projektors führte zum Film. Jede neue Technologie bringt neue Ausdrucksmittel mit sich. Dementsprechend eröffnen moderne grafische Techniken auch neue Arten der Kommunikation und führen vielleicht zu neuartigen Darstellungsweisen. In keinem schöpferischen Bereich – einschließlich der Gebrauchsgrafik – stimmt die Behauptung, sämtliche möglichen Ausdrucksformen seien ausgeschöpft.«

«Tout comme l'invention de la guitare électrique et du synthétiseur a donné naissance au rock'n'roll et à la musique techno, et celle du projecteur au cinéma, les nouvelles technologies engendrent de nouveaux moyens d'expression. Parallèlement, dans le domaine du graphisme, elles offrent de nouveaux outils de communication et, peut-être, de représentation. En graphisme comme dans tous les autres domaines d'expression, on ne peut jamais dire ‹on a déjà épuisé toutes les formes possibles de représentations›.»

**Hideki Nakajima**
Nakajima Design
Kaiho Bldg-4F
4–11, Uguisudani-cho
Shibuya-ku
Tokyo 150–0032
Japan

T +81 3 5489 1757
F +81 3 5489 1758

E nkjm-d@
kd5.so-net.ne.jp

**Biography**
1961 Born in Saitama,
Japan

**Professional experience**
1988–1991 Senior
Designer, Masami
Shimizu Design Office,
Tokyo
1992–1995 Art Director,
Rockin'on, Tokyo

**Recent exhibitions**
1994 "Tokyo Visual
Groove", Tokyo
1998 "Japan Graphic
Design Exhibition", Paris;
Art Exhibition for Seiko's
Neatnik, Tokyo
2000 "Graphic Wave 5"
at ggg, Tokyo
2001 "Takeo Paper Show
2001", Tokyo; "Graphis-
me(s)", Paris; "Typo-
Janchi", Seoul; 032c's
"The Searching Stays
with You", Berlin and
London
2002 code exhibition
[new village], Tokyo,
Osaka, Kyoto

**Recent awards**
1995–2000 Gold Award
(x5) and Silver Award (x7),
The Art Directors Club,
New York
1999 Tokyo ADC Award
2000 Best Book Design,
19th International Bien-
nale of Graphic Design,
Brno, Czech Republic
2001 Good Design
Award, Chicago
Athenaeum

**Clients**
Issey Miyake
The National Museum of
Modern Art, Tokyo
Nestle Japan
PARCO
Rockin'on
Sony Music
Toshiba-EMI
Warner Music Japan
Victor Entertainment

**Project**
Poster for 'code
exhibition/new village'

**Title**
S/N

**Client**
Code

**Year**
2002

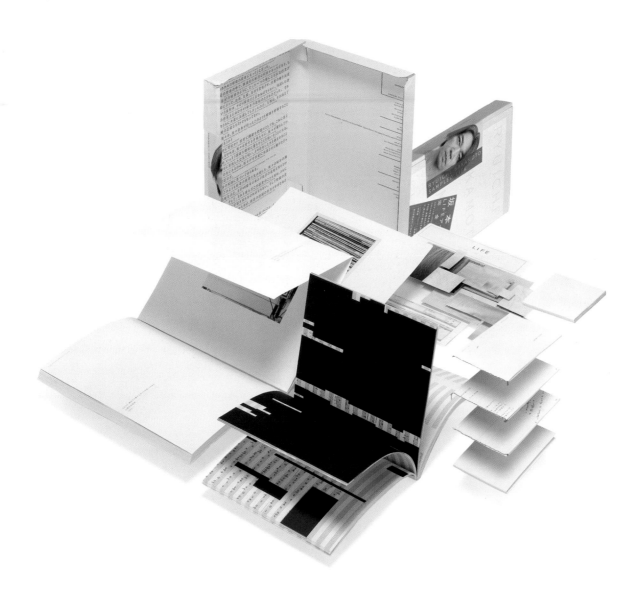

**Project**
Art box for Ryuichi
Sakamoto's opera 'LIFE'

**Title**
Sampled Life

**Client**
Code

**Year**
1999

**Project**
Artwork for 'IDEA'
magazine

**Title**
re-cycling

**Client**
IDEA

**Year**
2002

# Norm

## "Norm follows function."

Opposite page:

**Project**
Poster

**Title**
As found

**Client**
Museum für Gestaltung,
Zurich

**Year**
2001

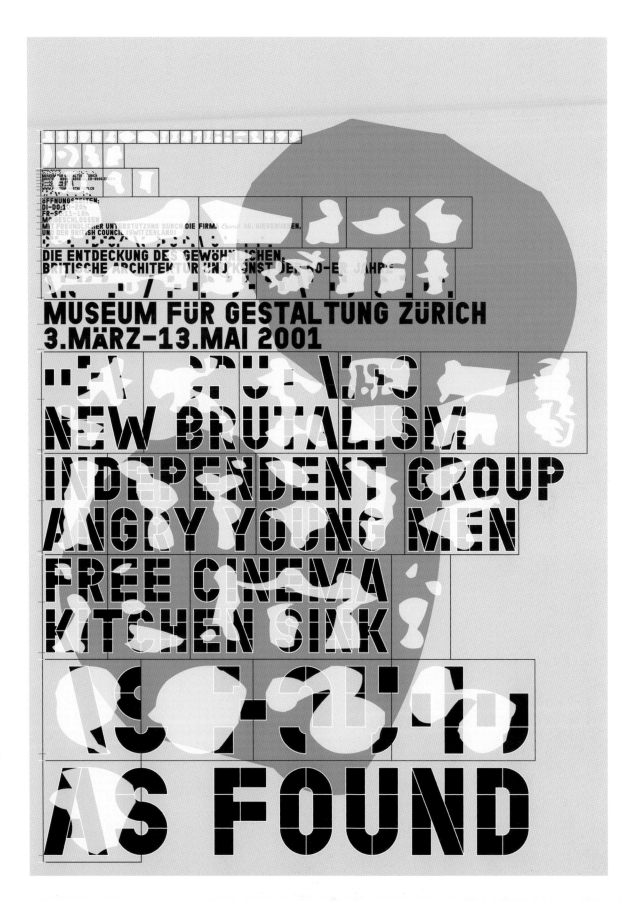

MUSEUM FÜR GESTALTUNG ZÜRICH
3.MÄRZ–13.MAI 2001

NEW BRUTALISM
INDEPENDENT GROUP
ANGRY YOUNG MEN
FREE CINEMA
KITCHEN SINK

AS FOUND

"Our approach to design, when looking back at the last three years (since we founded Norm), turns out to be quite systematic. We didn't aim for this, we'd even say it's bad to have too much of a system or a language (a project should be treated in the way it deserves). In fact we believe that routine is fatal and that maybe a designer shouldn't design too much. Anyway, that is what we have observed … We only work with our own fonts, which means, for each project we develop a new typeface. This means that most of our typefaces are relatively rough because they have to be done fast (except for 'Normetica' and 'Simple' that were designed as textfonts). For many designs we use type (and special signs) exclusively. We have a strong preference for vectors, we rarely work with images (this is not a dogma) because we prefer that perfection and purity of a vector at 6400% … And lastly but most importantly, we try to avoid QuarkXpress because the programme is a real prison."

» Wenn wir auf die drei Jahre seit der Gründung von Norm zurückblicken, stellt sich unser Designansatz als recht systematisch heraus. Das haben wir nicht angestrebt, wir haben gesagt, es sei nicht gut, zu viel System oder eine zu ausgeprägte eigene Sprache zu pflegen (jedes Projekt sollte auf die ihm zustehende Art bearbeitet werden). Tatsächlich glauben wir, dass Routine tödlich ist und Grafiker vielleicht nicht zu viel entwerfen sollten. Das ist jedenfalls unsere Beobachtung… Wir arbeiten nur mit unseren eigenen Schriften, das heißt, für jedes Projekt entwickeln wir ein neues Schriftbild. Deshalb sind unsere Schriftarten alle relativ grob, weil sie schnell entworfen werden müssen (bis auf die vollständigen Schrifttypensätze ›Normetica‹ und ›Simple‹). Unsere Arbeiten sind vielfach rein typografische Lösungen (inklusive Sonderzeichen). Wir haben eine Vorliebe für Vektorgrafiken und arbeiten selten mit Fotos (ohne daraus jedoch ein Dogma zu machen), weil wir die Perfektion und Reinheit eines Vektorbilds bei 6400 % vorziehen… Zuletzt, und das ist das Wichtigste, meiden wir, wenn es geht, QuarkXpress, weil das Programm ein echtes Gefängnis ist.«

« Avec le recul, nous nous rendons compte qu'au cours des trois dernières années (depuis que nous avons fondé Norm), notre approche a été plutôt systématique. Ce n'était pas le but recherché et nous dirions même qu'il n'est pas bon de trop se reposer sur un système ou un langage (un projet devrait être traité comme il le mérite). En effet, nous pensons que la routine est fatale et que, peut-être, un créateur ne devrait pas trop créer. C'est en tout cas ce que nous avons constaté… Nous ne travaillons qu'avec nos propres polices, ce qui signifie que nous développons de nouveaux types de caractères pour chaque projet. Par conséquent, la plupart de nos caractères sont relativement rudimentaires car ils doivent être réalisés rapidement (à l'exception de ‹Normetica› et de ‹Simple› conçus pour le texte courant). Pour de nombreux graphismes, nous utilisons exclusivement des caractères d'imprimerie (et des symboles spéciaux). Nous avons une nette préférence pour les vecteurs. Nous travaillons rarement avec des images (ce n'est pas un dogme) parce que nous préférons la perfection et la pureté d'un vecteur à 6400%… Dernier point, mais essentiel, nous essayons d'éviter QuarkXpress parce que ce programme est une vraie prison. »

**Norm**
Pfingstweidstrasse 31B
8005 Zurich
Switzerland

T +41 1 273 66 33
F +41 1 273 66 31

E nrm@norm.to

www.norm.to

**Design group history**
1999 Founded by Dimitri Bruni and Manuel Krebs in Zurich

**Founders' biographies**
Dimitri Bruni
1970 Born in Bienne, Switzerland
1991–1996 Graphic Design, School of Visual Arts, Bienne, Switzerland
1996–1998 Worked for various design studios in Zurich
2000 Professor at the ECAL (École Cantonale d'Art de Lausanne) – Graphic Design Department
Manuel Krebs
1970 Born in Berne
1991–1996 Graphic Design, School of Visual Arts, Bienne
1996–1998 Worked for various design studios in Geneva and Zurich
2000 Professor at the ECAL (École Cantonale d'Art de Lausanne) – Graphic Design Department

**Recent exhibitions**
1999 "Swiss Federal Prize for Design", Dampfzentrale, Berne
2000 "Submeet", Migrosmuseum für Gegenwartskunst, Zurich; Swiss "Federal Prize for Design", Museum Bellerive, Zurich

**Recent awards**
1999 Swiss Federal Prize for Design
2000 Swiss Federal Prize for Design

**Clients**
Family
Migros Museum für Gegenwartskunst, Zurich
Museum für Gestaltung, Zurich
Swiss Federal Office of Culture

**Project**
Cover design

**Title**
International Designers
Network

**Client**
Idn-Magazine, Hong Kong

**Year**
2001

**Project**
Book

**Title**
Norm: The Things

**Client**
Self-published

**Year**
2002

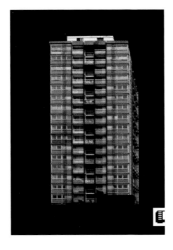

# Martijn Oostra

"There are things that we usually do not see, do not look at. Sometimes you need someone to show you the beauty of these 'ugly' everyday things."

Opposite page:

**Project**
Magazine submission

**Title**
Mutation

**Client**
Ad!dict, Brussels

**Year**
2001

"The difference between various creative occupations will be less clear in the future. More often designers are seen to be editors and designers of magazines and books, or designer and artist at the same time. I work as a graphic designer, photographer, artist and publicist. My projects vary from video art to typography. There's a continuous thread in all my activities, whether it's a graphic design or an article, it's made with the 'tools' by which I communicate. I find my tools in the media or in public areas (the street). The reality is about reality. One shows how daily life is coded. What is banal in one context becomes meaningful in another. I'm always looking for beauty in triviality, but my work does have meaning, it's about what surrounds us. I look for the details that say as much as the whole and sometimes more. Many designers work in similar individual manners with their design. The message is more important than the aesthetics. In the future designers will be communication specialists, working in diverse areas from art to advertising, from poetry to photography. The difference between the specialisations will be the 'tools' they use."

» Die Unterscheidung zwischen den verschiedenen kreativen Berufen wird in Zukunft undeutlicher werden. Immer öfter sind Grafikdesigner Redakteure und Gestalter von Zeitschriften und Büchern oder Designer und Künstler zugleich. Ich arbeite als Grafiker, Fotograf, Künstler und Publizist. Meine Arbeiten können zur Videokunst oder zur Typografie gehören.
Der rote Faden, der sich durch alle meine Tätigkeiten zieht – ob grafisches Gestalten oder Artikel schreiben – sind die ›Werkzeuge‹, mit denen ich arbeite. Ich finde sie in den Massenmedien oder im öffentlichen Raum (auf der Straße). Bei der Realität geht es um Realität. Man zeigt, wie der Alltag verschlüsselt ist. Was im einen Kontext banal wirkt, ist in einem anderen bedeutungsvoll. Ich halte stets Ausschau nach Schönheit im Trivialen, aber meine Arbeiten haben auch inhaltliche Bedeutung, befassen sich mit dem, was uns täglich umgibt. Ich suche die Details, die ebenso viel aussagen wie das Ganze – und manchmal sogar mehr. Viele Grafiker arbeiten in ähnlich individueller Weise wie ich. Die Aussage ist wichtiger als die Ästhetik. In Zukunft werden wir Grafiker Kommunikationsspezialisten sein, die in verschiedenen Bereichen tätig sind: von Kunst bis Werbung, von Dichtung bis Fotografie. Unterscheiden werden sich die Spezialisierungen durch die verwendeten ›Werkzeuge‹.«

« A l'avenir, les différences entre les divers métiers de la création seront moins nettes. On voit de plus en plus les graphistes prendre le rôle de rédacteur et de concepteur de revues et de livres en meme temps, ou comme étant à la fois créateurs et artistes. Je travaille en tant que graphiste, photographe, artiste et publicitaire. Mes projets vont de la vidéo artistique à la typographie. Il existe néanmoins un lien entre toutes mes activités : qu'il s'agisse d'une création graphique ou d'un article, elles sont réalisées avec les ‹outils› avec lesquels je communique. Je trouve ces outils dans les médias ou le domaine public (la rue). La réalité parle de la réalité. Il s'agit de révéler les codes de la vie quotidienne. Ce qui est banal dans un contexte prend tout son sens dans un autre. Je recherche toujours la beauté dans la futilité mais mon travail a un sens : il traite de ce qui nous entoure. Je traque les détails qui en disent aussi long qu'une vue d'ensemble, voire plus. De nombreux graphistes travaillent pareillement avec leurs propres méthodes. Le message est plus important que l'esthétique. A l'avenir, les créateurs deviendront des spécialistes de la communication, travaillant dans des domaines aussi variés que l'art et la publicité, la poésie et la photographie. La différence entre ces spécialisations sera les ‹outils› qu'elles requièrent. »

**Martijn Oostra**
Donker Curtiusstraat 25e
1051 JM Amsterdam
The Netherlands

T +31 20 688 96 46
F +31 84 223 61 31

E info@oostra.org

**Biography**
1971 Born in Waalre, The Netherlands
1994 Worked for Atelier Fabrizi, Paris
1995 Graduated in graphic design at the Arnhem Institute for the Arts; began working as a freelance designer and undertook several projects with the Arnhem-based graphic designer Martijn Smeets

**Professional experience**
1996 Worked at an advertising agency and a communication agency; granted rights for the BlackMail font to 2Rebels, Montreal
1997 Founded own studio in Amsterdam; granted rights for five fonts to 2Rebels, Montreal
1999 PARK 4DTV television station broadcasted video art works, "2e Kostverlorenkade" and "Omdat bouwvakkers ook wel eens moeten" (Construction workers have to go sometimes, too)
2000 Granted rights for EricsSome font to 2Rebels, Montreal; began writing for Adformatie and published other essays

**Recent exhibitions**
1999 Participated in Millennium Calendar project for CDR Associates, Seoul
2001 "CityJam#2", Arnhem; "KXvNX", Arnhem

**Clients**
Adformatie,
Carp*
CDR Associates
Credits
Cult Uur
Dorp & Dal/Fontshop
DrukGoed
G.A.N.G.
I-Jusi
Items
LUST
PARK 4DTV
Quality Services Int.
Randstad Transportdiensten
"Rotterdam 2001"
Shift!
Stadsdeel De Baarsjes, Amsterdam
Stadsdeel Westerpark, Amsterdam
Stap TK&O
Stichting Gezondheidszorg voor Dansers
Stichting Hooghuis
Sybolt Meindertsma
Tegenwind
Theater Instituut Nederland
TMPW
Vandejong
Vormgevingsassociatie
VeRes

Opposite page:

**Project**
Magazine submission

**Title**
Mutation

**Client**
Ad!dict, Brussels

**Year**
2001

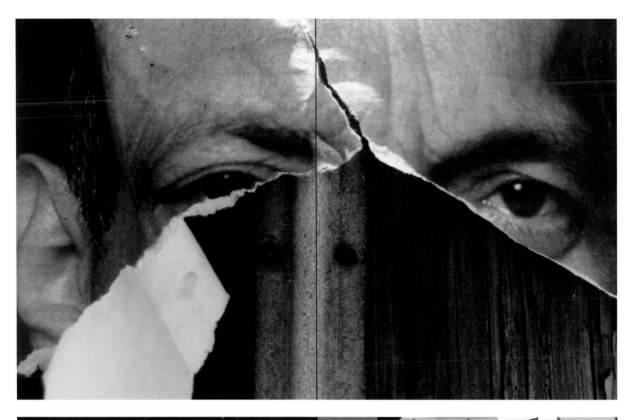

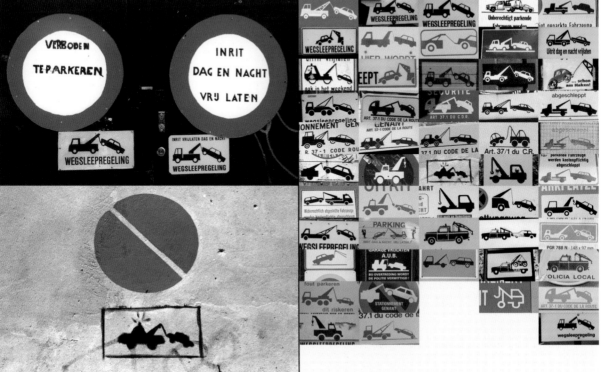

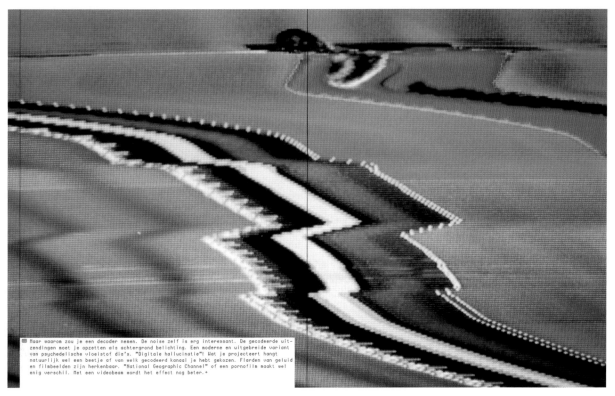

**Project**
Television broadcast

**Title**
Digital Hallucination

**Client**
Credits (prepublication),
Amsterdam / Ad!dict,
Brussels / PARK 4DTV,
Amsterdam

**Year**
1999–2002

Opposite page:

**Project**
Millennium calendar
project

**Title**
November 2000

**Client**
CDR Associates, Seoul

**Year**
1999

| | | | | |
|---|---|---|---|---|
| **Monday** Lundi Montag Lunedi Maandag | | – 6 NOV. 2000 | 1 3 NOV. 2000 | 2 0 NOV. 2000 | 2 7 NOV. 2000 |
| **Tuesday** Mardi Dienstag Martedi Dinsdag | | – 7 NOV. 2000 | 1 4 NOV. 2000 | 2 1 NOV. 2000 | 2 8 NOV. 2000 |
| **Wednesday** Mercredi Mittwoch Mercoledi Woensdag | – 1 NOV. 2000 | – 8 NOV. 2000 | 1 5 NOV. 2000 | 2 2 NOV. 2000 | 2 9 NOV. 2000 |
| **Thursday** Jeudi Donnerstag Giovedi Donderdag | – 2 NOV. 2000 | – 9 NOV. 2000 | 1 6 NOV. 2000 | 2 3 NOV. 2000 | 3 0 NOV. 2000 |
| **Friday** Vendredi Freitag Venerdi Vrijdag | – 3 NOV. 2000 | 1 0 NOV. 2000 | 1 7 NOV. 2000 | 2 4 NOV. 2000 | |
| **Saturday** Samedi Samstag Sabato Zaterdag | – 4 NOV. 2000 | 1 1 NOV. 2000 | 1 8 NOV. 2000 | 2 5 NOV. 2000 | |
| **Sunday** Dimanche Sonntag Domenica Zondag | – 5 NOV. 2000 | 1 2 NOV. 2000 | 1 9 NOV. 2000 | 2 6 NOV. 2000 | |

# Optimo

## "We are interested in finding the most appropriate way to communicate an idea."

Opposite page:

**Project**
Poster / Typewriter font
collection / Type Specimen:
Optimo Executive

**Title**
Optimo Executive

**Client**
Optimo Type Foundry

**Year**
2001

# Optimo Executive

ABCDEFGHIJKLMNOPQRSTUVWXYZ
abcdefghijklmnopqrstuvwxyz
0123456789*@&$!?®©

[New Typewriter Collection available on *www.optimo.ch*]

"Real"         » Echt«         « Réel »

**Optimo**
24, Cotes-de-Montbenon
1003 Lausanne
10, rue des Vieux
Grenadiers
1205 Geneva
Switzerland

T +41 21 311 51 45
F +41 21 311 52 77

E service@optimo.ch

www.optimo.ch

**Design group history**
1997 Gilles Gavillet and
David Rust established
their typographic label
and began to publish
various typefaces through
www.optimo.ch

**Founders' biographies**
Gilles Gavillet
1973 Born in Lausanne,
Switzerland
1993–1998 École can-
tonale d'art de Lausanne
1996–1998 Welcomex
magazine, Lausanne
1997 Cranbrook Academy
of Art, Michigan
1998–2001 Cornel
Windlin Studio, Zurich
1999 Lectured and
conducted a workshop
at Vital, Tel Aviv
David Rust
1969 Born in Bienne,
Switzerland
1991–1996 École Can-
tonale d'Art de Lausanne
1996–1998 Art Director,
Lysis, Lausanne
1997 Cranbrook Academy
of Art, Michigan
1998–2000 Professor,
École Cantonale d'Art de
Lausanne
1999+ Jury member,
"The Most Beautiful
Swiss Books" competi-
tion
2000+ Expert for the
Swiss National Design
Awards

**Recent exhibitions**
1998 Swiss National
Design Awards, Basle Art
Fair, Switzerland
1999 Swiss National
Design Awards, Basle Art
Fair, Switzerland
2002 National Design
Awards, Museum für
Gestaltung Zurich

**Recent awards**
1998 Winner, Swiss
National Design Award
1999 Winner, Swiss
National Design Award;
Winner, Swiss Poster
of the Year Competition
2000 Winner, Swiss
Poster of the Year
Competition
2002 Winner, Most
Beautiful Swiss Books
Competition; Winner,
Swiss National Design
Award

**Clients**
Crédit Lyonnais Suisse
Lausanne School of
Polytechnics
International Red Cross
Museum
JRP Editions
NanoDimension
SCI-Arc
Swiss Federal Office
for Culture

**Project**
Multiple Master Font

**Title**
Ctrl MM

**Client**
Optimo Type Foundry

**Year**
1999

**Project**
Book

**Title**
Common Ground

**Client**
Swiss Federal Office of
Culture

**Year**
2002

**Project**
Book

**Title**
Timewave Zero –
A Psychedelic Reader

**Client**
JRP Editions

**Year**
2001

Across/
Art/Suisse/1975–2000/
Lionel Bovier (éd.)

ISBN 88-8491-003-X
Skira editore
28,97 €/190 F

**Project**
Book

**Title**
Across/Art/Suisse/1975-
2000

**Client**
Crédit Lyonnais Suisse
S.A.

**Year**
2001

# Matt Owens

## "An ongoing examination/conversation between the dynamics and interrelationships of personal exploration and professional practice."

Opposite page:

**Project**
CD Rom cover and poster

**Title**
CODEX SERIES 1 and 2

**Client**
Self-published

**Year**
1999/2000

# ① the**Codex**series
### narrative exploration beyond the book
#### Josh Ulm. Tree Axis. Orangeflux. Volumeone.

**Persistence
of Vision**
Josh Ulm.

**Fantasy Island**
Tree Axis.

**Love Horse**
Orangeflux.

**Heterotopia**
Volumeone.

the**Codex**series is a quarterly document of new projects by four different talents working in the digital medium, exploring the interrelation of narrative, design and the interactive.

"The definition of where graphic design ends and begins is becoming more and more blurred as technology and functional constraints begin to further determine visual constraints. As a result, I think that 'design' will become more clearly divided along visual and technological lines. I really enjoy the space between the visual and the technological and feel that designers who can negotiate the space between technology and aesthetics will be the most successful in the future. The interrelationship between print and interactive and motion graphics is an interesting space that will become more and more important in the future. Visual language exists all around us and this will not change. How visual language interacts with popular culture, technology and media/mediums will remain at the heart of what makes graphic design as a discipline so interesting and ever-evolving."

» Die Bestimmung der Punkte, an denen die Gebrauchsgrafik beginnt und endet, wird mit den durch Technik und funktionale Zwänge immer enger gezogenen optisch-bildlichen Grenzen zunehmend schwieriger. Meiner Meinung nach wird man ›Design‹ deshalb künftig noch klarer nach visuellen und technischen Kriterien kategorisieren. Mir macht das Spannungsfeld zwischen den visuellen Aspekten und der Technik Spaß und ich glaube, dass diejenigen Grafiker, denen die Verbindung von Technik und Ästhetik gelingt, in Zukunft am erfolgreichsten sein werden. Die Wechselbeziehung zwischen Druckgrafik und interaktiver Grafik mit bewegten Bildern stellt ein interessantes Feld dar, das in Zukunft an Bedeutung gewinnen wird. Wir sind auf allen Seiten von Bildsprachen umgeben und das wird auch so bleiben. Wie sie mit Popkultur, Technik und verschiedenen Medien interagieren, wird auch weiterhin den Kern des Grafikdesigns ausmachen, der es so interessant und entwicklungsfähig erhält.«

« La technologie et les restrictions fonctionnelles déterminant chaque fois plus les contraintes visuelles, on a de plus en plus de mal à définir où commence le graphisme et où il finit. Par conséquent, je pense que la ‹création› sera plus clairement divisée par des frontières visuelles et technologiques. Je me plais bien dans l'espace contenu entre le visuel et le technologique et pense que les graphistes qui s'en sortiront le mieux seront ceux capables de négocier l'aire située entre la technologie et l'esthétique. Les interactions entre l'impression et le graphisme interactif et animé forment un domaine intéressant qui prendra de plus en plus d'importance. Le langage visuel est partout autour de nous et cela ne devrait pas changer. La manière dont il interagit avec la culture populaire, la technologie et les médias restera au cœur de ce qui fait du graphisme une discipline intéressante et en évolution constante. »

**Matt Owens**
Volumeone
Suite 607
54 West 21st Street
New York
NY 10010
USA

T +1 212 929 7828

E matt@volumeone.com

www.one9ine.com
www.volumeone.com

**Biography**
1971 Born in Dallas, Texas
1993 Graduated from the University of Texas
1994 MFA Graphic Design, Cranbrook Academy of Arts, Michigan

**Professional experience**
1995–1997 Creative Director, MethodFive, New York
1997 Founded Volumeone in New York
1999 Co-founded the design company one9ine with Warren Corbitt

**Recent exhibitions**
1999 "Young Guns 2", Art Directors Club, New York; "The Remedi Project", www.theremediproject.com
2001 "Young Guns 3", Art Directors Club, New York; "VidelLisboa", Lisbon; RMX TWO, "Extended Play", Sydney Fresh Conference

**Recent awards**
1999 Shockwave Site of the Day
2000 Shockwave Site of the Day; Flash Film Festival finalist – flashforward.com
2001 Flash Film Festival finalist – flashforward.com

**Clients**
Bartle Bogle Hegarty
Cooper-Hewitt, National Design Museum
National Geographic
The Museum of Modern Art, New York
United Nations
Wieden+Kennedy

**Project**
Postcards

**Title**
Arrival/Departure

**Client**
Self-published

**Year**
1999

**Project**
IdN magazine cover

**Title**
IdN magazine, vol. 6 no. 3
cover

**Client**
IdN

**Year**
1999

**Project**
Website

**Title**
Volumeone, Spring 2001
(volumeone.com)

**Client**
Self-published

**Year**
1997–2001

Opposite page:

**Project**
Emigre magazine spreads

**Title**
Deep End

**Client**
Emigre Magazine 51

**Year**
1999

# Mirco Pasqualini

"I like design work because I can express my ideas and my thoughts. I can share my mind…"

Opposite page:

**Project**
Personal Book

**Title**
Graphic Design
Experiment 5

**Client**
Self-published

**Year**
2002

"I'd like to create and build an entire city – I have been drawing buildings for a long time, I project streets, bridges, plazas; I'd like to create fashion; I'd like to create music; I'd like to cover the Chrysler Building in New York with images; I'd like to open a sunshine bar on a Caribbean beach; I'd like to follow important and creative projects for Human Interface research; I'd like to make drums, taking the wood and working it into an instrument; I'd like to travel for my business more weeks in a year; I'd like to live in Rovigo, in Paris, in New York, in Los Angeles, in Sydney and Tokyo; I'd like to learn every single creative technique; I'd like to have a son; I'd like all that means creativity. I'd like to dream forever ;-)"

» Ich würde gerne eine ganze Stadt entwerfen und bauen. Seit langem schon zeichne ich Gebäude, plane Straßen, Brücken und Plätze. Ich würde gerne Mode machen und Musik komponieren. Ich würde gerne das Chrysler Building in New York mit Bildern bedecken. Ich würde gerne eine Bar an einem Strand in der Karibik eröffnen. Ich würde gerne wichtige kreative Projekte im Bereich der Human Interface Forschung entwickeln. Ich würde gerne Trommeln herstellen, Holz nehmen und daraus ein Instrument bauen. Ich würde gerne jedes Jahr längere Geschäftsreisen als bisher machen. Ich würde gerne in Rovigo, in Paris, New York, Los Angeles, Sydney und Tokio leben. Ich würde gerne jede einzige kreative Technik erlernen. Ich hätte gerne einen Sohn. Ich hätte gerne alles, was Kreativität ausmacht. Ich würde gerne für immer und ewig träumen ;-)«

« J'aimerais créer et construire une ville entière. Je dessine des bâtiments depuis longtemps. J'imagine des rues, des ponts, des places. J'aimerais dessiner des vêtements. J'aimerais composer de la musique. J'aimerais recouvrir d'images le Chrysler Building à New York. J'aimerais ouvrir un bar paillote sur une plage des Caraïbes. J'aimerais suivre des projets importants et créatifs pour la recherche sur les interfaces ergonomiques. J'aimerais fabriquer des tambours, façonnant l'instrument à partir du bois brut. J'aimerais voyager plus souvent pour mon travail. J'aimerais vivre à Rovigo, à Paris, à New York, à Los Angeles, à Sydney et à Tokyo. J'aimerais apprendre toutes les techniques créatives. J'aimerais avoir un fils. J'aime tout ce qui signifie créativité. J'aimerais rêver toujours ;-) »

**Mirco Pasqualini**
Ootworld Srl
Piazza Serenissima, 40
31033 Castelfranco
Veneto (TV)
Italy

T +39 042 342 5311
F +39 042 342 5312

E mirco.pasqualini@
ootworld.com

www.mircopasqualini.com

**Biography**
1975 Born in Lendinara, Italy
1994 Graduated from technical commercial college

**Professional experience**
1999 Multimedia art director, Seven, Treviso, Italy
2000+ Co-founder and creative director, Ootworld, Italy

**Recent exhibitions**
2001 "Flashforum IBTS", Milan, Italy; "Flashforum", Perugia, Italy
2002 "Opera Totale", Mestre, Italy

**Recent awards**
1998 Macromedia Site of the Day (x2), USA
1999 Site of the Week, Communication Arts for Giglio project
2000 New Media Talent 2000, AKQA and Creative Review
2001 Mediastar and Bardi awards, Italy; Silver Lions, Cannes Festival

**Clients**
Expanets
FILA skates
Giglio
ItaliaOnLine Spa
King's markets
SAI Assicurazioni
Savannah International Trade Center
Sebastian International Hairstyling
Sillary Mayer & Partners
Teatro Massimo di Palermo
Wall Street Journal

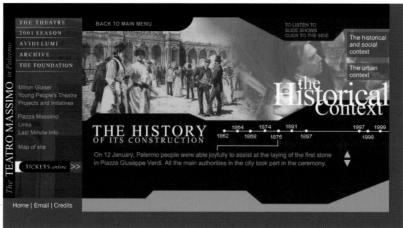

**Project**
Website Teatro Massimo of Palermo

**Title**
Teatro Massimo

**Client**
Foundation Teatro Massimo

**Year**
2000

Opposite page:

**Project**
Personal book

**Title**
Japanese Web Design Annual 1999

**Client**
Self-published

**Year**
2000

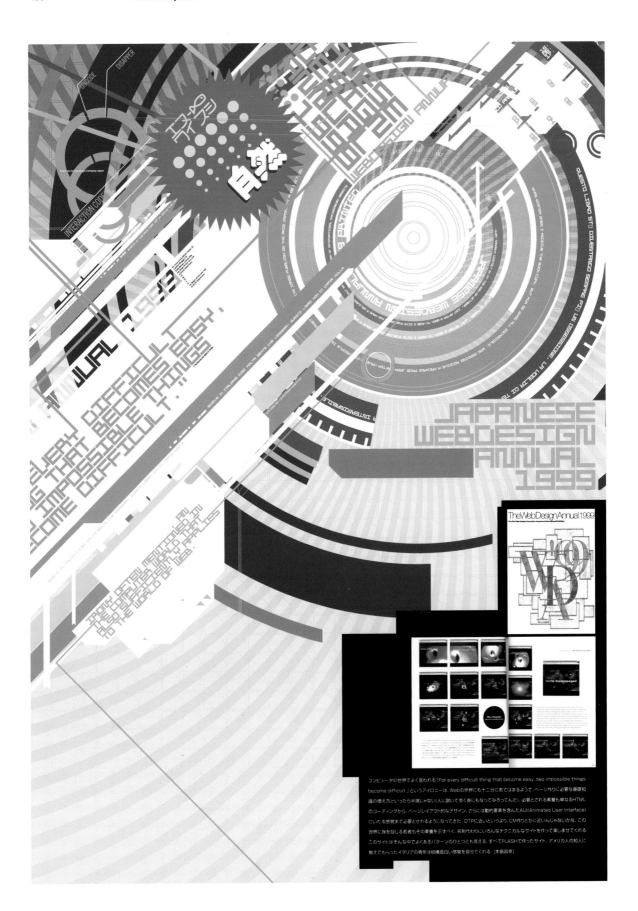

コンピュータの世界でよく言われる「For every difficult thing that become easy, two impossible things become difficult.」というアイロニーは、Webの世界にも十二分にあてはまるようで、ページ作りに必要な基礎知識の増え方といったら半端じゃない.人に説いて歩く身にもなってみろってんだ.必要とされる素養も単なるHTMLのコーディングから、ページレイアウト的なデザイン、さらには動的要素を含んだAUI(Animated User Interface)にいたる感覚まで必要とされるようになってきた.DTPに近いというより、CM作りとかに近いんじゃないかな.この世界に身を投じる若者もその素養を示すべく、名刺代わりにいろんなテクニカルなサイトを作って楽しませてくれる.このサイトはそんな中でよくある「パターンのひとつとも言える.すべてFLASHで作ったサイト、アメリカ人の知人に教えてもらったイタリアの青年は結構面白い感覚を見せてくれる[本島邦幸]

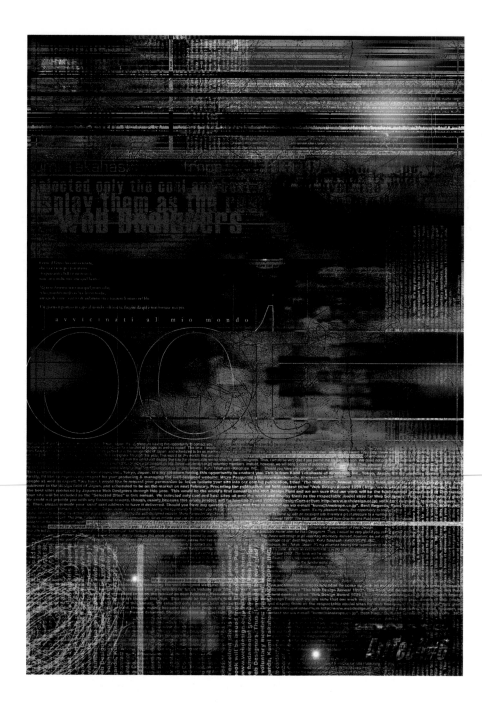

**Project**
Personal book

**Title**
No words

**Client**
Self-published

**Year**
2000

Opposite page, top:

**Project**
Personal book

**Title**
Teatro Massimo vision
remix

**Client**
Self-published

**Year**
2001

Opposite page, bottom:

**Project**
Personal book

**Title**
FILA Skates vision remix

**Client**
FILA

**Year**
2001

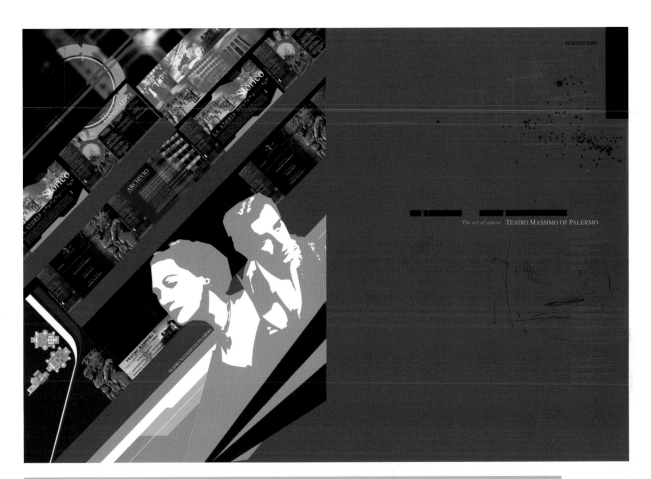

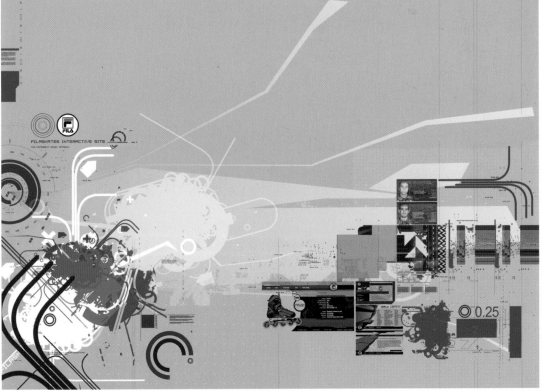

# Katrin Petursdottir

**"We are all just bobbing around."**

**Project**
Illustration

**Title**
Angel

**Client**
M.Y. Studio

**Year**
2002

"I like to tell and produce stories in my work, in a kind of visual comfort which I hope can speak to and entertain others as well. In a more detailed way these images spring out of a desire to explore and expand imaginary worlds and to cultivate them in computer-generated environments. With computer technology the possibilities for expressing this has become so detailed and expansive that these worlds have developed their own kinetic momentum within the structures that I have created for them. In modern society we breathe the air of visual communications. It envelops us, inside and outside, and we accept it, under the illusion of making a choice. This is our reality and with the multitude of choices all around us we have become very trained at analysing, making connections and drawing conclusions about the messages and codes we are forced to absorb. I think that it's possible to intertwine different creative languages without making a sticky mixture, and that design in the future will be practised in a much more 'interfused,' fluid way, resulting in a freer mental environment. It definitely won't be just logos."

» Mit meinen Arbeiten erzähle ich gern Geschichten als eine Art visueller Trost, der auch andere Menschen anspricht. Wenn man es genauer betrachtet, entspringen diese Bilder dem Wunsch, imaginäre Welten zu erkunden und zu erweitern und sie in computersimulierten Umgebungen zu kultivieren. Mit der Computertechnik sind die Ausdrucksmöglichkeiten dafür so detailliert und weitreichend geworden, dass diese Welten innerhalb der Strukturen, die ich für sie geschaffen habe, eine Eigendynamik entwickelt haben. In der modernen Gesellschaft atmen wir die Luft der visuellen Kommunikation. Das ist unsere Realität und bei der allgegenwärtigen Fülle von Angeboten haben wir es inzwischen gelernt, in all den uns aufgezwungenen Botschaften und Zeichen Zusammenhänge zu erkennen und daraus Schlüsse zu ziehen. Ich halte es für möglich, verschiedene kreative Sprachen zu mischen, ohne dass dabei etwas Klebriges herauskommt. Ich halte es auch für möglich, dass Design in Zukunft viel übergreifender und fließender sein wird und mehr geistigen Freiraum schafft. Auf keinen Fall wird es sich nur mit Firmenlogos befassen.«

« Dans mon travail, j'aimerais raconter et produire des histoires, trouver une forme de confort visuel qui, je l'espère, parvienne à toucher et divertir les autres. Mes images naissent d'un désir d'explorer et d'élargir des mondes imaginaires et de les cultiver dans des environnements générés par ordinateur. Grâce à l'informatique, les possibilités d'expression sont si détaillées et expansives que ces mondes ont développé leur propre élan cinétique au sein des structures que je leur ai créés. Dans la société moderne, nous respirons l'air des communications visuelles. Il nous enveloppe, et nous l'acceptons, croyant faire un choix. Du fait de la multitude des choix, nous sommes très bien entraînés à analyser, à établir des liens et à tirer des conclusions sur les messages et les codes que nous sommes contraints d'absorber. Je crois qu'il est possible d'entremêler différents langages créatifs sans en faire une mixture poisseuse, et que le graphisme sera pratiqué à l'avenir d'une manière beaucoup plus fluide, débouchant sur un environnement psychologique plus libre. Une chose est sûre, il ne s'agira pas uniquement de logos. »

**Katrin Petursdottir**
M.Y. Studio Ltd.
Box 498
Reykjavík 121
Iceland

T/F +354 561 2327

E katrin@simnet.is
E katrin.petursd@lhi.is

**Biography**
1967 Born in Akureyi, Iceland
1990 Foundation Course, Polycrea, Paris; Design Diploma, Industrial Design, E.S.D.I., Paris

**Professional experience**
1996 Product Development, Philippe Starck office, Paris
1997 Product Development, Ross Lovegrove studio, London
1998–2001 Product Development, Michael Young – M.Y. Studio Ltd., Reykjavík
2000 Curated Design in Iceland exhibition, Reykjavík
2000–2001 Director of Studies, Iceland Academy of Art, Reykjavík

**Recent exhibitions**
2000 "Art Is.", Interactive art piece designed in collaboration with an Icelandic artist and Michael Young, National Art Museum, Reykjavík
2001 "Drew", Designers Block, Osaka, Japan; 100% Design, London

**Clients**
66 N
Casa Brutus
Channel 2 Iceland
Corian
ERES
Iceland Spring
Idée
Ritzenhoff
Rosenthal
S.M.A.K.

**Project**
Illustration

**Title**
Flags

**Client**
Self-published

**Year**
2001

**Project**
Illustration

**Title**
flowers&bugs

**Client**
Self-published

**Year**
2000

左のオブジェは「マジックワゴン」というストレージテーブル。右は、ヴァイキング・ベースボールの現代版で、もちろん、骨はプラスチックで作ってあります。ともに4月に行われるミラノ・サローネで発表！

マイケル・ヤング＆キャトリン・ピータースドッター　マイケルは仕事でノルウェーに行ったり、サローネの準備などで、相変わらずアイスランドをお留守のよう。キャトリンも。洋服のデザインに乗り出してパリまで出張。

✳ パフィン通信
## フェロー諸島上空 38,000フィートからのリポート
# インターナショナルな犬とは。

マイケルとキャトリンは本当に動物好き。中でも犬がお気に入り。で、今回は世界の犬の性格判断をしてみました（飛行機の中で）。つーか、とどのつまりは人間の国別性格判断か？

text_Michael Young　illustration_Katrin Petursdottir
translation_Chise Taguchi

も　しあなたが『Emergency Vet』や『Animal Planet TV』というテレビ番組を見たことがあるならば、アメリカの犬はドイツの犬に比べてあまり頭がよくない、ということにおそらく気がついていると思う。これは、つまりどういうことかというと、ほとんどの国民性は、犬科王国のメンバーに反映されるということだ。最近の僕みたいに、世界各国の犬を通して友達を作ることに楽しみを発見した人なら、この意味はもっとクリアになるはずだ。

ロンドンのMYオフィスの上に住むクライドは、イギリス産の中でも重要な種類のボクサー犬で、何につけ、とても「ブリティッシュな行動」を見せてくれる。クライドは、足を使ってスタジオのドアのノブを回し、さらにドアを押して、中に入ってくることができるんだ。だけど、部屋を出る時は、同じ方法ではドアは開かないということが見えてなくて、彼はいつまでもドアを押しつづけてる。これってすごく典型的なブリティッシュなんだよね。僕の親友のひとり、ジェームス・アーヴァインからクライドの外国の友達、イタリア生まれのロッキーをデザイナーの時に紹介されたんだけど、これがでかいのなんの……想像できる隙間の倍の大きさはある犬、それがロッキー！だった。しかし、デブのイタリアンで何が悪い？　って思ったよ。すべて……彼らは歌うじゃないか！

僕らのほとんどが考えるウェールズ人って、羊が好きで女嫌い。これ、ホント。ウェールズのパブはロンドンのゲイバーみたいなんだ。友達のオーウェンは、彼のウェルシュ・ブラドールのベントリーとソファに座りながら「僕のいちばん好きなのは毛深い男、君だよ」とかって話しかけるくらいだ。

それから上のスプレーブドールの絵を見てくれれば分かると思うけど、アイスランドの犬たちも例外じゃない。なぜなら、アイスランドの人たちって、何か特別な条件があるというよりは、ただ単にマッドだから。

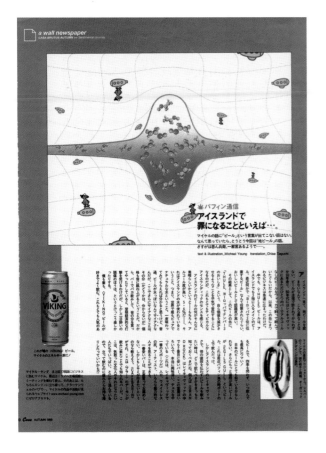

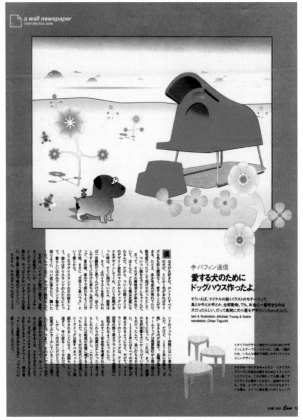

Opposite page:

**Project**
Illustration

**Title**
Puffin Mail, May

**Client**
Casa Brutus, Japan

**Year**
2002

**Project**
Illustration

**Title**
Puffin Mail, Winter

**Client**
Casa Brutus, Japan

**Year**
1999

**Project**
Illustration

**Title**
Puffin Mail, June

**Client**
Casa Brutus, Japan

**Year**
2001

# Posttool

## "It takes two."

Opposite page:

**Project**
Real time, interactive,
animating, audio-visual
organ

**Title**
Variations (sketches)

**Client**
2001 Experimental
Design Award Exhibition,
San Francisco Museum of
Modern Art

**Year**
2001

"If the last millennium was obsessed with the pursuit of information, the coming millennium will surely be preoccupied with the task of making our way through the mass of data we have accumulated. The greatest challenge of the information age that is opening before us is not discovery but navigation. From the beginning, Posttool's most ambitious projects have been concerned with navigation. The proliferation of ideas, information and images that are so striking a feature of our time have rendered our mental geographies so complex that we cannot hope to find our way through them unescorted."

» Wenn wir im vergangenen Jahrtausend von der Jagd nach Information besessen waren, werden wir uns im kommenden sicherlich damit befassen, uns einen Weg durch die Massen der angesammelten Daten zu bahnen. Die größte Herausforderung des Informationszeitalters besteht künftig nicht im Entdecken, sondern im Navigieren. Von Anfang an hat sich Posttool bei seinen ehrgeizigsten Projekten mit Navigation auseinandergesetzt. Das unglaubliche Anwachsen von Ideen, Wissen und Bildern hat unsere mentale Landschaft derart kompliziert, dass wir ohne Lotsen keine Chance mehr haben, uns darin zurechtzufinden.«

« Si le millénaire précédent était obnubilé par la quête de l'information, celui qui commence sera certainement accaparé par la tâche de faire le tri dans la masse de données que nous avons accumulées. Le plus grand défi de l'ère de l'information qui s'ouvre à nous n'est pas la découverte mais la navigation. Dès le début, les projets les plus ambitieux de Posttool y ont été liés. La prolifération des idées, des informations et des images qui constitue un aspect si frappant de notre temps a rendu nos géographies mentales tellement complexes que nous ne pouvons espérer nous orienter dedans sans guides. »

**Posttool**
417 14th Street
San Francisco
CA 94103
USA

T +1 415 255 1094
F +1 415 255 2208

E david@posttool.com
gigi@posttool.com

www.posttool.com

**Design group history**
1993 Co-founded by David Karam and Gigi Obrecht in San Francisco

**Founders' biographies**
David Karam
1969 Born in Rolla, Missouri
Self-taught
Gigi Obrecht
1964 Born in Paris
1986 Graduated in Fine Arts/Art History from Skidmore College, New York

**Recent exhibitions**
1998 "Four Walls", Artists Explorations in Outer Space, San Francisco
2000 "Cardinal Directions", Cooper Hewitt National Design Museum, Smithsonian Institute, New York City
2001–2002 "Variations", San Francisco Museum of Modern Art

**Recent awards**
1999 Interactive Silver, I.D. magazine; Best CD-Rom, E-Phos International Festival of Film and New Media, Greece
2000 Chrysler Award Nominee for Innovation in Design
2001 Experimental Design Award, SECA/A+D SFMOMA, San Francisco

**Clients**
Apple Computers
Autodesk
Body Shop International
California College of Arts and Crafts
CCAC Institute
Chiat Day
Chronicle Books
Colossal Pictures
Dwell Magazine
Frogdesign
Getty Information Institute
Marks & Spencer
Nazraeli Press
Organic Online
Penguin Putnam Publishing
San Francisco AIGA
San Francisco Museum of Modern Art
Sony Pictures Entertainment
Steelcase Seating
Swatch
Teknion Office Systems
Sony
Vh1
Warner Records

**Project**
Real time, interactive, animating, audio-visual keyboard

**Title**
Variations (installation)

**Client**
2001 Experimental Design Award Exhibition, San Francisco Museum of Modern Art

**Year**
2001

**Project**
Video installation

**Title**
Cardinal Directions

**Client**
Cooper-Hewitt, National
Design Museum

**Year**
2000

**Project**
Real time, interactive,
animating, audio-visual
organ

**Title**
Variations (screenshots)

**Client**
2001 Experimental
Design Award Exhibition,
San Francisco Museum of
Modern Art

**Year**
2000

# Research Studios

## "Visual communication is soulfood for the mind."

Opposite page:

**Project**
Main promotional poster

**Title**
Fuse 18, Secrets

**Client**
Self-published

**Year**
2000

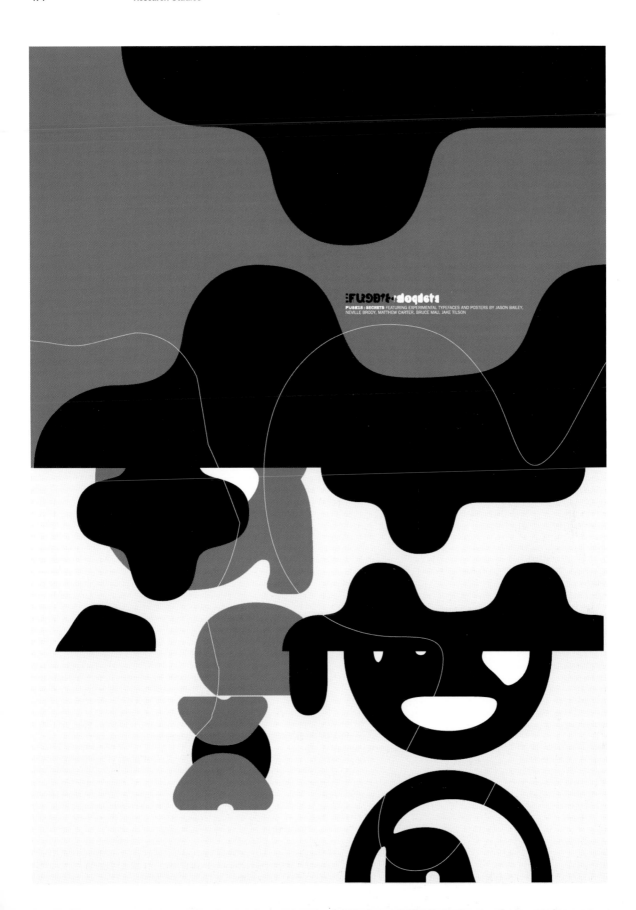

FUSE18 : SECRETS FEATURING EXPERIMENTAL TYPEFACES AND POSTERS BY JASON BAILEY, NEVILLE BRODY, MATTHEW CARTER, BRUCE MAU, JAKE TILSON

"Research Studios is a dynamic, experienced and innovative visual communications and design studio with offices in London, Paris, Berlin, San Francisco and New York, operating across a broad range of commissions and media, from one-off creative projects to complete visual communication strategies. A small team infrastructure maintains a strong human aspect. For each project we work by creating solid systems and constructions over a well researched and rooted foundation or DNA. Over this solidity we then improvise, so as to explore new possibilities while remaining rooted in clear structure and code – a basic language model. Our approach to design is one of an exploratory process leading wherever we can to constantly evolving solutions focused on a criteria of revealing, not concealing, the underlying control mechanisms evident at the root level of visual communication. We attempt to actively engage the viewer emotionally and intellectually by confronting them with ambiguous and often incomplete or abstracted images, usually underpinned by a formal typography, which create a dialogue that by necessity can only be completed by the viewer's own interpretation, ensuring a fluidity of communication. This can help highlight directly the insubstantiality of consumer culture through a kind of experiential shift, and can often create a vital place of quiet, peace and oxygen."

» Research Studios ist eine dynamische, erfahrene und innovative Agentur für visuelle Kommunikation mit Niederlassungen in London, Paris, Berlin, San Francisco und New York. Wir bearbeiten eine breite Palette von Aufträgen und Medien, von kreativen Sonderlösungen bis hin zu kompletten visuellen Kommunikationsprogrammen. Aufgrund unserer Arbeitsweise in kleinen Teams bewahren unsere Entwürfe einen ausgeprägt menschlichen Aspekt. Jedes Projekt wird als ein stabiles System auf dem Fundament einer gründlich recherchierten Grundlage oder DNA entwickelt. Unser Gestaltungsansatz ist ein Erkundungsprozess, der uns zu sich stets entwickelnden Lösungen führt und sich darauf konzentriert, die Steuerungsmechanismen der visuellen Kommunikation aufzudecken statt zu verbergen. Wir bemühen uns, die Gefühle und den Verstand der Betrachter anzusprechen, indem wir ihnen zweideutige, vielfach auch unvollständige oder abstrahierte Bilder zeigen, begleitet von einer entsprechenden Typografie. Diese führt zu einem Dialog mit den Bildern, der nur von der Interpretation durch den Betrachter vervollständigt werden kann und so für eine fließende, unvorhersehbare Kommunikation sorgt. Das streicht – mithilfe einer Art Erfahrungsverschiebung – die Substanzlosigkeit der Konsumkultur heraus und ist oft dazu angetan, einen lebenswichtigen Ort der Stille, des Friedens und Luft zum Atmen zu schaffen.«

« Research Studios est un bureau de graphisme et de communication visuelle dynamique, expérimenté et innovateur avec des agences à Londres, Paris, Berlin, San Francisco et New York. Il gère une vaste gamme de commandes et de moyens de communications, des projets créatifs isolés et des stratégies de communication visuelle complètes. Notre infrastructure en petites équipes nous permet de conserver un caractère très humain. Pour chaque projet, nous créons des systèmes et des constructions solides s'appuyant sur des fondations bien documentées. A partir de cet appui stable, nous improvisons, nous recherchons de nouvelles possibilités tout en restant enracinés dans un cadre et des codes clairs. Notre approche du graphisme repose sur l'exploration, sur une quête de solutions en évolution constante. Notre critère est de révéler, non de cacher, les mécanismes de contrôle sous-jacents à la base de la communication visuelle. Nous tentons de faire intervenir les émotions et l'intellect du public en le confrontant à des images ambiguës, souvent incomplètes ou abstraites, généralement encadrées par une typographie formelle, créant un dialogue qui ne peut être complété que par l'interprétation personnelle de notre interlocuteur. Cela contribue parfois à souligner le caractère insaisissable de la culture de consommation et crée souvent un espace vital de tranquillité, de paix et d'oxygène. »

**Research Studios**
94 Islington High Street
Islington
London N1 8EG
UK

T +44 20 7704 2445
F +44 20 7704 2447

E info@
  researchstudios.com

www.research-
  studios.com

**Design group history**
1994 Founded by Neville Brody in London

**Founder's biography**
1957 Born in London
1976–1979 BA (Hons) Graphic Design, London College of Printing
1981–1986 Art Director, The Face magazine
1983–1987 Designer, City Limits, New Socialist and Touch magazines
1986–1990 Art Director, Arena magazine
1994 Founded Research Studios, London, and Research Arts, London, and Research Publishing, London
2000 Established Research Studios in Paris and San Francisco

**Exhibitions**
1988 "The Graphic Language of Neville Brody" (Retrospective exhibition), Victoria & Albert Museum, London

**Clients**
AGFA
Allied Dunbar
Amdocs
Armand Basi
Armani
BMW
Body Shop
British Council
British Airways
Calman & King
Camper
Channel Four
Citadium
Dentsu
Deutsche Bank
Domus Magazine
Electrolux
Fiorucci
Guardian Newspaper Group
Haus der Kulturen der Welt
Jean-Paul Gaultier Parfums
Katherine Hamnett
Kenzo
Leopold Hoesch Museum
Maceo

Macromedia
Martell
Max Magazine
Men's Bigi
The Museum of Modern Art, New York
N.B.C.
The National Theatre
Nike
NMEC
ORF
Parco
Pathé
Premiere Television
Reuters
Ricoh
Salomon
Scitex
Sony
Swatch
Thames & Hudson
Turner Network Television
United Artists
Vauxhall
Vitsoe
Yedioth Ahronoth
Young & Rubican
Zumtobel

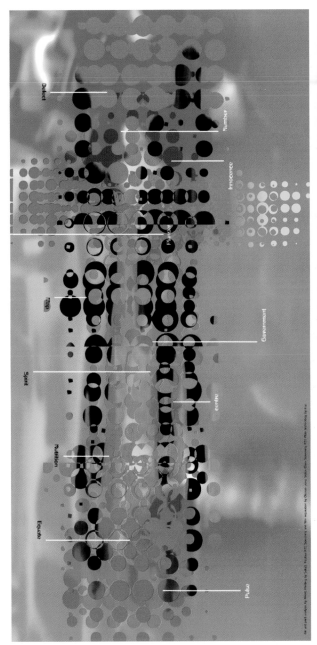

**Project**
Box edition of 'The
Graphic Language of
Neville Brody', Books 1
and 2

**Title**
Special Poster Insert

**Client**
Thames and Hudson,
London

**Year**
1994

**Project**
Cover of Typography
Issue

**Title**
MacUser

**Client**
Dennis Publishing,
London

**Year**
2001

**Project**
Main promotional poster

**Title**
Fuse 14, Cyber

**Client**
FSI, Berlin

**Year**
1995

**Project**
Main promotional poster

**Title**
Fuse 15, Cities

**Client**
FSI, Berlin

**Year**
1996

# Rinzen

"A post-ironic, post-pastoral, post-humorist approach to graphic design, championing the expression of the very minutiae of human experience through the mathematics of magnitude and direction (with the occasional bitmap)."

**Project**
RMX (no. 2) book

**Title**
RINZEN PRESENTS RMX
EXTENDED PLAY
Featuring 30 Contributors
from around the World

**Client**
Die Gestalten Verlag

**Year**
2001

"In the future there will be increasingly visually-literate and style-conscious communities, personal graphical representation in real or virtual spaces will become all-pervasive by calm necessity, as omnipresent and invisible as clothing and complexion. The ultimate statement of graphic authorship – 'I am'. Trends will drift, coalesce and divide like pixel clouds as geographical-space will become subservient to idea-space; dreamers, outsiders and heretics will shine like beacons, quickly to be extinguished or exalted … Elsewhere, laws will be passed banning the use of Gill Sans."

» In Zukunft wird es zunehmend visuell bewanderte und stilbewusste Gruppen geben. Die persönliche grafische Darstellung in realen oder virtuellen Räumen wird sich infolge der allgemein stillschweigend anerkannten Notwendigkeit überall verbreiten und ebenso allgegenwärtig und unsichtbar sein wie Kleidung und Teint. Die ultimativen Worte des grafischen Urhebers: ›Ich bin.‹ Trends werden dahintreiben, sich bündeln und wieder zerteilen wie Pixelwolken, wenn der geografische Raum sich dem Ideenraum unterordnet. Träumer, Außenseiter und Häretiker werden wie Leuchtfeuer strahlen, die entweder rasch gelöscht oder aber in den Himmel gehoben werden … Anderswo wird man die Verwendung der Gill Sans gesetzlich verbieten.«

« A l'avenir, il y aura de plus en plus de communautés possédant une grande culture visuelle et une conscience de style. La représentation graphique personnelle s'imposera tranquillement dans tous les espaces réels ou virtuels par nécessité, aussi omniprésente et invisible que les vêtements ou le teint, affirmation même de la qualité d'auteur graphique – ‹Je suis›. Les tendances passeront, fusionneront, se diviseront telles des nuages de pixels tandis que l'espace géographique deviendra subordonné à l'espace idée. Les rêveurs, les marginaux et les hérétiques brilleront comme des balises, rapidement éteintes ou exaltées… Ailleurs, on adoptera des lois pour interdire l'utilisation du Gill Sans. »

**Rinzen**
PO Box 1729
New Farm 4005
Queensland
Australia

E they@rinzen.com

www.rinzen.com

**Biography**
Rinzen is an Australian collective, working on a range of client and personal projects – in print and web design, illustration, fonts, characters, animation and music. Published in magazines such as The Face, Wired, Zoo, Creative Review and Nylon, Rinzen's work has also been exhibited in Australia, Asia and Europe, broadcast on German Music Television station, Viva Plus and included in the Diesel Friendship Gallery. Rinzen is also extremely active in self-initiated and contributor-based projects, participating in a number of online and print-based graphic works, as well as directing the RMX series of projects. RMX Extended Play, the second RMX project, was published in book-form in September 2001. It features the visual remixing talents of around 30 designers from Australia, the US, the UK, Switzerland, Japan and Germany.

**Recent exhibitions**
2000 "We are the World", Brisbane; "RMX//A Visual Remix Project", Brisbane and Berlin
2001 "Rinzen Presents RMX Extended Play", Sydney, Brisbane and Berlin; "All about Bec", Sydney; "Kitten", Melbourne

**Clients**
Black + White
Blue
Brisbane Marketing
Family/Empire/Pressclub
Kitten
Mushroom
The Face
Warner
Wink Media
Wired

**Project**
Promotional material (flyers, stickers, passes)

**Title**
Family

**Client**
Family (Nightclub)

**Year**
2001

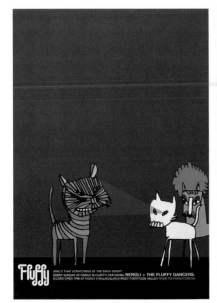

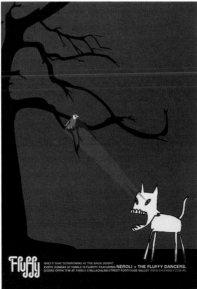

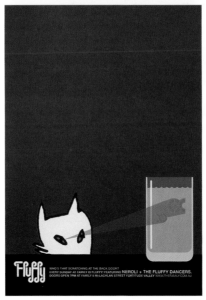

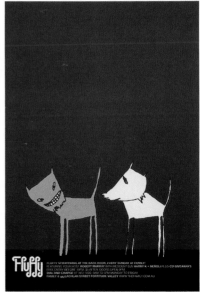

**Project**
Flyers

**Title**
Who's that Scratching at
the Back Door?

**Client**
Family (Nightclub)

**Year**
2001

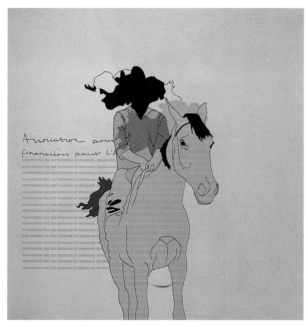

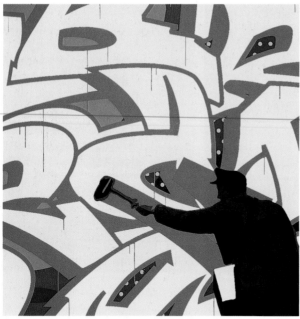

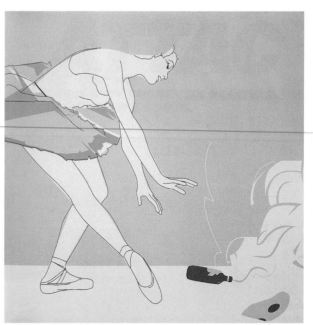

**Project**
Spreads from RMX (No. 2)
Various contributing
designers

**Title**
RINZEN PRESENTS RMX
EXTENDED PLAY

**Client**
Die Gestalten Verlag

**Year**
2001

# Bernardo Rivavelarde

## "Today, graphic design is defined predominantly by the technologies we are creating and using."

Opposite page:

**Project**
Digital exhibition
"Escuchando imágenes"
(listening to images)

**Title**
Digital evolution

**Client**
IconMedialab

**Year**
1999

"Well, in my opinion graphic design is being increasingly shaped by technology. Since the early '90s computers have allowed us to create new codes, new visual languages. That is great, but at the same time the risk we have is that in a short period of time most of our creations made with the help of the latest software are not able to live more than one or two years. Quickly something new appears and what we thought was wonderful, now is just ok. It means the relation between the graphic design, designers and computers is still very young and there's a long way to go."

» Meiner Meinung nach wird die Gebrauchsgrafik immer stärker von der Technologie geprägt. Seit Anfang der 90er Jahre hat der Computer es uns ermöglicht, neue Codes und Bildsprachen zu entwickeln. Das ist großartig, aber damit riskieren wir auch, dass die meisten unserer mithilfe der neuesten Software entstandenen Arbeiten spätestens nach ein oder zwei Jahren überholt sind. Schnell kommt etwas Neues auf und das, was wir für fabelhaft hielten, ist jetzt nur noch ›ganz in Ordnung‹. Das bedeutet, dass die Beziehung zwischen Grafikdesign, Grafikern und Computern noch immer in den Anfängen steckt und noch einen langen Weg vor sich hat.«

« Le graphisme est de plus en plus façonné par la technologie. Depuis le début des années 90, les ordinateurs nous ont permis de créer de nouveaux codes, de nouveaux langages visuels. C'est très bien, mais nous risquons également de voir la plupart de nos créations réalisées avec les derniers logiciels dépassées au bout d'un ou deux ans. Dès qu'un nouveau programme paraît nous nous précipitons dessus avec émerveillement, pour nous en lasser aussi rapidement. Cela signifie que la relation entre le graphisme, les créateurs et les ordinateurs est très jeune et qu'il y a encore beaucoup de chemin à parcourir. »

**Bernardo Rivavelarde**
Avda. Ciudad de
Barcelona 110
(4a esc. 7 F)
28007 Madrid
Spain

T +34 91 5016830
F +34 91 5210080

E bernardo@
iconmedialab.es
ber@smartec.es

**Biography**
1970 Born in Santander, Spain
1993 Tecnico Superior de Grafica Publicitaria, Escuela De Arte N° 10, Madrid

**Professional experience**
1994 Designed first Spanish magazine in CD-ROM format, "CD-Magazine"
1995 Art Director, Teknoland, Madrid
1997+ Art Director, Icon Medialab, Madrid
2000 Designed national campaign for the Compania Nacional de Danza (National Ballet)

**Recent exhibitions**
1999 "Escuchando Imágenes" (Listening to Images), Galeria Valle Quintana, Madrid; "Signs of the Century, 100 Years of Graphic Design in Spain", Reina Sofia Museum, Madrid
2002 Animation multimedia for national ballet choreography, Compañia Nacional de Danza, Spain
2002 "Pasion Diseño Español", Berlin, Vienna and Salamanca

**Recent awards**
1999 Camara de Comercio Award for Best Business Site, Madrid
1999 LAUS AWARD, Barcelona, for the best non-commercial website with Escuchando imágenes (listening to images) www.iconmedialab.es/ei
1999 MOBIUS AWARD, Barcelona, for the best net-art application with Escuchando imágenes (listening to images) www.iconmedialab.es/ei.

**Clients**
Air Europa
Airtel
BT
Mapfre
Oni Way
Opel
Suzuki
Telecinco
Vegasicilia

**Project**
Digital exhibition "Escuchando imágenes" (listening to images)

**Title**
Cortina de lluvia

**Client**
IconMedialab

**Year**
1999

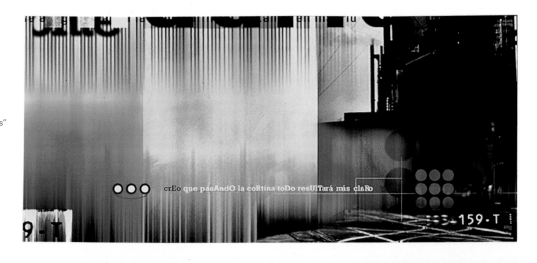

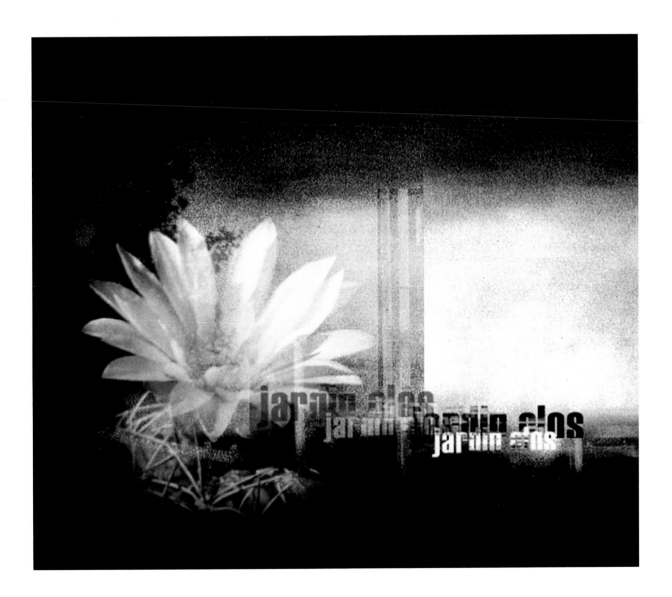

**Project**
Digital exhibition
"Escuchando imágenes"
(listening to images)

**Title**
Jardin Clos

**Client**
IconMedialab

**Year**
1999

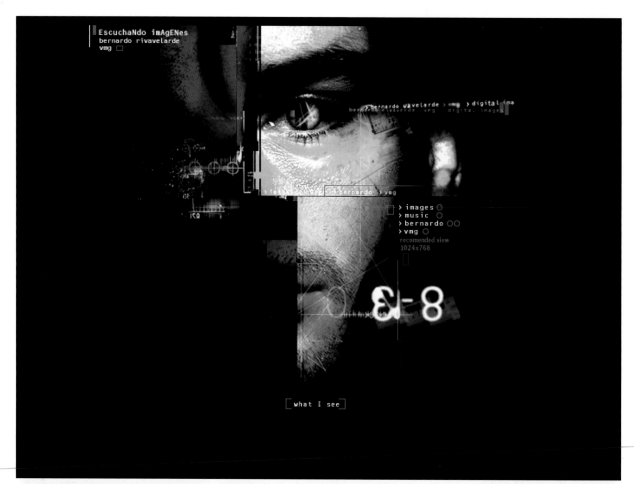

**Project**
Digital exhibition
"Escuchando imágenes"
(listening to images)

**Title**
Homepage and
three webpages of
"Escuchando imágenes"
www.iconmedialab.es/ei

**Client**
IconMedialab

**Year**
1999

**Project**
Digital exhibition
"Escuchando imágenes"
(listening to images)

**Title**
Mouth

**Client**
IconMedialab

**Year**
1999

# Stefan Sagmeister

## "STYLE = FART"

Opposite page:

**Project**
Lecture poster

**Client**
Cranbrook Academy of
Art and AIGA Detroit

**Year**
1999

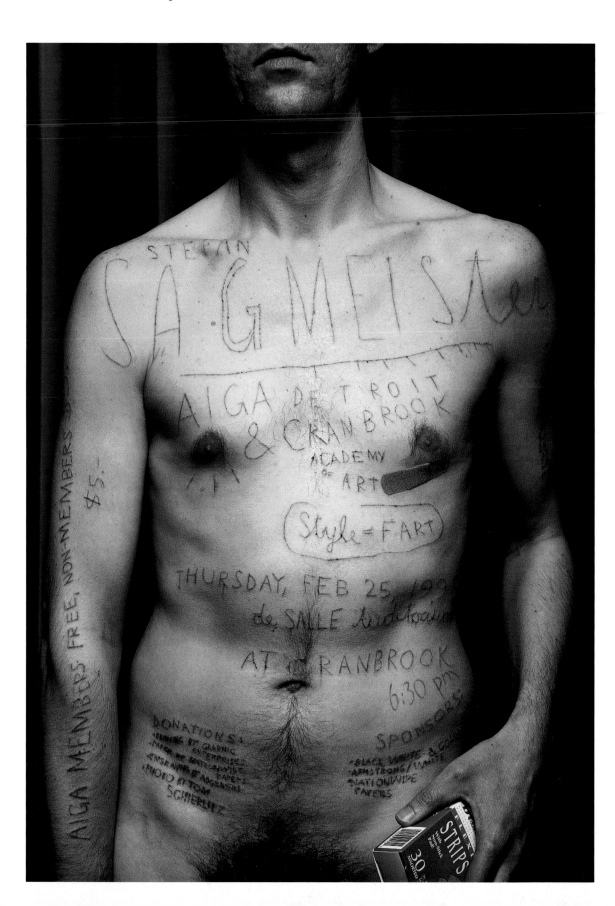

"I am mostly concerned with design that has the ability to touch the viewer's heart. We see so much professionally done and well executed graphic design around us, beautifully illustrated and masterfully photographed, nevertheless, almost all of it leaves me (and I suspect many other viewers) cold. There is just so much fluff: well produced, tongue-in-cheek, pretty fluff. Nothing that moves you, nothing to think about, some is informing, but still all fluff. I think the main reason for all this fluff is that most designers don't believe in anything. We are not much into politics, or into religion, have no stand on any important issue. When your conscience is so flexible, how can you do strong design? I've seen movies that moved me, read books that changed my outlook on things and listened to numerous pieces of music that influenced my mood. Our goal for the future will be to touch somebody's heart with design."

» Mir geht es vor allem um Design, das dem Betrachter zu Herzen gehen kann. Wir sehen überall so viele professionelle Grafikarbeiten, die mich (und ich vermute auch viele andere Betrachter) kalt lassen. Es gibt so viele Schaumschläger, die technisch perfekten, hübschen Schaum produzieren. Nichts, das rührt oder zum Nachdenken anregt. Der Grund für all diese Schaumschlägerei ist, dass die Designer an nichts mehr glauben. Wir haben mit Politik nichts am Hut, mit Religion nicht, haben zu keiner wichtigen Frage einen eigenen Standpunkt. Wenn das Gewissen so wenig ausgeprägt ist, wie kann man dann überzeugendes Design schaffen? Ich habe Filme gesehen, die mich bewegt haben, Bücher gelesen, die meine Sicht der Dinge verändert, und Musikstücke gehört, die meine Stimmung beeinflusst haben. Unser Ziel muss es werden, mit unserem Design die Herzen zu berühren.«

«Je m'intéresse à un graphisme capable de toucher le cœur des gens. Nous voyons partout tant de créations graphiques bien réalisées, joliment illustrées, photographiées de main de maître. Pourtant, la plupart d'entre elles me laissent froid. C'est bien produit, ironique, agréable à regarder, mais ce n'est que du vent. Il n'y a rien qui vous émeuve, rien qui vous fasse réfléchir. Certaines vous informent, mais ça reste du vent. La plupart des créateurs ne croient en rien. Nous nous occupons peu de politique et de religion, nous ne prenons position sur aucune question importante. Avec une conscience aussi flexible, comment réaliser un graphisme fort? J'ai vu des films bouleversants, lu des livres qui ont changé ma vision des choses et écouté des morceaux de musique qui ont influencé mon humeur. A l'avenir, notre objectif sera de toucher le cœur d'un être humain avec notre graphisme. »

**Stefan Sagmeister**
Sagmeister Inc.
222 West 14th Street
New York
NY 10011
USA

T +1 212 647 1789
F +1 212 647 1788

E info@sagmeister.com

www.sagmeister.com

**Biography**
1962 Born in Bregenz, Austria
1982–1986 MFA Graphic Design, University of Applied Arts, Vienna
1986–1988 MSc Communication Design, Pratt Institute, New York (as a Fulbright Scholar)

**Professional experience**
1983–1984 Designer, ETC. magazine, Vienna
1984–1987 Designer, Schauspielhaus, Vienna
1987–1988 Designer, Parham Santana, New York
1988–1989 Designer, Muir Cornelius Moore, New York
1989 Art Director, Sagmeister Graphics, New York
1989–1990 Art Director, Sagmeister Graphics, Vienna
1991–1993 Creative Director, Leo Burnett (Hong Kong Office)
1993 Creative Director, M&Co, New York
1993+ Principal of Sagmeister Inc. in New York

**Recent exhibitions**
2000 "Design Biannual", Cooper Hewitt National Design Museum, New York
2001 "Stealing Eyeballs", Künstlerhaus, Vienna; Solo exhibition, Gallery Frederic Sanchez, Paris
2002 Solo exhibition – MAK, Vienna

**Recent awards**
Has won over 200 design awards, including four Grammy nominations and gold medals from The New York Art Directors Club and the D&AD plus:
2000 Gold Medal, poster biannual Brno; Gold Medal, Warsaw poster exhibit
2001 Chrysler Design Award
2002 Grand Prize, TDC Tokyo

**Clients**
Aiga Detroit
Amilus
Anni Kuan Design
Booth Clibborn Editions
Business Leaders for Sensible Priorities
Capitol Records
Gotham
Warner Bros.
Warner Jazz

**Project**
AIGA national conference poster, New Orleans

**Title**
Jambalaya

**Client**
American Institute for Graphic Arts

**Year**
1997

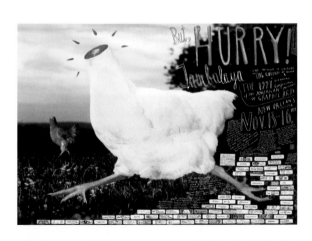

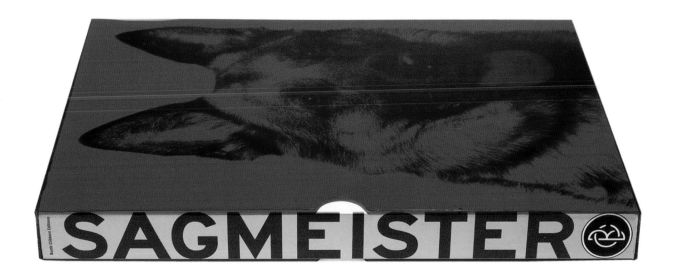

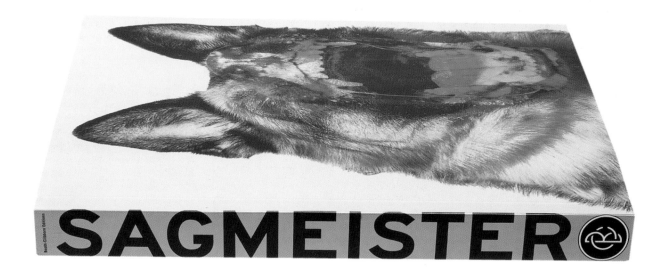

**Project**
Design monograph

**Title**
Made You Look

**Client**
Self-published

**Year**
2001

Project
Design monograph

Title
Made You Look

Client
Self-published

Year
2001

Opposite page:

Project
Poster

Title
Set the Twilight Reeling

Client
Warner Bros.

Year
1996

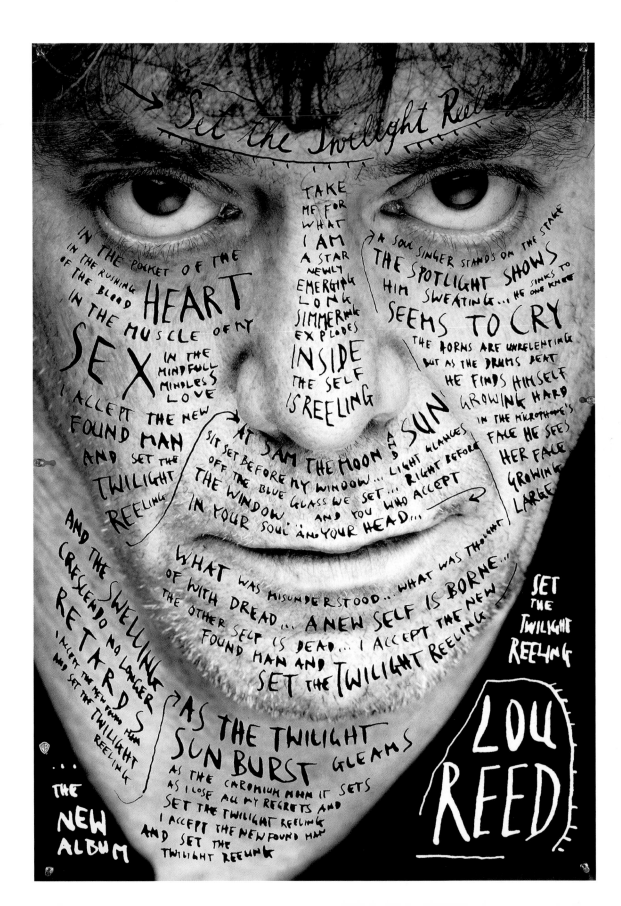

# Peter Saville

## "Do your best."

Opposite page:

**Project**
Illustration

**Title**
Waste Painting #3

**Client**
Graphic art Howard
Wakefield, Peter Saville &
Paul Hetherington

**Year**
2001

"As the interface of today's social and cultural change, graphic design will continue to evolve as a reflection of the needs and values of its audience and its practitioners."

» Als Schnittstelle des derzeitigen sozialen und kulturellen Wandels wird das Grafikdesign sich als Reflexion der Bedürfnisse und Werte seines Publikums und seiner Schöpfer weiterentwickeln.«

« En tant qu'interface des changements sociaux et culturels contemporains, le graphisme continuera d'évoluer, reflet des besoins et des valeurs de son public et de ses exécutants. »

**Peter Saville**
Saville Associates
Expert House
25–31 Ironmongers Row
London EC 1V 3QN
UK

T +44 20 7253 4334
F +44 20 7253 4366

E sarah@
saville-associates.com

**Biography**
1955 Born in Manchester, England
1978 BA (Hons) Graphic Design, Manchester Polytechnic

**Professional Experience**
1979–1991 Founding Partner and Art Director, Factory Records, Manchester
1981–1983 Art Director, Dindisc (Virgin Records), London
1983–1990 Established his own studio, Peter Saville Associates, London
1990–1993 Partner, Pentagram Design, London
1993–1994 Creative Director, Frankfurt Balkind, Los Angeles
1995–1998 Established London office for German communications agency, Meire und Meire
1999 Co-founded multidisciplinary new media project, SHOWstudio, with photographer Nick Knight
2000–2001 Co-curator, SHOWstudio with Nick Knight, London

**Clients**
ABC Television
Balenciaga
Brian Eno / David Byrne
Centre Georges Pompidou / La Villette
Channel One
China Crisis
Christian Dior
Chrysalis
Depeche Mode
Digital Entertainment Network
Electronic
Estée Lauder
Factory Communications
Fine Young Cannibals
Fruitmarket Gallery
Gay Dad
Gagosian Gallery
George Michael
Givenchy
Goldie
Gucci / Sapient
Holland & Holland
Institute of Contemporary Arts
Jil Sander
John Cooper Clarke
Joy Division
King Crimson
London Records
Lounge Lizards
Mandarina Duck
Marconi / Pres.co
Martha & The Muffins
Martine Sitbon
Mercedes Benz / Smart Car
Midge Ure
Ministry of Culture
Museum Boijmans Van Beuningen
Natural History Museum
New Order
OMD
Paul McCartney
Peter Gabriel
Pringle of Scotland
Pulp
Richard James
Roxy Music
Selfridges
Sergio Rossi
Stella McCartney
Suede
The Hacienda
Ultravox
Visage
Wham!
Whitechapel Art Gallery
White Cube
Yohji Yamamoto
Y's Company

**Project**
Illustration. Graphic art
Paul Hetherington &
Howard Wakefield

**Title**
Sister Honey

**Client**
Dazed & Confused

**Year**
1999

**Project**
CD cover
Art Direction: Peter Saville
Concept: Paul Barnes

**Title**
Gay Dad "Leisure Noise"

**Client**
London Records

**Year**
1999

**Project**
CD artwork
Photography: Jürgen
Teller
Design: Howard
Wakefield

**Title**
New Order "Get Ready"

**Client**
London Records

**Year**
2001

# Walter Schönauer

## "Keep the crowd involved in the project small!"

Opposite page:

**Project**
Album promotional poster

**Title**
Mensch

**Client**
Herbert Grönemeyer

**Year**
2002

"During the last few years, more and more graphic designers have been operating in one-person or similarly small studios. Through their work for clients in the industry, where an expansive sense of creativity and individuality prevails, they have been able to maintain an independent image. You can get clients almost anywhere but the symbolism in the design can't be simply a result of your own traditions, you need to find new ways to present it to both local or global audiences."

»In den letzten Jahren sind immer mehr Grafiker dazu übergegangen, in Ein-Mann-Ateliers oder in kleinen Teams zu arbeiten. Durch ihre Auftraggeber, die ein hohes Maß an Kreativität und Individualität fordern, ist es ihnen gelungen, ein unabhängiges Image zu wahren. Kunden findet man überall, aber die Symbolik eines Entwurfs kann nicht ausschließlich das Ergebnis der Kenntnisse und Ideen des Designers sein. Man muss neue Wege und Möglichkeiten finden, um sie sowohl dem lokalen als auch einem internationalen Publikum zu vermitteln.«

«Ces dernières années, de plus en plus de graphistes se sont installés seuls ou dans de petits bureaux. Au travers de leur travail dans ce secteur, dominé par un grand sens de créativité et d'individualité, ils ont su conserver une image indépendante. On peut trouver des clients dans pratiquement tous les domaines mais, en graphisme, le symbolisme ne peut être le seul produit de ses propres traditions. Il faut trouver de nouvelles manières de le présenter au public tant local que mondial. »

**Walter Schönauer**
Meinekestrasse 5
10719 Berlin
Germany

T +49 30 885 52169
F +49 30 885 52148

E ws@pentagon.de

**Biography**
1963 Born in Linz, Austria
1981–1986 Graphic Design School, Vienna

**Professional experience**
1986–1987 Art Director, Wiener Magazine, Vienna and Munich
1987–1991 Art Director, Tempo Magazine, Hamburg
1991–1993 Art Director, LA Style Magazine, Los Angeles
1996–1999 Owner, Phoor-Design, Hamburg
2000–2002 Co-owner, Pentagon-Design, Berlin

**Recent exhibitions**
1998 "Baader/Meinhof", Dazed and Confused Gallery, London
1999 "Hans und Grete", Gallery Niemann, Berlin
2000 "re-present! Berlin", Sonar Festival CCCB, Barcelona

**Recent awards**
1987–2000 Gold (x2), Silver (x5), Bronze (x12), Art Directors Club Germany, Hamburg
1991–1993 Silver (x2), Bronze (x3), Art Directors Club Los Angeles
1998 Silver, CLIO, New York; Silver, ONE Show, London; Silver, NY Festival
2000 Bronze, NY Festival; Silver, CLIO, New York
2001 Finalists (x2), NY Festival

**Clients**
agnès b.
Beat Records, Japan
Capitol Music
Chicks on Speed Records
DaimlerChrysler
EMI Records
German Telekom
Gronland Records, London
Kiepenheuer&Witsch
Linotype
MTV
Palais de Tokyo
SCALO
Schirmer/Mosel
Steidl
Universal Music
Warner Music

Opposite page:

**Project**
CD's for the 70's cult band Neu! in cooperation with Klaus Dinger and Michael Rother

**Title**
Neu!

**Client**
Gronland Records

**Year**
2001

**Project**
Artist's book

**Title**
Hanayo

**Client**
agnès b.

**Year**
2003

# Pierre di Sciullo

"Graphic design: see forms and meanings/ forms: see sign (cf. signification) and de-sign/design: see graphic. 'I was walking in the forest when suddenly this graphic design totally modified my life'."

Automne

Été

Été tardif

Printemps

Hiver

Poumon
Peine

Cœur
Joie

Rate
Anxiété

Foie
Colère

Reins
Peur

Sécheresse

Feu

Humidité

Vent

Froid

Le corps, ses émotions
et son environnement
climatique

**Project**
Exhibition "médecines
chinoises"

**Title**
Hierarchy of organs and
their relations with
feelings and weather

**Client**
Grande Halle de la Villette,
Paris

**Year**
2001

"Most of the independent graphic designers will be employed by big agencies to clean the windows. The survivors will be the one's who don't ask silly questions such as 'Is it something else other than business?', 'Why is the world of fashion so empty?', 'Am I only a servant of the enterprise?'. If you take the money and run, no problem. But sometimes it's hard to be a citizen of a rich country – you have misgivings. Your way will be the graphic design of nice sentiments, which I call 'Gradenice': war, poverty, Aids, what a shame … In the future I hope the use of media will become more efficient again, so the question of the inner value of the work will appear more and more indecent: my work is good because it is visible – of course it is visible because it is good. But to save this situation commissioners will have to study at art and design schools. This next generation will begin making strong, open, intelligent projects and the sun will shine on a pacified world."

» Die meisten freischaffenden Grafiker werden von den großen Agenturen als Fensterputzer beschäftigt. Überleben werden diejenigen, die keine dummen Fragen stellen wie etwa: ›Geht es außer ums Geschäft noch um etwas anderes?‹ – ›Warum ist die Modewelt so leer?‹ – ›Bin ich nur ein Diener des Unternehmens?‹ Wenn man das Geld nimmt und denkt: ›Nach mir die Sintflut‹, ist das in Ordnung. Manchmal aber ist es gar nicht so leicht, Bürger eines reichen Landes zu sein – man ahnt Böses. Der Weg wird das Grafikdesign angenehmer Gefühle sein: Krieg, Armut, Aids, bedauerlich, aber … In Zukunft, so hoffe ich, wird das Medium wieder wirksamer werden, so dass die Frage nach dem inneren Wert einer Grafik zunehmend als unangebracht gelten wird. Meine Arbeit ist gut, weil sie auffällt – und natürlich fällt sie auf, weil sie gut ist. Die nächste Generation wird starke, offene, intelligente Projekte in Angriff nehmen und die Sonne wird über einer befriedeten Welt aufgehen.«

« La plupart des graphistes indépendants seront engagés dans les grandes agences pour nettoyer les vitres. Les survivants seront ceux qui ne poseront pas de questions bêtes comme : ‹ Y a-t-il autre chose que le commerce ? Pourquoi le monde de la mode est-il si vide ? Suis-je au bout du compte le serviteur des entreprises ? › Prends l'argent et tire-toi, ça ne pose pas de problème. Mais quelquefois c'est dur d'être le citoyen d'un pays riche, on a des états d'âme ; solution : pratiquer le GRABS, le GRAphisme des Bons Sentiments, à propos de la guerre, du Sida, de la pauvreté, quel dommage… L'usage des médias sera encore plus efficace afin que la question de la valeur même d'un travail semble indécente. ‹ Mon travail est bon car il est visible, bien sûr il est visible parce qu'il est formidable en vérité. › Pour sauver la situation les commanditaires feront leur apprentissage dans les écoles d'art et de design. Cette nouvelle génération lancera des projets intelligents, forts et ouverts et le soleil brillera sur un monde pacifié. »

**Pierre di Sciullo**
12, avenue du Château
77220 Gretz Armainvilliers
France

T +33 1 64 07 24 32

E atelier@quiresiste.com

www.quiresiste.com

**Biography**
1961 Born in Paris
Self-taught

**Professional experience**
1983+ Published "Qui? Résiste" (10 issues).
1994+ Workshops and lectures in the art schools of Strasbourg, Orléans, Amiens, Saint-Étienne, Nancy, Besançon, Pau, Valence, Lyon, Cergy–Pontoise, Nevers, Cambrai, Paris, Lausanne, Basle and Tel Aviv

**Recent exhibitions**
1997 "Aquarelles", La Chaufferie, Strasbourg
1996–1997 "Approche", touring exhibition, Barcelona, Seville, Madrid, Buenos Aires, Chaumont, Paris, Sofia, Warsaw and Prague

**Recent awards**
1995 Grants from the French Ministry of Culture
1995 Charles Nypel Prize, The Netherlands

**Clients**
AFAA (Ministry of Foreign Relations)
City of Nantes
Collège de Pataphysique
Éditions Brøndum
Grande Halle de la Villette
Ministry of Culture
Reporters Sans Frontières
Wines Nicolas

**Project**
Visual identity of PrimalineaFactory.com

**Title**
Intro of the Website. This site sells online original creations of graphic artists and designers

**Client**
Primalinea agency, Paris

**Year**
2001

**Project**
Two typefaces designed
specially for glass, easy to
cut in this medium

**Title**
Minimum overlap
Blocs

**Client**
Self-published

**Year**
2001

**Project**
Exhibition "Médecines
chinoises"

**Title**
Médecines chinoises

**Client**
Grande Halle de la Villette,
Paris

**Year**
2001

Opposite page:

**Project**
Exhibition "Médecines
chinoises"

**Title**
Acupuncture: the body as
an irrigation system

**Client**
Grande Halle de la Villette,
Paris

**Year**
2001

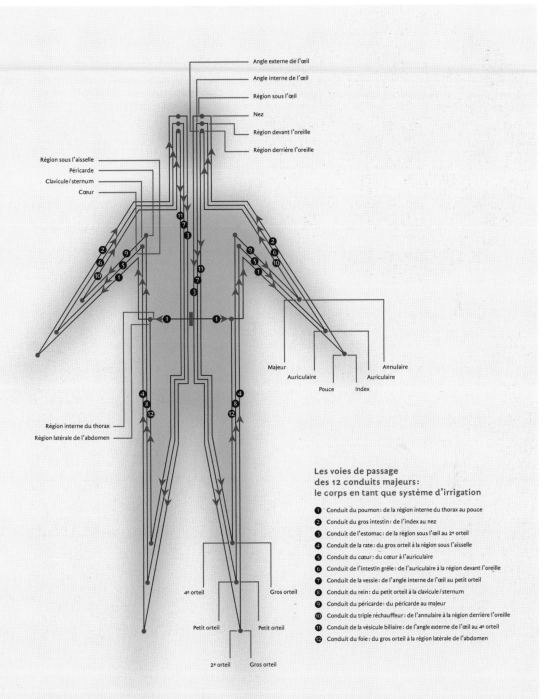

Angle externe de l'œil
Angle interne de l'œil
Région sous l'œil
Nez
Région devant l'oreille
Région derrière l'oreille

Région sous l'aisselle
Péricarde
Clavicule/sternum
Cœur

Majeur
Auriculaire
Pouce
Index
Annulaire
Auriculaire

Région interne du thorax
Région latérale de l'abdomen

4e orteil
Gros orteil

Petit orteil
Petit orteil

2e orteil
Gros orteil

Les voies de passage
des 12 conduits majeurs :
le corps en tant que système d'irrigation

1  Conduit du poumon : de la région interne du thorax au pouce
2  Conduit du gros intestin : de l'index au nez
3  Conduit de l'estomac : de la région sous l'œil au 2e orteil
4  Conduit de la rate : du gros orteil à la région sous l'aisselle
5  Conduit du cœur : du cœur à l'auriculaire
6  Conduit de l'intestin grêle : de l'auriculaire à la région devant l'oreille
7  Conduit de la vessie : de l'angle interne de l'œil au petit orteil
8  Conduit du rein : du petit orteil à la clavicule/sternum
9  Conduit du péricarde : du péricarde au majeur
10  Conduit du triple réchauffeur : de l'annulaire à la région derrière l'oreille
11  Conduit de la vésicule biliaire : de l'angle externe de l'œil au 4e orteil
12  Conduit du foie : du gros orteil à la région latérale de l'abdomen

# Carlos Segura

## "Communication that doesn't take a chance, doesn't stand a chance"

Opposite page:

**Project**
Poster

**Title**
Faces

**Client**
[T-26] Digital Type
Foundry

**Year**
1997

"No clue"         »Keine Ahnung«         «Aucune idée»

**Carlos Segura**
Segura Inc.
1110 North Milwaukee
Avenue
Chicago
IL 60622.4017
USA

T +1 773 862 5667
F +1 773 862 1214

E info@segura-inc.com

www.segura-inc.com
www.segurainteractive.com
www.5inch.com
www.t26.com

**Biography**
1957 Born in Santiago,
Cuba
1965 Moved to Miami
1980 Moved to Chicago
1980–1991 Worked for
advertising agencies
Marsteller, Foote Cone &
Belding, Young &
Rubicam, Ketchum, DDB
Needham
1991 Founded Segura
Inc. in Chicago
1994 Founded [T-26]
Digital Type Foundry
in Chicago
2000 Founded Segura
Interactive
2001 Launched 5inch.com

**Recent exhibitions**
2002 "US Design:
1975–2000", Denver Art
Museum

**Recent awards**
1998 Silver and Certificate
of Merit (x2), Chicago
Show; Certificate of Merit,
100 Show, American
Center for Design; Certifi-
cates of Merit (x3), Ameri-
can Corporate Identity,
14th Edition; Certificates
of Merit (x2), NY Type
Directors Club, TDC44
1999 Certificates of Merit
(x2), Logo 2000 Annual
2000 Certificates of Merit
(x3), NY Art Directors
Club; Certificates of Merit
(x4), Tokyo Type Directors
Club, 2000 Annual; Certifi-
cates of Merit (x2), NY
Type Directors Club,
TDC46
2001 Bronze, Certificates
of Merit (x9) and Special
Section in annual, Tokyo
Type Directors Club, 2001
Annual; Best of Category
(x2) (won a car) and Best
of Show, Eyewire Awards
2002 Certificates of Merit
(x2), Tokyo Type Directors
Club, 2002 Annual

**Clients**
American Crew
Computer Café
DC Comics
Elevation
Emmis Communications
FTD
Kicksology
Mongoose Bikes
Motorola
MRSA Architects
Plungees
Q101 Radio (Chicago)
Rockwell
Sioux Printing
Swatch
The Syndicate
Tiaxa
TNN

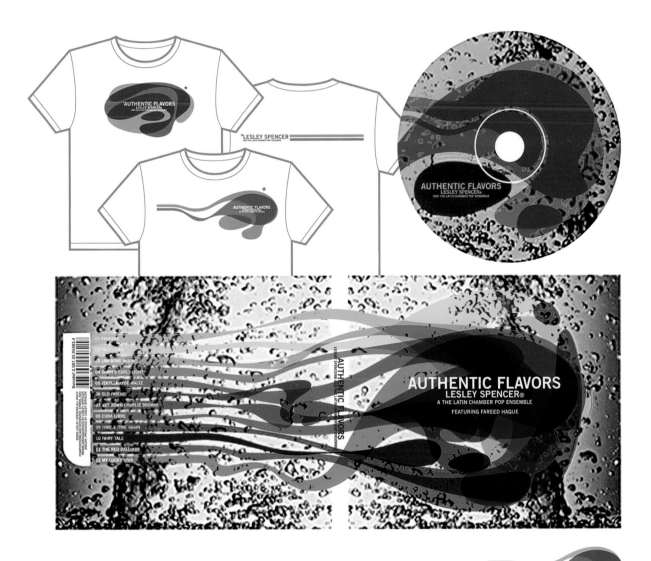

One of a series of Digipak CD sets for Lesley Spencer. This one is *Authentic Flavors* with t-shirts.  **AUTHENTIC FLAVORS** LESLEY SPENCER® AND THE LATIN CHAMBER POP ENSEMBLE

**Project**
CD and T-shirts

**Title**
Authentic Flavors

**Client**
Lesley Spencer

**Year**
2002

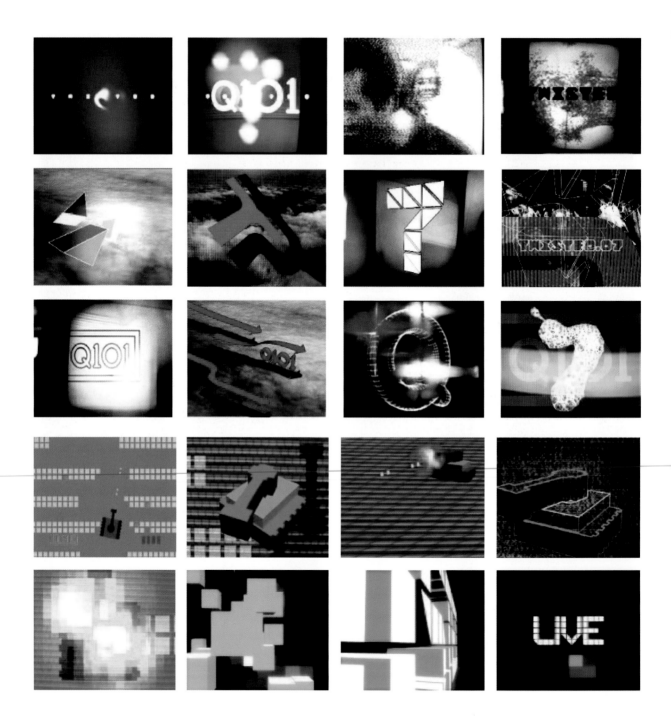

**Project**
Quicktime movie
campaign

**Title**
Twisted 7

**Client**
Q101 Radio

**Year**
2001

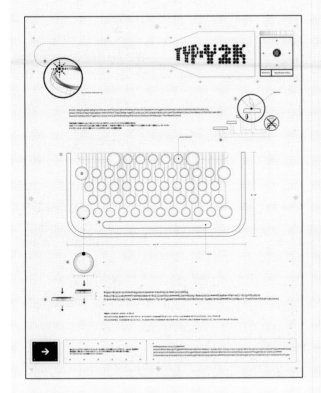

**Project**
Conference material

**Title**
TYPY2K

**Client**
New York Type Directors
Club

**Year**
1999

# Spin

## "Show and tell."

Opposite page:

**Project**
Magazine

**Title**
Visuell reverse

**Client**
Deutsche Bank

**Year**
2001

"The delivery of information on digital formats will change what we expect from graphic design. The thinking behind the hierarchical and navigational devices employed on the Internet and in mobile phones are already seeping through to print, the moving image and advertising. This influence will continue to grow, affecting and probably improving our ability to cope with increasing amounts of information. Your campaign/publication/website will be ignored if it has nothing to say. There is so much choice that the quality of the content has to match the strength of expression to make an impact. Bells and whistles alone don't cut it. Dumb TV can be turned off, a boring book can be put down. A website told to log off. The masses now have their hands on the means of design production. This might, on the face of it, seem like grounds for a homemade graphic Armageddon. But the amateur efforts of a growing portion of the population will lead to greater visual awareness. As a result good design will be more influential, impactful and important than ever. Then again …"

» Dass wir Informationen im Digitalformat aufbereiten können, verändert unsere Erwartungen an das Grafikdesign. Die Denkweisen hinter den hierarchischen Navigationsmechanismen von Internet und Handy schleichen sich inzwischen auch in die Druckmedien, den Film und die Werbung ein. Dieser Einfluss wird sich verstärken und unseren Umgang mit wachsenden Datenmengen verbessern. Eine Kampagne, Publikation oder Homepage wird ignoriert, wenn sie nichtssagend ist. Das Angebot ist so groß, dass die Qualität des Inhalts der Ausdruckskraft entsprechen muss, um Wirkung zu zeigen. Bei blöden Fernsehsendungen kann man abschalten, ein langweiliges Buch weglegen, eine Homepage wegklicken. Die Massen haben heute die Mittel der Designproduktion in der Hand. Die Bemühungen einer wachsenden Zahl von Amateuren wird zu einer gesteigerten visuellen Wahrnehmung der Massen führen. Infolge dessen wird gutes Design einflussreicher, wirksamer und wichtiger denn je zuvor sein. Andererseits …«

« La transmission de l'information sous des formats numériques modifiera ce qu'on attend du graphisme. La pensée derrière les dispositifs de hiérarchisation et de navigation utilisés sur l'internet et dans les téléphones mobiles s'immisce déjà dans l'imprimerie, les images animées et la publicité. Cette influence continuera à s'étendre, affectant et améliorant notre capacité à traiter des quantités toujours croissantes de données. Les campagnes / publications / pages web qui n'ont rien à dire passeront à l'as. Il y a tant de choix que, pour avoir un impact, la qualité du contenu doit être à la hauteur de la force d'expression. Pour se faire entendre, faire du bruit ne suffira pas. Les masses ont désormais entre les mains les moyens de production graphique. Cela pourrait déboucher sur une cacophonie graphique. Mais les efforts amateurs d'une portion croissante de la population entraîneront une plus grande conscience visuelle. Par conséquent, le bon graphisme deviendra plus influent, percutant et important que jamais. A moins que… »

**Spin**
12 Canterbury Court
Kennington Park
1–3 Brixton Road
London SW9 6DE
UK

T +44 20 7793 9555
F +44 20 7793 9666

E post@spin.co.uk

www.spin.co.uk

**Design group history**
1992 Founded by Tony Brook and Patricia Finegan in London
1997 Warren Beeby (b. 1968 – Nuneaton) joined Spin having previously worked for Time Out (1993–97)

**Founders' biographies**
Tony Brook
1962 Born in Halifax, West Yorkshire, England
1978–1980 Foundation Course, Percival Whitley College of Further Education, Halifax
1980–1982 SIAD, Somerset College of Arts & Technology
1983–1987 Worked for Shoot That Tiger!, London
1987–1990 Worked for Icon, London
1990–1991 Worked for SMS Communications, London
Patricia Finegan
1965 Born in Manchester, England
1985–1989 BA (Hons) Design Management, London College of Fashion
1989–1990 Worked for Lynne Franks PR, London
1990–1992 Worked for PR Unlimited, London

**Recent exhibitions**
1998 "Powerhouse:UK", Design Council, London; "One Dot Zero", ICA, London
1999 "One Dot Zero", ICA, London
2000 "One Dot Zero", ICA, London
2001 "Stealing Eyeballs", Künstlerhaus, Vienna; "Great Expectations" (Design Council), Grand Central Station, New York

**Recent awards**
1998 Silver Award for Most Outstanding CD Rom, D&AD; Silver Interactive Media Award, The International Design Magazine; Global Top Forty Award, The International Design Magazine
2001 Gold Award, Promax (MTV Wrestlers promotion)
2001 Best Development of an Identity in the Last Ten Years, Superbrand
2002 Silver D&AD Award, Television & Cinema Graphics Brand Identity, Channel

**Clients**
Booth-Clibborn Editions
Bowieart.com
British Council
Central Office of Information
Channel 4
Channel 5
Christie's
Deutsche Bank
Diesel
Electronic Arts
English Heritage
Levi Strauss
Mother
MTV
Nike
Orange
Precise
UBS Warburg
VH-1
Vision on Publishing
Whitechapel Gallery

Opposite page:

**Project**
On-Air identity

**Title**
Vapour trail
Traffic

**Client**
Channel 4

**Year**
2002

**Project**
Magazine

**Title**
Visuell reverse

**Client**
Deutsche Bank

**Year**
2001

# State

"It's inspiring to work across different mediums, it gives you new methodologies, it means you can attack each new situation with a range of contrasting approaches and ideas."

Opposite page:

**Project**
re:play (a book about
the visual history of video
games)

**Title**
re:play, a page from the
book's visual introduction:
a sequence of iconic
graphic game elements

**Client**
Laurence King Publishing

**Year**
1998

"Increased production to meet demand."

» Gesteigerte Produktionsleistung, um den Bedarf zu decken.«

« Une production accrue pour satisfaire à la demande. »

**State**
212C Curtain House
134–146 Curtain Road
London EC2R 3AR
UK

T +44 20 7729 0171
F +44 20 7729 0284

E staff@statedesign.com

www.statedesign.com

**Design group history**
1997 Co-founded by
Mark Hough, Philip
O'Dwyer and Mark
Breslin in London

**Founders' biographies**
Mark Hough
1971 Born in Cambridge,
England
1991–1995 BA (Hons)
Graphic Design, London
College of Printing
1995–1996 MA Commu-
nication Design, Central
St Martins College of Art
and Design, London
1995–1996 Freelance
designer, Bell Design &
Doublespace, New York
1996–1997 Freelance
designer, Raise magazine
Philip O'Dwyer
1974 Born in Dublin
1992–1995 BA (Hons)
Graphic Design, Limerick
School of Art & Design
1995–1996 MA Commu-
nication Design, Central
St Martins College of Art
and Design, London
1996–1997 Freelance
designer, Raise magazine
and Wired (UK) magazine

**Recent exhibitions**
2001 "Onedotzero",
Saatchi Gallery, Akasaka,
Tokyo

**Clients**
Barbican
Blackwatch
BT
Creative Review
Dazed & Confused
EC1 Media
EMI/Parlophone
Film Four
Financial Times
Heart
Illuminations TV
Laurence King Publishing
MacUser
Mediasurface
MTV Japan
Ninja Tune
NMR
Onedotzero
Pavement
PD*3
Sapcote
Sega Europe
Sony Computer
Entertainment Europe
Soup & Salad

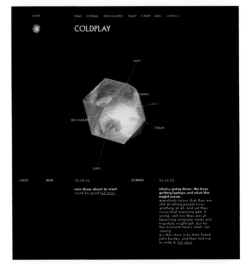

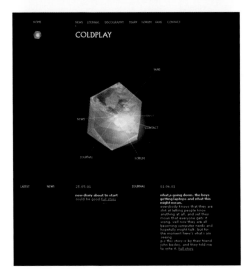

**Project**
Website

**Title**
Coldplay

**Client**
Parlophone

**Year**
2000

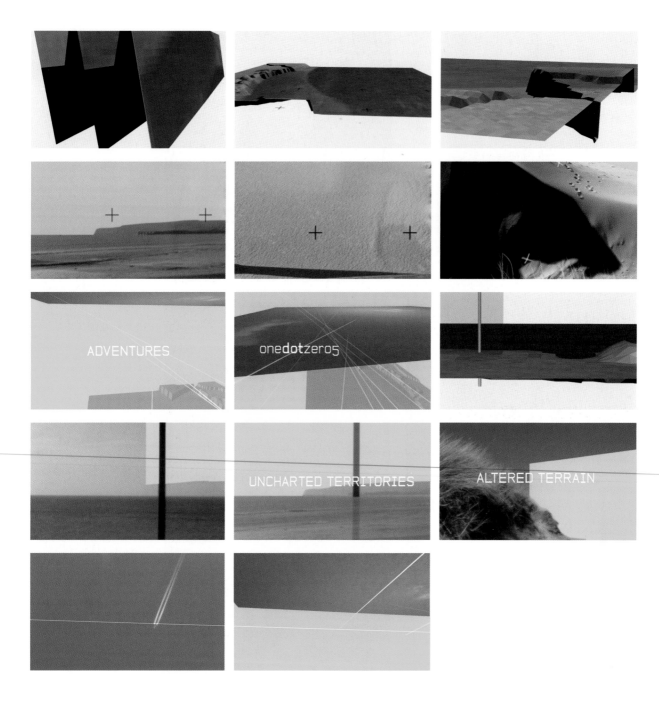

**Project**
onedotzero5 title
sequence

**Title**
onedotzero5

**Client**
onedotzero

**Year**
2001

Opposite page:

**Project**
onedottv_global is a
twelve-part television
series showcasing the
work of moving image
makers

**Title**
onedottv_global

**Client**
onedotzero

**Year**
2001

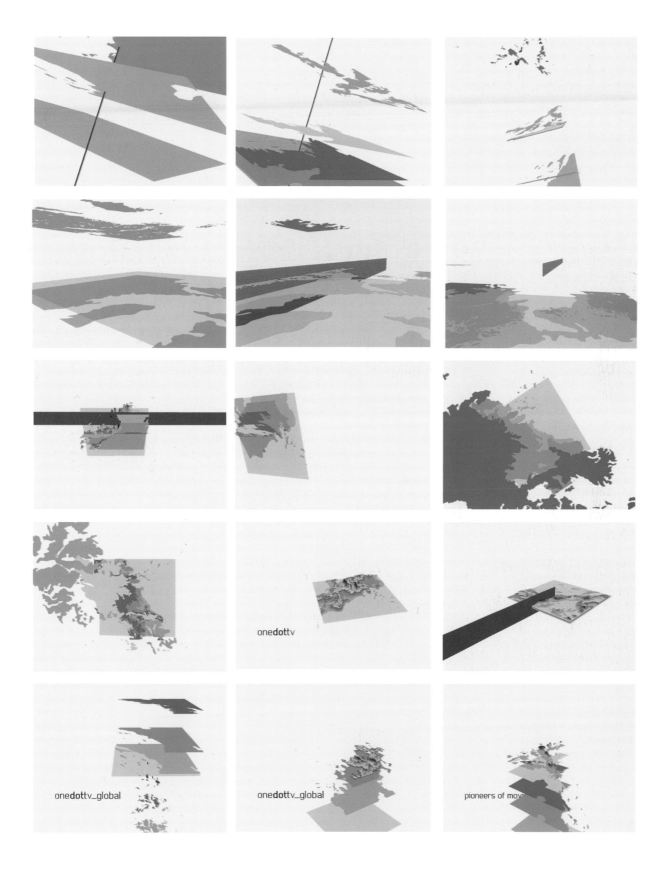

# Suburbia

"We are reaching for a perfect synergy of information, image, design and parties."

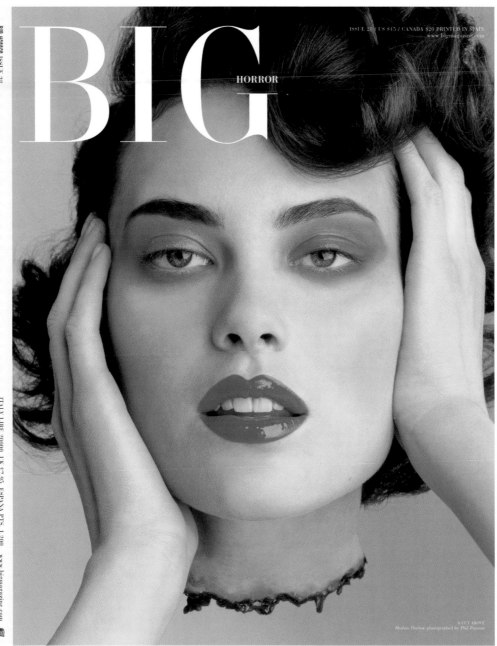

**Project**
Magazine cover
Photography by
Phil Poynter

**Title**
Big Magazine – Horror

**Client**
Big

**Year**
2000

"We here at Suburbia are inclined to approach the future sideways – laterally if you like. This way we feel less likely to be caught out by it. Thinking about the future in general was enormously popular in pre-revolutionary Russia, but not so much nowadays. Cultural determinants you see are not really dictated by designers, and there are pitfalls in thinking so. The sands, you might say, on which the future rests are always shifting (this is an adaptation or bastardisation of an old Chinese proverb about trusting those who you do business with), which is definitely something we're going to pay more attention to in the future."

» Wir von Suburbia tendieren dazu, uns der Zukunft von der Seite zu nähern. So haben wir das Gefühl, dass sie uns nicht so schnell ertappen kann. Im vorrevolutionären Russland war es äußerst populär, sich Gedanken über die Zukunft im Allgemeinen zu machen, das ist heute nicht mehr so. Kulturelle Determinanten werden nicht wirklich von den Designern diktiert. Das zu glauben, birgt Risiken. Der Sand, auf dem die Zukunft steht, wandert immer weiter (so könnte man in Abwandlung eines alten chinesischen Sprichworts über das Vertrauen zu denen sagen, mit denen man Geschäfte macht) und das ist definitiv etwas, dem wir in Zukunft mehr Aufmerksamkeit widmen werden.«

« Ici à Suburbia, on tend à aborder le futur de biais, latéralement si vous préférez. On espère ainsi limiter le risque d'être pris de court. Dans la Russie d'avant la révolution, réfléchir à l'avenir était une activité très prisée. Ça l'est moins aujourd'hui. Il serait dangereux de croire que les déterminants culturels apparents sont en fait dictés par les créateurs. Les ‹bancs de sable› sur lesquels repose le futur sont aussi mouvants (j'adapte, ou plutôt je détourne, un vieux proverbe chinois parlant de la confiance que l'on peut accorder à ses partenaires en affaire), un aspect auquel nous serons certainement plus attentifs à l'avenir. »

**Suburbia**
74 Rochester Place
London NW1 9JX
UK

T +44 20 7424 0680
F +44 20 7424 0681

E info@
   suburbia-media.com

www.suburbia-
   media.com

**Design group history**
1998 Co-founded by Lee Swillingham and Stuart Spalding in London

**Founders' biographies**
Lee Swillingham
1969 Born in Manchester, England
1988–1991 Studied Graphic Design, Central St Martins College of Art and Design, London
1992–1998 Art Director, The Face magazine, London
1998 Creative Director, Suburbia, London
Stuart Spalding
1969 Born in Hawick, Scotland
1987 Foundation Level Art& Design, Manchester Polytechnic
1988–1991 Graphic Design, Newcastle upon Tyne Polytechnic
1992–1998 Art Editor, The Face magazine, London
1998 Creative Director, Suburbia, London

**Clients**
Alexander McQueen
Anna Molinari
Big
BMG Records
Bottega Veneta
Emap Publishing
Gucci
London Records
Luella
Mercury Records
Patrick Cox
Vision on Publishing
Warner Records

**Project**
Logo and identity for new fashion magazine

**Title**
Pop Logo

**Client**
Emap Publishing

**Year**
2000

Opposite page:

**Project**
Creative Review anniversary artwork

**Title**
Infinity Poster

**Client**
Creative Review

**Year**
2001

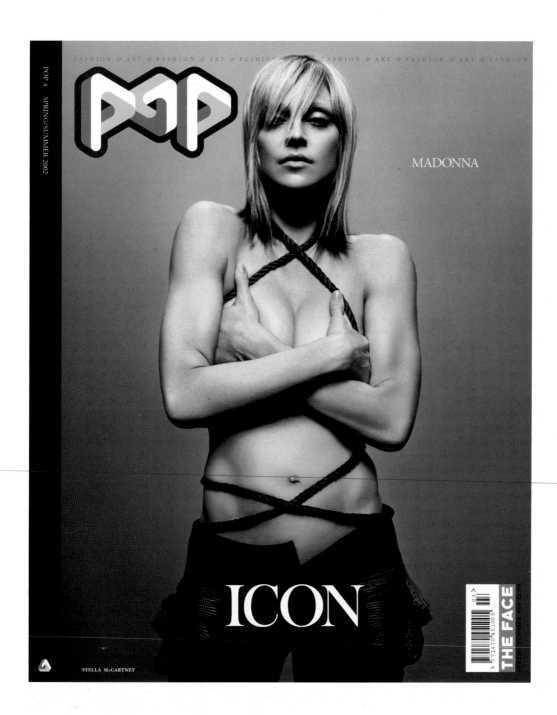

**Project**
Magazine cover
Photography by Mert
Allas and Marcus Piggot

**Title**
Pop, issue 4 – Icons

**Client**
Emap Publishing

**Year**
2002

Opposite page:

**Project**
Magazine spreads
Photography by Mert
Allas and Marcus Piggot

**Title**
Pop, issue 4 – Icons

**Client**
Emap Publishing

**Year**
2002

Stella's *ico*

*ons*

MOTHER, ARTIST, REBEL, FRIEND, SURVIVOR, SEX GODDESS... ICON

**MRS RITCHIE**

*Occupation: Whatever*

*Location: Some shithole that took forever to get to*

*Who's your icon? What's an icon?*

*What are you wearing? Some rope*

Madonna wears pink satin
shirt and pale pink trousers,
both by Stella McCartney
from her rollcocus for
spring/summer 2002, black
knee-high lace-up boots by
Yves Saint Laurent, rope worn
around body from VV
Rouleaux

[COVER] Madonna wears
trousers with lace pockets
detailing by Stella
McCartney, rope worn
around body from
VV Rouleaux

*Stella McCartney has a famous family and some very
famous friends. She knows an icon when she invites one
over for dinner. But with the first year of Stella's own
label still unfolding, one question remains: >*

# Surface

## "It is all about the attempt to find a logical explanation and find an illogical approach, and vice versa."

Opposite page:

**Project**
Ballet poster

**Title**
Ballett Frankfurt Artifact

**Client**
Ballett Frankfurt

**Year**
campaign 2000/01

# BALLETT
# FRANKFURT
## ARTIFACT
WIEDERAUFNAHME

7. 8. 9. 10. UND 11. JUNI

CHOREOGRAPHIE: WILLIAM FORSYTHE

MUSIK: JOHANN SEBASTIAN BACH, EVA CROSSMAN-HECHT

OPERNHAUS AM WILLY-BRANDT-PLATZ 20.00 UHR

**KARTEN: 069 / 13 40 400**

UND AN ALLEN BEKANNTEN
VORVERKAUFSSTELLEN

WWW.FRANKFURT-BALLETT.DE

JPMorgan

STEIGENBERGER

Markgraph

media! AG

Klassik Radio

journal

"Graphic design only happens through different approaches and views regarding analysis (exact transfer) and subjective artistic positions (vague transfer). Or more specifically, the transposition from the topic or task to design. What interests us in this case is the potential margin of error involved on the path towards finding a possible solution. One of several possibilities lies in working with mappings as an interim phase, swapping the parameters around in the process, and handling the given information as 'freely' as possible."

» Grafikdesign kommt nur durch die unterschiedlichen Ansichten über Analyse (exakter Transfer) und subjektive künstlerische Position (unscharfer Transfer) zustande, genauer gesagt die spezielle Art der Übersetzungsmöglichkeiten von Thema oder Aufgabe ins Design. Hier interessiert uns die Fehlermarge, die eine Rolle für den Weg zur möglichen Lösung spielen kann. Eine von vielen Möglichkeiten ist, in einem Zwischenstadium mit Mappings zu arbeiten, deren Parameter man im Arbeitsprozess hin und her schiebt und dabei möglichst ›frei‹ mit den vorliegenden Informationen umgeht.«

« Le graphisme ne fonctionne qu'au travers de démarches et de vues différentes sur l'analyse (transfert exact) et les positions artistiques subjectives (transfert vague). Plus précisément, au travers de la transposition du sujet ou de la tâche à accomplir en création. Ce qui nous intéresse dans ce cas, c'est la marge d'erreur potentielle dans la recherche d'une solution éventuelle. L'une des possibilités réside dans une phase intermédiaire basée sur le recours à des applications, modifiant progressivement les paramètres et manipulant les informations le plus ‹librement› possible. »

**Surface**
Gesellschaft für Gestaltung
Petersstrasse 4
60313 Frankfurt/Main
Germany

T +49 69 29 00 21 0
F +49 69 29 00 21 22

E info@surface.de

www.surface.de

**Design group history**
1997 Co-founded by Markus Weisbeck and Niko Waesche in Frankfurt/Main

**Founders' biographies**
Markus Weisbeck
1965 Born in Offenburg, Germany
1997 Diploma in Visual Communication, Hochschule für Gestaltung Offenbach
2002 Guest Professor in System Design, Hochschule für Grafik und Buchkunst, Leipzig
Niko Waesche
1968 Born in Singapore
2001 PhD in International Political Economy, London School of Economics

**Recent exhibitions**
1994 "The Retrographic Beat", Deutscher Werkbund, Frankfurt/Main and Galerie Perdue, Hamburg
1995 "Disc Style", Markthalle, Hamburg
1996 "Gestalt: Visions of German Design", IDCA, Aspen Colorado
1997 "Signes", Musée de la Poste, Paris
2000 "Jahresgaben", Frankfurter Kunstverein
2001 "Trade", with Thomas Demand, Andreas Gursky, Blank & Geron, Nina Pohl, Fotomuseum Winterthur, Nederland Foto Institut, Rotterdam; "Dedalic Convention", curated by Liam Gillick, MAK, Vienna
2002 "The Mallory Project", with Siegrun Appelt, Turn & Taxis Palais, Bregenz; "Mapping", with Ruedi Baur, Nikolaus Hirsch, Makoto Saiko (AA London), 1822-Forum, Frankfurt

**Clients**
Ballett Frankfurt/William Forsythe
Best Seven
Birkhäuser
Cocoon Event Gmbh
DaimlerChrysler
Deutsche Bank Kunst
Deutsche Guggenheim
Edition Olms
EnOf
Frankfurter Kunstverein
Frankfurt RheinMain
Galerie Johann König
Galerie Schipper & Krome
Hugo Boss
IFA – institute for foreign cultural relations
Institute of Contemporary Art Boston
Johnen und Schöttle
Jourdan und Müller PAS
Jüdisches Museum Frankfurt
K7 Records
Karaoke Kalk
Kostas Murkudis
Kunsthaus Schloss Wendlinghausen
Lenbachhaus
Lukas & Sternberg

Mille Plateaux
Pitti Immagine
Rhizome
Schirn Kunsthalle
Staubgold
Ursula Blickle Stiftung
Verlag für Moderne Kunst
Verlag Hatje Cantz
Virgin Records

**Project**
CD cover

**Title**
März Love Streams

**Client**
Karaoke Kalk

**Year**
2002

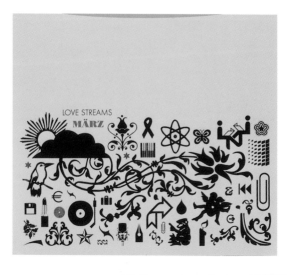

Joseph Suchy
Canoeing Instructional

**Project**
CD cover

**Title**
Joseph Suchy Canoeing
Instructional

**Client**
Whatness

**Year**
2002

**Project**
Pocket-book series on
contemporary art

**Title**
Lukas & Sternberg
001–005

**Client**
Lukas & Sternberg

**Year**
2002

Opposite page:

**Project**
Exhibition catalogue

**Title**
Frequencies (Hz)

**Client**
Schirn Kunsthalle,
Frankfurt am Main

**Year**
2002

Frequenzen [Hz] / Frequencies [Hz]
Audiovisuelle Räume / Audio-visual Spaces

Knut Åsdam, Mark Bain, Angela Bulloch, Farmersmanual, Tommi Grönlund\Petteri Nisunen,
Carl Michael von Hausswolff, Ryoji Ikeda, Ann Lislegaard, Carsten Nicolai, Daniel Pflumm,
Franz Pomassl, Ultra-red, Mika Vainio

57   "Frozen Water", 2000.

## Carsten Nicolai

Carsten Nicolai arbeitet in den Bereichen Klang und bildende Kunst. Seine Aktivitäten umfassen die Konstruktion von skulpturalen und Bildinstallationen, Aktionen in den Medien und im öffentlichen Raum, die Organisation und Aufführung von Konzerten; er komponiert, produziert und veröffentlicht Musik. Nicolai verknüpft elektronischen Klang und visuelle Kunst, um einen mikroskopischen Blick auf kreative Prozesse zu erzielen und erforscht elektrische und elektronische Frequenzen, indem er die Eigenschaften und Wirkungen des elektro-akustischen Materials transformiert.

Nicolais Installationen haben häufig einen skulpturalen Charakter, doch bewegen sie sich an der Schnittstelle zwischen Klang und Visualität, da der Künstler vermittels Konstruktionen aus Objekten, Bildmaterial und elektronischem Klang wellenförmige Datenaufzeichnungen erforscht. Die Arbeiten basieren auf Bildstrukturen, die von Klangfrequenzen erzeugt werden und/oder Klang, der aus visuellen Formen und Mustern entsteht. Auf diese Weise beziehen sie sich

Carsten Nicolai works in the fields of visual art and sound, his activities including that of constructing sculptural and visual installations, interventions in the media and urban environment, performing and staging concerts, composing, producing and releasing music. He researches electronics and electric frequencies, converting the principles as well as the effects of the electro-acoustic material.

Nicolai's installations often have a sculptural character, yet address the intersection between sound and visuality as he investigates wave-shaped data through structures produced by objects, visual material and electronic sound. The works rely on visual structures created by sound frequencies and/or sound constructed from visual forms and patterns. In this way they come to refer to sign structures, thus the sound and images become types of logo-related statements. In his active installations (as opposed to his painterly practice) the visual 'statements' are in continuous process, temporarily pinned down then shifting to refor-

# Sweden Graphics

## "Not by making interesting graphic design but by making graphic design interesting"

Opposite page:

**Project**
Poster

**Title**
Utopist – Javisst

**Client**
Formfront

**Year**
1998

"After all these years of dedicated work and the problems with embracing new media and technology, graphic design is finally starting to achieve what it really needed all along – an audience. Graphic design has always been a kind of sidekick to almost every other kind of cultural platform such as literature, film, art, advertising, music etc – sometimes appreciated but often neglected. At times debated, but only within the design community itself. But in the last ten years or so a massive interest has started to grow among the younger generation in graphic design as an end in itself. It is our guess that it is mainly through the process of making their own web sites that young people of today automatically gain a hands-on knowledge of typefaces, colour and composition, and that these insights make them more capable and interested in seeking out, evaluating and at best appreciating the work of more professional designers. This is the single most important factor which, in the foreseeable future, will turn graphic design into a means of expression in itself, and more so than ever before. A language that is powerful not only because there are competent speakers but because there are competent listeners. Thank you for your attention."

» Nach all den Jahren Arbeit und Schwierigkeiten mit den neuen Medien und ihrer Technik beginnt die Grafikdesignbranche endlich das zu erreichen, was sie die ganze Zeit über schon gebraucht hätte – ein Publikum. Die Gebrauchsgrafik hat andere Kulturbereiche wie Literatur, Film, Kunst, Werbung, Musik usw. immer begleitet und wurde dabei manchmal geschätzt, oft aber vernachlässigt. Mitunter umstritten, aber nur innerhalb der Grafikerzunft selbst. In den letzten zehn Jahren ist jedoch das Interesse am Grafikdesign an sich gestiegen, besonders unter jüngeren Leuten. Sie haben mit ihren eigenen Internetportalen den praktischen Umgang mit Schriftarten, Farben und Bildkomosition geübt, so dass sie sich nun auch für die Arbeiten professioneller Grafiker interessieren, sie bewerten und – im günstigsten Fall – schätzen lernen. Das ist der wichtigste Faktor, der in naher Zukunft aus dem Grafikdesign ein eigenständiges Ausdrucksmedium machen wird, eine Sprache, die nicht nur deshalb wirkungsvoll ist, weil sie von kompetenten Interpreten benutzt wird, sondern weil sie von kompetenten Zuhörern aufgenommen wird. Vielen Dank für Ihre Aufmerksamkeit.«

« Après toutes ces années de travail acharné et de problèmes pour s'adapter aux nouveaux moyens de communication et à la technologie, le graphisme commence enfin à obtenir ce dont il avait vraiment besoin: un public. Il a toujours été une sorte de parent pauvre de presque toutes les autres plates-formes culturelles telles que la littérature, le cinéma, l'art, la publicité, la musique, etc., parfois apprécié mais le plus souvent négligé. Si on en débattait, cela ne sortait pas de la communauté des créateurs. Toutefois, ces dix dernières années, on a observé un intérêt massif de la nouvelle génération pour le graphisme en tant que tel. C'est probablement en réalisant leurs propres pages web que les jeunes ont acquis sur le tas une connaissance des types de caractères, des couleurs et de la composition. Cela les a incités à rechercher, à évaluer et, au mieux, à apprécier le travail de graphistes plus professionnels. C'est sans doute le principal facteur qui, dans un futur proche, transformera le graphisme en un moyen d'expression à part entière. Un langage qui puise sa force non seulement dans la compétence de ceux qui le parlent mais également dans celle de ceux qui l'écoutent. Merci pour votre attention. »

**Sweden Graphics**
Blekingegatan 46
11664 Stockholm
Sweden

T +46 8 652 0066
F +46 8 652 0033

E hello@
swedengraphics.com

www.swedengraphics.com

**Design group history**
1998 Sweden Graphics was founded in Stockholm

**Project**
CD covers & tour poster

**Title**
Doktor Kosmos

**Client**
NONS Records

**Year**
2000

**Project**
Illustrations

**Title**
Islands

**Client**
Raket

**Year**
2000

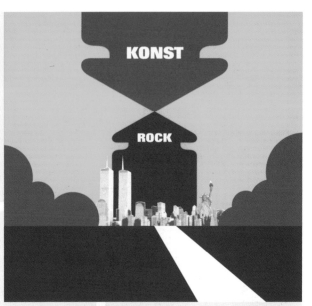

**Project**
Newspaper illustrations
for music review pages

**Title**
Newspaper illustrations
for music review pages

**Client**
DN På Stan

**Year**
1999–2001

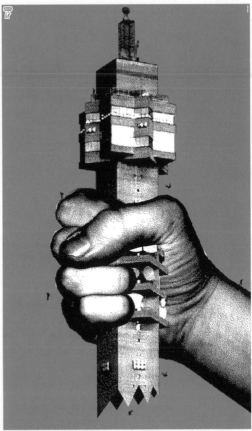

# Skala 1:1

**En improviserad helaftonsföreställning. Premiär 18 februari**

Improvisationsformen i Skala 1:1 är inspirerad av den San Franciscobaserade improvisationsgruppen True Fiction Magazine. Små bitar av historier läggs samman till längre berättelser. Dessa bildar en helhet I full skala som pendlar mellan tid och rum, logik och fantasi, komedi och tragedi. Regina Saisi från True Fiction Magazine inledde med en tre veckor lång workshop varefter Roger Westberg tog över och slutförde repetitionsarbetet. Detta är grunden till en mer fördjupad och variationsrik improvisationsform där publiken lovas en ny händelserik föreställning varje kväll.

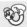 **Stockholms Improvisationsteater** | Biljetter och information **08-30 62 42**
Torsdag–Lördag kl.19.00 Sigtunagatan 12, T-Odenplan | www.impro.a.se

# Skala 1:1

**En improviserad helaftonsföreställning. Premiär 16 Februari**

Med en berättarteknik, lik den i Robert Altmans film "Short Cuts", framförs korta sekvenser av historier som läggs samman till längre berättelser. Dessa bildar en helhet i full skala som pendlar mellan tid och rum, logik och fantasi, komedi och tragedi. I varje föreställning skapas helt nya historier och berättelser, karaktärer och öden – vilket gör varje kväll till en premiär.

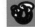 **Stockholms Improvisationsteater** | Biljetter och information **08-30 62 42**
Fredag–Lördag kl.19.00 Sigtunagatan 12, T-S:t Eriksplan | www.impro.a.se

**Project**
Flyers

**Title**
Skala 1:1

**Client**
Stockholms
Improvisationsteater

**Year**
2000

# Felipe Taborda

## "Curiosity, a paper and a pencil is what one needs to make everything happen."

Opposite page:

**Project**
Poster
design Felipe Taborda /
Priscila Andrade
photo Rodrigo Lopes

**Title**
Dança Brasil

**Client**
Centro Cultural Banco do
Brasil

**Year**
2000

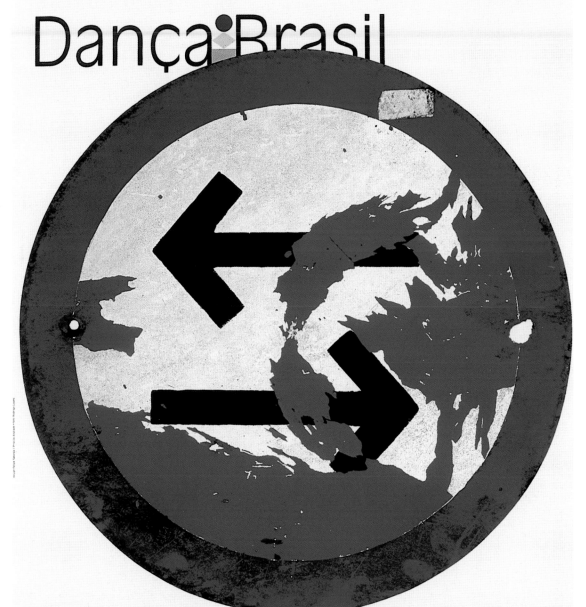

BRASILCAP | O GLOBO EM MOVIMENTO | CENTRO CULTURAL BANCO DO BRASIL | apresentam

# Dança Brasil

6 a 9 abril | **Renata Melo** | São Paulo  **F.A.R. 15** | São Paulo

13 a 16 abril | **Cia Teatral do Movimento / Ana Kfouri** | Rio de Janeiro

20, 22 e 23 abril | **Dos à Deux** | Brasil (SP/RJ)/França

27 a 30 abril | **Verve Cia de Dança** | Paraná

4 a 7 maio | **Luiz Carlos Vasconcelos** | Paraíba/Rio de Janeiro

11 a 14 maio | **Cia As Palavras** | Brasil (CE)/Bélgica

6 abril a 14 maio 2000 · Quinta a domingo · 19h30
Centro Cultural Banco do Brasil · Teatro II
Rua 1º de Março 66 · Centro · Rio de Janeiro · (+21) 808 2020

"Graphic design? Will there be graphic design or will everyone and everything be transformed into Nike, AOL, Microsoft, Coca-Cola, etc, etc. Individuality is what has always been in demand."

» Grafikdesign? Wird es künftig noch Grafikdesign geben oder wird jeder und alles in Nike, AOL, Microsoft, Coca-Cola usw. verwandelt? Individualität war schon immer gefragt.«

« La création graphique ? Elle vivra, ou tout et chacun sera transformé en Nike, AOL, Microsoft, Coca-Cola, etc. etc. La demande d'individualité n'a jamais baissé. »

**Felipe Taborda**
Rua Maria Angélica
428 / 101
Jardim Botânico
22461–150
Rio de Janeiro RJ
Brazil

T +55 21 2527 5153
F +55 21 2537 3844

E felipe.taborda@
pobox.com

**Biography**
1956 Born in Rio de Janeiro
1975–1978 BA Visual Communication, Pontifícia Universidade Católica, Brazil
1978–1980 Filmmaking and photography, The London International Film School
1980–1982 MA Communication Arts, New York Institute of Technology
1980 Graphic Design with Milton Glaser, School of Visual Art, New York

**Professional experience**
1984–1988 Head of Design Department, Sigla Records, Rio de Janeiro
1988–1989 Head of Design Department, DPZ Publicidade, Rio de Janeiro
1989–1990 Creative Director, MPM Propaganda, Rio de Janeiro
1990+ Creative Director, Felipe Taborda Design, Rio de Janeiro
1990 Jury Member, XIV Biennale of Graphic Design, Brno, Czech Republic
1993 Jury Member, 7th Annual International Exhibition, The Art Directors Club, New York
1995+ Professor of Graphic Design, Universidade and Pontifícia Universidade Católica, Rio de Janeiro
1998 Jury Member, International Poster Biennale, Mexico City
2001 Jury Member, The Art Directors Club 80th Annual Awards, New York; Jury Member, Output 4, Minneapolis and Frankfurt

**Recent exhibitions**
1990 "International Poster Biennale", Mexico City; "International Poster Biennale", Warsaw
1992 "Biennale of Graphic Design", Brno, Czech Republic
1993 "Quatrièmes Rencontres Internationales des Arts Graphiques", Chaumont, France
1995 "Colorado International Invitational Poster Exhibition"
1996 "International Poster Biennale", Warsaw
1997 "Colorado International Invitational Poster Exhibition"
1998 "International Poster Biennale", Mexico City
1999 "Colorado International Invitational Poster Exhibition"
2000 "Biennale of Graphic Design", Brno, Czech Republic; "International Poster Biennale", Mexico City; "Paisagens Particulares" (with Tom Taborda and Alfredo Britto), Museum of Modern Art, Rio de Janeiro; "Literatura Passageira", Paço Imperial, Rio de Janeiro
2001 "La Danse S'Affiche", Centre du Graphisme et de La Communication Visuelle d'Echirolles, France; "Colorado International Invitational Poster Exhibition"
2002 "Carteles Desde Rio", Museo de Arte y Diseño Contemporâneo, San José, Costa Rica; "Biennale of Graphic Design", Brno, Czech Republic; "International Poster Biennale", Mexico City

**Recent awards**
1988 President of the Jury Award, XIII Biennale of Graphic Design, Brno, Czech Republic

**Clients**
Caravana Productions
Centro Cultural Banco do Brasil
Imperial Beer
Lumiar Records
Neon Rio Film Production
O Globo Newspaper
Sony Records

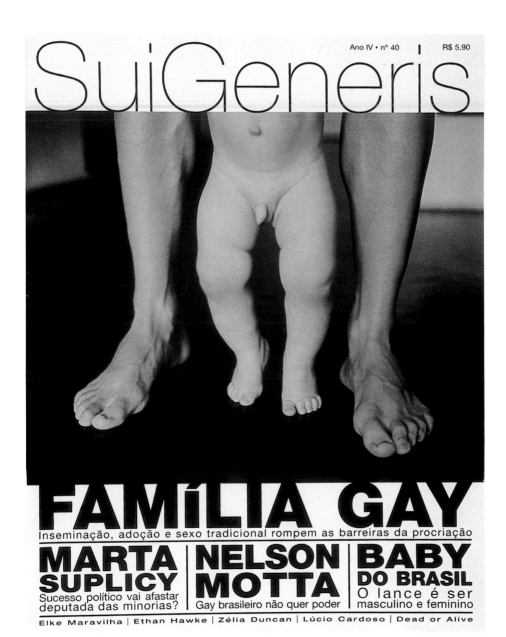

Ano IV • nº 40          R$ 5,90

# SuiGeneris

# FAMÍLIA GAY
Inseminação, adoção e sexo tradicional rompem as barreiras da procriação

**MARTA SUPLICY**
Sucesso político vai afastar deputada das minorias?

**NELSON MOTTA**
Gay brasileiro não quer poder

**BABY DO BRASIL**
O lance é ser masculino e feminino

Elke Maravilha | Ethan Hawke | Zélia Duncan | Lúcio Cardoso | Dead or Alive

**Project**
Magazine cover
Design: Felipe Taborda /
Priscila Andrade / Tonho
Photography: Marco
Frossard

**Title**
SuiGeneris

**Client**
SG Press

**Year**
1998

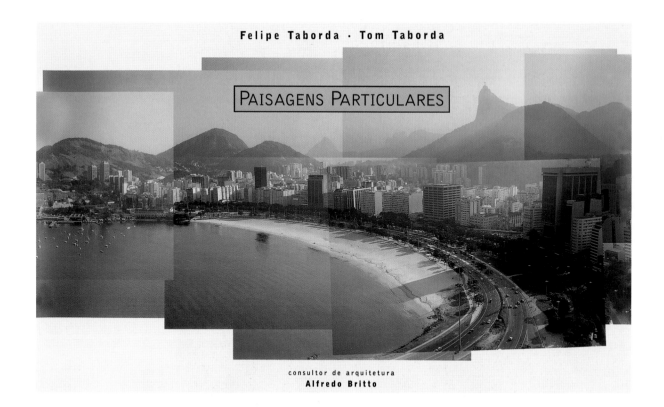

**Project**
Book cover
Design: Felipe Taborda /
Alexandre Northfleet
Photography: Tom
Taborda

**Title**
Paisagens Particulares

**Client**
UBS

**Year**
2000

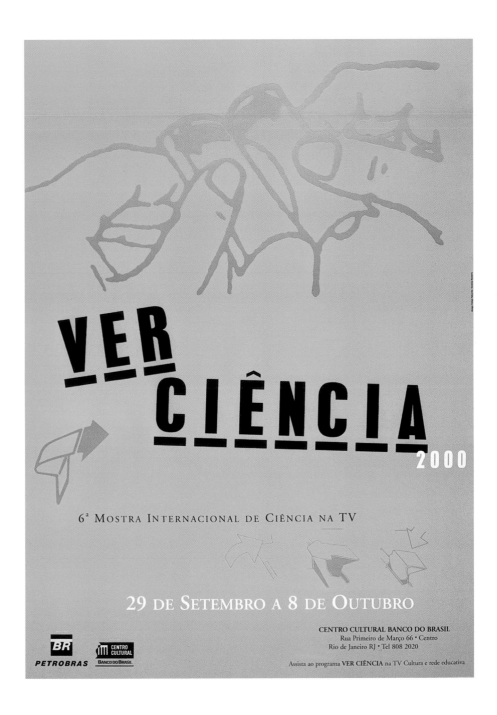

**Project**
Poster for an international
science festival
Design: Felipe Taborda /
Andrea Bezerra

**Title**
Ver Ciência

**Client**
Centro Cultural Banco do
Brasil

**Year**
2000

# ten_do_ten

## "ten means pixel in Japanese."

**Project**
ten_do

**Title**
do you like japan?

**Client**
Self-published

**Year**
2001

"ten means pixel in Japanese.
ten may be drawn on anyone.
ten may be drawn on no one.
ten may be understood only
by aliens.
ten may be understood only
by human beings.
ten may be understood only
by Japanese people.
ten may be understood only by you!"

» Pixel heißt auf Japanisch ten.
Mit ten kann man alle bezeichnen.
Mit ten kann man niemanden
bezeichnen.
ten kann nur von Außerirdischen
verstanden werden.
ten kann nur von Menschen
verstanden werden.
ten kann nur von Japanern
verstanden werden.
ten kann nur von dir verstanden
werden!«

« ten signifie pixel en japonais.
ten peut être dessiné sur n'importe
qui.
ten ne peut être dessiné sur
personne.
ten ne peut être compris que par
un extraterrestre.
ten ne peut être compris que par
un être humain.
ten ne peut être compris que par
les Japonais.
ten ne peut être compris que par
vous!»

**ten_do_ten**
Vira Bianca #504
2–22–12 Jingumae
Shibuya-ku
Tokyo 150–0001
Japan

T/F +81 3 3796 6545

E ten@tententen.net

www.tententen.net

**Design group history**
2001 Founded by Shinya
Takemura in Tokyo

**Biography**
1996–2001 Worked with
the group Delaware as a
guitarist who does not
play the guitar, as a lead
vocalist and as a graphic
designer who plays
design. Main perfor-
mances took place at the
Mac World Expo '98 in
Makuhari and at p.s.1/The
Museum of Modern Art
in New York in 2001

**Clients**
ClubKing
College Chart Japan
Gakken
Magazine House
NTT
NTT-ls
Shift
Tachibana Hajime Design

**Project**
ten_do

**Title**
sex pistols

**Client**
Self-published

**Year**
2001

**Project**
ten_do

**Title**
composition of 2 Ten

**Client**
Self-published

**Year**
2001

**Project**
ten_do

**Title**
plastics

**Client**
Self-published

**Year**
2001

**Project**
ten_do

**Title**
hanging scroll

**Client**
Self-published

**Year**
2001

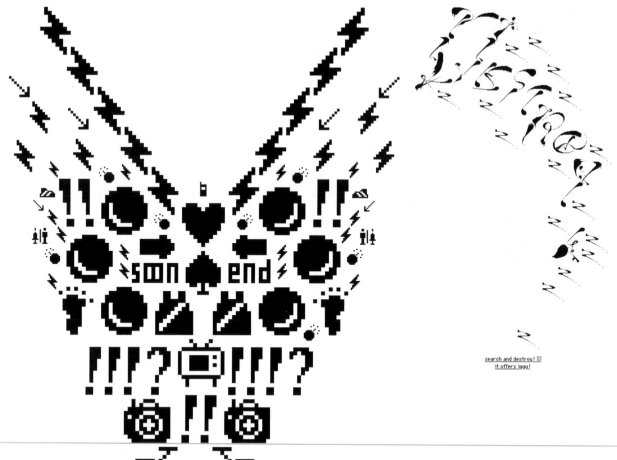

**Project**
ten_do

**Title**
david bowie's atmosphere

**Client**
Self-published

**Year**
2001

**Project**
ten_do

**Title**
search and destroy
offered to iggy pop

**Client**
Self-published

**Year**
2001

tokyo logo mark 点／テン・ドゥ

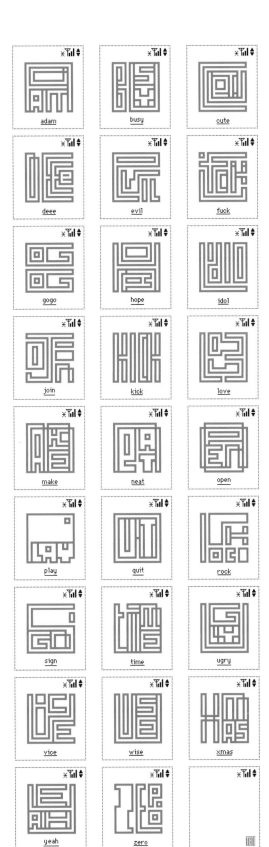

**Project**
ten_do

**Title**
logo mark of tokyo

**Client**
Magazine House

**Year**
2001

**Project**
ten_do

**Title**
good morning

**Client**
Self-published

**Year**
2001

**Project**
ten_do

**Title**
kaneiji

**Client**
Self-published

**Year**
2001

# The Designers Republic

## "Design or Die"

Opposite page:

**Project**
Poster

**Title**
Mitdarchitec_ure™

**Client**
Self-published

**Year**
2001

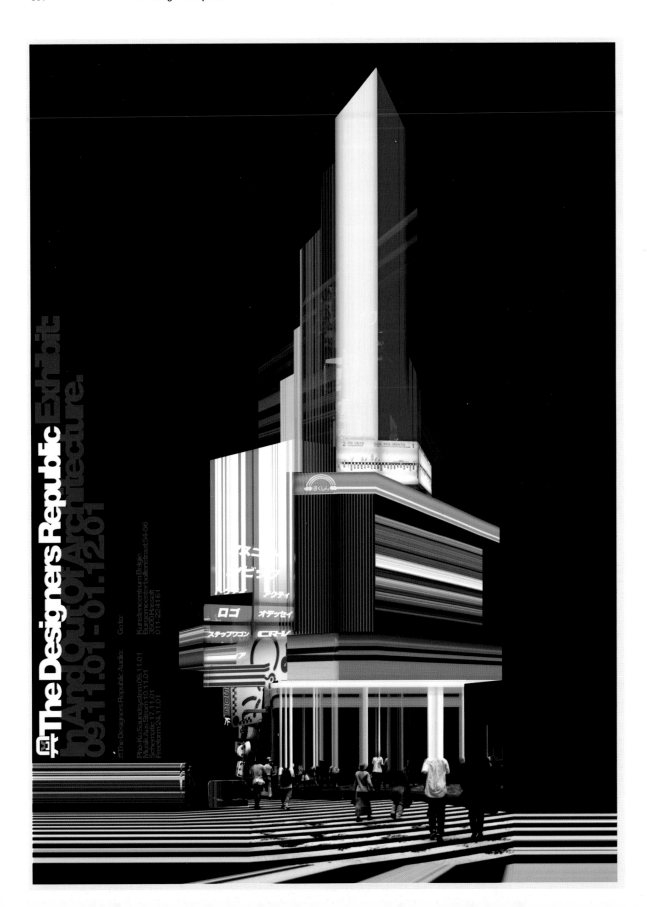

**The Designers Republic Exhibit**
In And Out of Architecture.
09.11.01 – 01.12.01

The Designers Republic AutoFix

Photo-Ku Soundsystem 09.11.01
Mixat/Aus:Strom 10.11.01
Schematic 17.11.01
Freeform 24.11.01

© The Designers Republic

Go to:

Kunstencentrum Belge
Europloaster
3500 Hasselt
Bxtropknesterbdlensbraat 54-56
011-224161

"Brain Aided Design. Brain Aided Design. Brain Aided Design. Brain Aided Design. Brain Aided Design. Brain Aided Design. Brain Aided Design. Brain Aided Design. Brain Aided Design. Brain Aided Design. Brain Aided Design. Brain Aided Design. Brain Aided Design. Brain Aided Design. Brain Aided Design. Brain Aided Design. Brain Aided Design. Brain Aided Design. Brain Aided Design. Brain Aided Design. Brain Aided Design. Brain Aided Design. Brain Aided Design. Brain Aided Design. Brain Aided Design. Brain Aided Design. Brain Aided Design. Brain Aided Design. Brain Aided Design. Brain Aided Design. Brain Aided Design. Brain Aided Design. Brain Aided Design. Brain Aided Design. Brain Aided Design. Brain Aided Design. Brain Aided Design. Brain Aided Design. Brain Aided Design. Brain Aided Design. Brain Aided Design. Brain Aided Design."

» Brain Aided Design. Brain Aided Design. Brain Aided Design. Brain Aided Design. Brain Aided Design. Brain Aided Design. Brain Aided Design. Brain Aided Design. Brain Aided Design. Brain Aided Design. Brain Aided Design. Brain Aided Design. Brain Aided Design. Brain Aided Design. Brain Aided Design. Brain Aided Design. Brain Aided Design. Brain Aided Design. Brain Aided Design. Brain Aided Design. Brain Aided Design. Brain Aided Design. Brain Aided Design. Brain Aided Design. Brain Aided Design. Brain Aided Design. Brain Aided Design. Brain Aided Design. Brain Aided Design. Brain Aided Design. Brain Aided Design. Brain Aided Design. Brain Aided Design. Brain Aided Design. Brain Aided Design. Brain Aided Design. Brain Aided Design. Brain Aided Design. Brain Aided Design. Brain Aided Design.«

« Brain Aided Design. Brain Aided Design. Brain Aided Design. Brain Aided Design. Brain Aided Design. Brain Aided Design. Brain Aided Design. Brain Aided Design. Brain Aided Design. Brain Aided Design. Brain Aided Design. Brain Aided Design. Brain Aided Design. Brain Aided Design. Brain Aided Design. Brain Aided Design. Brain Aided Design. Brain Aided Design. Brain Aided Design. Brain Aided Design. Brain Aided Design. Brain Aided Design. Brain Aided Design. Brain Aided Design. Brain Aided Design. Brain Aided Design. Brain Aided Design. Brain Aided Design. Brain Aided Design. Brain Aided Design. Brain Aided Design. Brain Aided Design. Brain Aided Design. Brain Aided Design. Brain Aided Design. Brain Aided Design. Brain Aided Design. Brain Aided Design. Brain Aided Design. Brain Aided Design. »

**The Designers Republic**
The Workstation
15 Paternoster Row
Sheffield S1 2BX
UK

T +44 114 275 4982
F +44 114 275 9127

E disinfo@
thedesignersrepublic.com

www.thedesigners
republic.com
www.thepeoples
bureau.com
www.pho-ku.com

**Biography**
1986 Founded by Ian Anderson in Sheffield

**Recent exhibitions**
1998 "DR Modern Art", Sheffield, Glasgow, Manchester, London, Vienna, Tokyo
1999 "Sound in Motion", Hasselt; EXIT, London
2000 "Sound and Files", Vienna; "Sound Design", Japan, Brunei, Singapore, Hong Kong etc.
2001 "3D>2D>15Y", Magma Clerkenwell, London; "In and Out of Architecture", Hasselt; JAM, Barbican, London, "Brain Aided Design"™, Barcelona.

**Clients**
!K7/Funkstörung
Adidas
Branson Coates Architects/Moshi Moshi Sushi
Cartoon Network TV, UK
Emigre Magazine
EMI/Parlophone Records
Gatecrasher
Issey Miyake
KesselsKramer
Moloko
MTV Europe
Nickelodeon
PowerGen/Saatchi& Saatchi
Pringles/MTV
Psygnosis/Wipeout
PWEI
Sadar Vuga Arhitekti
Satoshi Tomiie
Supergrass
SuperNoodles/Mother Advertising
Swatch
Telia Telecom
Towa Tei
Warp Records

1994
2001

**Towa Tei / Best**   Cover Design Kit

1 x Letraset sheet   1 x sticker sheet
1 x jewel case   1 x trayliner
1 x 8 page booklet   1 x compact disc

**LETRASET®**
www.letraset.com

akashic records   ar ar ar

www.towatei.com   www.thedesignersrepublic.com
www.towatei.com   www.thedesignersrepublic.com

テイ・トウワ Towa Tei テイ・トウワ

**Towa Tei**

ベスト
BEST!

Best!
Best!
Best!
Best!
Best!

Price:

DESIGN BY THE DESIGNERS REPUBLIC™
AND

01 Happy
02 Technova
03 Butterfly
04 Luv Connection
05 Forget Me Not
06 Lá Douce Vie
07 Let Me Know
08 Congratulations!
09 GBI
10 Mars
11 Last Century Modern
12 Obrigato
13 Incense & A Night of UBUD

Produced by Towa Tei
Produced by Towa Tei

AMCT-4567

4 988029 456731

**Project**
CD packaging

**Title**
Towa Tei Best

**Client**
Akashic Records

**Year**
2001

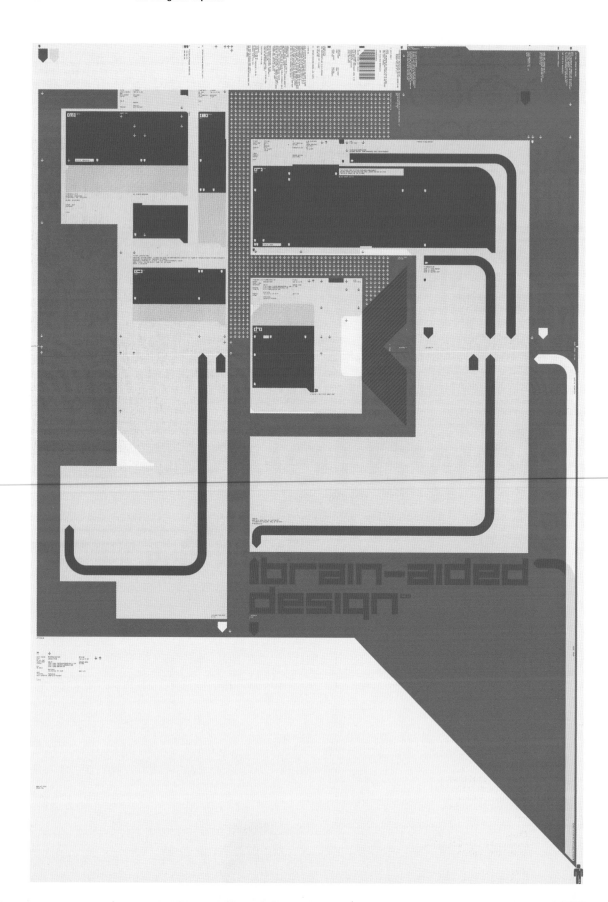

Opposite page:

**Project**
Poster

**Title**
Brain Aided Design™

**Client**
Self-published / The
Peoples Bureau for
Consumer Information

**Year**
2002

**Project**
Book

**Title**
The Designers Republic's
Adventures in and out of
Architecture with Sadar
Vuga Arhitekti and Spela
Mlakar

**Client**
Laurence King Publishing /
Sadar Vuga Arhitekti

**Year**
2001

# Andrea Tinnes

"With a passion for visual eloquence I try to establish my own place between commerce and art."

Opposite page:

**Project**
Poster announcing the
German filmfestival in
Georgia (Eastern Europe)

**Title**
Tage des deutschen Films
in Tbilissi

**Client**
Medea:
Film/Production/Service

**Year**
2002

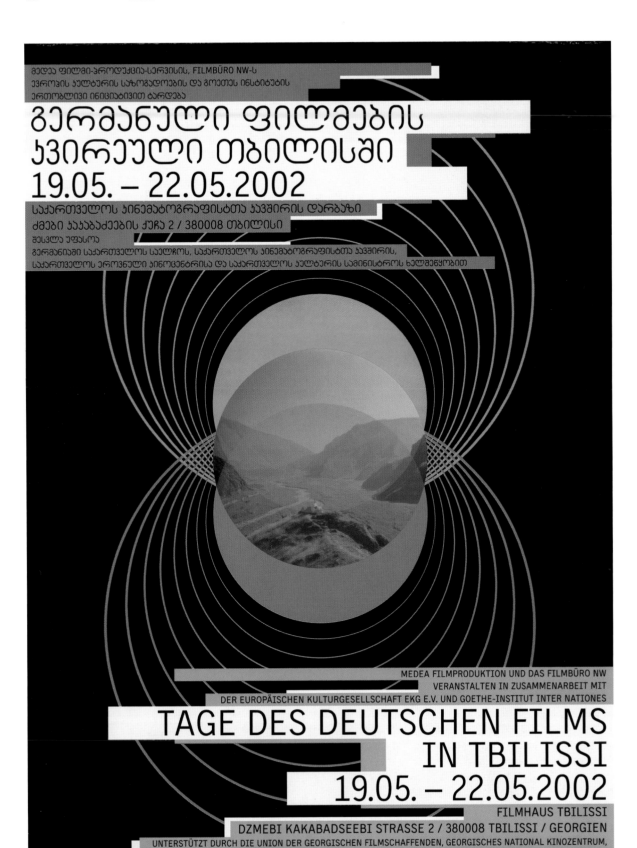

"While reflecting on the themes and schemes within graphic design over the last decade the hype of the information superhighway, blind enthusiasm for hardware and software, a bigger is better attitude, the demise of the cutting edge, the chase after the next new thing, the dawn of Helvetica Neo-Modernism, the vector vs. bitmap battles, the buzz about branding, the self-indulgent identity crisis of graphic design – I find myself with a paradoxical and rather romantic vision of the graphic design of the future: a return to graphic design's classical virtues: a return to original ideas, to creative imagination, to skilled craftmanship, to idiosyncratic aesthetics, to political awareness, to social responsibility and to critical attitudes."

» Wenn ich über all die Themen und Programme innerhalb der Grafik-design-Debatten der letzten Jahre nachdenke – den enormen ›Hype‹ um den ›Information Superhighway‹, den blinden Enthusiasmus für Hard- und Software, den ganzen ›größer, besser, schneller‹-Wahnsinn, den ruhmlosen Niedergang des ›Cutting Edge‹, die ununterbrochene Jagd nach dem nächsten letzten Schrei, das Aufkeimen einer neuen Helvetica-Moderne, die Vector-versus-Bitmap-Schlachten, die übersteigerte Aufregung um den Begriff des ›Brandings‹, die selbst gestrickte Identitätskrise des Grafikdesigns – dann stelle ich paradoxerweise fest, dass meine Vision eines zukünftigen Grafikdesigns ziemlich romantisch anmutet; nämlich eine einfache Rückbesinnung auf seine klassischen Tugenden: intelligente Ideen, kühne Fantasien, ungewohnte Ästhetik, handwerkliches Können, politisches Bewusstsein sowie soziale Verantwortlichkeit.«

« Quand je réfléchis aux thèmes et schémas de la création graphique des dix dernières années, au battage médiatique sur la super autoroute de l'information, à l'enthousiasme aveugle pour le matériel informatique et les logiciels, à l'attitude ‹plus c'est grand, mieux c'est›, à la disparition de l'avant-garde, à la course après la nouveauté, à l'avènement du ‹Néomodernisme Helvetica›, aux combats du vectoriel contre le matriciel, au tintouin autour du ‹branding›, à la crise d'identité complaisante du graphiste, je me rends compte que j'ai une vision paradoxale et plutôt romantique de l'avenir de ma profession : un retour aux vertus classiques, aux idées originales, à l'imagination créative, au savoir-faire artisanal, aux esthétiques individuelles, à la conscience politique, à la responsabilité sociale et aux attitudes critiques. »

**Andrea Tinnes**
DASDECK
Schliemansstrasse 6
10437 Berlin
Germany

T +49 30 61 60 95 54
F +49 30 44 03 16 29

E andrea@dasdeck.de

**Biography**
1969 Born in Puettlingen, Germany
1988–1989 Art History, University of Saarland, Saarbrücken
1989–1996 Diplom FH Communication Design, Fachhochschule Rheinland-Pfalz, Mainz
1992 Exchange programme, Plymouth College of Art and Design
1996–1998 MFA Graphic Design California Institute of the Arts, Valencia/CA

**Professional experience**
1988 Internship, Villeroy & Boch, Design- and Photostudio, Mettlach/Saar
1991 Internship, Now Design, Saarbrücken
1993 Practical training, Ogilvy and Mather, Marketing & Communications, Frankfurt/Main; internship, Giant Limited, Graphic Design Consultancy, London; internship, the Team, Design Consultancy, London
1994 Freelance designer, Ogilvy and Mather Healthcare, Marketing and Communications, Frankfurt/Main
1995 Internship and subsequent freelance designer, HWL & Partner Design, Frankfurt/Main
1997 Internship, Ciphertype, Los Angeles
1998–1999 Design Assistant to Jeffrey Keedy, Ciphertype, Los Angeles; freelance designer, Lorraine Wild, the Offices of Anne Burdick, CalArts, Los Angeles
1999–2000 Taught typography, Fachhochschule Rheinland-Pfalz, Mainz
2000+ Independent Graphic Designer, Typographer and TypeDesigner, DASDECK, Berlin

**Recent exhibitions**
1999 "TwentySecond" Annual 100 Show, Chicago
2000 "Alphabets, Codes und andere Zeichen", Gutenberg Pavillon, Mainz
2001 "Acceptance, Rebellion, Overdrive, CalArts Type Design 1988–2001", CalArts, Valencia, California
2001 Red Dot Award, Communication Design 2001/2002, Zeche Zollverein, Essen

**Recent awards**
1999 Selected, 22 Annual 100 Show, American Center for Design, Chicago (awarded work: poster announcing a lecture by the artist Thomas Lawson at CalArts)
1999 Selected, Output 02: Awarded Works of Graphic Design Students, Rat für Formgebung (German Design Council), Frankfurt/Main (awarded work: Family Affair: a family album of font marriages; final Thesis project at CalArts)
2001 Red Dot Award, Communication Design 2001/2002 Design Zentrum Nordrhein-Westfalen (awarded work: Calendar DYWIDAG 2001 Design Studio: Büro für Gestaltung/Lahn; Creative Director: Hardy Lahn; Graphic Design: Andrea Tinnes)

**Clients**
Atsolute
DasDeck
DYWIDAG
MEDEA
NICI
Sun&Cycle
Walter Bau

**Project**
Image calendar 2001

**Title**
DYWIDAG calendar 2001

**Client**
Dyckerhoff & Widmann
AG; Büro für
Gestaltung/Lahn

**Year**
2000/2001

**Project**
Font / Interface /
http://volvox.dasdeck.com

**Title**
Volvox

**Client**
Self-published /
Martin Perlbach

**Year**
1999/2002

**Project**
Poster displaying the
typeface "Stitch-me"

**Title**
Stitch-Me

**Client**
Self-published

**Year**
2001

# Jan van Toorn

## "La liaison dangereuse and the 21st century"

Opposite page:

**Project**
Poster for a poster
exhibition in the Peace-
palace, The Hague

**Title**
War is over

**Client**
International poster gallery
foundation, The Hague

**Year**
1999

ontwerp Jan van Toorn Amsterdam

28 april tm 7 mei 1999

Vredespaleis Den Haag

lezing in Theater Zeebelt 28 april 20.30 uur. sprekers
o.m. Rudolf de Jong (politicoloog) en Jan van Toorn
Willemstraat 7, toegang fl 10,--. reserveren 070.3656546

academiegebouw
Carnegieplein 2*
maandag tm vrijdag
van 11 tot 16.30 uur,
zaterdag en zondag
van 11 tot 15.30 uur
gesloten 30 april, 5 mei

an exhibition of posters on the theme of peace organised
by the International Poster Gallery Foundation
een tentoonstelling met affiches over de vrede georganiseerd
door de Stichting Internationale Affiche Galerij
curator Jan van Toorn

de oorlog voorbij!
waris over

*bezoek na schriftelijke
aanmelding Bankaplein 1
2585 EV Den Haag
fax 070.3307546
telefoon 070.3307545

"The practice of communication design has become increasingly constricted. The thinking, pleasure and risks of the profession have become more and more limited to those of a liaison officer linked to global capitalism and the cultural and political hegemony of the West. Although communication design in itself is unable to change much of the shameless exploitation of people and the natural environment, it is high time for it to relate its own practice and discourse again to social relations. This would in turn give its 'liaison dangereuse' the potential to work on the possibility of a liberating and multi-centred global public sphere."

» Die Praxis des Kommunikations-designs sieht sich mit immer mehr Einschränkungen konfrontiert. Die Gedanken, Freuden und Risiken des Berufs beschränken sich mehr und mehr auf die eines Verbindungs-offiziers zum Weltkapitalismus sowie zur kulturellen und politischen Hegemonie der westlichen Länder. Das Kommunikationsdesign allein ist zwar nicht in der Lage, die schamlose Ausbeutung von Menschen und Ressourcen abzuschaffen, dennoch ist es für die in diesem Bereich Tätigen höchste Zeit, ihre Arbeit und Arbeiten auf gesellschaftliche Themen zu beziehen. Das würde dieser verhängnisvollen Liaison die Möglichkeit geben, sich für einen befreienden, multizentrischen, globalen öffentlichen Raum einzusetzen.«

« Le design de communication est devenu de plus en plus étriqué. La pensée, le plaisir et les risques de la profession se sont progressivement réduits aux services d'un officier de liaison à la solde du capitalisme mondial et de l'hégémonie politique de l'Occident. Bien que le graphisme ne puisse pas, en lui-même, faire grand-chose contre l'exploitation sans scrupule des populations et de l'environnement, il est grand temps qu'il réintègre les relations sociales dans sa pratique et son discours. Cela donnerait en retour à sa ‹liaison dangereuse› la possibilité d'œuvrer dans une sphère publique mondiale libératrice et décentralisée. »

**Jan van Toorn**
Javakade 742
1019 SH Amsterdam
The Netherlands

T +31 20 419 4163

E wjvt@xs4all.nl

**Biography**
1932 Born in Tiel, The Netherlands
1950–1953 Studied graphic design, Institute of Arts and Crafts, Amsterdam

**Professional experience**
1957+ Freelance designer
1963+ Taught Graphic Design and Visual Com-munication at various academies and universi-ties in The Netherlands and abroad, including the Gerrit Rietveld Academie, Amsterdam, Rijksacade-mie, Amsterdam, Techni-cal University, Eindhoven, Technical University, Ban-dung and the University of Western Sydney
1972+ Member, Alliance Graphique Internationale (AGI)
1989+ Associate Profes-sor, Rhode Island School of Design, Providence
1991–1998 Founding Director, Postgraduate Programme for Fine Art, Design and Theory, Jan van Eyck Academie, Maastricht
1993+ Member, Advisory Board, Visible language magazine, Providence, Rhode Island
1997 Organized the con-ference "Design beyond design, critical reflection and the practice of visual communication", Jan van Eyck Academie, Maas-tricht
1997+ Member, Advisory Board, Design Issues magazine, Cambridge, Massachusetts

**Exhibitions**
1968 "Poster Biennial", Warsaw
1970 "Poster Biennial", Warsaw; Typomundus 20/2, New York
1972 "Poster Biennial", Warsaw; "Jan van Toorn", Museum Fodor, Amster-dam; "Europalia, Stedelijk 60–70", Brussels
1973 "Dutchposters 1956–1970", Nederlandse Kunststichting, Amster-dam
1981 "ZGRAF, Internation-al exhibition of graphic design and visual com-munication", Zagreb
1985 "Wat Amsterdam betreft", Stedelijk Museum, Amsterdam
1986 "Jan van Toorn", De Beyerd, Breda; "Holland in vorm", Stedelijk Museum, Amsterdam
1986–1989 "Rietveld heirs", touring exhibition of Dutch design in the USA
1995 Dutch design, The Museum of Modern Art, New York
2000 "Work from Holland (graphic design in con-text)", Moravian Gallery and Governor's Palace, Brno, Czech Republic
2001 "Graphisme[s]; 200 créateurs 1997–2001", Bibliothèque Nationale de France, Paris; "Typo-Janchi; first typography biennial", Design Centre, Seoul

**Awards**
1965 H.N. Werkman Prize, City of Amsterdam
1972 H.N. Werkman Prize, City of Amsterdam
1985 Piet Zwart prize, The Netherlands

**Clients**
Ministry of Culture
Mart. Spruijt Printers
Ministry of Public Works
PTT Post
Rosbeek Printers
Stedelijk van Abbe-museum Eindhoven
Utrecht Centraal Museum
Visual Arts Center De Beyerd
V pro television

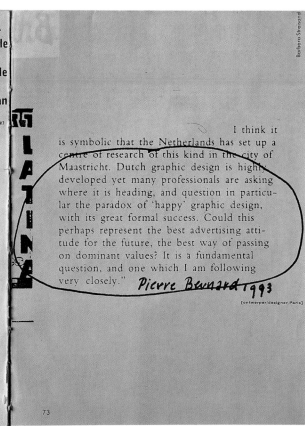

David Geffen

**De eerste dag van de conferentie 'Design beyond design' zal worden besteed aan de discrepantie tussen de sociaal-economische en symbolische werkelijkheid van de mondiale informatie- en consumptiecultuur, aan de perspectieven voor het democratiseren van de media en de rol van visuele producenten en theoretici daarbij. De tweede dag gaat over het ontwerpen dat bewust 'de opheffing nastreeft van de grenzen tussen alledaagse en esthetische ervaring' en behandelt de strategieën en uitdrukkingsvormen van de operationele en reflectieve tradities. Aan de orde komen initiatieven op gebieden buiten het blikveld van het**
[Gert Selle, literatuur- en ontwerpcriticus, Oldenburg]
Nadere informatie over het symposium,
**officiële design evenals dialogische vormen van visuele**
waaronder de namen van de sprekers,
**bemiddeling binnen het ontwerpen gericht op**
zal voorjaar 1997 worden gepubliceerd
**onafhankelijke oordeelsvorming en participatie.**

The first day of the conference 'Design beyond design' will be devoted to the discrepancy between the socio-economic and symbolic reality of the worldwide information and consumer culture, the prospects for a democratisation of the media, and the role of visual producers and theoreticians in this development. The second day will be devoted to design that deliberately aims at 'abolishing the boundaries between everyday and aesthetic experience' and will deal with the strategies and forms of expression of the operational and reflexive traditions. Initiatives in areas outside the realm of official design will be discussed, as well as dialogic forms of visual mediation within design aimed at the forming of independent opinion and participation.
[Gert Selle, literary and design critic, Oldenburg]
More detailed information on the conference, including the names of the speakers, will be published in spring 1997

Barbara Streisand

72    73

I think it is symbolic that the Netherlands has set up a centre of research of this kind in the city of Maastricht. Dutch graphic design is highly developed yet many professionals are asking where it is heading, and question in particular the paradox of 'happy' graphic design, with its great formal success. Could this perhaps represent the best advertising attitude for the future, the best way of passing on dominant values? It is a fundamental question, and one which I am following very closely." *Pierre Bernard 1993*
[ontwerper/designer, Paris]

**Project**
Spreads of a brochure
announcing the
conference "Design
beyond design"

**Title**
Design beyond design

**Client**
Jan van Eyck Academie,
Maastricht

**Year**
1997

**Project**
Spread from the goodwill
publication

**Title**
Cultiver notre jardin [visual
essay]

**Client**
Rosbeek printers, Nuth

**Year**
1999

Opposite page:

**Project**
Poster on the occasion of
the centenary of the
death of Toulouse-Lautrec

**Title**
Le Nouveau Salon des
Cent – Exposition
internationale d'affiches

**Client**
Toulouse-Lautrec
museum partners' club

**Year**
2001

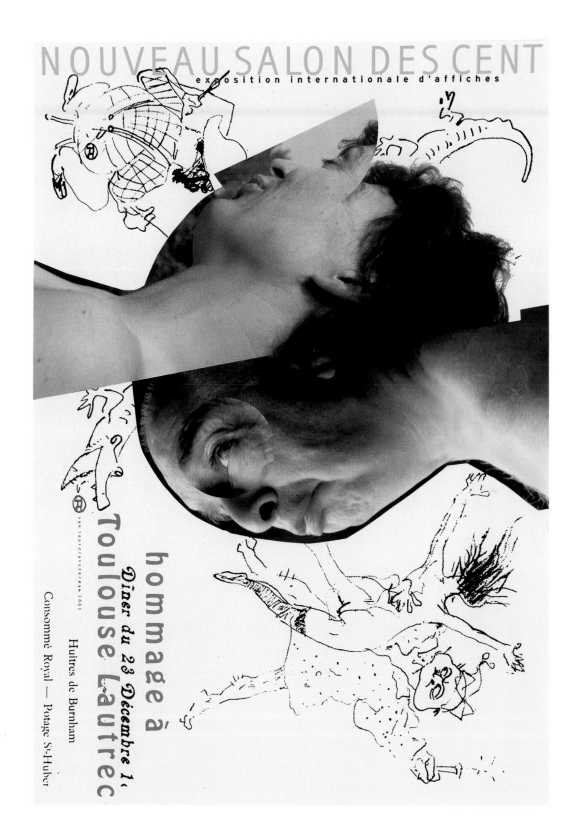

# Tycoon Graphics

"Like using a Time-Machine. Leap into the consciousness of the future then bring it back to the present, and design."

Opposite page:

**Project**
Poster

**Title**
Atehaca

**Client**
Toshiba Corporation

**Year**
2001

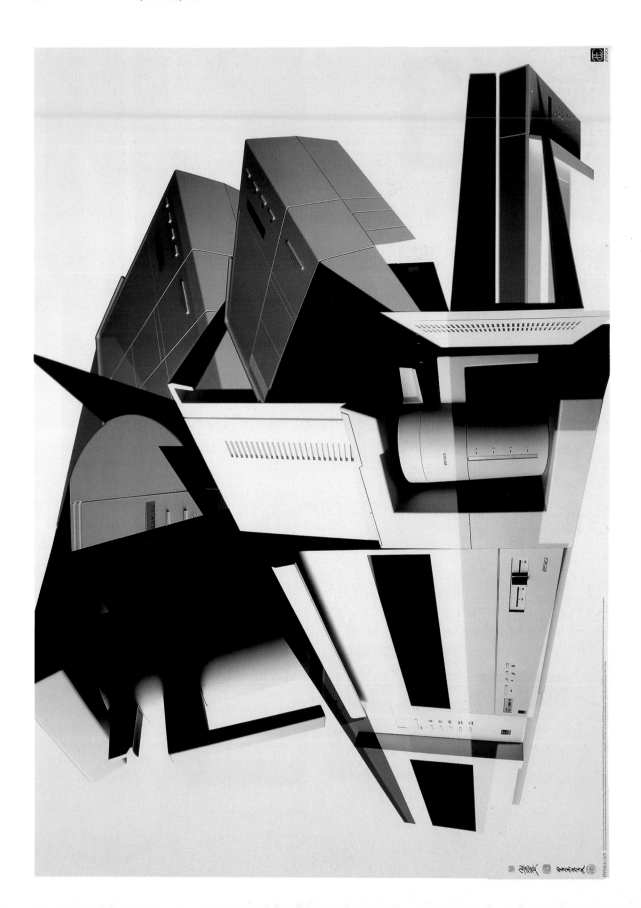

"The importance of graphic design as a language will be raised more than ever in the future. Yet on the other hand, as the global trend of youth becomes increasingly sensuous, graphic design will be used as a sensory medium which cannot be described as a verbal language, or as an entertainment tool. As such, the role of graphic design will become more important as a cultural medium and graphic designers will find themselves in high demand."

» Die Bedeutung des Grafikdesigns als Kommunikationssprache wird künftig noch zunehmen. Andererseits wird die Gebrauchsgrafik in dem Maße, in dem Jugendliche in aller Welt zu sinnlicheren Ausdrucksformen tendieren, zum Werkzeug dieser Entwicklung, die sich mit Sprache nicht ausdrücken lässt. Oder aber sie wird zum Instrument der Unterhaltung. Dadurch wird die Gebrauchsgrafik als Kulturmedium an Bedeutung gewinnen und Grafiker werden sehr gefragt sein.«

« A l'avenir, le graphisme en tant que langage prendra encore plus d'importance. Parallèlement, à mesure que la tendance mondiale en faveur de la jeunesse se fera de plus en plus sensuelle, le graphisme servira d'outil pour décrire ce qui ne peut l'être verbalement, ou comme un instrument de divertissement. A ce titre, son rôle de moyen de communication culturel se renforcera encore et les graphistes seront très demandés. »

**Tycoon Graphics**
402 Villa Gloria
2–31–7 Jingumae
Shibuya-ku
Tokyo 150–0001
Japan

T +81 3 5411 5341
F +81 3 5411 5342

E mail@tyg.co.jp

**Design group history**
1991 Co-founded by
Yuichi Miyashi and
Naoyuki Suzuki in Tokyo

**Founders' biographies**
Yuichi Miyashi
1964 Born in Tokyo
1985–1990 Worked for
Diamond Heads Inc. in
Tokyo
1990 Moved to New York
1991 Returned to Japan
and co-founded Tycoon
Graphics
1994 Tycoon Graphics
was converted into a
corporation
Naoyuki Suzuki
1964 Born in Niigata
Prefecture
1987–1990 Worked for
Contemporary Production
in Tokyo
1990 Moved to New York
1991 Returned to Japan
and co-founded Tycoon
Graphics

**Recent exhibitions**
2000 "Atlantis Festival
Graphic Exhibition",
Switzerland; Graphic
Wave, Ginza Graphic
Gallery, Japan; "International Film Festival Rotterdam", The Netherlands;
"Onedotzero", England
2001 "Onedotzero",
England; "Tokyo Zone",
Café de la Danse, France

**Recent awards**
1999 Gold Award and
Silver Award, Art Directors Club, New York
2000 Merit Award, Art
Directors Club, New York

**Project**
CD cover

**Title**
Towa Tei "Mars" CD

**Client**
Akashic Records/East
West Japan inc.

**Year**
2000

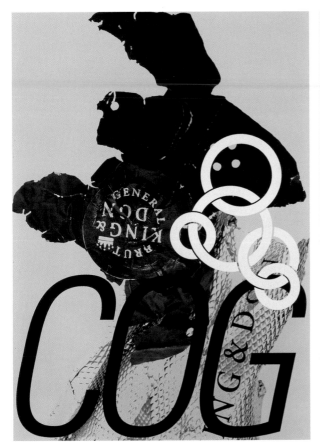

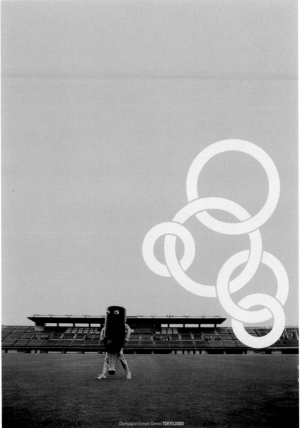

**Project**
Poster

**Title**
Champagne Design
poster

**Client**
Self-published

**Year**
2000

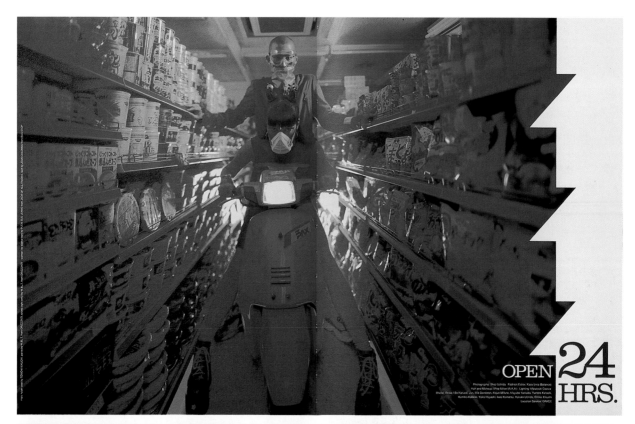

OPEN **24** HRS.

Photography: Shoji Uchida  Fashion Editor: Kaze Ijima (Balance)
Hair and Makeup: Mika Mitani (K.A.)  Lighting: Masatoshi Gyoza
Model: Anita / Bo Natural, Jun, Mie Danceron, Kisyn Mifune, Mayuko Yamada, Yumiko Kikuchi,
Kumiko Kobiaki, Yoko Hayashi, Isao Komatsu, Haruka Uchida, Eiriko Kitsuchi
Location Service: GRACE

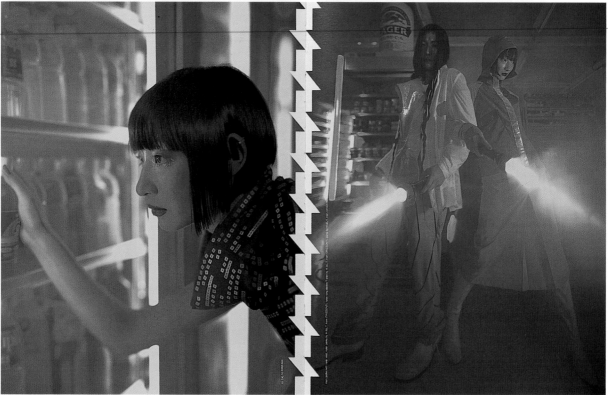

**Project**
Big Magazine spreads
and cover

**Title**
Big EDC! Tokyo Issue

**Client**
Big Magazine

**Year**
1998

# UNA (Amsterdam) designers

**"Get to know the client, understand his particular style of language, fathom his questions, and in your own original and unique voice give a lucid response."**

**Project**
Identity/stationery
designed by André
Cremer

**Title**
D&A

**Client**
D&A medical group

**Year**
2001

"The creation of a strong cohesion between impressions expressed through printed and digital media demands of a graphic designer a substantial supply of cultural equipment. It places the designer in the vicarious position of director, conductor and composer. Similarly, the designer must have insight into the possibilities of text, image, sound and production. To be able to survive in a world inundated by consultants, communication experts, marketing specialists, co-ordinators and supervisors – in other words those who deem themselves proficient in a variety of disciplines and are thus qualified to be at the vanguard leading the rest of us – requires a certain degree of authority. Authority is not bestowed upon us as a gift. It is accomplished through education and experience. Education encapsulating a broad spectrum of disciplines. Unfortunately, the length of time necessary for training is shortened and learning to be in command of diverse programmes demands time. The vital question is where the much needed general development and broad orientation eventually lands."

» Das Entstehen der starken Kohäsion zwischen den Eindrücken, die mit Druck- und digitalen Medien vermittelt werden, verlangt vom Grafiker ein umfangreiches kulturelles Rüstzeug. Das versetzt ihn in die Position des stellvertretenden Regisseurs, Dirigenten und Komponisten. In ähnlicher Weise muss der Grafiker ein Gespür für das Potenzial von Text, Bild, Klang und Herstellungsverfahren haben. Um sich in einem von Beratern, Kommunikationsexperten, Marketingspezialisten, Organisatoren und Kontrolleuren wimmelnden Markt durchzusetzen – umgeben von Leuten also, die sich in verschiedenen Fachbereichen für kompetent halten und somit für qualifiziert, die Vorhut zu bilden und uns alle anzuführen –, braucht man ein gewisses Maß an Autorität. Die wird keinem geschenkt. Man erlangt sie durch Bildung, mit einem breiten Wissensspektrum. Leider werden die Ausbildungszeiten immer kürzer, während es doch Zeit erfordert, um die verschiedenen Fächer zu beherrschen. Die Hauptfrage ist, wohin die allgemeine Entwicklung und breite Orientierung führt.«

« Pour pouvoir créer une forte cohésion entre les impressions s'exprimant à travers les médias imprimés et numériques le graphiste a besoin d'un important bagage culturel. Il se trouve indirectement dans la position d'un directeur, d'un chef d'orchestre et d'un compositeur. De même, le créateur doit bien connaître les possibilités de texte, d'image, de son et de production. Pour survivre dans un monde surpeuplé de consultants, d'experts en communication, de spécialistes du marketing, de coordinateurs et superviseurs – en d'autres termes de personnes s'estimant compétentes dans une variété de disciplines et donc qualifiées pour nous conduire tous – il faut une certaine autorité. Celle-ci ne tombe pas du ciel, on l'acquiert par une éducation englobant un large éventail de disciplines. Malheureusement, on nous laisse de moins en moins le temps de nous former alors qu'apprendre à maîtriser les différents programmes en demande de plus en plus. La question cruciale est : où nous mènent le développement et l'orientation générale si nécessaires ? »

| UNA (Amsterdam) designers | Design group history | Founders' biographies | Recent awards | Clients |
|---|---|---|---|---|
| Korte Papaverweg 7a 1032 KA Amsterdam The Netherlands<br><br>T +31 20 668 62 16 F +31 20 668 55 09<br><br>E una@unadesigners.nl<br><br>www.unadesigners.nl | 1987 Co-founded by Hans Bockting and Will de l'Ecluse in Amsterdam | Hans Bockting 1945 Born in Bladel, The Netherlands 1963 College of Art & Industry AKI, Enschede, The Netherlands 1967 HVR Advertising, The Hague 1970 Freelance designer, The Hague 1982 Partner, Concepts, Amsterdam 1987 Partner, UNA, Amsterdam<br>Will de l'Ecluse 1951 Born in Leyden, The Netherlands 1967 Royal College of Art, The Hague 1972 Ruder and Finn, Jerusalem 1975 HDA International, London 1977 Tel Design, The Hague 1979 Freelance designer, Amsterdam 1982 Partner, Concepts, Amsterdam 1987 Partner, UNA, Amsterdam | 1991 Best Annual Report Design 1998, 1999, 2000, 2002 Design Week Awards 1998, 2001 ISTD Typographic Awards 2001 Dutch Letterhead Competition, Red Dot Awards 2001, 2002 ADC Awards, Best Calendar Design | Asko/Schönberg Ensemble Consumer Safety Insitute D&A medical group De Arbeiderspers Delta Lloyd Design Zentrum NRW F. van Lanschot Bankiers InnoCap KLM Royal Dutch Airlines Meervaart Theatre National Archives Royal Picture Gallery Stedelijk Museum TEFAF Wolters-Noordhoff |

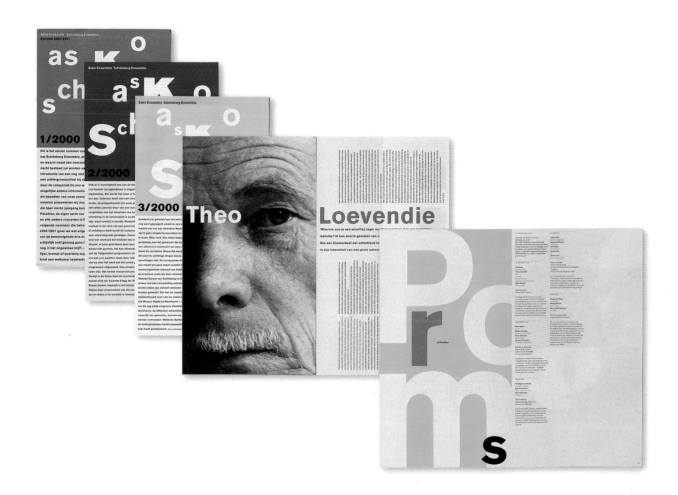

**Project**
Series of newsletters
designed by Will de
l'Ecluse and Mijke
Wondergem

**Title**
AskoSchönberg

**Client**
Asko Ensemble /
Schönberg Ensemble

**Year**
2000

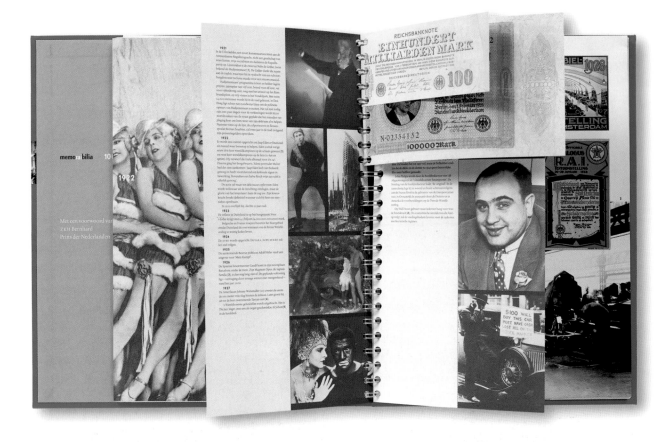

**Project**
Anniversary publication
designed by André
Cremer

**Title**
MemoRAIbilia/100 jaar
AutoRAI

**Client**
Amsterdam RAI
International Exhibition &
Congress Organizers

**Year**
2000

Opposite page:

**Project**
Exhibition poster
designed by Hans
Bockting and Sabine
Reinhardt

**Title**
Baselitz / Reise in die
Niederlande

**Client**
Stedelijk Museum,
Amsterdam

**Year**
1999

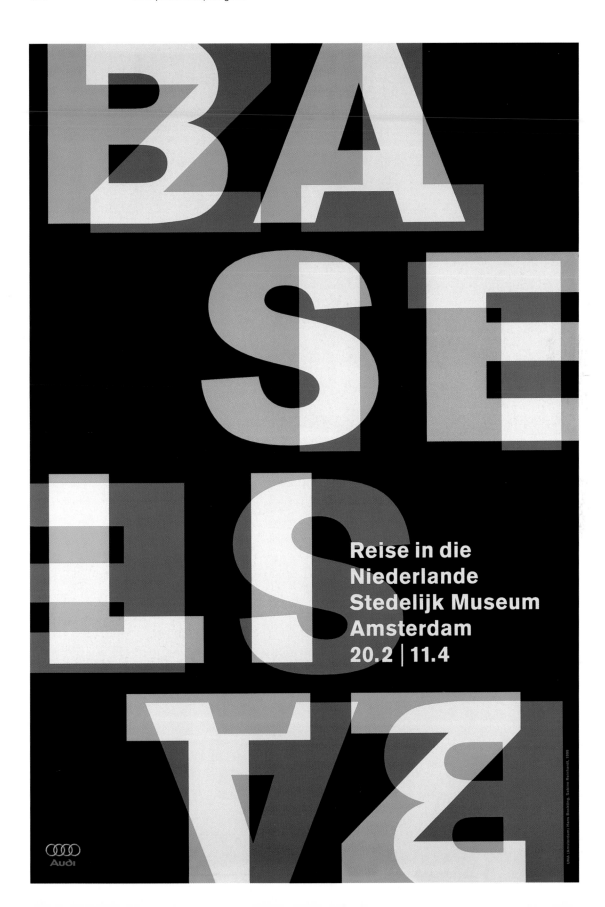

Reise in die
Niederlande
Stedelijk Museum
Amsterdam
20.2 | 11.4

# Martin Venezky

"Design doesn't just straighten and clarify the world, it also reflects the world as it ventures beyond problem solving into process, experiment and discovery."

Opposite page:

**Project**
Magazine

**Title**
Issue 12

**Client**
Speak Magazine

**Year**
1998

SPEAK

filmfiction **conver**musicsationart

# HO-HO

TRADE MARK

november/december **$4.50**98
**$6.75**Canada

"There is joy in clashing consequence. And there is something to be said in favour of the euphoric, bustling world – for the intense, harmonic, ragged, mysterious, teetering messiness of all things. I take pleasure in making something whole out of unexpected parts. And if that pleasure can be transmitted to others, whether they be clients or viewers, then I feel that I have added something of value to the world. Must all design perform a duty beyond itself, or if it is in service, must its message be transparent? Design doesn't just straighten and clarify the world, it also reflects the world. That doesn't mean that design can't help alleviate suffering, or ease someone's life, or point the way for help and support. But design can also decorate, and in so doing, can add to the beauty and mystery of it all. There is an inherent pleasure in making things that survive even for a short while. And I believe there is a growing body of designers whose disenchantment with the machine may return them to the tool."

» Es macht Spaß, das Zusammentreffen gegensätzlicher Wirkungen zu beobachten. Und die euphorische, geschäftige Welt – die intensive, harmonische, zerrissene, mysteriöse, schwankende Unordentlichkeit aller Dinge – hat etwas für sich. Ich schaffe gerne, aus Teilen, die an der jeweiligen Stelle überraschend wirken, ein neues Ganzes. Wenn sich dieses Vergnügen anderen mitteilt – egal ob Kunden oder Betrachtern –, habe ich das Gefühl, einen wertvollen gesellschaftlichen Beitrag geleistet zu haben. Muss jedes Design einen Zweck erfüllen oder eine einleuchtende Botschaft übermitteln? Design rückt die Welt nicht nur zurecht und erklärt sie, sondern reflektiert sie auch. Zwar kann es auch Leiden mindern, den Menschen das Leben erleichtern oder den Weg zu Unterstützung weisen. Aber Design kann auch dekorativ sein und allem so mehr Schönheit und Geheimnis verleihen. Und ich glaube, die Entzauberung der Maschine könnte viele Grafiker wieder zum Handwerkszeug zurückführen.«

« Les résultats contradictoires peuvent engendrer la joie. Notre monde effervescent et euphorique a du bon : on peut apprécier le chaos intense, harmonique, décousu, mystérieux, vacillant de toutes choses. J'éprouve du plaisir à fabriquer un objet à partir d'éléments insolites. Si ce plaisir peut être transmis aux autres, qu'ils soient commanditaires ou spectateurs, j'ai le sentiment d'avoir ajouté un peu de valeur au monde. Le graphisme doit-il nécessairement apporter quelque chose en plus de sa fonction première, ou son message doit-il être transparent ? Il ne se contente pas de redresser et de clarifier le monde, il le reflète. Cela ne signifie pas qu'il ne puisse contribuer à soulager la souffrance, à faciliter la vie d'autrui, ou à indiquer la voie vers l'aide et le soutien. Mais il peut également être décoratif. Il y a un plaisir intrinsèque à réaliser des choses éphémères. Je crois qu'un nombre croissant de créateurs, déçus par la machine, reviendront à l'outil. »

**Martin Venezky**
Appetite Engineers
218 Noe Street
San Francisco
CA 94114
USA

T +1 415 252 8122
F +1 415 252 8142

E venezky@
appetiteengineers.com

www.appetite
engineers.com

**Biography**
1957 Born in Miami Beach, Florida
1975–1979 BA Visual Studies (Distinction), Dartmouth College, Hanover, New Hampshire
1991–1993 MFA Design, Cranbrook Academy of Art, Michigan

**Professional experience**
1993+ Taught at California College of Arts & Crafts, San Francisco
1997 Founded own studio, Appetite Engineers, in San Francisco

**Recent exhibitions**
2000 "Cooper-Hewitt Design Triennial", Cooper Hewitt National Design Museum, New York
2001 "Martin Venezky: Selections from the Permanent Collection of Architecture and Design", solo exhibition, San Francisco Museum of Modern Art; "Byproduct", Southern Exposure Gallery, San Francisco

**Recent awards**
1998 100 Show, American Center for Design (ACD), Chicago; Design Achievement Award, I.D. magazine; Book Design Award, 50 Books 50 Covers, American Institute of Graphic Arts (AIGA)
1999 Self Promotion Best of 1999, How magazine; 100 Show, American Center for Design (ACD), Chicago
2000 Museum Publications Design Competition, American Association of Museums (AMM); Regional Design Annual, Print magazine 2000; Design Annual, Communication Arts (CA); Book Design Award, 50 Books 50 Covers, American Institute of Graphic Arts (AIGA); 100 Show, American Center for Design (ACD), Chicago
2002 Honourable Mention, I.D. magazine Design Annual

**Clients**
American Center for Design
American Institute of Graphic Arts
Blue Note Records
California College of Arts & Crafts
Caroline Herter Studios
CCAC Institute
Chronicle Books
PFAU Architecture
Reebok
Rockport
San Francisco International Gay & Lesbian Film Festival
San Francisco Lesbian, Gay, Bisexual, Transgender Community Center
San Francisco Museum of Modern Art
San Jose Museum of Art
Speak Magazine
Sundance Film Festival

**Project**
Magazine

**Title**
Speak, issue 10

**Client**
Speak magazine

**Year**
1998

**Project**
Magazine

**Title**
Speak, issue 21

**Client**
Speak magazine

**Year**
2001

**Project**
Magazine

**Title**
Open, issue 3

**Client**
San Francisco Museum of
Modern Art

**Year**
2000

**Project**
Magazine

**Title**
Open, issue 2

**Client**
San Francisco Museum of
Modern Art

**Year**
2000

Opposite page:

**Project**
Magazine

**Title**
Open, issue 5

**Client**
San Francisco Museum of
Modern Art

**Year**
2001

# Alberto Vieceli

**"The future of design remains open."**

XENIX FEBRUAR 2001

VITAL UND MELANCHOLISCH.
←DAS DOKUMENTARISCHE WERK
VON HEDDY HONIGMANN

OLIVIER ASSAYAS—CINÉASTE→

BRITISH HUMOUR — SHORTS
DOKFILM AM SONNTAG: THE PUNISHMENT
KINDERKINO AM MITTWOCH: HEXEN AUS DER VORSTADT
NOCTURNE: TEUFEL UND DÄMONEN

**Project**
Poster

**Title**
Xenix Cinema

**Client**
Xenix Cinema, Zurich

**Year**
2001

"For my contribution to this publication I was asked to give my view on the future of graphic design. To be honest, I rarely give any thought to such questions. But I might venture the following. A few years ago, when digital media (web design, CD-ROMs, e-books etc.) were becoming more widespread, it was predicted that this meant the death of print products, and I found myself wondering whether I'd be able to go on designing books for publishers. But reality and consumer habits have shown that developments in the two fields are continuing parallel, and interest in the print media and their design remains an important factor. I have been taking an interest in the SILEX group's marvellous use of sign-like representation."

» Die Anfrage für diese Publikation war mit einer Beschreibung über meine Sicht der Zukunft des Grafikdesigns verbunden – ehrlich gesagt überlege ich mir solche Fragestellungen selten. Aber Folgendes könnte ich hier zum Ausdruck bringen. Als vor einigen Jahren mit der zunehmenden Verbreitung der digitalen Medien (Webdesign, CD-ROMs, elektronische Bücher usw.) das Ende der Printprodukte vorausgesagt wurde, hatte ich Bedenken, ob ich zum Beispiel weiterhin Bücher für Verlage gestalten könnte. Die Realität und die Gewohnheiten der Konsumenten weisen aber auf eine parallele Entwicklung hin und so bleibt das Interesse für das Gedruckte und dessen Gestaltung auch weiterhin von Bedeutung. Mit Interesse verfolge ich die Tendenz zu zeichenhaften Darstellungen, wie sie zum Beispiel die Gruppe SILEX auf wunderbare Weise zeigt.«

« Pour cet ouvrage, on m'a demandé ma vision du futur de la création graphique. Pour être honnête, je me pose rarement ce genre de questions, mais je peux me hasarder aux prévisions suivantes : il y a quelques années, lorsque les moyens numériques (l'infographie, les cédéroms, le livre électronique, etc.) ont commencé à se propager, on a prédit la mort de l'imprimerie et je me suis demandé si je pouvais continuer à concevoir des ouvrages pour des éditeurs. Toutefois, la réalité et les habitudes des consommateurs ont démontré que les deux domaines pouvaient cohabiter et que l'intérêt pour l'objet imprimé et son graphisme demeurait un facteur important. J'ai également commencé à m'intéresser à la merveilleuse utilisation de la représentation sous forme de symboles du groupe SILEX. »

**Alberto Vieceli**
Heinrichstrasse 50
8005 Zurich
Switzerland

T/F +41 1 273 11 52

E a.vieceli@bluewin.ch

**Biography**
1965 Born in Zurich
1988–1992 Graphic Design, School of Design, Zurich

**Professional experience**
1992–1994 Graphic Designer, Polly Bertram & Jul Keyser, Zurich
1995–1996 Graphic Designer, Lars Müller, Baden
1996+ Founded his own graphic design studio, Zurich
2001+ Collaborative ventures with graphic designer Tania Prill, Zurich

**Exhibitions**
1997 "Swiss Design Competition Show" (Eidgenössischer Wettbewerb für Gestaltung), organized by the Swiss Arts Office, Basle
2001 "Swissmade", an exhibition of contemporary Swiss design, Museum of Applied Arts, Cologne

**Awards**
1996 Design Prize, Hochparterre magazine, Zurich
1997 Swiss Book Design Award (x2), Zurich
1998 Swiss Book Design Award, Zurich
1999 Swiss Book Design Award, Zurich
2001 Second Prize (collaboration with Tania Prill), competition to design the Munich Playhouse (Kammerspiele); First Prize (collaboration with Tania Prill), Zurich Office of Structural Engineering's Design Competition

**Clients**
Atlantis Children's Books
Bildwurf Kinodia
Kontrast Publishing
Leukerbad Festival of Literature
Orell Füssli Publishing
Pro Helvetia Film Department
Ricco Bilger Publishing
RiffRaff Cinema
Sec 52 bookstore
The Selection
Skim.com
Tages Anzeiger
Xenix Cinema
Xenix Film Distributors
Zurich Office of Structural Engineering
Zurich / Tangostadt Opera House

**Project**
Flyer

**Title**
The Sixth International
Festival of Literature

**Client**
Festival of Literature,
Leukerbad

**Year**
2001

EINLADUNG

Wir freuen uns, Sie als unseren Special Guest
zur **MAGAZIN-FOTONACHT** einzuladen.

**Freitag, 31. März 2000, um 20.00 Uhr,
im ewz-Unterwerk Selnau, Zürich**

Die MAGAZIN-FOTONACHT präsentiert sich in einem neuen Kleid und
bietet neuen Inhalt: In der schönen Industriehalle des Zürcher
Elektrizitätswerks zeigt DAS MAGAZIN mit der grössten Werkschau der
Schweizer Fotografie, was die aktuelle Schweizer Berufsfotografie zu
bieten hat.

In Kooperation mit der vfg. (vereinigung fotografischer gestalterInnen)
zeigt DAS MAGAZIN «The Selection vfg.», einen Wettbewerb für alle
Schweizer Berufsfotografinnen und -fotografen. Eine internationale
Jury bewertete über 375 eingereichte Arbeiten und wählte die 19
besten des vergangenen Jahres aus. An der MAGAZIN-FOTONACHT
sind diese Arbeiten zum ersten Mal zu sehen. Zusätzlich kürt die Jury
an diesem Abend einen «Primus inter Pares», der mit dem MAGAZIN-
Fotopreis
geehrt wird. Die 19 besten Arbeiten mit über 160 Bildern reisen nach
der Fotonacht als Wanderausstellung durch die ganze Schweiz.

Erleben Sie mit uns die Vernissage dieser eindrücklichen Werkschau
der Schweizer Fotografie. Wir freuen uns, Sie an diesem Abend
begrüssen zu dürfen.

Mit freundlichen Grüssen
DAS MAGAZIN

**Roger Köppel**          **Dietrich Berg**
Chefredaktor            Verlagsleiter

**PROGRAMM MAGAZIN-FOTONACHT**

20.00 Uhr
Türöffnung mit Willkommensdrink

20.30 Uhr
Begrüssung durch Roger Köppel, Chefredaktor DAS MAGAZIN,
Bruno Härismann, Geschäftsleitung ewz, und einem
Geschäftsleitungs-Mitglied der Orange Communications SA

21.15 Uhr
Lucia Degonda zur vfg. Werkschau,
anschliessend Verteilung des MAGAZIN-Fotopreises durch
Thomas Cugini, Jurypräsident, Wendelin Hess, Art Director,
und Tiberio Cardu, Bildredaktor DAS MAGAZIN

21.30 Uhr
Auftritt der Basler Soulstimme Nubya, begleitet
von der Gino Todesco Combo
Bars, Fotostudios und vieles mehr

Durch den Abend führt die «next»-Moderatorin Monika Schärer.

P.S. Senden Sie uns bitte Ihre Anmeldung mit
beiliegender Karte bis spätestens 17. März 2000.

**ANMELDUNG**

Gerne nehme ich die Einladung zur MAGAZIN-FOTONACHT
vom Freitag, 31. März 2000, im ewz-Unterwerk Selnau an.

Bitte senden Sie mir:

☐ ein Ticket
☐ zwei Tickets
☐ Ich habe an diesem Abend bereits etwas anderes vor

Name

Firma

Strasse

PLZ/Ort

Telefon

Anmeldung bitte bis spätestens **17. März 2000** zurück an:
DAS MAGAZIN, Margrit Steiner, Werdstrasse 21, 8021 Zürich
Fax 01/248 41 77 oder per E-Mail: margrit.steiner@tages-
anzeiger.ch

**Project**
Invitation to photographic
exihibition

**Title**
The Selection

**Client**
Tamedia AG, Zurich

**Year**
2000

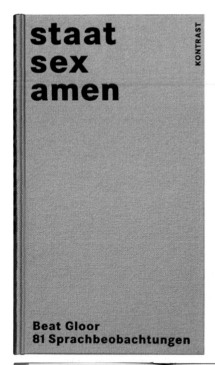

**Project**
Book

**Title**
Staatsexamen

**Client**
Kontrast Publishing,
Zurich

**Year**
1999

# Gunnar Thor Vilhjalmsson

## "Relax and enjoy the ride."

Opposite page:

**Project**
Schedule for Sirkus

**Title**
Boy

**Client**
Sirkus

**Year**
2000

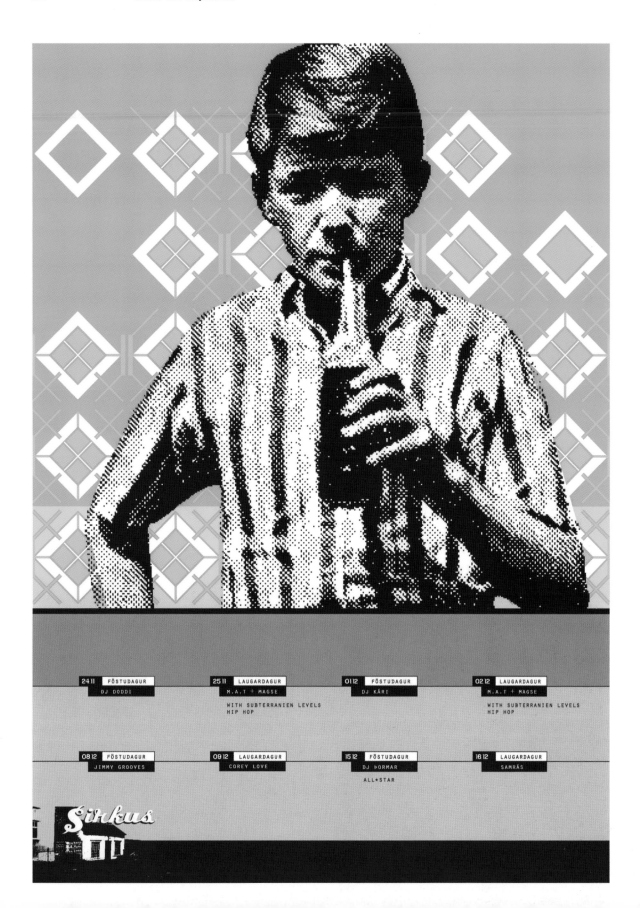

"The future of graphic design will be minimal – not so minimal – definitely not minimal – total chaos. Followed by definitely not minimal – not so minimal – minimal – not so minimal – definitely not minimal – total chaos – ∞"

» Die Zukunft des Grafikdesigns ist minimales – nicht so minimales – definitiv nicht minimales – totales Chaos. Gefolgt von definitiv nicht minimalem – nicht so minimalem – minimalem – nicht so minimalem – definitiv nicht minimalem – totalem Chaos – ∞«

« L'avenir de la création graphique sera minimal – pas si minimal – pas minimal du tout – un chaos total. Suivi par pas du tout minimal – pas si minimal que ça – minimal – pas si minimal que ça – pas du tout minimal – un chaos total – ∞ »

**Gunnar Thor Vilhjalmsson**
Fagrihjalli 26
200 Kopavogur
Iceland

T +35 4 823 2884

E gunnar@deluxe.is

www.deluxe.is

**Biography**
1978 Born in Reykjavík, Iceland
2000–2001 Graphic Design, Iceland Academy of the Arts, Reykjavík

**Professional experience**
1999–2000 Designer, De Luxe, Reykjavík
2001 Designer, Gott Folk McCann-Erickson, Reykjavík
2001 Designer, De Luxe, Reykjavík

**Recent exhibitions**
2000 "Design in Iceland", Reykjavík Art Museum

**Clients**
Mínus – Smekkleysa
Reykjavík Guesthouse
Rymi
Sirkus
Skyjum Ofar
Undirtónar
Unglist

**Project**
Poster for art festival held in Reykjavík for young artists

**Title**
Unglist 1999

**Client**
Unglist

**Year**
1999

**Project**
Poster for the famous Drum&Bass radio show Skyjum Ofar

**Title**
Drumb&BassJungleJazz FunkBreakbeatFusion!

**Client**
Skyjum Ofar

**Year**
2000

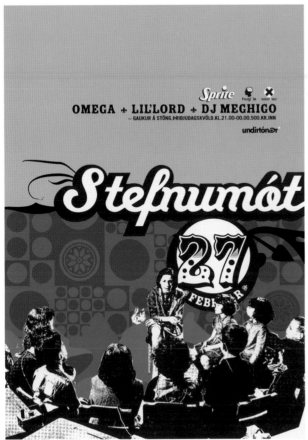

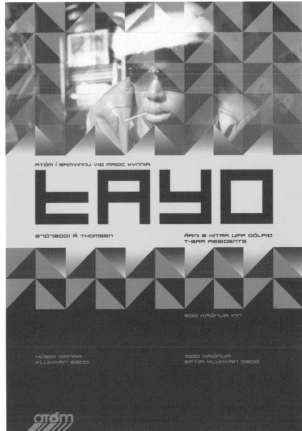

**Project**
Poster for Stefnumot

**Title**
Stefnumot

**Client**
Undirtonar

**Year**
2000

**Project**
Poster for the dub event
Atom

**Title**
Tayo

**Client**
Undirtónar

**Year**
2001

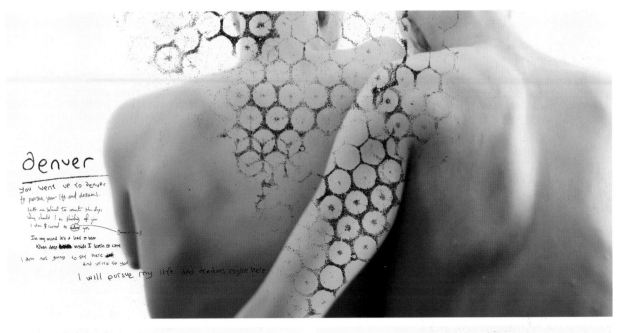

Opposite page:

**Project**
Poster for the film
"Reykjavík Guesthouse –
Rent a Bike"

**Title**
Reykjavík Guesthouse

**Client**
Rettur Dagsins

**Year**
2001

**Project**
CD cover for the hardcore
punkrock band Mínus

**Title**
Jesus Christ Bobby

**Client**
Mínus – Smekkleysa

**Year**
2000

# Why Not Associates

## "Trying to enjoy it as much as possible, while getting paid."

Opposite page:

**Project**
Exhibition poster

**Title**
Malcolm McLaren's
Casino of Authenticity and
Karaoke

**Client**
Malcolm McLaren

**Year**
2001

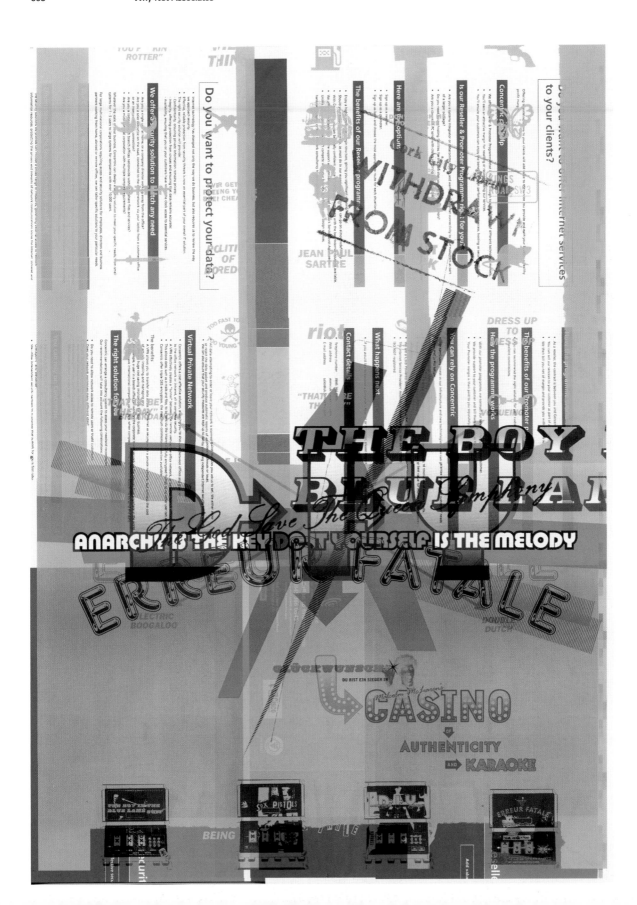

"God only knows"          »Gott allein kennt sie«          «Dieu seul le sait»

**Why Not Associates**
22C Shepherdess Walk
London N1 7LB
UK

T +44 207 253 2244
F +44 207 253 2299

E info@
   whynotassociates.com

www.whynotassociates.com

**Design group history**
1987 Co-founded by
Andy Altmann, David Ellis
and Howard Greenhalgh
in London

**Recent exhibitions**
2001 "City/Mesto", The
Czech Centre, London,
Prague

**Clients**
BBC
Centre Georges
Pompidou
Design Museum
Kobe Fashion Museum
Lincoln Cars
Malcolm McLaren
Nike
Royal Academy of Arts
Royal Mail
Saatchi and Saatchi
The Green Party

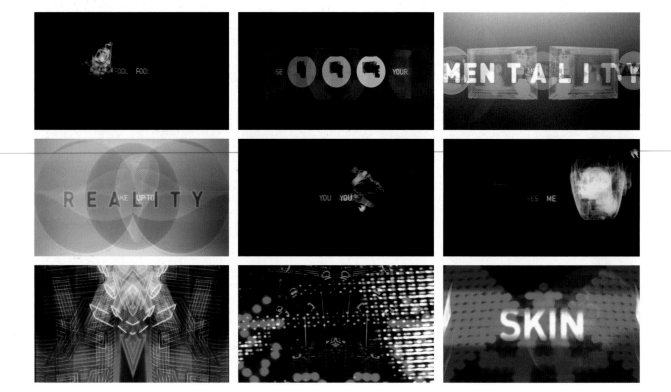

**Project**
Promotional film

**Title**
Under my skin

**Client**
Nick Veasey

**Year**
2001

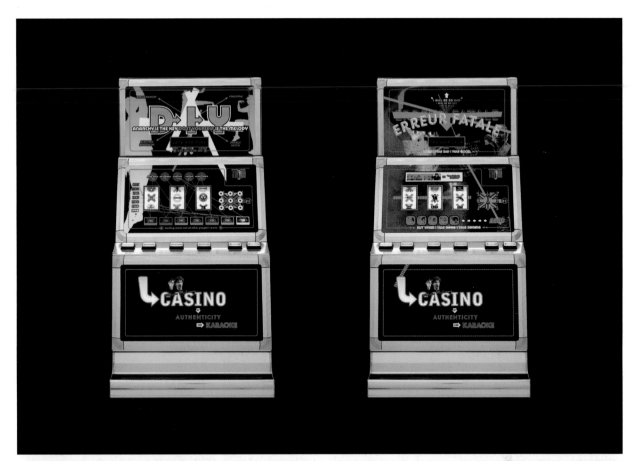

**Project**
Exhibition installation &
T-shirt design

**Title**
Malcolm McLaren's
Casino of Authenticity and
Karaoke

**Client**
Malcolm McLaren

**Year**
2001

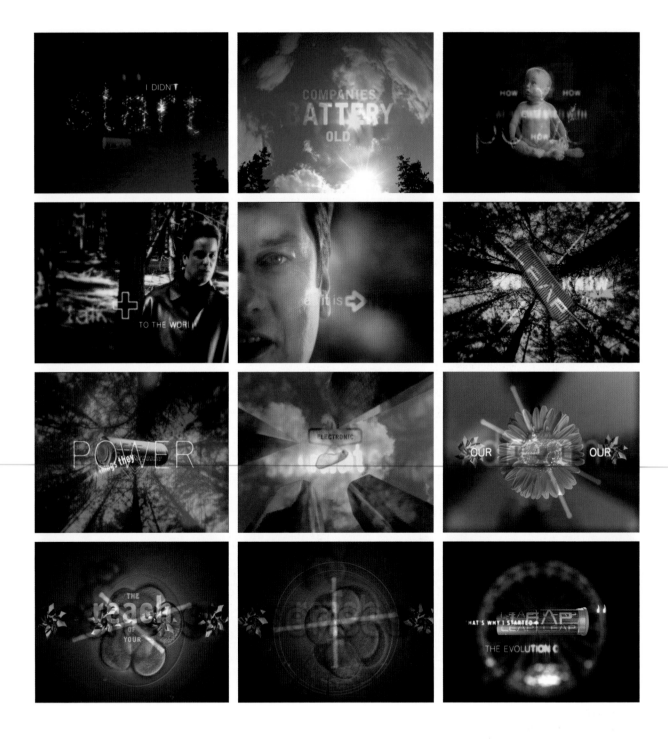

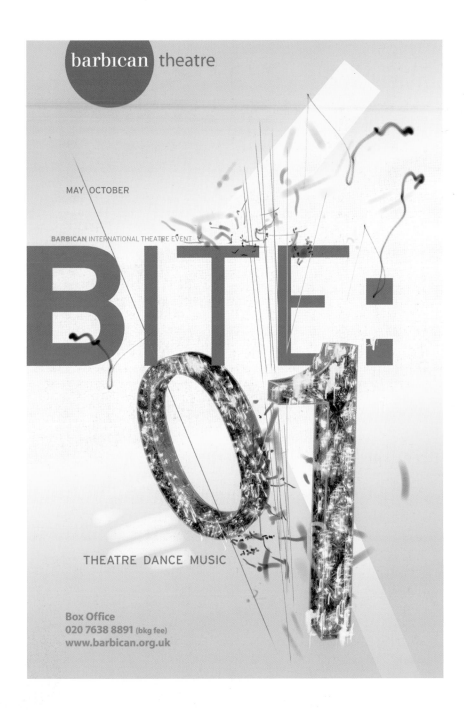

Opposite page:

**Project**
Television commercial

**Title**
Forest

**Client**
Leap Batteries

**Year**
2001

**Project**
Exhibition poster

**Title**
Bite 01

**Client**
The Barbican

**Year**
2001

# Martin Woodtli

## "Search / Find / Reject / Search Again / Find Again / Reject Again"

Opposite page:

**Project**
Poster

**Title**
from door to door

**Client**
Stadtgalerie Bern

**Year**
1999

"What others are doing was always important to me. I want to get an insight into other people's crafts. I want to know, for example, what happens in the printing process, what can be predicted – not just the various printing techniques in theory … The computer is an instrument with a lot of givens. I'm investigating what happens when data is exchanged between programs. I use applications in other ways than originally intended … A lot of people depend far too much on the possibilities of one kind of software and overlook the fact that the apparently zany effects tend to look as if they had been reprogrammed. I combine older and newer versions of programmes, because I've discovered which functions produce errors. While I'm working, I'm always searching for a point at which my preconceptions get shattered … I've hardly ever made posters, it's not my thing. I want people to break down their preconceptions, to learn to look and to read … I see myself somewhere between applied graphics and art. My things communicate content mostly based on a client's brief, but always in their own language … I don't like theoretical models or cornerstones, which already provide a system of co-ordinates for an interpretation."

» Es war mir immer wichtig, was andere machen. Ich will Einblick gewinnen in andere Berufsfelder. Ich will zum Beispiel wissen, was beim Druck passiert, was dabei vorhersehbar ist, und die verschiedenen Drucktechniken nicht nur theoretisch kennen. Der Computer ist ein Instrument mit sehr vielen Vorgaben. Ich untersuche, was bei der Datenübertragung zwischen verschiedenen Programmen passiert. Ich nutze Anwendungen anders als vorgesehen. Viele Leute verlassen sich viel zu sehr auf ein einziges Programm und übersehen dabei, dass die damit erzeugten scheinbar schrägen Effekte nur wie ein bisschen umprogrammiert wirken. Ich kombiniere ältere und neuere Programmversionen, weil ich gemerkt habe, welche Funktionen Fehler produzieren. Bei der Arbeit suche ich immer nach dem Punkt, an dem meine Ausgangskonzeption zunichte gemacht wird. Ich habe kaum je einmal ein Plakat gemacht, das ist einfach nicht mein Ding. Ich will, dass die Menschen ihre vorgefassten Meinungen aufgeben, richtig hinschauen und lesen lernen. Ich sehe mich selbst irgendwo zwischen Gebrauchsgrafik und Kunst. Meine Projekte gehen bei der Vermittlung der Inhalte zwar größtenteils von den Vorgaben des Kunden aus, haben aber immer eine eigene Sprache. Ich mag keine theoretischen Modelle oder Eckdaten, die schon ein ganzes Koordinatensystem für die Interpretation vorgeben.«

« J'ai toujours été attentif au travail des autres. Je veux connaître la manière de procéder de mes confrères. Je veux savoir, par exemple, comment se déroule l'impression, ce qui est prévisible, pas uniquement la théorie des différentes techniques… L'ordinateur est un instrument avec beaucoup d'éléments préétablis. J'étudie ce qui se passe lorsque les données passent d'un programme à l'autre. Je détourne l'utilisation première des applications pour les utiliser à ma manière… Nombre de gens dépendent beaucoup trop des possibilités d'un type de logiciel et oublient que leurs effets apparemment aléatoires finissent par avoir l'air programmé. J'associe les versions nouvelles et anciennes des programmes parce que j'ai découvert quelles fonctions produisent des erreurs. Tout en travaillant, je guette toujours le moment où mes idées reçues s'effondreront en miettes… Je ne réalise presque jamais d'affiches, ce n'est pas mon truc. Je veux que les gens se débarrassent de leurs préjugés, qu'ils apprennent à regarder et à lire… Je me situe quelque part entre le graphisme appliqué et l'art. Mes objets communiquent un contenu basé principalement sur les directives du client mais avec un langage qui leur est propre… Je n'aime pas trop les modèles théoriques ni les principes fondamentaux: ils fournissent à l'avance un système de coordonnées pour une interprétation. »

**Martin Woodtli**
Schöneggstrasse 5
8004 Zürich
Switzerland

T +41 1 291 24 19
F +41 1 291 24 29

E martin@woodt.li

www.woodt.li

**Biography**
1971 Born in Berne, Switzerland
1990–1995 Graphic Design, School of Design, Berne
1996–1998 Visual Communication, Academy of Art and Design, Zurich

**Professional experience**
1998–1999 Worked in New York with David Carson and Stefan Sagmeister
1999 Founded own studio in Zurich
2000 Became a member of AGI
2001 First book about work published

**Recent awards**
1999 Swiss Federal Design Prize
2000 "The I.D. Forty", I.D. magazine, USA
2001 "IDEA 285", Japan
2001 The most beautiful Swiss books "Book of the Jury"

**Project**
Flyers for an art gallery

**Title**
Various

**Client**
Stadtgalerie Berne

**Year**
2001

teil 01 ⊗ city tracks ⊗ 05.08 - 22.09          teil 02 ⊗ public messages ⊗ 23.09 - 03.11

wer ist die öffentlichkeit?
wo ist die kunst?
wie treffen sie sich?

beiträge von >>> Steven Bachelder (Stockholm) >>> Vera Bourgeois (Frankfurt) >>> Ruth Buck (Basel) >>> Christoph Büchel (Basel/Berlin) >>> Daniele Buetti (Zür
(Kopenhagen) >>> Jomini/Reist (Bern) >>> Nic Hess (Zürich) >>> Mathilde ter Heijne (Berlin) >>> Anne Hody (Basel) >>> Bernhard Huwiler (Bern) >>> JMARRABEUF (Be
Chantal Michel (Thun) >>> Muda Mathis (Basel) >>> Marc Mouci (Bern) >>> Regina Möller (Berlin) >>> Nullkunst (CH) >>> Daniel Pflumm (Berlin) >>> Renée Kool (Am
Michael Stauffer (Bern) >>> Stöckerselig (Basel) >>> S.U.S.I. mit Peter Brand, Martin Guldimann u. Andrea Loux (Zürich/Bern) >>> Sybilla Walpen (Bern) >>> Markus

**Project**
Flyer for an art event

**Title**
City Tracks

**Client**
On the Spot

**Year**
2000

teil 03 ⊗ secret spots ⊗ 04.11 - 25.11

kunst und diverse öffentlichkeiten
work in progress 05.08 - 25.11

>>> Olaf Breuning [Zürich] >>> Dias/Riedweg [Basel] >>> Andrea Fraser [New York] >>> Peter Friedl [Berlin/Basel] >>> Heinrich Gartentor [Thun] >>> Jens Haaning >>> Daniela Keiser [Zürich] >>> San Keller [Zürich] >>> Daniel Knorr [Berlin] >>> Jan Kopp [Paris/New York] >>> Köppl/Zacek [Zürich] >>> Heinrich Lüber [Basel] >>> rdam] >>> Hinrichs Sachs [Basel] >>> Karoline Schreiber [Zürich] >>> Markus Schwander [Basel] >>> Sexismus Productions [Zürich] >>> Nika Spalinger [Bern] >>> tzel [Zürich] >>> Philippe Winniger [Zürich] >>> Annie Wu [Zürich] >>> Brigitte Zieger [Paris]

# Worthington Design

## "There are many correct answers, but they are all smart and sexy."

Opposite page:

**Project**
Poster

**Title**
Teatro Amazonas

**Client**
Sharon Lockhart

**Year**
2001

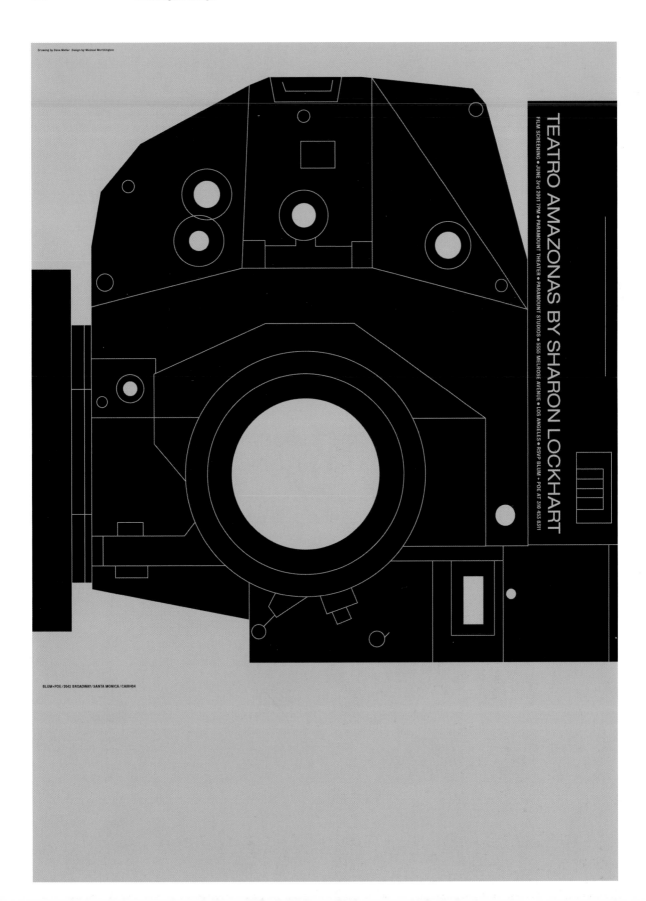

Drawing by Dave Muller  Design by Michael Worthington

TEATRO AMAZONAS BY SHARON LOCKHART

FILM SCREENING • JUNE 3rd 2001 7PM • PARAMOUNT THEATER • PARAMOUNT STUDIOS • 5555 MELROSE AVENUE • LOS ANGELES • RSVP BLUM • POE AT 310 453 8311

BLUM+POE/2042 BROADWAY/SANTA MONICA/CA90404

"The future is rarely true to that which is predicted of it. There will either be massive unexpected changes of an unforeseen nature, or disappointment at the futuristic promises of tomorrow that go unfulfilled. Graphic design could disappear or become the most important cultural practice – there is no point worrying about the future of graphic design – whatever happens designers will adapt and change and always find something and some way to make design."

» Die Zukunft hält sich selten an die Prognosen. Entweder erleben wir gewaltige unerwartete Veränderungen von unvorhersehbarer Art oder aber Enttäuschung über unerfüllte Versprechungen. Das Grafikdesign könnte in Zukunft ganz verschwinden oder zur wichtigsten Form kultureller Praxis werden. Es ist sinnlos, sich über die Zukunft der Gebrauchsgrafik Sorgen zu machen. Was auch immer geschieht, die Grafiker werden sich anpassen, ändern und immer einen Weg und eine Möglichkeit finden, etwas zu gestalten.«

« Le futur correspond rarement à ce qu'on avait prédit. Soit on assistera à des changements massifs et inattendus d'une nature imprévue, soit on sera déçu devant des promesses futuristes non tenues. La création graphique pourrait disparaître ou devenir la pratique culturelle la plus répandue. Il ne sert à rien de s'inquiéter sur son avenir, quoi qu'il arrive, les créateurs s'adapteront, changeront et trouveront toujours quelque chose et un moyen de créer. »

**Michael Worthington**
California Institute of the Arts
24700 McBean Parkway
Valencia
CA 91355
USA

T +1 323 934 3691

E maxfish@attbi.com

**Biography**
1966 Born in Cornwall, England
1991 BA (Hons) Graphic Design, Central St Martins College of Art and Design, London
1995 MFA Graphic Design, California Institute of the Arts, Valencia

**Professional experience**
1996+ Faculty CalArts Design Programme, Valencia, California
1998+ Programme Co-Director, CalArts Design Programme, Valencia, California

**Recent exhibitions**
2002 "Take It It's Yours" (part of the COLA fellowship show), Japanese American National Museum, Los Angeles

**Recent awards**
1998 Medal Winner, Art Directors Club 77th Annual; 100 Show, American Center for Design
1999 100 Show, American Center for Design
2000 50 books, 50 covers, AIGA
2001 Recipient of COLA Individual Artist Fellowship 2001–2002, Los Angeles; I.D. magazine 47th Annual Design Review

**Clients**
CalArts
Henry Art Gallery, Seattle
LaEyeworks
MAK Center for Art and Architecture
MOCA Los Angeles
Sci-Arc
The Broad Foundation
Violette Editions

**Project**
Poster

**Title**
Adversary poster

**Client**
Ken Fitzgerald

**Year**
2001

Opposite page:

**Project**
Book

**Title**
Creative Impulse 6

**Client**
TBP

**Year**
2002

Opposite page:

**Project**
Book

**Title**
Restart: New systems in
Graphic Design, spreads

**Client**
Self-published

**Year**
2001

**Project**
Plastic inflatable poster

**Title**
Plastic inflatable poster

**Client**
Sci-Arc

**Year**
2000

# Yacht

## "To learn and be better"

Opposite page:

**Project**
12" Vinyl sleeve

**Title**
TLM Electrastars 77

**Client**
Hydrogen Dukebox

**Year**
2001

TLM
ELECTRASTARS

A01 Electra Electra   B01 Everything But The Sun   Duke2 TSW   www.hydrogendukebox.com
A02 Dub Machine   B02 Hypnotica   All Songs Composed by Kort & Co.   P&C Hydrogen Dukebox Records Ltd
    *Experiment Remix*   *Electrad by Numbers Mix*   All Tracks Published by Copyright   2001 Manufactured in England
A03 Flip Backwards   B03 Shaq Slab Remix   Control / Hydrogen Dukebox /   "What is this life all about ... Music?"
A04 Inside My Soul Is   B04 Dragonflymania   Reverb Music
    Burning With You   *Paul Flosgard Remix*   A Yacht Associates Design   HYDROGEN DUKEBOX RECORDS

77

"To learn and be better."        » Dazulernen und besser werden.«        « Apprendre et s'améliorer. »

**Yacht Associates**
Unit 7
Stephendale Yard
Stephendale Road
Fulham
London SW6 2LR
UK

T +44 20 7371 8788
F +44 20 7371 8766

E info@
  yachtassociates.com

**Design group history**
1996 Co-founded
by Richard Bull and
Christopher Steven
Thomson in Kensington,
London

**Founders' biographies**
Richard Bull
1968 Born in London
1987–1989 BTEC Art &
Design, Chelsea School
of Art, London
1989–1992 BA (Hons)
Graphic Design, Chelsea
School of Art, London
Christopher Steven
Thomson
1969 Born in Bury St
Edmunds, England
1987–1989 HND Graphic
Design, Salford College
of Technology

**Recent exhibitions**
1998 Opening Installation,
Urban Outfitters, London
1999 "Furniture Design
Exhibition", sponsored
by Sony, Haus, London
2001 "Five Year Retro-
spective", Waterstones
Piccadilly, London

**Recent awards**
2000 Best Album Design,
Music Week Awards
2001 Best Photography,
Music Week Awards;
Editorial & Book Design,
D&AD

**Clients**
GettyStone
Millennium Images
Next Level Magazine
Parlophone Records
Penguin Books
Sony
Toshiba EMI
United Business Media
Urban Outfitters
Warwick Worldwide

**Project**
Magazine commission

**Title**
2lb's of Pix'n'Mix

**Client**
Selfish Magazine, Japan

**Year**
2001

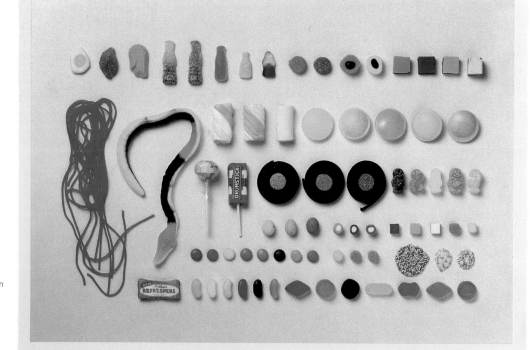

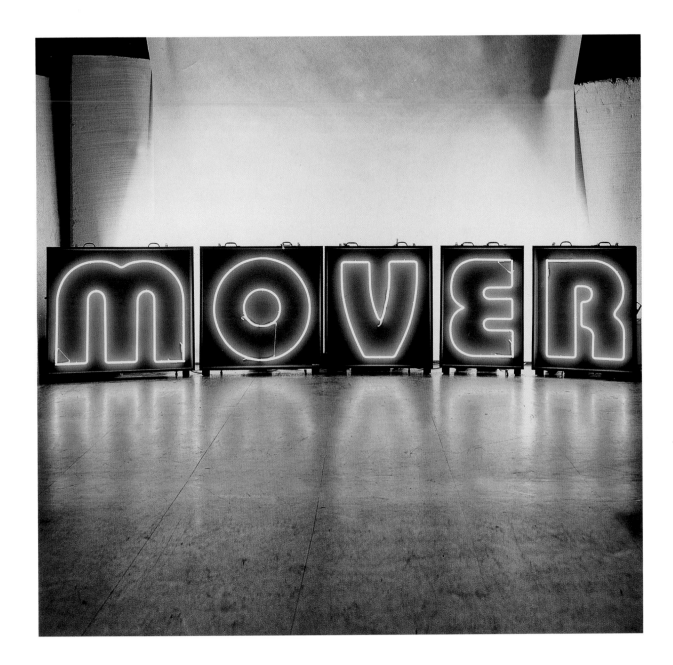

**Project**
Album sleeve

**Title**
Mover

**Client**
A&M Records

**Year**
1998

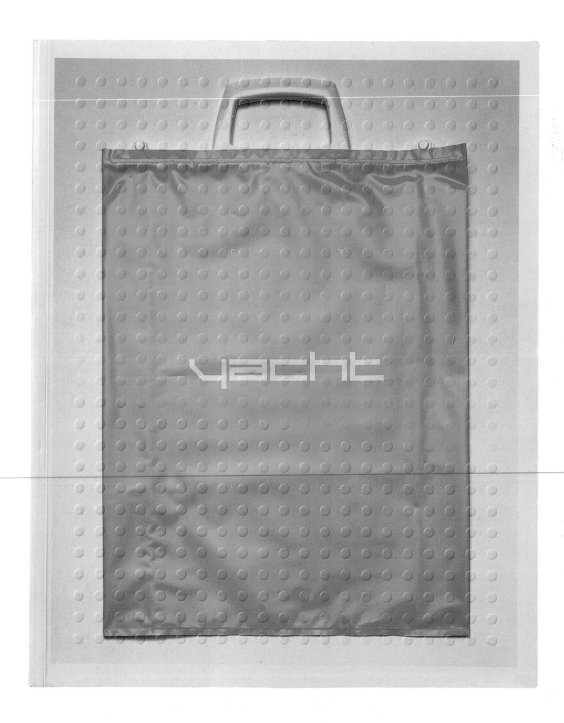

**Project**
Book

**Title**
Yacht

**Client**
Yacht Associates / DGV

**Year**
2000

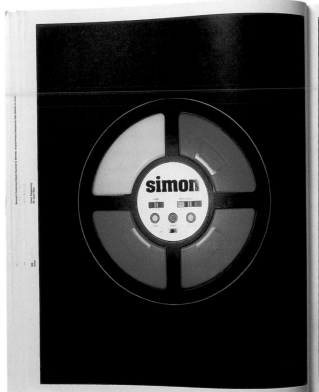

# Tadanori Yokoo

## "It is just produced from inside of me."

Opposite page:

**Project**
Poster for the PERUSONA
exhibition

**Title**
A Ballad Dedicated to the
Small Finger Cutting
Ceremony

**Client**
Yakuza Shobo

**Year**
1966

"Graphic design was the main aspect of my work until 1980. Around this time, however, I expanded my agenda to include painting. Although I see some differences between fine art and graphic work, it is hard to draw a boundary. After all, they are both created by one individual – me – and drawn from the same aesthetic reservoir. I intend to keep producing work that crosses these genres."

» Bis 1980 war ich vor allem als Grafik-designerin tätig. Etwa um die Zeit fing ich auch mit dem Malen an. Obwohl ich sehr wohl Unterschiede zwischen bildender und angewandter Kunst erkenne, ist es schwer, sie von-einander abzugrenzen. Schließlich werden beide von ein und der selben Person geschaffen – nämlich von mir – und werden aus der gleichen ästhetischen Quelle gespeist. Ich habe vor, auch weiterhin fachüber-greifende Werke zu schaffen.«

«Jusqu'en 1980, le graphisme consti-tuait l'aspect principal de mon travail. Vers cette époque, j'ai élargi mes activités à la peinture. Bien que je constate des différences entre les beaux-arts et le graphisme, j'ai du mal à délimiter une frontière. Après tout, tous deux sont créés par un individu (moi) puisant dans un même réservoir esthétique. Je compte continuer à travailler en allant et venant entre ces genres. »

**Tadanori Yokoo**
4–19–7 Seijyo
Setagaya-ku
Tokyo157–0066
Japan

T +81 3 3482 2826
F +81 3 3482 2451

E k-yokoo@s2.ocv.ne.jp

www.tadanoriyokoo.com

**Biography**
1936 Born in Nishiwaki City, Hyogo Prefecture, Japan
1955 Nishiwaki Hyogo Prefecture high school Self-taught

**Recent exhibitions**
1999 Solo exhibition, The Museum of Modern Art, Wakayama; Poster Design of New Japan, Chicago Public Library, Chicago; solo exhibition, Telecommunications Museum, Tokyo; "Ground Zero Japan", Contempo-rary Art Gallery, Art Tower Mito, Japan
2000 "Seven Banzais: Followers of Taro Oka-moto Who Don't Pursue His Path", Taro Okamoto Museum of Art, Kawasa-ki; solo exhibition, Station Art Museum, Kyoto and other venues; "MOMA Highlights", The Museum of Modern Art, New York; "Modern Contemporary", The Museum of Modern Art, New York
2001 Solo exhibition, Loyola University, New Orleans; "Century City: Fine Arts and Culture of Contemporary Cities", Tate Modern, London; solo exhibition, Hara Museum of Contempo-rary Art, Tokyo
2002 "The International Posters Exhibition 2002", Museum of Huis ten Bosch, Nagasaki; "Pop Pop Pop", Museum of Modern Art, Ibaraki; "Screen Memories", Contemporary Art Gallery, Art Tower Mito, Japan; solo exhibition, Museum of Contemporary Art, Tokyo; solo exhibition, Museum of Contempo-rary Art, Hiroshima

**Recent awards**
1999 Silver Award, New York Art Directors Club
2000 Elected to the Hall of Fame, New York Art Directors Club
2001 Medal with Purple Ribbon, the Japanese Government
2002 Merit Award, New York Art Directors Club; Icograda Award, 20th Brno International Biennial of Graphic Design

Opposite page:

**Project**
Poster

**Title**
The 750 Year Anniversary of Nichirenn shu Buddhism.2002.4.28

**Client**
Nichirenn shu Newspaper Company

**Year**
2001

**Project**
Magazine

**Title**
Brutus

**Client**
Magazine House Ltd.

**Year**
1999

Opposite page:

**Project**
Poster

**Title**
Koshimaki-Osen

**Client**
Gekidan Jokyo Gekijo

**Year**
1966

Credits

We are immensely grateful to those individuals, studios and institutions that have allowed us to reproduce images. The publisher has endeavoured to respect the rights of third parties and if any such rights have been overlooked in individual cases, the mistake will be correspondingly amended where possible. The majority of historic images were sourced from the editors' personal design archives.

| | |
|---|---|
| 4-5 | © Jonathan Barnbrook / Barnbrook Studios, London |
| 10-11 | © François Chalet, Paris |
| 13 | © Why Not Associates, London |
| 14 | © Ed Fella, Valencia, California |
| 16 | © Research Studios, London |
| 17-20 | Fiell International Limited, London |
| 21 | © Stedelijk Museum, Amsterdam |
| 22-26 | Fiell International Limited, London |
| 27 right | © Wolfgang Weingart, Basel |
| 28 | Fiell International Limited, London |
| 29 | © Jamie Reid, England |
| 30 | © April Greiman / Made in Space, Los Angeles |
| 31 | © Jan van Toorn, Amsterdam |
| 32 | © Emigre Inc, Sacramento, California |
| 33 left | © M/M (Paris), Paris |
| 33 right | © UNA (London) designers / Eye magazine, London |
| 34 | © Jonathan Barnbrook / Barnbrook Studios, London |
| 35 left | © Mevis & van Deursen, Amsterdam |
| 35 right | © Adbusters, Vancouver |
| 36 left | © Inkahoots, Brisbane |
| 36/37 | © UNA (London) designers, London |
| 37 right | © Banksy / Adbusters (London / Vancouver) |
| 39-43 | © Aboud Sodano, London |
| 45-49 | © Acne, Stockholm |
| 51-55 | © Alexander Boxill, London |
| 57-61 | © Ames Design, Seattle |
| 63-67 | © Peter Anderson / Interfield Design, London |
| 69-73 | © Philippe Apeloig, Paris |
| 75-79 | © August Media, London |
| 81-85 | © Jonathan Barnbrook / Barnbrook Studios, London |
| 87-91 | © Ruedi Baur / Intégral, Paris |
| 93-97 | © Jop van Bennekom, Amsterdam |
| 99-103 | © Irma Boom / Irma Boom Office, Amsterdam |
| 105-109 | © Bump, London |
| 111-115 | © Büro Destruct, Berne |
| 117-121 | © büro für form, Munich |
| 123-127 | © François Chalet, Paris |
| 129-133 | © Warren Corbitt, New York |
| 135-139 | © Cyan, Berlin |
| 141-145 | © DED Associates, Sheffield |
| 147-151 | © Delaware, Tokyo |
| 153-157 | © Dextro |
| 159-163 | © Daniel Eatock / Foundation 33, London |
| 165-169 | © Paul Elliman, London |
| 171-175 | © Experimental Jetset, Amsterdam |
| 177-181 | © Extra Design, Sapporo |
| 183-187 | © Farrow Design, London |
| 189-193 | © Fellow Designers, Stockholm |
| 195-199 | © Flúor, Lisbon |
| 201-205 | © Fold 7, London |
| 207-211 | © Dávid Földvári, London |
| 213-217 | © Form, London |
| 219-223 | © Tina Frank, Vienna |
| 225-229 | © Vince Frost, London |
| 231-235 | © Gabor Palotai Design, Stockholm |
| 237-241 | © James Goggin, London |
| 243-247 | © April Greiman / Made in Space, Los Angeles |
| 249-253 | © Fernando Gutiérrez / Pentagram Design Ltd., London |
| 255-259 | © Ippei Gyoubu, Osaka |
| 261-265 | © Hahn Smith Design Inc., Toronto |
| 267-268 | © Fons M. Hickmann / Fons Hickmann m23, Berlin |
| 269 | © Matthias Gephart, Fons M. Hickmann |
| 270-271 | © Fons M. Hickmann / Fons Hickmann m23, Berlin |
| 273-277 | © Kim Hiorthøy, Oslo |
| 279 | © Hi-Res!, London |
| 281 | © LeAnne Gaynor, Santa Monica |
| 282-283 | © Hi-Res!, London |
| 285-289 | © Angus Hyland / Pentagram Design Ltd., London |
| 291-295 | © Hideki Inaba, Tokyo |
| 297-301 | © Inkahoots, Brisbane |
| 303-307 | © Intro, London |
| 309-313 | © Gila Kaplan, Tel Aviv |
| 315-319 | © KesselsKramer, Amsterdam |
| 321-325 | © Scott King / Magnani, London |
| 327-331 | © Jeff Kleinsmith, Seattle |
| 333-337 | © KM7, Frankfurt/Main |
| 339-343 | © Christian Küsters / CHK Design, London |
| 345-349 | © Lateral Net Ltd., London |
| 351-355 | © Golan Levin, Brooklyn |
| 357-361 | © Lust, The Hague |
| 363-367 | © M.A.D., Sausalito |
| 369-373 | © Gudmundur Oddur Magnússon, Reykjavík |
| 375-379 | © Karel Martens, Hoog-Keppel |
| 381-385 | © Me Company, London |
| 387-391 | © MetaDesign, Berlin |
| 393-397 | © Mevis & van Deursen, Amsterdam |
| 398 | Quote originally appeared in: Rick Poynor, "Obey the Giant: Life in the Image World", August/Birkhäuser, 2001 |
| 399-403 | © Miles Murray Sorrell / FUEL, London |
| 405-409 | © J. Abbott Miller / Pentagram Design, New York |
| 411-415 | © Michael Amzalag / M/M (Paris), Paris |
| 417-421 | © Mutabor, Hamburg |
| 423-427 | © Hideki Nakajima, Tokyo |
| 429-433 | © Norm, Zurich |
| 435-439 | © Martijn Oostra, Amsterdam |
| 441-445 | © Optimo, Geneva |
| 447-551 | © Matt Owens, New York |
| 453-457 | © Mirco Pasqualini, Veneto |
| 459-463 | © Katrin Petursdottir, Reykjavík |
| 465-469 | © Posttool, San Francisco |
| 471-475 | © Research Studios, London |
| 477-481 | © Rinzen, Brisbane |
| 483-487 | © Bernado Rivavelarde, Madrid |
| 489-493 | © Stefan Sagmeister, New York |
| 495-499 | © Peter Saville / Saville Associates, London |
| 501-505 | © Walter Schönauer, Berlin |
| 507-511 | © Pierre di Sciullo, Gretz Armainvilliers |
| 513-517 | © Carlos Segura, Chicago |
| 519-523 | © Spin, London |
| 525-529 | © State, London |
| 531-535 | © Suburbia, London |
| 537-541 | © Surface, Frankfurt/Main |
| 543-547 | © Sweden Graphics, Stockholm |
| 549-553 | © Felipe Taborda, Rio de Janeiro |
| 555-559 | © ten_do_ten, Tokyo |
| 561-565 | © The Designers Republic, Sheffield |
| 567-571 | © Andrea Tinnes / DASDECK, Berlin |
| 573-577 | © Jan van Toorn, Amsterdam |
| 579-583 | © Tycoon Graphics, Tokyo |
| 585-589 | © UNA (Amsterdam) designers, Amsterdam |
| 591-595 | © Martin Venezky, San Francisco |
| 597-601 | © Alberto Vieceli, Zurich |
| 603-607 | © Gunnar Thor Vilhjalmsson, Kopavogur, Iceland |
| 609-613 | © Why Not Associates, London |
| 615-619 | © Martin Woodtli, Zurich |
| 621-625 | © Worthington Design, Valencia, California |
| 627-631 | © Yacht Associates, London |
| 633-637 | © Tadanori Yokoo, Tokyo |

# Future tense
## Designers ahead of time

How do today's brightest and best designers see the future of design? What are the defining elements of form, function, and aesthetics at the turn of the millennium? In response to these burning questions, we've put together *the* definitive book on cutting-edge product design, furniture, ceramics, glassware, and textiles. Including a cross section of the world's most influential designers, from superstars to newcomers, and stunning images of their most progressive work, *Designing the 21st Century* is like no other book of its kind. Making it especially unique are the contributions from all designers featured: each sent us his or her answer to the question, "What is your vision for the future

of design?" Crack the book to see how their revolutionary ways of thinking take shape. The experimental concepts and predictions featured here will serve as an important reference for generations to come—when researchers in 2101 want to see what was going on in design a century earlier, this is the book they'll turn to.

The authors: **Charlotte J. Fiell** studied at the British Institute, Florence, and at Camberwell School of Arts & Crafts, London, where she received a BA (Hons) in the History of Drawing and Printmaking with Material Science. She later trained with Sotheby's

Educational Studies, also in London. **Peter M. Fiell** trained with Sotheby's Educational Studies in London and later received an MA in Design Studies from Central St Martins College of Art & Design, London. Together, the Fiells run a design consultancy in London specializing in the sale, acquisition, study and promotion of design artifacts. They have lectured widely, curated a number of exhibitions and written numerous articles and books on design and designers, including TASCHEN's *Decorative Art series, Charles Rennie Mackintosh, William Morris, 1000 Chairs, Design of the 20th Century, Industrial Design A–Z,* and *Scandinavian Design.*

**DESIGNING THE 21ST CENTURY**
Ed. Charlotte & Peter Fiell / Flexi-cover, format: 19.6 x 24.9 cm
(7.7 x 9.8 in.), 576 pp. / available in INT, IEP
ONLY € 29.99 / $ 39.99
£ 19.99 / ¥ 4.900

© Vent Design

**Designers include:** Werner Aisslinger, Ron Arad, Jane Atfield, Shin & Tomoko Azumi, Babylon Design, Bartoli Design, Sebastian Bergne, Bibi Gutjahr, Riccardo Blumer, Jonas Bohlin, Ronan and Erwan Bouroullec, Julian Brown, Debbie Jane Buchan, Büro für Form, Humberto and Fernando Campana, Antonio Citterio, Björn Dahlström, Emmanuel Dietrich, Dumoffice, James Dyson, ECCO Design, El Ultimo Grito, Elephant Design, Naoto Fukasawa, Jean-Marc Gady, Stefano Giovannoni, Konstantin Grcic, Sam Hecht, Keith Helfet, Matthew Hilton, Geoff Hollington, Isao Hosoe, Inflate, Massimo Iosa Ghini, James Irvine, Jonathan Ive, IXI, JAM Design, Hella Jongerius, Kazuo Kawasaki, King–Miranda, Tom Kirk, Ubald Klug, Harri Koskinen, Kristina Lassus, Roberto Lazzeroni, Isabelle Leijn, Arik Levy, Piero Lissoni, Ross Lovegrove, Lunar Design, Enzo Mari, Michael Marriott, Sharon Marston, Ingo Maurer, J Mays, Alberto Meda, Jasper Morrison, Pascal Mourgue, N2 Design, Marc Newson, PearsonLloyd, Stephen Peart, Jorge Pensi, Roberto Pezzetta, Christophe Pillet, RADI Designers, Ingegerd Råman, Karim Rashid, Prospero Rasulo, Rivieran Design, Timo Salli, Thomas Sandell, Marta Sansoni, Santos & Adolfsdóttir, Schamburg + Alvisse, Peter Schreyer, Jerszy Seymour, Seymour Powell, Michael Sodeau, Sony Design Center, SowdenDesign, Philippe Starck, Reiko Sudo, Ilkka Suppanen, Sydney 621, Martin Szekely, Tangerine, Matteo Thun, TKO, Kazuhiko Tomita, Arnout Visser, Jean-Pierre Vitrac, Pia Wallén, Marcel Wanders, Robert Wettstein, Kazuhiro Yamanaka, Helen Yardley, Yellow Diva, Michael Young

# Scandtastic!

## From Aalto to Wirkkala, more than 200 outstanding Scandinavian designers of the past century

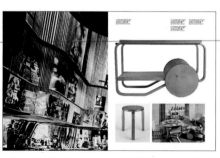

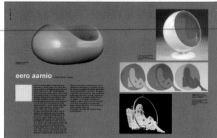

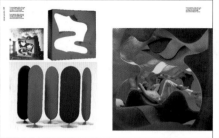

Scandinavians are exceptionally gifted in design. They are world famous for their inimitable, democratic designs which bridge the gap between crafts and industrial production. The marriage of beautiful, organic forms with everyday functionality is one of the primary strengths of Scandinavian design and one of the reasons why Scandinavian creations are so cherished and sought after. This all-you-need guide includes a detailed look at Scandinavian furniture, glass, ceramics, textiles, jewelry, metalware and industrial design from 1900 to the present day, with in-depth entries on over 200 designers and designled companies, plus essays on the similarities and differences in approach between Norway, Sweden, Finland, Iceland, and Denmark. Also included is a list of important design-related places to visit for readers planning to travel to Scandinavia.

The authors: **Charlotte J. Fiell** studied at the British Institute, Florence, and at Camberwell School of Arts & Crafts, London, where she received a BA (Hons) in the History of Drawing and Printmaking with Material Science. She later trained with Sotheby's Educational Studies, also in London. **Peter M. Fiell** trained with Sotheby's Educational Studies in London and later received an MA in Design Studies from Central St Martins College of Art & Design, London. Together, the Fiells run a design consultancy in London specializing in the sale, acquisition, study and promotion of design artifacts. They have lectured widely, curated a number of exhibitions and written numerous articles and books on design and designers, including TASCHEN's *Decorative Art series*, *Charles Rennie Mackintosh*, *William Morris*, *1000 Chairs*,

*Design of the 20th Century*, *Industrial Design A-Z*, and *Designing the 21st Century*.

**SCANDINAVIAN DESIGN**
Charlotte & Peter Fiell / Flexi-cover, format: 19.6 x 25.2 cm
(7.6 x 9.9 in.), 576 pp. / available in GB, D, F, E, I, DK, S

# ONLY € 29.99 / $ 39.99
# £ 19.99 / ¥ 4.900

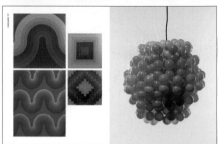